CONTEMPORARY HOLLYWOOD MASCULINITIES

Contemporary Hollywood Masculinities

Gender, Genre, and Politics

Susanne Kord and Elisabeth Krimmer

CONTEMPORARY HOLLYWOOD MASCULINITIES
Copyright © Susanne Kord and Elisabeth Krimmer, 2011.

First published in hardcover in 2011 by
PALGRAVE MACMILLAN®
in the United States—a division of St. Martin's Press LLC,
175 Fifth Avenue, New York, NY 10010.

Where this book is distributed in the UK, Europe and the rest of the World,
this is by Palgrave Macmillan, a division of Macmillan Publishers Limited,
registered in England, company number 785998, of Houndmills,
Basingstoke, Hampshire RG21 6XS.

Palgrave Macmillan is the global academic imprint of the above
companies and has companies and representatives throughout the world.

Palgrave® and Macmillan® are registered trademarks in the United
States, the United Kingdom, Europe and other countries.

ISBN: 978–1–137–37283–3

The Library of Congress has cataloged the hardcover edition as follows:

Kord, Susanne.
 Contemporary Hollywood masculinities: gender, genre, and politics / Susanne
 Kord and Elisabeth Krimmer.
 p. cm.
 Includes bibliographical references and index.
 ISBN 978–0–230–33841–8 (alk. paper)
 1. Masculinity in motion pictures. 2. Men in motion pictures.
 3. Motion pictures—United States—History—20th century. 4. Motion
 pictures—United States—History—21st century. I. Krimmer, Elisabeth,
 1967– II. Title.
 PN1995.9.M34K68 2011
 791.43′653—dc23 2011021690

A catalogue record of the book is available from the British Library.

Design by Integra Software Services

First PALGRAVE MACMILLAN paperback edition: December 2013

10 9 8 7 6 5 4 3 2 1

To John

To Cecily

Contents

LIST OF FIGURES

INTRODUCTION

I'm the big rubber clown doll you had as a kid, and every time you hit it, it bounces back. . . .

That's me—the harder you hit me, the faster I come back up.

<div align="right">Clinton to Newt Gingrich, qtd. in John F. Harris 334</div>

I like a moral problem so much better than a real problem.

<div align="right">Elaine May, qtd. in Vidal 70</div>

IN HIS ARTICLE ON HOLLYWOOD BLOCKBUSTERS, Thomas Elsaesser likens the production of a movie to a military campaign ("The Blockbuster" 17). For Elsaesser, the points of comparison are logistic complexity and finance. After all, only assault helicopters cost as much as the average blockbuster. Although Elsaesser does not elaborate on it, his comparison implies another truism about film, namely the fact that most movies are still decidedly masculine affairs. A large number of Hollywood films are written by and for men, and they are centrally concerned with the challenges and dilemmas of masculinity today.

Since the 1990s, the field of men studies has grown exponentially. Although different in ideology and method, most of these works agree on one defining parameter: contemporary masculinity is in crisis (see West/Lay; Faludi, *Stiffed*; Bordo; Connell; Gilmore; Berger/Wallis/Watson). No longer the unquestioned masters of the universe, men now perceive themselves and are portrayed as beleaguered and oppressed. According to the film critic Wlodarz, "cultural discourses surrounding 'white victimization' [. . .] have been increasingly prevalent in the United States since the Vietnam War" (76). Indeed, if we turn our attention to the most recent crop of Hollywood blockbusters, we will find some support for this theory. A large number of films ranging from *The Bourne Identity* (2002) to *Iron Man* (2008), from *The Matrix* (1999) to *Casino Royale* (2006), and from *Training Day* (2001) to *War of the Worlds* (2005) depict a hero who is beaten down, betrayed, overpowered, and outwitted. The sources of this perceived emasculation are manifold, ranging from government bureaucracies and the military to the modern workplace and the family (see Gabbard 9). More often than not, though, these seemingly defeated protagonists rise from the ashes

and convert their setbacks into ever-greater glory.[1] In contrast, films that depict the "disintegration of the phallic economy" (Powrie/Davies/Babington 11) are few and far between and often do not fare well at the box office. Thus, any claim that men are losing their hold on power should be treated with caution. Certainly, it is true that manhood is under siege, but it is equally true that crisis is correlated to catharsis. The absence of setbacks and defeats is not what differentiates winners from losers. Rather, the ability to transcend victimization provides the yardstick by which films measure their heroes.

The vast majority of recent cinematic hits derive their power from the revitalization of a threatened or temporarily destabilized masculinity. But these triumphs are often short-lived. Their tenuous nature is evident not only in the considerable irony with which some of these films treat their excessively capable heroes, but also in the preference for sequels in which the hero must prove his masculinity over and over again.[2] Through the repetition compulsion of the ever-triumphant sequel hero, these films replay the moment of crisis and substitute provisional victories for permanent solutions. Moreover, sequels not only show that masculinity is a never-ending problem, but are themselves a symptom of the disease. Hollywood increasingly relies on pre-sold products that draw, for example, on the audience's familiarity with a story or character.[3] The actor hero's masculinity, however, is hardly enhanced by the fact that "the franchise is the star" (Kristin Thompson 6). In light of these emasculating trends, the most potent hero in today's cinema is not the steady fighter, but the man who has undergone castration and still emerges as the guy with the biggest stick. Unlike femininity, which is construed as natural, masculinity is seen as the proud product of a prolonged struggle. Conversely, while real men keep working on their manhood, losers are losers not because they experience an effeminate, powerless state, but because they remain stuck in it.

The following chapters show that remasculinization figures as a defining narrative in contemporary Hollywood films, even if some protagonists fail to live up to its promise. It is a narrative that was much needed after the "feminization" of America on 9/11 (see Faludi, *Terror*). It is also a narrative that informed the perception of the two presidents whose time in office provides the frame for our study. When it comes to male role models in the United States, the importance of the presidency can hardly be overestimated. Since, as Gore Vidal suggests, personality is about all that our media can cope with (69), the country's leaders are not only at the top of the political hierarchy but also serve as our "leading men." As is to be expected, remasculinization, the ability to rise like a phoenix from the ashes, is a central trope in the lives and presidencies of William Jefferson Clinton and George W. Bush. Tellingly, one of the most popular accounts of Clinton's presidency is entitled *The Survivor* (John F. Harris 2005). Clinton's entire presidency is defined by setbacks and reversals. Before he rose to national prominence as the "comeback kid," Clinton was both the youngest governor and the youngest ex-governor after Arkansas voters ousted him two years after his election. As president, Clinton recovered from a devastating loss in both houses of Congress in 1994 to face down his opponents in a government shutdown that left Clinton as clear winner. And he reemerged from a demeaning sex scandal to leave office with a 60 percent approval rating. Ducat attributes this astonishing comeback to the fact that the affair remasculinized Clinton, who was long perceived as

"pussy-whipped" by his wife (11). Similarly, George W. Bush's entire campaign was based on a narrative of triumph over adversity. In the absence of any other demonstrable successes, Bush trumpeted his triumph over his alcohol addiction as proof of his leadership qualities and general strength of character. Throughout his presidency, he emphasized his masculinity through carefully staged "red-meat moments" such as his G.I. Joe stunt on the aircraft carrier USS *Lincoln* to declare victory in Iraq in 2003, seven years before the United States initiated its final retreat.

If the perception of the presidency and the representation of masculinity in film are isomorphic, it is because they both draw on the same reservoir of cultural values and myths. In particular, contemporary U.S. culture remains enamored with what Spicer identifies as the "core American masculine myth": "successful, competitive individualism" (*Typical Men* 65). In film after film, clear and present danger is averted by exceptional individuals, never by organizations or, God forbid, institutions (see Jeffords, "Masculinity" 257–8; Parenti 2). Incompetent and malevolent bureaucracies do not solve problems; they *are* the problem. Seen in this light, Wilentz's claim that we still live in the age of Reagan with its excessive distrust of institutions and its advocacy of the "self-made and remade man" holds true (129). Hollywood film is enamored with change, national progress, and personal growth. But, as Ina Rae Hark points out, it is less willing to acknowledge the inherent conflict between its love affair with the exceptional individual and its purported promotion of democratic values. To present the relation between the superhero and his community as harmonious, these films must "efface any suggestion that true masculinity could express itself undemocratically" (Rae Hark 152). Hence, numerous films, from *Zorro* to *Spider-Man*, labor to include an otherwise superfluous scene in which the masses come together to aid the hero in his quest.

In addition to his phoenix-like ability to pick himself up and start all over again, the contemporary male hero is defined by his ability to negotiate contradictory identities imposed by conflicting social roles.[4] Here too, film and politics converge: the desire for a manhood that integrates diametrically opposed attitudes is also evident in the public perception of Clinton and Bush. Bill Clinton's public image is defined by blatant contradictions. Clinton is known as both an adulterous lecher and a feminist; a simple son of a drunkard father from Hope and an elitist Rhodes scholar who attended Oxford and Yale; a bleeding-heart liberal pushover and a tough reformer; a calculating, devious politician whose decisions are based on polls and a transparent gusher who cannot control his impulses. Similarly, George W. Bush combined the elite upbringing of his East Coast pedigree with frontiersman credentials on his Crawford farm. He marketed himself variously as a public advocate of compassionate conservatism and the fearless fighter of terrorism in the wake of 9/11. In fact, the most effective ad of Bush's 2004 campaign successfully combined both traits: "The Hug" shows Bush embracing a young girl who lost her mother to the attack on the World Trade Tower, thus establishing his credentials as caring father and strong protector.

Clearly, if the 1980s are the era of the "hard body" action hero and the early 1990s the heyday of the loving, sensitive, protective family man (see Jeffords, "Masculinity" and Sutton 146), the heroes of the Clinton and Bush eras strive to combine both types in one package.[5] Consequently, the films abound with protagonists who have

secret identities, including Zorro, Spider-Man, and Iron Man. But they also feature numerous heroes who have what one can only call split personalities. Thus, the father in *Road to Perdition* (2002) is both a cold assassin and a devoted family man. The soldiers in *Saving Private Ryan* (1998) are citizens and warriors, and the new Bond in *Casino Royale* is both vulnerable and impregnable. Even action heroes must now reconcile the sensitivity of the new family man with the violence required for the job. Indeed, the way in which films solve this dilemma determines their genre. In a comedy, such a *Grosse Pointe Blank* (1997), the conflict between violence and sensitivity is played for fun. In a thriller, the same conflict is all-consuming, and its resolution will not come easy.

As these examples show, the conflicting demands imposed on the new hero call for a skilled negotiation of the interface of masculinity and violence. In film after film, violence emerges as the crux of masculinity. How can men be both violent and loving, both sociable and competitive? Some films solve this conflict—or obfuscate it, as a less optimistic reading might conclude—by portraying aggression as essentially defensive, the flipside of a man's duty to protect and serve. A good man will fight for his family and his country. Conversely, a protagonist who is defined through a romantic relationship will never be violent unless he is called upon to defend his beloved. In *The 40-Year Old Virgin* (2005), for example, the loser protagonist is lovable precisely because he never resorts to violence. In both lover and lovable loser films, he-men are despicable, and immature protagonists shed their Peter Pan syndrome and assume the responsibilities of adult masculinity without donning the mantle of aggression. In contrast, the real loser, such as the protagonist of *One Hour Photo* (2002), cannot control his violent impulses.

Films that feature secret agents and cops resolve the conflict of violence and emotion through different narrative tacks but essentially along the same parameters. The violence of the secret agent, for example, is unproblematic because he remains a loner. Any female mate of Bond, Bourne, or Ethan Hunt is either killed off at the end or silently disappears before the sequel. In contrast, cop films and detective films find it much harder to reconcile normative masculinity and violence. Many recent cop films erode the boundary between criminals and the detective, between illegal and lawful aggression. In a world gone awry, cops are killers, killers escape justice, and sociopathy is a normal human response. Here, the hero emerges as exceptional because his actions alone are untarnished by this confusion of right and wrong, of killer and citizen. Finally, while the incorruptible cop is a figure in splendid isolation surrounded by men who are infected with violence, war films that succeed at the box office depict manhood as essentially intact. Here, violence and masculinity can be reconciled because aggression serves a national purpose. In the most lucrative recent war films, the acquisition of martial skills is part of a maturation process: "learning to be a good soldier is a natural phase in the process of reaching adulthood" (Dittmar/Michaud 11).

Just as it must seek to reconcile violence and "softness," successful masculinity must also achieve a workable balance between the tent poles of paranoia and omnipotence. One of the most popular narratives in contemporary film centers on betrayal. Heroes are stabbed in the back, literally, such as Maximus in *Gladiator* (2000), and figuratively. Traitors surround them, and paranoia of the "trust no one" variety, as

simultaneously portrayed and lampooned in Richard Donner's *Conspiracy Theory* (1997), is the only reasonable response. Contemporary masculinity is defined by its ability to navigate between the threat of betrayal and the challenge to trust, between the splendor of heroic individualism and the need for cooperation and community, between killing and caring.

Because of these conflicting imperatives, the intimate relation between violence and masculinity has become suspect, and many films of the last two decades set out to question, explain, or legitimize it. Again and again, the threat of violence, its tendency to corrode all civil and familial relations, must be tampered or defused. The individual performer's charisma is crucial in this respect. In order to negotiate positions that are essentially irreconcilable, film relies heavily on the "star effect," that is, the star's ability to effect "a 'magic' reconciliation of the apparently incompatible terms" (Dyer, *Stars* 30). Furthermore, the hero's paradoxical duality also has implications for a film's choice of genre. Specifically, the imperative to reconcile positions that are mutually exclusive is mirrored in the preference for genre hybrids. Of course, there is also a strong economic incentive for the production of ever more films that integrate different genres and thus appeal to different audience segments simultaneously. But this "hyperconscious eclecticism" (Collins 250), the knowing combination of romantic comedy and action thriller, evident in films such as *Mr. & Mrs. Smith* (2005), also expresses the conflicting demands placed on contemporary manhood.[6]

In addition to personal charisma and genre hybrids, style and narrative also serve to reconcile the audience to the preeminent role of violence in the construction of masculinity. For example, many films reduce violence in status and portray it as one skill set among many. In the rogue or spy film, old-style brawn is frequently supplemented with "softer" qualities such as intelligence, experience, cunning, and wit. Moreover, many recent films negotiate their heroes' split identity through a pervasive sense of irony.[7] As Greven suggests, "masculinity became aware of itself as both monolith and joke [...] Heroes can now employ the alternate techniques of ironic distance and violence—joking or punching one's way out of complicity" (16).

Films that cast violence as self-defensive frequently mark its target as eminently lethal and morally deficient. And, of course, since we are dealing with a visual medium, this moral abjection is written on the body. In Hollywood blockbusters, morality remains destiny (see Philip Green 55), and the eighteenth-century science of physiognomy rules supreme. Today's James Bond villains still have the same scars or disfigurements that characterized their fictional 1960s ancestors. The pirates of the *Pirates of the Caribbean* franchise (2003; 2006; 2007) have bad teeth, and all villains in *The Lord of the Rings* (2001; 2002; 2003) truly look their part. Their visual deviancy signals that they can be dispatched with impunity. Conversely, one of the most intriguing and innovative features of *The Matrix* consists in the fact that here ultimate evil looks just like you.

One of the most intriguing aspects of male-centered Hollywood films is the fact that violence, possibly because its reign is so supreme, is often employed as a metaphor for issues of an entirely different nature. Translating the figurative into the literal, these films transform the mundane challenges of our everyday world into high-action drama. Thus, in *Grosse Pointe Blank*, the contract killer exemplifies the demands placed on personal integrity by the contemporary workplace, a cutthroat

environment in which you have to walk over dead bodies to make a killing. Similarly, *Mr. & Mrs. Smith* relies on an orgy of violence to dramatize the emotional cost of marital life. To be sure, most films that depict spectacular explosions, lethal combat, and bloody fights are concerned with the interrelation of violence and masculinity. But violence also offers a convenient visual metaphor for countless other male challenges.

In his study of recent Hollywood film, Greven calls the early 1990s "the period in which Hollywood masculinity became self-aware" (13). Increasingly, film theory is taking its leave from Mulvey's influential 1970s paradigm of the masculine gaze.[8] Today, the male figure "just as often and just as intently connotes to-be-looked-at-ness" (Greven 13). A man is no longer defined exclusively by his actions as the same regime of bodily ideals that has long tormented women now expands its reign to men. Even so, important gender differences still hold. In spite of this focus on the male body, "male desirability is still considered much less important than male desire in cinema" (Susan White 189). Similarly, the narrative context in which men's bodies are presented as objects of the gaze differs from the female setting. As Kirkham and Thumim point out, the "eroticization of the male body is routinely motivated by the evidence of suffering and endurance" (12). When the Bond girl undresses, it is for sex. When Bond disrobes, he is about to be tortured.

Although the focus on the male body is arguably new, its specific contours conform to expectations. In Hollywood film, "to be a real man is to look like one, to be tall, strong, powerful" (Lehman, *Running Scared* 89). Typical male heroes, the subjects of the chapters on the superhero, spy, adventurer, and lover, are muscular, tall, and handsome. Clearly, the "undoubtable marketability of the male body in the 1980s" (Tasker, "Dumb Movies" 232) continues through the 1990s into the new millennium, even if the hard bodies of Sly Stallone and Arnold Schwarzenegger have been toned down a notch. Action heroes now look like Matt Damon and Tom Cruise, and, in films such as *The Mask of Zorro* (1998) and *Mission Impossible* (1996), balletic grace complements traditional strength.[9]

In its attempt to capture the paradoxes of contemporary masculinity, this volume pays attention to the representation of the male body, the interrelation of violence and masculinity, and the bonds between the individual and his community. The analyses of specific films are attuned to real and perceived threats to manhood and seek to relate their findings to contemporary cultural and political contexts. Each chapter is devoted to a particular type of masculinity: the cop, the father, the cowboy, the superhero, the spy, the soldier, the rogue, the lover, and the loser. The decision to organize the material discussed in these pages according to distinct types of masculinity reflects the defining impact of genre concepts, but it is also designed to facilitate a dialogue between filmic representations of masculinity and contemporary reality during Bill Clinton's and George W. Bush's presidencies. Although the transition between social types and archetypes is fluid, our focus is on social types because they are intimately related to the political, economic, and social realities of the late twentieth- and early twenty-first centuries. The assumption here is that there is an inextricable link between the fate of masculinity and that of the nation. Narratives of empowered nationhood often go together with images of dominant masculinity (see Parpart 176), whereas crumbling male authority is co-joined with the decline of

Empire. Clearly, an attack on Bond's balls, as happens in *Casino Royale,* concerns far more than the private parts of Her Majesty's secret agent.

There are many different kinds of films in contemporary Hollywood: blockbusters and everyday schmaltz, but also consciousness-raising and explicitly political films, such as *Michael Clayton* (2007), which deals with corporate corruption, and *Syriana* (2005), a film that explores the global impact of the oil industry. Today's Hollywood films are highly intertextual, a veritable "mirror-house of self-referentiality" (Sanjek 113; see also Elsaesser, "Specularity"), and often rely on irony and in-jokes. Still, even though some films with artistic aspirations have penetrated the market, the movies that receive the bulk of attention in the media are by definition the big blockbusters. As Schatz explains, "blockbuster hits are, for better or worse, what the New Hollywood is about, and thus are necessary starting points for any analysis of contemporary American cinema" (10).[10] The bottom line, that is, the profitability of a film at the box office, speaks to the cultural resonance of its motifs, characters, and narrative. Consequently, the films selected for discussion in these pages are chosen in part for box-office performance, and information on "the numbers" headlines the analysis of each film. However, profitability is not necessarily a marker of quality, and in the age of niche markets, success is defined differently in different venues. Thus, we have expanded our selection to include a variety of films that do not qualify for blockbuster status.

Just as the films themselves are in large part chosen for popularity, the types that we have culled from this corpus are selected for the frequency with which they recur. Each type stands at multiple intersections between important contemporary discourses and developing models of masculinity. The first section deals with films in which masculinity is in crisis. The interpretations of cop and serial killer movies relate their findings to the contemporary reality of law enforcement. The analysis of cinematic representations of the father explores connections to political debates on the family, and the chapter on the cowboy discusses the role of myth in the conceptualization of manhood and nation. The second section deals with traditional versions of masculinity, films in which masculinity emerges triumphant. Chapter 4 establishes a connection between the exploits of superheroes, Bush's war on terror, and competing leadership styles. Chapter 5 links the spy film to political discourses on torture and intelligence, and Chapter 6 relates its analysis of the soldier to the historical wars that inform these films. Finally, the third section deals with films that seek to redefine, update, or "airbrush" old-style masculinity. Chapter 7 analyzes how the figure of the rogue is used to negotiate colonial power dynamics, concepts of race, and processes of "Othering." The chapter on the lover reads romance against the backdrop of contemporary discourses on gender equality, and the chapter on the loser refers to discourses on welfare and the notion of a meritocracy.

As this conceptualization plainly suggests, all interpretations in this book are guided by the assumption that Hollywood films convey political messages even if their desire to reach large segments of the market prevents them from peddling their convictions openly. Certainly, every big Hollywood production is designed not to alienate any potentially lucrative segment of its market. But, as King explains, "this does not make the films any the less political in their implications [...] it makes them less explicitly and recognizably political" (*New Hollywood* 80).[11] Thus, the

political messages of Hollywood film are often indirect and tend to remain below our threshold of conscious perception. This, however, does not lessen their hold on our imagination or reduce their power to influence our actions. On the contrary, if anything, the subliminal nature of their politics makes them all the more effective. When movies become "agents of social change" (Trice/Holland, *Heroes* 2), it is not because they convey specific messages, but because they impose "structures of perception upon the audience" (Braudy 46). Films provide models of leadership; they show us how to respond to danger and how to think about violence; they teach us when to start wars and how to use or not use technology. They show us whom to trust and how to negotiate the demands of family and state. And they define masculinity as a composite of varying parts of professionalism, intellectual superiority, learning, brute power, looks, and language (see Lehman, *Running Scared* 58). Every film establishes subtle but distinct links to our contemporary world. In representing and misrepresenting reality, films inform and even create the standards by which we judge our current and future actions. Thus, any analysis of film benefits from a working concept of ideology that seeks to link the silver screen to the reality behind it in order to alert us to a film's méconnaissance of its time.

Of course, to say that Hollywood films are highly political is not to say that they offer solutions to contemporary problems.[12] Even if we accept that these films portray real crises, we need not assume that the solutions they offer are equally genuine. Rather, as Michael Wood suggests, films offer "imaginary solutions to an authentic dilemma . . . the solution has to be imaginary *because* the dilemma is authentic" (xiii).[13] We tend to overestimate the representational work of film as much as we underestimate and misjudge the nature of their political impact. Although Hollywood films are demonstrably political, they tend to recast political preferences as emotional differences.[14] Ideology is converted into psychology so that a critique of capitalism is rephrased as a denunciation of greed. For example, a surprisingly large number of films evince a discomfort with material riches and consumerism. At times, this is played out as a humorous attack on the suburban lifestyle, such as the destruction of the designer house in *Mr. & Mrs. Smith*. But it also features as a source of personal tragedy and deep unhappiness, as in *Punch-Drunk Love* (2002). And yet, although the films and their heroes are troubled by the emptiness of the consumer lifestyle, they tend to convert what could be a powerful critique of society, corporate capitalism, and imperialism into a moral tale. Again and again, personal growth renders structural change unnecessary. Similarly, instead of highlighting the power dynamics of colonialism, films such as *The Mummy* (1999) and *The Pirates of the Caribbean* denounce greed and licentiousness. Inevitably, politics gives way to psychology, and structural problems are translated into personal motivations and aspirations.

In light of this preference for psychology over politics, it is hardly surprising that corruption, which features prominently in many contemporary films, is hardly ever portrayed as systemic but rather as the result of the moral failure of particular individuals. Again, we are not dealing with larger socioeconomic structures, but with moral shortcomings, which can be addressed by removing the culprit. As Elaine May put it so poignantly, "I prefer a moral problem to a real problem" (qtd. in Vidal 70). If a film does portray systemic corruption, the prime victim is invariably the average

American citizen (white, male) rather than, say, a citizen of Arab descent. Still, it would be hasty to conclude that "the majority of mainstream films are brilliantly supportive of the status quo, all the while pretending to subvert it" (Bell-Metereau, "Eating" 93). Rather, we assume with Nadel that "no narrative can be a seamless and perfect manifestation of its ideological presumptions" (11). Similarly, although a star's charisma may reconcile us to ideological contradictions and thus functions "as the bait for swallowing ideological assumptions that are repressive and demeaning" (Nochimson 34), it can also have the opposite effect. As Loukides and Fuller point out, "in the hands of skilled actors, every role in every formula was at risk of being subverted by unintended ambiguities" (47). As this book shows, contemporary films are riven with contradictory messages.[15] They fall short of both their liberal intentions and their conservative inclinations. For example, a large number of recent blockbusters appear to suggest that good old violence is the best way to deal with any kind of crisis, be it criminal or international in scope. And yet, in spite of such clandestine and overt support for war and violence, a surprisingly large group of films refuses to fall in line with the notion of an "Axis of Evil," in which you are either with us or against us. In film after film, good and evil are blurred. You can be both a pirate and a good man in *The Pirates of the Caribbean*. Almost everyone is corruptible in *The Lord of the Rings,* and almost everyone can be redeemed. In *Identity* (2003), the psyche of the killer is composed of both moral and amoral characters. In *Mission: Impossible III* (2006), the hero's similarity with the villain is evident long before a facemask and voice decoder make them indistinguishable. Finally, in cop and detective films, the good guys, if we can even call them that, are (occasionally) successful because of their emotional and intellectual closeness to the bad guys. And the actions of the bad guys often have a surprisingly "moral" motivation, such as Hannibal's impatience with common foibles or the serial killer's quest to punish sins in *Se7en* (1995). Again and again, these films fly in the face of neat divisions of good and evil.

The most successful Hollywood blockbusters offer a hodgepodge of contradictory messages. They advocate what Richard Slotkin has termed *Regeneration through Violence,* even as they simultaneously problematize and refute violence. They are marked by a "nostalgia for a prelapsarian homosocial economy of white male centrality" (Fradley 238), even as they display the damaging effects of such structures. They are testimonies to a culture of "fearsome male narcissism, a culture of aggrandizement and inflation" (Horrocks 20–21), and they rely on irony and self-parody to deflate their heroes' grandstanding. Faludi is right when she claims that a "new John Wayne masculinity was ascendant" after 9/11 (*Terror* 4), but this trend did not remain uncontested. As our analyses show, the films of the Clinton and Bush presidencies seek to negotiate the complex demands made on manhood today. Especially films that portray lovers, cowboys, fathers, cops, and losers tend to deconstruct traditional notions of masculinity, whereas spy and redeemer films are more likely to uphold them. Admittedly, films often run the danger of trivializing and obfuscating the problems they discuss. But more often than not, a film's greatest selling point and its most truthful and intriguing message lies not in the solution it offers, but in its inability to resolve the contradictions that inform it.

The image of masculinity that emerges in these films may not be encouraging, but it does help us understand what it means to be a man in today's society. And

if some recent trends hold, then this is by no ways a small accomplishment. Many blockbusters discussed in these pages have successfully combined spectacular special effects with a coherent narrative (see King, *Narratives*; Buckland 167; Murray Smith 13). Some are "as formally strict as a minuet" (Bordwell 109). However, there is a disturbing trend in the most recent blockbusters, such as *Iron Man 2* (2010), to sacrifice coherence in favor of an aesthetics that is based on video games. Seen in this light, the ever-increasing importance of the teen market and secondary markets, ranging from DVDs to theme parks and merchandising (see Winston Dixon, "Fighting" 127; Krämer, "Aimed at Kids" 362), represents both an aesthetic and a narrative challenge. Since the current conditions of production and distribution are based on horizontal integration and favor texts that are open to "multimedia reiteration" (see King, *Narratives* 188), this form of video game aesthetics is likely to thrive. While many of the films discussed here hold our interest precisely because they strive to but ultimately cannot solder the porous border of violence and masculinity, the next generation of blockbusters may no longer be afflicted by this dilemma. Taking its cue from first-person shooter games, the new hero may well obliterate conflicts and complexity once and for all.

MEN IN TROUBLE

CHAPTER 2

LAWLESSNESS AND DISORDER: COPS AND OTHER SERIAL KILLERS

"LAW"

[Cops] do not care. We regular people, who suck, can clean up the mess.

Neal King, *Heroes in Hard Times*, 209

This is a movie about a couple of killers. Harry Callahan and a homicidal maniac.
The one with the badge is Harry.

Don Siegel about his film *Dirty Harry* (1971)

When I was your age they would say we could become cops or criminals.
Today, what I'm saying to you is this: when you're facing a loaded gun—what's the difference?

Francis Costello in *The Departed* (2006)

TO VIEWERS WHO THINK THAT COPS AND KILLERS ARE ON OPPOSITE SIDES, that cops chase killers and bring them to justice, a whole range of films proclaim: think again.

During the past twenty years, the cinematic detective genre has undergone a seismic shift. The modern detective is a compromised cop, often undistinguished by brain or brawn. He is crippled, like Lincoln Rhyme (Denzel Washington) in *The Bone Collector* (1999). He spends most of the film on the wrong track, like Del Spooner (Will Smith) in *I, Robot* (2004). He is teamed up with, and at times undermined by, a more competent female colleague,[1] like the cute but colorless detective trainee Reuben Goetz (Dermot Mulroney) opposite the rather more formidable M. J. Monahan (Holly Hunter) in *Copycat* (1995). And he frequently knows no more than the viewer. The great revelation scenes of the past, in which Sherlock Holmes, Hercule Poirot, or Detective Columbo unveil the mystery, leaving the audience in breathless admiration of their dizzying deductive leaps, have vanished together with the brain detective.

Worst of all, cop-and-killer films of recent decades blur the distinction between the two to a worrying degree.[2] "In Hollywood movies since the mid-1960s, the police

have become increasingly like the criminals they face. There is no evidence of a reversal of this trend during the 1990s. Today's Hollywood moviemakers draw a much thinner line between the heroes and villains than they did in the studio days" (Powers, Rothman and Rothman 116). In films since the 1990s, even that thin line is often crossed. The ethical cop is portrayed as the exception, the clean or only half-spoiled apple in a barrel of rotten ones, the lone individual standing up to the corrupt system either to clear his name or to assuage his guilty conscience (*The Negotiator*, 1998; *Edison*, 2005). If he starts out as ethically intact, he may lose his innocence in the course of the film, for example, through unwilling identification with the criminal initially necessary for "detecting," but also because, having been too close to evil, he is lured into the criminal underworld by love, greed, or anger (*Narc*, 2002; *Miami Vice*, 2006). Usually, however, he is already there; he *is* the bad guy, or worse than the bad guy. Hannibal Lecter (Anthony Hopkins in *Hannibal*, 2001) may be a sadistic killer, but compared with the slimy backstabbing sexist pig Paul Krendler (Ray Liotta), he comes off rather well.[3]

So what has happened to the detective who is intellectually, physically, and ethically superior to "regular people" and therefore able to protect and serve them? This stalwart of order has not disappeared entirely, but makes an occasional comeback in films that desperately counterbalance the cinematic trend toward corrupt cop films (*U.S. Marshals*, 1998, for example, in its starry-eyed portrayal of the Blue Brotherhood, protests entirely too much). Or, more tellingly, the brainy detective has been banished to costume dramas portraying the distant past,[4] like Johnny Depp's police constable Ichabod Crane in *Sleepy Hollow* (1999). In the vast majority of detective films set in the contemporary world, however, he no longer plays a significant role.[5] Modern cop films are no longer about good versus bad, but about middling versus bad. Even films in which cops undergo a development and change for the slightly better (*L.A. Confidential*) or manage, in the end, to resist the temptation of corruption (*Training Day*) do not link the "good" cop to the police force as an institution; rather, he remains exceptional and alone. Moreover, even films that still distinguish between "good" (cops) and "evil" (criminals) tend to establish a visual "identity" between the two and refuse to deal out justice in the traditional sense. In Martin Scorsese's star-studded *The Departed* (2006), for example, good cop Billy Costigan (Leonardo DiCaprio), an undercover policeman who has infiltrated the Irish mafia, is visually conflated with bad guy Colin Sullivan (Matt Damon), a mole for the Irish mafia in the police department. In the chase scene, both wear identical outfits of jeans, shirt, and baseball cap and are distinguished only by positioning (the good guy is, naturally, behind). Both "depart" life in an identical manner: they are murdered, as are their respective bosses, Police Captain Queenan (Martin Sheen) and Mob boss Frank Costello (Jack Nicholson). The film's portrayal of the police captains Queenan and Ellerby (Alec Baldwin) as utterly clueless confirms the rather low level of confidence in the justice system indicated by this ending. All the grand talk of building a case against the baddies and bringing them to justice is just that, talk; in fact, the only person in the film who does any jail time is good guy Billy, who thus establishes his criminal credentials in preparation for his undercover role.

Cinematic misgivings about policemen and the police force can easily be read as mirroring a real-life distrust in "the law," any form of systemic justice in general

and the police in particular. Such distrust, some would argue, is richly earned. Over the past decades, the New York Police Department (NYPD) has repeatedly come under scrutiny for corruption, the Los Angeles Police Department (LAPD) for excessive force.[6] Former police officers have published memoirs alleging widespread and largely unpunished abuse of suspects and other citizens (for example, Crouch, Doyle, Juarez), and these individual allegations have found statistical support in a number of studies.[7] "Nearly 60 percent of the observed police-citizen encounters involved some form of force," claims a report on 3,544 relevant cases in St. Petersburg and Indianapolis (data collected in 1996–97; Terrill 223). The account goes on to state that the police met with verbal or physical resistance in only about 12 percent of these cases and that "[c]itizens who displayed disrespectful behavior toward officers were no more likely to have force used on them than those who were respectful" (Terrill 223–35). The NYPD has admitted that only one in ten stops are ever recorded—that is, that hundreds of thousands have been stopped and searched without any record documenting this (Daniels 244). There is now a published list of people killed by police officers for holding toy guns, brooms, telephones, VCR remotes, beer bottles, and cigarette lighters and of people killed while reaching for their IDs or standing with their hands up in the air. In all cases, the shooting officer claimed to have mistaken the object in the victim's hand for a gun (Thorne). Recent incidents include the killing of Amadou Diallo, an unarmed street vendor, by four NYPD officers (who were acquitted) in 1999; the killing of Archie Elliott in Prince Georges County, Maryland, in 1993 (Elliott, sitting in the front seat of a police cruiser while his hands were being cuffed behind his back, was shot 14 times); the execution of Kim Groves by a policeman in 1994 who had learned that she had filed a police abuse complaint against him; and the shooting of Ivory McQueen for holding a kitchen knife (Daniels 240–44). Undoubtedly the decade's most debated act of police brutality was the beating of Rodney King by four LAPD officers in 1991. It resulted in four days of civil disorder in South Central L.A. and a widespread (largely academic) police brutality debate over the following two decades; it did not result in serious punishment for any officer who had either participated in or observed the beating, or in the awarding of punitive damages to King.[8] Several film critics have linked the brutalization of Rodney King to the post-1991 resurgence in cop flicks that portray the criminals with the badge as a bigger problem than those without (see Greek, Surette, Lott).

While Rodney King's abusers furnished the social blueprint for many corrupt movie cops since 1992, the renegade cop exemplified by Clint Eastwood's Harry Callahan (*Dirty Harry*, 1971) provided a cinematic model.[9] Unlike his successors in the 1990s and beyond, Dirty Harry is not "dirty" because he is on the take, but because he gets his hands dirty by cleaning up the mess that the legal institutions (the police and the courts) are afraid to touch. Like the Lone Cowboy, another character practically owned by Eastwood,[10] he deals out vigilante justice; like the cowboy, he symbolizes "a resurgent America [in the Vietnam era]. The cops, the government, the armed forces were losing. America needed a hero, a winner" (Houck 66). Harry expresses virulent dislike of hippies and peaceniks in his battle with the long-haired killer Scorpio, a perfect visual image of the type. Harry's half-hearted attempt to work within the system fails when a legal expert from Berkeley, that hotbed of hippies, claims that the evidence against Scorpio is useless because Harry collected it in

legally inadmissible ways (Houck 84). In response, Harry takes the law into his own hands, his adversary now being not only the hippie killer but also the hippie politics protecting him.

The film's tension feeds largely off the question whether Harry's vigilantism is justified or not. On the one hand, viewers are invited to speculate that the abducted girl could have been saved if Harry had been allowed to beat her location out of the suspect. On the other hand, Callahan is identified with Scorpio visually, for example through the similarity between Callahan's police badge and Scorpio's large round metal belt buckle. Clearly, Callahan gets results that the system cannot. And yet, he too is on a downward spiral. At the outset of the film, Harry is an angry cop who, shielded by his badge, tries to goad the suspect into one false move to justify shooting him ("Do you feel lucky, punk?"). At the end, he is an angry guy who throws away the badge but, disturbingly, keeps the gun. Scorpio finally makes that false move (and Callahan's day); Callahan shoots him, blowing him backwards into the river, and throws his badge after him. The badge drowning alongside the belt buckle (Houck 88) is visual shorthand. It tells us that the results-oriented Callahan cannot work within the impotent legal system and that, *for this reason,* he himself becomes a threat. The film essentially presents us with two unlivable alternatives, a legal machinery that cannot catch the killer and a guy who can, but turns out to be as much of a "homicidal maniac"—in Siegel's words—as the killer himself.

Dirty Harry is the prototype for one variety of corrupt cops, the righteous vigilante who bends the rules to get results (Bud White and Ed Exley in *L.A. Confidential,* 1997). The other variety is the cop on the take (Dudley Smith in *L.A. Confidential;* virtually the entire population of Garrison, New Jersey, in *Cop Land,* 1997; Alonzo Harris in *Training Day,* 2001; Jack Wander in *Street Kings,* 2008, and many more).

L.A. Confidential (1997). Dir. Curtis Hanson. Writers: Brian Helgeland, Curtis Hanson. Universal. 2 Academy Awards (9 nominations). Domestic Total Gross: $64,616,940. Foreign Gross: $61,600,000. Total Box Office: $126,216,940. Production Budget: $60 million.

Cop Land (1997). Dir. James Mangold. Writer: James Mangold. Miramax. Domestic Total Gross: $44,862,187. Foreign Gross not available. Production Budget: $15 million.

Training Day (2001). Dir. Antoine Fuqua. Writer: David Ayer. Warner Bros. 1 Academy Award (2 nominations). Domestic Total Gross: $76,631,907. Foreign Gross: $28,244,326. Total Box Office: $104,876,233. Production Budget not available.

In *L.A. Confidential,* set in 1950s Los Angeles, the LAPD, led by Captain Dudley Smith (James Cromwell), tries to project a self-image modeled on the hit show *Badge of Honor,* for which one of the LAPD's officers, Sergeant Jack Vincennes (Kevin Spacey) serves as a consultant. With the song "Accentuate the Positive" playing in the background, the voice of Sid Hudgens (Danny DeVito), *Hush-Hush Magazine's* sleazy reporter, lays out the basics: "In the hit show *Badge of Honor,* the L.A. cops walk on water as they keep the city clean of crooks. Yep, you'd think this place was the

Garden of Eden, but there's trouble in Paradise." Trouble takes the shape of Mickey Cohen, organized crime boss who runs drugs and whores in the city and is responsible for dozens of murders a year. To viewers who wonder "how can organized crime exist in the city with the best police force in the world?" the film offers a simple answer: Mickey C is arrested in due time, like Al Capone, for income tax evasion, but his rackets are taken over by the Hollywood mogul Pierce Patchett (David Strathairn), the district attorney (Ron Rifkin), and LAPD Captain Dudley Smith himself. Both the TV show and Sid's magazine define two recurring Hollywood tropes, the collaboration between press and police and the difference between appearance and reality, as among the film's overt themes. The magazine's motto, repeated several times in a Sid voice-over ("off the record, on the QT, and very, very hush-hush") tips viewers off that just as tabloid reporters uncover sleaze for less-than-noble motives, those who uncover crime in this movie are hardly stand-up, do-right good cops.

The film's three main characters, all members of the LAPD, do not exactly walk on water. Jack Vincennes, knee-deep in Hollywood corruption, is a celebrity chaser and clotheshorse interested only in promoting his own image and making a quick buck. His arrests are coordinated with and payrolled by Sid, who needs fodder for his sleazy magazine. Ed Exley (Guy Pearce) is the LAPD's golden boy. Exley refuses to bend the rules or accept bribes. He is driven by cold-blooded ambition and an expert in psychological warfare who ruthlessly uses his colleagues for his own advancement. Finally, Bud White (Russell Crowe), a legitimate heir of Dirty Harry, breaks every rule in the book in search of "justice." Most of the time, he is not in control of his rage. When we first encounter him, he brutally beats up a man in front of his own home. Later, he executes a defenseless suspect, who remains blissfully unaware of Bud's presence until a bullet hits him in the chest. Tellingly, the commanding officer advertises Bud's renegade behavior as the way to get ahead and uses him to brutalize suspects. When Ed, ever eager to advance in the ranks, asks Dudley what he must do to make detective, Dudley offers the following piece of advice:

> *Dudley.* Would you be willing to plant corroborative evidence on a suspect you knew to be guilty in order to ensure an indictment? [...]
> *Ed.* No.
> *Dudley.* Would you be willing to beat a confession out of a suspect you knew to be guilty?
> *Ed.* No.
> *Dudley.* Would you be willing to shoot a hardened criminal in the back, in order to offset the chance that some lawyer ... ?
> *Ed.* No.
> *Dudley.* Then for the love of God, don't be a detective. Stick to assignments where you don't have to make those kinds of choices.

In spite of this, *L.A. Confidential* shows great faith in compromised cops' ability to come through for justice. When Dudley engineers the murder of a policeman and blames the crime all too conveniently on three black youths, viewers witness a miracle: the sleazeball, the thug, and the rat, three bent cops who despise each other, team up to catch the real crook. All three manage to garner the audience's sympathy in various ways. Jack ditches his TV showmanship for real police work and ends

up a martyr. He is killed by Dudley when he gets too close to the truth. Bud has a "thing for helping women." His family background—his father beat his mother to death—motivates his anger and brutality particularly toward wife beaters. Ed, too, is motivated by the death of a parent. His father was shot by a purse snatcher who got away and whom Ed has christened Rolo Tommasi: "Rolo Tommasi is the reason I became a cop. I wanted to catch the guys who thought they could get away with it. It's supposed to be about justice. Then somewhere along the way I lost sight of that." Overcoming their considerable differences and (in Bud's and Ed's case) their rivalry for the high-class prostitute Lynn Bracken (Kim Basinger), they set out to find the real killer, little imagining that they would find him at the very top of their own outfit.

In a final shootout between Bud, Ed, and Dudley, Ed's desire to get the guy who thinks he can get away with it trumps the career advancement carrot, which Dudley dangles temptingly in front of his nose. "You gonna shoot me or arrest me?" Dudley asks contemptuously as Ed trains the gun on him, with Bud severely wounded on the ground. "Good lad. Always the politician. Let me do the talking. After I've done they'll make you chief of detectives." Ed shoots Dudley in the back and at the following inquest tells the truth, indicting LAPD officers for drug trafficking and murder. But he is not above accepting his promotion on the condition that he keep both Dudley's and the D.A.'s involvement a secret. To save the LAPD's image, Dudley dies a hero's death in the press; the D.A. remains in charge of crime—in more ways than one—and Ed is awarded a medal of valor. "They're using me, and for a little while, I'm using them," he sums up his relationship with the LAPD to Lynn and Bud, who await the results of the inquest in a car outside the courthouse, ready to depart for Arizona. When Ed thanks Bud, who has not sufficiently recovered from his wounds to speak, "for the push" (the push in the right direction? the push up the career ladder?), Lynn answers, "Some men get the world. Others get ex-hookers and a trip to Arizona."

On the personal level, *L.A. Confidential* rather neatly resolves the dilemmas that drive the main characters. Both Bud and Ed achieve what they have always wanted, a loving family life in Bud's case, and career advancement in Ed's. Even Jack gets the fame he craved, albeit posthumously: after the credits, we are shown a 1950s TV screen with the credits for a *Badge of Honor* show dedicated to Sergeant Jack Vincennes. But personal wish fulfillment comes at the price of uneasy compromises. Jack, who was, after all, murdered by a cop, is used after his death to uphold the police department's reputation. Ed takes a leaf out of Bud's vigilantism, not to mention Dudley's advice, and shoots a hardened criminal in the back rather than arresting him. Thus, the film appears to endorse the assumption that vigilantism is the best guarantee of justice. Finally, the district attorney, the film's Rolo Tommasi, gets away clean. Street justice can provide a temporary sense of relief, here encapsulated in whatever pleasure the audience may feel in seeing Dudley go down. But it does little to eradicate corruption on an institutional level. The song "Accentuate the Positive," which recurs throughout the film, is also played over the credits, underscoring the film's final irony: "You've got to accentuate the positive, eliminate the negative, latch on to the affirmative, don't mess with Mr. In-Between." And yet In-Between, the murky land of compromise, is apparently as good as it gets: all one can do against

the representatives of a corrupt system is to use them back for a while or take a trip to Arizona. In-Between is also an apt description for the film's heroes, who compare favorably with "bad cops" like Dudley, but whose brutality (Bud), opportunism (Ed), and vanity (Jack) complicate a unilateral acceptance of these characters as "good cops."

Cop Land, set in the 1970s and made in the same year as *L.A. Confidential,* features a similarly compromised hero. Cop Land is shorthand for the city of Garrison, New Jersey, populated by New York City policemen who had themselves declared auxiliary transit police so they could live outside the city. It is a peaceful, idyllic, crime-free place, the cookie-cutter image of American suburbia with its little white houses, white residents,[11] neat lawns, and Jacuzzis. It is also a front for the Mob, and the resident cops owe their nice houses to their willingness to turn a blind eye to the Mob's drug runs through their precinct in New York. The town is "policed" by Sheriff Freddy Heflin (Sylvester Stallone), who, deaf in one ear after an accident, is repeatedly rejected for real police duty in the NYPD; in Cop Land, there is nothing for him to do but direct traffic and rescue kittens in trees. Cop Land is a town above the law: speeders are not stopped, shootings of unarmed black men are covered up, witnesses to corruption meet with unfortunate accidents, and Sheriff Freddy is contemptuously patronized by the NYPD residents, above all Ray Donlan (Harvey Keitel), the town's top cop and main Mob connection.

The central conflict develops when Ray loses control over two of his underlings, Figgsy (Ray Liotta), whose partner was murdered by Ray because he was ready to testify against him, and Superboy (Michael Rapaport), who is a liability because of a failed cover-up. At this point, Freddy must decide whether he wants to be a sheriff or a cop. As a "sheriff," he would remain Ray's creature and ignore corruption. As a "cop," he must throw in his lot with the Internal Affairs investigator Moe Tilden (Robert De Niro) to find and bring in Superboy, who, terrified of the cops, has gone into hiding. Predictably, Freddy decides to be a cop and comes through in grand style. He brings in Superboy and single-handedly takes down most of the big-time corrupt cops of Garrison in a glorious shootout at the end of the film.

On the surface, Freddy is an unlikely gunslinger.[12] He is a bachelor who spends half of the film walking around sloppily clad, his shirt hanging out of his pants. He sports a massive beer belly and spends his birthday alone in a bar playing pinball. Half deaf, he has difficulty understanding others, and nobody listens to him. But behind this unassuming exterior, there is a hero, or at least a former hero. As a young man he jumped into the Hudson River to rescue a teenage girl from drowning. This feat of heroism caused his deafness and essentially ruined his career, preventing him from getting a coveted spot in the NYPD. And this is not the only indignity he suffered. The rescued girl, with whom he fell in love, married someone else, another policeman and would-be informant whom Ray and his cronies murder. Freddy's decision to be a "cop" hinges centrally on his ability to find that kind of heroism in himself again, in the full knowledge that once again it may not be rewarded. But as a "sheriff," he has become too cowed. "You know, if I saw Liz drowning in the water, if I saw that today, I wouldn't go in. I'd stand there, and I'd think about it. And that's the best thing I ever did with my life." Freddy's deafness is his major handicap, but also testimony to his courage and profound integrity, which stands in the starkest possible contrast to the

corruption in town. Finally, it also serves as a reminder of the danger in which this integrity places him: in the shootout scene, he is completely deaf because one of his opponents fires a gun right next to his good ear. Having lost some (in this scene, all) of his hearing, Freddy is an obvious victim and unlikely hero.

In *Cop Land,* crime and payoff are as unrelated as heroism and happiness. Collaboration with the mafia does not result in mafia-style wealth. "The Mob runs millions in drugs through the precinct, and everybody gets a nice house." What the bent cops achieve is no more and no less than what most Americans want: a nice place to live, a safe place to raise families, and protection from crime. This dream of peaceful suburbia is the vision Ray sells to Freddy:

> Freddy, I invited men, cops, good men, to live in this town. And these men, to make a living, they cross that bridge every day to a place where everything is upside down, where the cop is the perp and the perp is the victim. But they play by the rules. They keep their guns in their holsters, and they play by the rules. The only thing they did was to get their families out before it got to them. We made a place where things make sense and you can walk across the street without fear.

Despite the obvious irony—in Garrison, New Jersey, the cop is the perp—the desire for order and safety expressed here is sure to resonate with a large part of the American audience. What Ray describes is, in fact, the reality lived by most middle-class Americans, who flee from crime-ridden cities to live in neat, all-white, and apparently crime-free suburbs. But the implicit question—what to do when corruption is universal and it becomes impossible to erect a "garrison" against it—is brutally quashed at the end. If ever a corrupt cop flick had its cake and ate it, surely this is it. Freddy's shooting spree is cast as self-defense, but also as a self-defining heroic act that turns him into a "cop" (Fig 2.1).

As if that were not enough, we are then informed that there is a just system *as well.* Brief news flashes at the end of the film pile one bit of good news upon another: Freddy will recover the hearing in his good ear. The murderers of would-be informants, including Liz's husband, are caught. The guilty cops are either dead or indicted. Three months later even Toy Torillo, the Mob boss who runs Garrison, is arrested. All the scum rises to the surface; even the town mayor is under investigation. And all because Freddy, in the voice-over moral of the film, "figured out: no one is above the law."

With its simultaneous endorsement of vigilantism and its proclaimed faith in a just legal system, the film neatly shelves the questions left open in *L.A. Confidential.* Unlike Dirty Harry, the rogue cop is not the unpalatable (but sometimes necessary) alternative to the ineffective play-by-the-rules police. Rather, street justice paves the way to court justice. Moe Tilden, having antagonized Freddy beyond endurance, deliberately uses Freddy's propensity for vigilantism to reopen a case already closed: "That cupcake makes a mess, we got a case again." In *Cop Land,* the legal system is not ineffectual; it is merely momentarily hamstrung, waiting for the vigilante to open the door to justice. Once that door is kicked open, the legal machinery gets to work and justice is done. And done. And done some more. Whether aware of the irony or

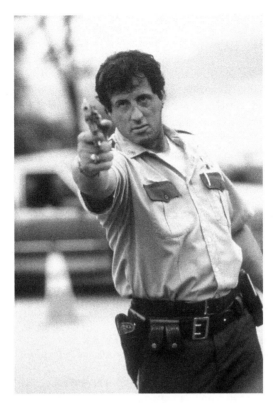

Figure 2.1 Vigilantism turns Sheriff Freddie Heflin (Sylvester Stallone) into a cop. Courtesy of Photofest, Inc.

not, the film's ending essentially endorses a sense of justice that parallels the rationale of Garrison: a place of peace and order, built on carnage.

Training Day escalates the theme of police corruption considerably.[13] The film portrays the first day on the force of the rookie officer Jake Hoyt (Ethan Hawke). Hoyt works for the narcotics officer Alonzo Harris (Denzel Washington), who initiates him in the abuse of police authority, from drinking and taking drugs on the job to brutalizing suspects all the way to stealing millions of drug money and to murder. Hoyt is as jittery as a kid at football try-out, desperate for praise, and determined. His ambitions to make detective are financial and idealistic: "You should see those guys' houses," he tells his wife, but he also tells his partner, "I became a cop to put away drug dealers." The film tells a traditional temptation-by-the-devil story as it asks where—and whether—an average guy like Hoyt will draw the line.

In *Training Day*, police activity equals police brutality. Rodney King no longer stands for a trauma but constitutes run-of-the-mill police work, if a bit outmoded. Watching Hispanic and black suspects being manhandled, Hoyt asks Alonzo, more bemused than upset: "Shit, man, you gonna teach me that old-school hard-charging beat-up-everything-that-moves Rodney King shit?" But modern law enforcement,

according to Alonzo, has progressed far beyond these crude methods: "We don't do that no more, that day is dead, dawg, we don't roll like that no more. Now we use this. Brain power. These niggas are too strong out here anyway."

"Brain power" vigilantism involves, as it does in *L.A. Confidential,* friends in high places. Alonzo's contacts with prosecutors, judges, and top-ranking police officials allow him to buy the search warrant he needs to "tax" his "dawg" Roger (Scott Glenn). He then robs Roger of millions of drug dollars to pay off the Russian mafia, who have a contract out on Alonzo's life, and crowns his crime with murder. The tired old chestnut that vigilantism leads to a justice that the institutions are powerless to achieve is trotted out only when Alonzo needs to keep Hoyt in line. Hoyt saves a fourteen-year-old girl from rape and wants to do regular police work; Alonzo brutalizes the suspects after Hoyt has handcuffed them, takes their drugs and money, and then lets them go (Fig 2.2). To Hoyt, he justifies this as follows:

> *Alonzo.* They got beat down, they lost their rock, they lost their money. Them éses
> from Hillside probably gonna smoke 'em. I mean, Jesus: what more you want?
> *Hoyt.* I want justice.
> *Alonzo.* Is that not justice?
> *Hoyt.* It's street justice.
> *Alonzo.* What's wrong with street justice?
> *Hoyt.* Oh, I just let the animals wipe themselves out?
> *Alonzo.* God willing. Fuck 'em, and everybody who looks like 'em.
> *Hoyt.* Come on.
> *Alonzo.* Unfortunately, it dudn't work that way. The good guys, they die first, right?
> The school kids and moms, family men, they don't wanna catch the stray bullets
> in their noodle. To protect the sheep, you gotta catch the wolf. And it takes a
> wolf to catch a wolf, you understand?

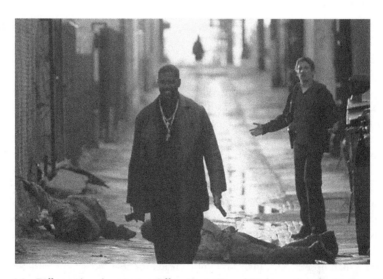

Figure 2.2 Different ideas about justice: Officer Harris (Denzel Washington) vs. Rookie Hoyt (Ethan Hawke). Courtesy of Photofest, Inc.

There is no sense here at all that the police are accountable to the public. The message is clear: if all police work is about the "protect" and none of it about the "serve," the police might as well be the Mob; there is no difference between the wolf threatening and the wolf protecting the sheep. What Alonzo gets out of being a policeman, other than all the money, drugs, and women he wants, is a constant surge of power. He thinks of himself as the master of all; everyone else is either his "nigga" or his "dawg." Hoyt's objections to searching a house without a warrant—"Come on, man, we can't do that"—are easily brushed aside: "Yes, we can. We the police. We can do what the fuck we wanna do." In the end, when Alonzo loses control over the ghetto population he has terrorized, he resorts to his police authority: "I'm puttin' cases on all you bitches. [. . .] I'm the man up in this piece! [. . .] I'm the police! I run shit here! You just live here!"

As in *Cop Land,* the majority of police officers in *Training Day*—Alonzo and his team[14]—are corrupt; Hoyt is a minority of one. As in *L.A. Confidential,* the top echelons of the justice system (the D.A., the police chief, the judge) are as corrupt as the beat cop on the street. For this reason, there can be no public exposure of corruption; Alonzo, shot by the Russian mafia, is praised in the news as a "highly decorated officer, a 13-year LAPD veteran." But *Training Day* takes the matter a significant step further by proclaiming that corruption is passed on through *training.* True, Hoyt extricates himself from Alonzo's poisonous influence and survives the film, limping home to his wife and child as the voice-over radio obituary intones that "Officer Alonzo Harris was survived by his wife and four sons." But there is no unequivocal sense of what Hoyt's future might be. Will he become a cop on the take or, as he swore in shock after Roger's murder, "go back to the valley" and "cut parking tickets"?

On the one hand, the film offers us a great deal of reassurance that right has triumphed over wrong. Most obviously, Hoyt survives while Alonzo does not; the fact that Hoyt owes his survival to his rescue of the potential rape victim exemplifies the immediate payoff of good deeds. Similarly, encouraging signs point to Hoyt's future as an ethical policeman. Although he smokes drugs and participates in two illegal search-and-seizure procedures, he eventually draws the line by refusing to accept his share of Roger's money and shoot him. Most importantly, he repeatedly distances himself from Alonzo's methods: "I am not like you," he tells him. Ultimately, however, the film leaves open whether Hoyt's ethical stance is a permanent feature or merely the attribute of a rookie, as indicated by Roger's disturbing assertion that Alonzo was just like Hoyt when he started out in the police force. Because viewers are not told what turned Rookie Alonzo into a corrupt cop, a residual uncertainty surrounds Rookie Hoyt's ethical future, for if Hoyt is Alonzo's past, it is also easily imaginable that Alonzo is Hoyt's future. This uncertainty serves as a reminder that we are no longer talking about a bad apple spoiling the barrel; instead, the whole barrel is rotten. In a barrel full of rotten apples, a lone good apple has little chance to stay clean.

Crooked cop films visualize audience illusions about truth, justice, and the American Way, including the fantasy that one heroic vigilante cop will wipe out crime and corruption. They show that crime pays, and that it pays even better if the legal system is part of the racket. Occasionally they let viewers off the hook by suggesting that in the absence of good cops, we can make do with middling ones. Sometimes,

Middling can stand up to Bad and survive, at least for a while. Films set in the 1950s and 1970s proclaim that police corruption is nothing new. It existed well before the beating of Rodney King forced the awareness on "regular people" everywhere. Audience illusions change over time, though. While the 1950s-style illusion subscribed to the idea that we can keep our cities clean (*L.A. Confidential*), the 1970s believed that we can keep our suburbs clean (*Cop Land*). Finally, the Los Angeles of *Training Day* is both present-day, set in the early years of the new millennium, and futuristic, in the sense of dystopian, reminiscent of the predatory L.A. of *Collateral* (2004) or the dark L.A. of futuristic films like *Blade Runner* (1982) and *Strange Days* (1995). It is a city populated by drug runners, hit men, dawgs, niggas, pushers, and police, but remarkably free of "regular people."

Where have all the regular people gone? They moved to the suburbs, of course, leaving the cities to the civil wars between the homicidal maniacs with a badge and those without, leaving behind also the awareness that their safe, middle-class, crime-free lifestyle is built on crime.

"ORDER"

In an ideal world of justice, now rarely portrayed in cop flicks, the contrast between cops and killers symbolizes that between order and chaos. Cops maintain order. Chaos is deviation from order. The most extreme chaos is found in the serial killer's diseased mind. Witness the following exchange between the FBI agent Clarice Starling and Hannibal Lecter's former keeper Barney in Harris's novel *Hannibal:*

> "Dr. Lecter has no interest in hypothesis. He doesn't believe in syllogism, or synthesis, or any absolute."
>
> "What does he believe in?"
>
> "Chaos. And you don't even have to believe in it. It's self-evident."
>
> Starling wanted to indulge Barney for the moment.
>
> "You say that like you believe it," she said, "but your whole job at Baltimore State was maintaining order. You were the chief *orderly.* You and I are both in the order business. Dr. Lecter never got away from you."
>
> (Harris 89–90, emphasis original)

By the end of the novel, Starling is Lecter's cannibalistic lover, and the faith in the neat divide between order and chaos is no more than a soothing fiction.[15] Harris's twist is not atypical. Many serial killer films also undermine the dichotomy of order and chaos. As we have seen, the police, who are supposed to be in the "order business," more often than not drop the ball. Occasionally—and curiously—the serial killer picks it up.

If serial murderers can symbolize order rather than chaos, it is because they are clearly distinguished from terrorists. Serial killers have always been perceived "As American As Apple Pie";[16] compared with foreign terrorists, they seem less scary, even comfortingly familiar.[17] When the 2002 serial shootings in Washington, D.C., turned out to be the work not of terrorists but of garden-variety American

serial killers, the press greeted this news with palpable relief (see Schmid 27); other post-9/11 serial killings, too, were reported in the media with "a note of relief that things had returned to normal" (Schmid 256; see McKinney). This perceived normalcy may account for the noticeably accelerated release rate of serial killer movies since 2001—including films about all-American serial murderers such as Jeffrey Dahmer and Ted Bundy.[18] In a world plunged into chaos by terrorism, cinema reestablishes a semblance of order by focusing on the devil one knows, a devil who—unlike terrorism—can be defeated. In a world of Us against Them, Serial Killers 'R Us' (Schmid 257; see McKinney).

Serial killer films reestablish order through oblique references to international politics and to the global economy. Many of these movies concern themselves centrally with one of society's most basic ordering principles, the workplace. They portray serial murder as a form of work, part or full time, paid or unpaid.[19] Countless contract killers describe what they do as just a regular job: "It's what I do for a living," states Vincent (Tom Cruise) in *Collateral* (2004), mocking the common justification that it's okay if the victims are bad people: "all I am is taking out the garbage." Borrowing language and imagery from the realm of economics, serial killer films teem with references to menial labor, pay, success, career prospects, fame, exploitation, unionization, and white-collar versus blue-collar workers.[20] The Hannibal-Lecter franchise plays off Hannibal, the "white-collar," genius serial murderer, against worker-bee serial killers to great effect. In *Silence of the Lambs* (1991), Jame Gumb sews clothes made from human skin. Working nearly naked and sweat-drenched in his dungeonlike basement, he is the very image of the sweatshop worker forced to perform menial labor in unacceptable conditions. The destruction and "consumption" of human beings in the workplace is taken at its most literal; Hannibal eats his victims, Jame clads himself in their skins. Elsewhere, serial murder is cast as the fulfillment of career dreams out of reach in the legitimate working world. Francis Dolarhyde's (Ralph Fiennes) murders in *Red Dragon* (2002) are "inspired" by William Blake's great art, but he is a mere film-processing technician in real life. Peter Foley (William McNamara in *Copycat,* 1995) is a lab assistant in a fertility clinic. He is not a doctor, but he plays doctor with his victims: "Now, this—this is gonna hurt a little bit, I'm afraid," he intones soothingly and with impeccable bedside manner as he approaches his victims with a scalpel or a syringe.

In any film featuring a paid assassin, the most commonly used shorthand for a killing is "a job." In films with serial killers, the motive most commonly attributed to the killer is the quest for fame. In other words, serial killers seek to earn public acknowledgment and admiration for a job well done.

Grosse Pointe Blank (1997). Dir. George Armitage. Writers: Tom Jankiewicz, D. V. DeVincentis, Steve Pink, John Cusack. Buena Vista. Domestic Total Gross: $28,084,357. Foreign Gross and Production Budget not available.

The working world, a subtext in many serial killer films, becomes an overt topic in *Grosse Pointe Blank.* The professional killer Martin Blank (John Cusack) falls out with fellow assassin Grocer (Dan Akroyd) when Blank refuses to join Grocer's professional killers' union. Grocer argues that individual negotiation leads to loss of

earnings: "Look, the employers are gettin' us a lot cheaper 'cause there's so many more of us." His pro-union arguments could be overheard at any business lunch: it's about "makin' big money," about improving conditions for the workers—"work less, make more"—about obtaining "shares, original shares on the ground floor," and "consolidated bargaining." By refusing, Martin enters into competition with Grocer's firm of assassins. The point is brought home when Grocer is informed in standard business jargon that he has lost a contract to Martin: "Services for Detroit contract terminated. Contract being serviced by alternate vendor for original quote."

Competition with Grocer is not Martin's only problem. Five years into his career as a professional killer, Martin is no longer happy with his job. In fact, he is starting to slip up. At one hit, he accidentally kills not only his target but also an innocent bystander-dog; at another, he has to shoot the victim after failing to poison him, upsetting his "employer," who specified that the victim must appear to have died in his sleep. As Martin confesses to his psychiatrist Dr. Oatman (Alan Arkin), "I've had problems at work. You know, concept/execution stuff." Martin, it seems, is stuck in a rut. How much of a rut becomes clear when he tells Oatman about appearing in his own dream as "the battery bunny." Oatman's diagnosis evokes the stereotypical image of the disaffected worker who keeps going through the motions long after the work has lost all interest or meaning. "It's a depressing dream to dream about that rabbit. It's got no brain. It's got no blood. It's got no anima. It just keeps banging on those meaningless cymbals endlessly and going and going and going."

During his visit to his hometown, Martin is perfectly upfront about what he does, but fails to shock anyone. Time and again, people to whom he identifies himself as a professional killer take this revelation in stride. Some ask about the qualifications required ("Do you have to do postgraduate work for that, or can you—or can you jump right in?") or the working conditions ("Do you get dental with that?"). Others congratulate Martin: "Oh. Good for you. It's a growth industry." The basis for these jokes is, of course, the assumption that nobody believes him—or perhaps his job simply does not appear all that outrageous in a society marked by violence. The use of business language and the general willingness to accept Martin's work as a job like any other, straight-faced and without missing a beat, have a "normalizing" effect. The humor relies on the difference between the film's version of reality and the audience's, since from the audience's presumed perspective, it is obviously absurd to accept professional killing as nothing out of the ordinary. But this buffer zone between the two realities wears thinner as the film goes on.

The film increasingly erodes the notion that Martin's work is different from similar jobs that are commonly perceived as perfectly legal and normal. If Martin does not stand out, it is because society as such is pervaded by violence. For example, during a conversation about real estate, the security guard, whose only qualification consists in a two-week training course, lets on that he has license to kill people if he finds them on someone else's lawn. When a hired killer attacks Martin in the local minimart, the employee fails to notice the shootout because the noise of guns is drowned out by the mayhem of his videogame. Moreover, the NSA agents Lardner (Hank Azaria) and McCullers (K. Todd Freeman), whom Grocer has hired to kill Martin, are far more sadistic than the level-headed Martin. Following Martin around in their car, they plan the details of the kill with a relish that is commonly attributed only to

serial killers. The only difference between the agents and Martin is a thin veneer of legitimacy provided by their institutional affiliation:

> *McCullers.* Man, why don't we just do his job so we can do our job and get the fuck out of here?
>
> *Lardner.* What do you mean, "do his job"? What am I, a cold-blooded killer? I'm not a cold-blooded killer. [...] You wanna kill the good guy, but not be the bad guy. Doesn't work like that. You gotta wait until the bad guy kills the good guy. Then when you kill the bad guy, you're the good guy.
>
> *McCullers.* So—just to clarify: if we do his job, we're the bad guys. And if we do our job, we're the good guys.
>
> *Lardner.* Yes.
>
> *McCullers.* That's great.

Dropping the pretense of being "the good guy" is, in fact, the only thing that changed for Martin when he left employment as an assassin in the service of the U.S. government to go into business for himself:

> In the beginning, you know, it matters, of course, that you have something to hang onto, you know, a specific ideology to defend. Right? I mean, "taming unchecked aggression," that was my personal favorite. Other guys like "Live free or die," but, you know, you get the idea. But that's all bullshit, and I know that now. That's all bullshit. You do it because you were trained to do it, you were encouraged to do it, and ultimately, you know, you ... get to like it.

Martin's admission is disturbing because it touches upon a recurring topic in serial killer films: the realm of pathology, killing for pleasure. For those who kill legally, the claim that they maintain order may be no more than an excuse to gratify sadistic desires. When killing is just a job, the pleasure one takes in it features under the heading "job satisfaction." In *Grosse Pointe Blank,* the difference between "good guys" and "bad guys" is not the difference between those who kill legally and those who do not, but that between those who enjoy it (Grocer, the NSA agents) and those who do not. Martin gets to be the film's "good guy" because he does not enjoy it anymore: "I've lost my taste for it completely." In a strange way, Martin's distinction supports his earlier statement: "I don't think necessarily what a person does for a living reflects who he is." It's not what you do, it's how you do it: there is a considerable difference between a sadistic and a dispassionate killer, but none at all between a killer with a badge and one without.

SIN

All hope abandon, ye who enter here.

<div align="right">Dante Alighieri, Inferno</div>

In metaphysical serial killer films, the cop is metaphorically and literally identified with (as) the killer. Metaphysical serial killer movies are related to and yet distinct from the neo-Gothic tradition that links folkloric and mythological themes with the

figure of the serial killer.[21] The neo-Gothic does not produce metaphysical serial killer films as such, but rather serial killers with a metaphysical *dimension*. One memorable example is Anton Chigurh (Javier Bardem) in *No Country for Old Men* (2007). Anton believes in kismet and predestination and occasionally uses coin toss to decide whether or not to kill someone: "I got here the same way the coin did." While Anton embraces metaphysics, Hannibal Lecter, perhaps the most iconic serial killer in recent cinematic history, has been viewed as a descendant of the vampire (see O'Brien; Picart and Greek, "Compulsions"). Anthony Hopkins, who by his own admission based his performance on Bela Lugosi's interpretation of Count Dracula, referred to Lecter as "a personification of the devil": "He is not just a killer, he is the darkness in us all" (cited in O'Brien 129 and 157). These aspects of the killer's personality aside, *Hannibal* retains the traditional serial killer film's most basic understanding that the main problem is crime. In contrast, metaphysical films consider crime a mere symptom of a more profound and universal predicament, which, for lack of a better term, we will refer to as "sin." Metaphysical films step up the spiritual game: it is no longer about right and wrong, but about good versus evil. The great cop-out of these movies lies in their implicit statement that social reform or political change are useless since there can be no social or political answer to a metaphysical problem. Paradoxically, some of these films (for example, *Seven*) shine a far more critical light on society's propensity for violence than traditional cop films, even as they conveniently relieve us of having to draw the social, political, or cultural consequences from this.

Fallen (1998). Dir. Gregory Hoblit. Writer: Nicholas Kazan. Warner Bros. Domestic Total Gross: $25,232,289. Foreign Gross and Production Budget not available.

Seven (1995). Dir. David Fincher. Writer: Andrew Kevin Walker. New Line. Nominated for 1 Academy Award (0 wins). Domestic Total Gross: $100,125,643. Foreign Gross: $227,186,216. Total Box Office: $327,311,859. Production Budget: $33 million.

Fallen is a demonic possession film that pits the fallen angel Azazel, who can inhabit human beings at will, against the good-guy cop John Hobbes (Denzel Washington). From the beginning, the film portrays Hobbes as a man of rare incorruptibility. In the following conversation with the brother cops Lou (James Gandolfini) and Jonesy (John Goodman), Hobbes is defined as a "fuckin' saint":

> *Lou.* You're an unusual cop, Hobbes. [. . .] I've been in this precinct about what, five, six months? Everybody says, "Hobbes don't take no cream. Hobbes don't take no cream." Now, is that true, or what?
> *Hobbes.* No, I don't like cream. [. . .]
> *Lou.* Now, is that "no" as in "never," "no" as in "sometimes," or "no" as in "I do, but I don't like to talk about it"?
> *Hobbes.* "No," as in "never".
> *Lou.* [. . .] We, we got a tradition to uphold. [. . .] This is hypothetical: A cop who's trying to make ends meet, you know, wants a little something on the side . . .
> *Hobbes.* I don't like cream, and I don't judge.

Lou. You don't judge. *To Jonesy:* He's a fuckin' saint, huh? *To Hobbes:* So you're telling me that under no circumstances will, would a holy man like you ever, you know, break the law or do something...

Hobbes. Look, Lou. I could jump across the table, all right, snatch your heart right out of your chest, squeeze the blood out, and stick it in your front pocket, I could do that. [...] If I lost control. But if I did, I would be no different than the people we bust. Now, as to your general question, you take any cop out on the force, cream or no, 99 percent of the time they're doing their job, aren't they? [...] So he or she, cream or no, is doing more good out there on the street every day than any lawyer or stockbroker or president of the United States can ever do in their lifetime. Cops are the chosen people.

Jonesy. Amen.

Despite Hobbes's spirited defense of cops as the "chosen people," police corruption is presented as ubiquitous in this conversation. The scene establishes a context in which Hobbes's honesty is so "unusual" that it is unbelievable, exaggerated ironically to the level of sainthood. Even though the remainder of the film drops the subject of corruption from its agenda, the religious rhetoric foreshadows Hobbes's future role as Azazel's adversary, for only a saint can combat the demon. In private life, too, Hobbes is cast as just this side of "holy." He sacrifices his own marriage and personal happiness to take care of his mildly retarded brother Art (Gabriel Casseus) and Art's little son Sammy (Michael J. Pagan). Throughout much of the film, the demon's threats to corrupt Hobbes—"I'll get so close to you, so close it breaks you"— shatter on the unbreachable armor of Hobbes's integrity. Although this is never made explicit, the film's underlying presumption is that Hobbes's "holiness" prevents the demon from possessing him. Until the final scene, Hobbes appears to be the only character who remains immune to demonic possession. Azazel deprives Hobbes of his livelihood and his family, but not of his ethics. Even when the demon frames him for several murders, Hobbes's innocence seems beyond question. When Hobbes is forced to shoot an innocent bystander who, briefly possessed by Azazel, threatens to kill him, this results in a crisis of conscience that further highlights Hobbes's impeccable character. Even from this standard corrupt-cop scenario—cop kills civilian—Hobbes emerges smelling like incense.

Hobbes is a good detective both ethically and professionally. Together with the theologian Gretta (Embeth Davidtz), he figures out that demons cannot survive long as pure spirit; they must enter a new host within minutes once the old one has died. Armed with this knowledge, Hobbes lures Azazel out to a lonely cabin deep in the woods. Hobbes mortally wounds Azazel, who appears in the body of Hobbes's beloved partner Jonesy, and commits suicide by smoking a cigarette laced with poison. Azazel, forced to exit Jonesy's corpse, briefly possesses Hobbes's dying body, finally making good on his threat to "get close to you"; after Hobbes's death, he desperately searches for a new host. And behold, a cat comes along in the nick of time, enabling Azazel to survive and continue his career of corrupting humanity.

Fallen reincarnates the ethical policeman, only to have him fail spectacularly. The film hypes up Hobbes's battle against evil as the one thing he was chosen to do with his life. In a conversation with his partner Jonesy, the two speculate that everyone was put on earth to accomplish one particular thing, which is simultaneously the pinnacle

and the end of that human being's life: "Maybe if you figure it out you die. Heart attack, stroke. You figure out what's what, you don't get to hang around anymore. You get promoted." Since Hobbes fails in the quest for which he was presumably chosen, it remains unclear whether Hobbes is "promoted." The audience is, of course, free to believe that it is the thought that counts, but the film's ending is shot from Azazel's perspective. Just before the credits roll over the Rolling Stones song "Sympathy for the Devil," the final shot shows a city sidewalk full of people: Azazel's future playing field.

Just as the good-guy cop Hobbes is an "unusual" character, *Fallen* is an unusual film in a cinematic tradition that assumes police corruption to be the norm. The film's attempt to return to a pre-modern world in which the difference between good and evil is always clear lands it in a quandary. The film tackles *both* Right and Wrong *and* Good and Evil and cannot decide whether its central conflict is between cop and killer or between holy man and demon. The tale of Good and Evil, which must rely on clear-cut distinctions (saint versus devil), is undercut by the necessity to borrow from the tradition of Right and Wrong, for example, the common topos in cop films that Right so often *is* Wrong, that cops are criminals. This quandary plays itself out in the film's inability to decide whether Hobbes and Azazel are opposites in terms or one and the same. On a metaphysical level, the film positions them as diametrically opposed. And yet, at times, they appear to be identical. Tantalizing snippets and incongruities raise suspicions about Hobbes's goodness and immunity to Evil. In particular, Hobbes's first-person voice-over narrates the entire story, but, visually, the film vacillates between Hobbes's and Azazel's perspective. This leads to jarring juxtapositions: the film's beginning and end use Hobbes's voice but show Azazel's perspective. Similarly, Hobbes's lines in the initial dialogue—"I could jump across the table, all right, snatch your heart right out of your chest, squeeze the blood out, and stick it in your front pocket, I could do that"—are entirely appropriate for Azazel but highly incongruous for the good guy Hobbes. Viewers may also wonder why Hobbes remains cool as a cucumber when he observes the execution of Edgar Reese (Elias Koteas), whereas all other spectators are visibly disturbed by the display. The film is shot through with moments that flirt with the idea that Hobbes and Azazel are not so far apart after all. And yet, none of these moments are consistently developed or have any impact on the development of Hobbes as a character. In other words, the film offers us glimpses of a possibility—Hobbes as a compromised character— that is common currency in cop films but that *Fallen* does not dare realize because its metaphysical project needs Hobbes to remain holy to combat the demon. Perhaps significantly, "Sympathy for the Devil" fades out over the closing credits *before* it arrives at the rather pertinent verse: "Just as every cop is a criminal/And all the sinners saints."

If *Fallen's* metaphysical dimension is undercut by its harking back to cop film traditions, the reverse also applies. As a cop film, which in the modern era emphasizes the murky division between Right and Wrong, *Fallen* is hampered by its metaphysical aspirations. To stage the grand battle of Good versus Evil, the film needs the assurance of stable contrasts. Holy man Hobbes, with his spotless soul and inane spiritual questions—"What are we doing here? You know what I'm saying? Why do

we even exist?"—is far less credible or interesting than the average cop "who wants a little something on the side." The film essentially presents us with a dreary Jesus who, following a lackluster Sermon on the Mount and juvenile anguish in Gethsemane, is outsmarted and possessed by the devil. If *Fallen* leaves us with any message, it is simply that once the battle of Right and Wrong turns into that of Good and Evil, Good can take a hike in the woods. Hobbes fails in his quest because we cannot eradicate Evil once and for all, although we may occasionally do the right thing. But this hardly comes as a shock to an audience accustomed to Evil (or at least to Corruption, Evil's common little brother) and perhaps also profoundly indifferent—given the mind-numbing tediousness of cinematic Good—towards Good's ultimate victory or defeat.

In *Seven,*[22] the starkest contrast is not that between Good and Evil but that between two characters on the side of Good, Detectives Somerset (Morgan Freeman) and Mills (Brad Pitt). Somerset is black, old before his time, highly educated, well read, sensitive and easily hurt, a meticulous dresser, a good listener and silent observer, and a patient man who asks pertinent questions. Weary of the daily horrors of his job, he looks forward to retirement, which at the outset of the film is one week away. His new partner, Mills, is cast as Somerset's opposite in every way: he is white, young, crass, disheveled, insensitive, garrulous, bursting with energy, and endowed only with the most rudimentary education. A mere five years into his career, he is profoundly insecure, eager to advance, willing to swallow the most obvious answer, and ready to kick some criminal ass. The disparities in the two detectives' private lives are as extreme as those in their character, background, and professional demeanor. Mills is newly married to Tracy (Gwyneth Paltrow), who, unbeknownst to Mills, is pregnant. Somerset is a lifelong bachelor and loner, a "cloistered monk" (Philip Simpson, *Psycho Paths* 196) who once coerced his pregnant girlfriend into an abortion because he could not imagine bringing a child into a world that he perceives as irredeemable. Somerset is profoundly disillusioned, while Mills, the only character in the film who has a happy home life, stands for the possibility of a better future.

In *Seven,* this pairing of opposites, while familiar from earlier cop movies (*Lethal Weapon*'s Murtaugh and Riggs spring to mind[23]), refers less to previous characters than to archetypes. Somerset with his impeccable dress, speech, and English-sounding name is a legitimate heir of Sherlock Holmes; Mills, whose policing style runs more toward kicking in doors, bribing witnesses, searching houses without warrants, and pursuing criminals with his gun drawn, is cast in the mold of Dirty Harry.[24] In teaming up two of the most successful detective types available in fiction, the quintessential brain detective *and* the ultimate brawn detective, the film sets up a seemingly invincible duo. And yet, never has a crime-fighting team conducted itself more haplessly.

While starkly contrasted with each other, both detectives are identified with the film's serial killer (Kevin Spacey), who calls himself John Doe. Like Doe, Somerset views the world as a den of iniquity and rails against the complacency with which even the worst crimes are accepted: "I just can't live in a place where apathy is embraced and nurtured as if it were a virtue. I can't take that anymore." Doe's murders are designed as shocking punishments of deadly sins (Gluttony, Greed, Sloth,

Lust, and Pride) in an attempt to combat the same apathy that is also Somerset's greatest psychological burden:

> An obese man, a disgusting man who could barely stand up. A man who if you saw him on the street, you'd point him out to your friends so they could join you in mocking him. A man who if you saw him while you were eating, you wouldn't be able to finish your meal. After him, I picked the lawyer. And you both must have been secretly thanking me for that one. This is a man who dedicated his life to making money by lying with every breath that he could muster to keeping murderers and rapists on the streets. [...] A woman so ugly on the inside that she couldn't bear to go on living if she couldn't be beautiful on the outside. A drug-dealer—a drug-dealing pederast, actually. And let's not forget the disease-spreading whore. Only in a world this shitty could you even try to say these were innocent people and keep a straight face. But that's the point. We see a deadly sin on every street corner, in every home, and we tolerate it. We tolerate it because it's common, it's trivial, we tolerate it morning, noon and night.

Like Doe, Somerset is unable to tolerate this "shitty world." Because Somerset, like Doe, is an intellectual, he is able to trace Doe's murderous path referenced by St. Thomas Aquinas, Milton, Dante, and Chaucer, the greatest Western humanistic writers on the subject of sin. Conversely Mills, whose exposure to great literature is limited to Cliff Notes and who has nothing but contempt for "fuckin' Dante" and "poetry-writing faggots,"[25] is hopelessly outgunned in the battle of wits. And yet, he too is ultimately likened to Doe. During the drive that precedes the final apocalyptic scene, both Doe and Mills (but not Somerset) are shown through the grille that divides the front and back seat of the police car. The shot/countershot close-ups of their faces behind "bars" imply a similarity that Doe puts into words when he tells Mills that he enjoyed committing the murders as much as Mills would enjoy "time alone with me in a room without windows." Both Doe and Mills are imprisoned in a cycle of violence; both derive sadistic enjoyment from violence; both view their use of violence as validated by a "just cause"; both are ultimately destroyed by violence (Dyer, *Seven* 26).

The dissimilarity between partner detectives and their similarity to the criminal they chase is standard M.O. in cop films.[26] But the purposes to which this character constellation is commonly put are not served here. The detectives' "closeness" to their target does not result in a critique of police corruption; their similarity with or understanding of the killer does not enable them to capture him. The film spends considerable time on the visual representation of police work: forensic examinations of crime scenes; Somerset analyzing Dante; Mills analyzing crime photos; Mills chasing Doe. Interestingly, though, all these procedures end in failure.[27] When Doe turns himself in after the fifth murder (out of a presumable seven), neither Somerset the "great brain"[28] nor Mills the man of action are anywhere close to catching him. The film's conclusion is brought about not by the police but by the killer, who lures Somerset and Mills out into the fields, promising to show them the location of corpses so far undiscovered. In the film's apocalyptic finale, a package addressed to Mills and containing Tracy's head is delivered. Doe confesses his final crime, the murder of Tracy, and his deadly sin, Envy (of Mills's happy family life). Doe then goads Mills into killing him, thus turning him into the embodiment of the seventh deadly sin, Wrath.

The baffling failure of the seemingly unbeatable team makes sense in light of the film's metaphysical character, its obsession with sin, not crime. The film's curt, one-word title implies a wealth of context, both related and unrelated to its plot, both literal and mysterious. There are seven deadly sins, days of the week, colors of the rainbow, days of creation, Christian sacraments, wonders of the world, pillars of wisdom, and, in some religious traditions, circles of hell (Dyer, *Seven* 8); seven churches of Asia (in the Book of Revelation), seven churches of Rome, seven gifts, seven angels (in Arabian legend),[29] seven Holy Days of Obligation (Christian doctrine), seven wedding blessings (Judaism), seven Egyptian deities, and seven states of purification (Egyptian dogma for the stages of the transmigration of the soul; see Radhakrishnan). In the film, Doe vows to commit seven murders within seven days; Somerset is seven days away from retirement; the resolution presents itself in the seventh hour of the seventh day (Lacey 14–15). In *Seven,* the magic number seven sets up the irresolvable mystery, as does the film's adoption of Doe's and Somerset's view of the world as a "shitty" place.[30] The locale of the film, an unnamed city, is "the most authentically hellish screen metropolis since Gotham City, a nameless warren of damp corridors, subterranean sex joints and dilapidated tenements, where it rains all the time."[31] It is a stifling, claustrophobic place without sky or sun, where darkness and rain obscure our view. Our ears, on the other hand, are exposed to a constant onslaught, a barrage of noise pollution composed of engines, horns, brakes, TVs, domestic and police radios, and loud conversations. Snatches of music, traffic, planes, trains, automobiles, and endlessly beating rain intrude upon every private moment and disturb every instant of repose (see Dyer, *Seven* 50–52). Like the city in Dante's *Divine Comedy*—a key text in the film—Doe's city is a circle of hell: "Through me you pass into the city of woe:/ Through me you pass into eternal pain . . ./ All hope abandon, ye who enter here."[32] Caught in this dark and drenched place for most of the film, we emerge into bright sunlight in the final scene. The light visualizes the illusory hope that now, finally, we will comprehend the killer and obtain clarity. Simultaneously, the light also conveys the disappointment of these hopes: at its visually brightest, the film plumbs the depths of metaphysical darkness. The film's locales are as intrusive and inescapable as sin: like light, like rain, sin "gets in everywhere" (Dyer, *Seven* 63). There is no escape.

The film confronts us with the ubiquity of sin, but denies the possibility of redemption. Crimes can be solved, sins cannot. All four main characters—Somerset, Mills, Tracy and John Doe—suffer enormously from the world. Yet all solutions suggested or attempted fail. The world cannot be "fixed," as Mills attempts to do, and it cannot be escaped from, as both Tracy and Somerset hope (Tracy dreams of a return to the country; Somerset of retirement). Mills's shooting of Doe is not "justice," not even merely a "crime" that, again, turns the cop into a murderer. It is, at its most metaphysically profound, a sin that is likened in severity to the sins committed by the killer (Lacey 34). The final tragedy is not physical but metaphysical; it lies in the destruction of Mills's life *and* in the corruption of his soul, not in the fact that the killer "wins" but in the fact that by shooting him, Mills confirms his view—the very worst view imaginable—of humanity.

In metaphysical movies, the most important aspects of cop-and-killer films are relegated to the sidelines. The killer's identity is beside the point: in *Fallen,* it could

be anyone; in *Seven,* the killer's name is shorthand for "anyone." Whether or not the killer is caught is equally immaterial: *Fallen,* in fact, *begins* with the "solution" of the crime, the execution of the culprit; in *Seven,* the killer's execution achieves nothing but to make his point. Metaphysical films put the criminal out of the law's reach and withhold a solution, since solutions apply only to individual acts, not the state of the world.

In this, metaphysical movies make explicit an assumption that has underpinned serial killer films all along, namely that there is neither a solution for nor protection against serial crime. Because it is universal rather than individual, it is motiveless; just as the killer could be anyone, everyone is a potential victim—any lawyer, any glutton, any disease-spreading whore. Because serial killing is universal rather than individual, it never ends; it is by definition endemic and recurring. The spectacular deaths of individual offenders (Jame Gumb in *Silence of the Lambs*; Peter Foley in *Copycat*) offer no more than a momentary respite. John Doe's scheme plays out precisely as planned. Hannibal escapes. Azazel survives. *Copycat's* serial murderer Cullum (Harry Connick Jr.) may be in jail, but he has no trouble recruiting new followers after the loss of his disciple Peter Foley; the final scene shows him enlisting the next serial killer-in-training by letter. The unsolvability of serial murder has consequences for the portrayal of the screen detective, who, reduced to curing the symptom rather than the disease, is left with a choice between disillusionment—throwing his badge away in disgust—and resignation: when told of the first murder, Somerset already knows that "It's gonna go on and on and on."

In a genre that used to be all about solving crime, we are now presented with any number of "unsolvables": endemic crime; endemic corruption (*Cop Land*); sociopathy (*Collateral; A History of Violence*); psychopathy (*Identity,* 2003); the problems created by an overreliance on or abuse of technology (*I, Robot*). Social order has been replaced by an antisocial order that is more often embodied by the killer than the cop. Reduced to delusional or obsessive behavior, "order" has become form without meaning. We might think here of Hannibal Lecter's elaborate preparations for his cannibalistic meals; Anton Chigurh's mania to allow fate to reveal itself through a coin toss; the hit man Vincent's absurd adherence to convention when he buys flowers for Max's hospitalized mother in *Collateral*; the illusion of the former gangster Joey Cusack (Viggo Mortensen) in *A History of Violence* that an ordered family life could erase his previous personality; or the protestations of contract killers everywhere that they are merely doing their jobs.

In the absence of a recognizable order, it is a complex matter to engage ethical questions about the legitimacy of violence. Some films, such as *Grosse Pointe Blank,* are humorous because they uncover the absurdity that underlines traditional differentiations between good and bad guys. Other films address the ubiquity of violence in explicit terms. Here is *Collateral's* killer Vincent, bemoaning the omnipresent indifference to human life: "I read about this guy gets on the MTA here, dies. Six hours he's riding the subway before anybody notices, his corpse doing laps around L.A., people on and off, sitting next to him. Nobody notices." Such indifference, formerly a defining aspect of sociopathy, is normalized, requiring only minimal rationalizations:

Max. What did he do to you?

Vincent. Nothing, I only met him tonight.

Max. You just met him once and you kill him like that?

Vincent. What, I should only kill people after I get to know them? [. . .] Max, six billion people on the planet, you're getting bent out of shape 'cause of one fat guy.

Max. Well, who was he?

Vincent. What do you care? Have you ever heard of Rwanda? [. . .] tens of thousands killed before sundown. Nobody's killed people that fast since Nagasaki and Hiroshima. Did you bat an eye, Max? [. . .] Did you join Amnesty International, Oxfam, Save the Whales, Greenpeace or something? No. I off one fat Angelino and you throw a hissy fit.

Max. Man, I don't know any Rwandans.

Vincent. You don't know the guy in the trunk, either. Okay, if it makes you feel any better, he was a criminal, involved in a continuing criminal enterprise.

Of course this is meant as a critique; it heaps scorn on the propensity of humans to feel indifference or even elation about someone else's suffering. At best, we experience brief twinges of remorse and then make ourselves feel better by reasoning that the dead guy deserved what he got. The minute this diegetic statement becomes extra-diegetic, however, the film is caught in a conflict of interest. Any serial killer film depends for its commercial success either on the spectators' enjoyment of violence or at least on their ability to tolerate it morning, noon, and night. Thus *Collateral,* unable to afford more than a light nibble at the hand that feeds it, offers Max to viewers as a figure of identification without requiring them to endure the moral anguish of killing. In metaphysical movies, the moral question assumes a religious dimension; in all other serial killer films, moral concerns are absent or come packaged as snazzy, throwaway lines.

The greatest dilemma confronting cop-and-killer films is not moral but commercial. Producers of serial killer films assume—and if box office numbers are any indication, they assume correctly—that audiences take pleasure in violence. At the same time, they must take care that the resulting lawlessness and disorder do not turn viewers off. Market research indicates that audiences enjoy the apocalypse only if the film makes clear that the human race will continue, with its basic ethical equipment intact or preferably enhanced, after the dust has settled (Newman; Wright). In disaster movies, Armaggeddon is a business proposition with a cost-benefit analysis. If 99 percent of the human race dies, the remaining one percent has to get something out of it, most often an epiphanic insight followed by a communal decision not to make the same mistakes again. For similar reasons, studios have occasionally objected to the nihilistic endings proposed for serial killer films. The ending of Harris's novel *Hannibal,* in which Clarice Starling becomes Lecter's cannibalistic lover and both vanish without a trace, was changed for the film at the studio's insistence (cf. Waugh; Philip Simpson, "Gothic Romance"; O'Brien). Similarly, nervous studio bosses were adamant that the original screenplay of *Seven* be rewritten. In the ending they favored, the head in the box is not Tracy's but her dog's; Somerset and Mills save Tracy in the nick of time; "justice" is served in Somerset's self-defense shooting of

Doe, and Mills and Tracy live happily ever after. The original ending was kept only because Brad Pitt wrote its retention into his contract (see Dyer, *Seven* 68; Schmid 120; Lacey 70).

Still, the studio succeeded in putting a Band-Aid on the festering wound of *Seven's* gloomy ending. By studio requirement, Somerset was given a final voice-over line, which, as the film's last spoken sentence, is charged to deliver its "message": "Ernest Hemingway once said, 'The world is a fine place and worth fighting for.' I agree with the last part." Leaving aside the irony of using the words of a writer who committed suicide to instill optimism, it remains unclear how Somerset's witnessing of the final catastrophe—Doe's murder of Tracy, Mills's murder of Doe—might have instilled hope and renewed commitment in place of his previous despondency and world-weariness. (In the scene itself, Somerset's reaction to Mills's shooting of Doe suggests the opposite; he turns away from Mills, his demeanor and facial expression that of a man who has abandoned all hope.) This attempt to throw the audience "some crumb of Hollywoodian comfort in a film so extraordinarily un-American in its pessimism"[33] shows more clearly than anything else that the most pressing questions asked in cop-and-killer films do not concern justice, violence, or moral dilemmas but the box office. Having offered a brief but disturbing glimpse at a dismal world where up is down, cops are killers, killers escape, justice miscarries, "order" is symbolized by murderers, and sociopathy is a normal human response, some films, fearing for their commercial viability, try to take it all back. "We're trying to simplify our view of the world, to make things comfortable. Hollywood is just learning that they can make some money on this."[34]

FATHERS, CRISES, AND NATIONS

Father!—to God himself we cannot give a holier name.

William Wordsworth

The place of the father in the modern suburban family is a very small one, particularly if he plays golf.

Bertrand Russell

SINCE THE 1980S, THERE HAS BEEN A BROAD CONSENSUS IN LITERATURE, albeit written from varying perspectives and with different agendas, that masculinity is in "crisis."[1] Socially, this crisis manifests itself as a challenge to men's absolute dominance of the workplace; culturally, it is often played out in the domestic realm. Reading the vast literature on the subject is like walking in a hall of funhouse mirrors. Upon entering the realm of cultural representation, a social diagnosis—the crisis of masculinity— metamorphoses into a crisis of *fatherhood*.[2] In this new guise, it is propelled to prominence by a plethora of scholarly works, social movements, and cultural narratives, Hollywood cinema being the most conspicuous among them. From this lofty platform, the crisis of fatherhood is effortlessly launched into the realm of politics, where it morphs yet again—into a crisis of the *family*.

The "family," still largely defined as two biological parents of different gender plus offspring,[3] has been the most sacred cow of U.S. politics since at least the 1980s— regardless of the relative degrees of "liberalism" or "conservatism" in the population at large and regardless of which political party dominated the Senate or House or had their man in the White House. It is uncontested in politics and culture that the ideal family must include a father, even as men underwent one crisis of masculinity (and fatherhood) after another over the past thirty years. In October 1995, President Clinton organized an entire address to the nation around what he perceived as "the single biggest social problem in our society:" "the growing absence of fathers from their children's homes."[4] Faced with devastating evidence documenting this absence—divorce statistics hovered around the 46 percent mark in the year of Clinton's speech; nine out of ten fathers involved in divorce moved out of the family

home; up to 10 percent of all birth certificates failed to reveal the father's identity[5]—
Clinton, who himself came from a fatherless family and was raised by a stepfather,
set himself the task of making the father, at least discursively, present and accounted
for. Fathers, he claimed,

> share with us their experiences and energies, creating the strong foundation on which
> our children build their lives. A father's arm is there to protect and steer—whether
> cradling a newborn baby, steadying the rider of a first two-wheeler, or walking his child
> down the aisle.
>
> (cited in Lupton and Barclay 2)

If the crisis of masculinity is really a crisis of fatherhood, it comes as no surprise that
the nation's most visible men have expended substantial effort to portray themselves
as successful fathers. Bill Clinton's carefully cultivated image as father to Chelsea
stood as an all-too-visible sign of his role as Father of the Nation, both during and
after his 1992 campaign.[6] And when the photographer Joyce Ostin sent out requests
to Hollywood celebrities to allow her to photograph them with their children, she
received an overwhelming response from dozens of men—including men of decid-
edly grandfatherly age—eager to be immortalized as fathers. Some comments hint at
the degree to which Hollywood's relentless youth culture is beginning to affect men as
well as women.[7] Rod Stewart, photographed at sixty with his three-month-old baby,
credited his forty-three-year history as a father with keeping him "young at heart"
(Ostin 87; photo on 86); Clint Eastwood, a new father at age sixty-eight, praised his
then one-year-old daughter Morgan for giving him the chance to "stay young . . . and
tired" (Holmlund, "The Aging Clint" 149). Such remarks indicate the pressure to
"stay young," but also the degree of conflation between masculinity and fatherhood.
Fatherhood signals vibrant masculinity while grandfatherhood proclaims its end.

If the crisis of masculinity is also a crisis of fatherhood, as cultural discourse pro-
claims, and if the crisis of fatherhood in turn plunges the family into crisis, as political
rhetoric tells us, women are centrally involved. Depending on the time of writing and
the author's ideological flavor, women stand accused of pushing men out of the job
market,[8] pushing them out of family life,[9] or—conversely—are seen to embody nur-
turing qualities that are indispensable for children and transferable to men. There is
no agreement on what kind of masculine type could solve the crisis of fatherhood
and family. In fact, the ideal father is cast in terms of polar opposites—the hypermas-
culine Iron Man or the sensitive feminized New Man. There is, however, substantial
agreement that if the crisis is to be solved at all, it has to be done by Father.

SAVING THE FAMILY: THE FATHER AS MOTHER

Junior (1994). Dir. Ivan Reitman. Writers: Kevin Wade, Chris Conrad. Universal.
Nominated for 1 Academy Award (0 wins). Domestic Total Gross: $36,763,355.
Foreign Gross: $71,668,000. Total Box Office: $108,431,355. Production Budget:
$60 million.

Mrs. Doubtfire (1993). Dir. Chris Columbus. Writers: Randy Mayem Singer,
Leslie Dixon. Twentieth Century Fox. 1 Academy Award. Domestic Total Gross:

$219,195,243. Foreign Gross: $222,090,952. Total Box Office: $441,286,195. Production Budget: $25 million.

The sensitive New Man is by no means the most prevalent father type in the movies, but he has attracted the lion's share of scholarly literature on cinematic fatherhood. Following the lead of Tania Modleski's influential *Feminism Without Women*, numerous critics have pointed out that men's annexation of "feminine" qualities such as tenderness, gentleness, nurturing, devotion, and so forth can be read as a "colonization of femininity"[10] with the aim of "reproducing white patriarchal hegemony" (Davies and Smith 18). Essentially, the effect is twofold. First, it permits men continued enjoyment of their "position of unbelievable privilege" while adding to it "the privilege of gentleness."[11] Second, it adds to the " 'real' historical event of women's expulsion from the public sphere" (Solomon-Godeau, cited in Krimmer 30) their expulsion from the cinematic domestic sphere. Paradoxically, then, the new valuation of feminine or maternal qualities in recent Hollywood films does not lead to a valorization of women or mothers. On the contrary, it initiates the co-optation of these qualities by fathers, while sidelining or even eliminating mothers from the film.[12]

In Hollywood movies (in stark contrast to social life) single parents are very often male.[13] This male co-optation of the mother's role is kicked up a notch when Father not only replaces Mother but *becomes* her through either cross-gendering or cross-dressing. In earlier films, such role reversal often spelled unmitigated horror. In Ridley Scott's *Alien* (1979), for example, the all-powerful computer "Mother" (MU/TH/UR 6000) deceived the crew with her/its wily feminine voice. The film features a graphic depiction of rape and forces motherhood onto an unwilling man, the character played by John Hurt (see Bell-Metereau, *Hollywood Androgyny* 210–16). Other films, such as *Three Men and a Baby* (1987) and Ivan Reitman's *Junior* (1994), focus on the funny side of mothering men.

Junior is perhaps the most literal enactment of the feminist co-optation theory imaginable. The egg implanted into the body of the male geneticist Alexander Hess (played by none other than Arnold Schwarzenegger) is stolen from Diana, a competing female scientist (Emma Thompson). During pregnancy, Alexander develops a new "feminine" persona, expressed rather stereotypically in maternal protectiveness; a new-found taste for cooking, pink flowers, and frilly curtains; uncontrollable appetites; a sudden and unpredictable emotionality; an ability to form friendships with women; even an angry response to the university's attempts to appropriate his pregnancy for research purposes, which he counters with the feminist classic "My body—my choice" (see Tincknell, *Mediating the Family* 73–75). This feminization (humanization?) is presented as a biological process, triggered through the artificial presence of female hormones, which rage uncontrollably inside Alexander's body (Harwood 184). In a neat enactment of the superiority of (masculine) science over (feminine) nature, the situation is, in the end, resolved scientifically through the Cesarian birth of Alexander's baby. Alexander, having thus "experienced" motherhood, becomes capable of forming a lasting relationship. He uses his new expertise to select an appropriate mother for his children (in the straightforward logic of the film, the same scientist whose egg he carried to term). Thus endowed, he reverts

to a "natural" fatherhood whose success is assured by his presumably enhanced understanding of women and children.

As Tincknell has pointed out, much of the film's comedy is based on the absurd contrast between Alexander's new-found femininity and Schwarzenegger's star image as the embodiment of high-octane machismo (*Mediating the Family* 74). Paradoxically, it is precisely this type of hypermasculinity that—reinstated at the end of the film, although somewhat tempered by Alexander's fond reminiscences of his pregnancy—signals the availability and acceptability of "feminine" parenting qualities for men in general. The fact that Alexander is momentarily reduced to a blubbering bundle of sentimentality under the influence of raging hormones ("motherhood") is ultimately less central to the film's message than the fact that this does not, in the end, prevent him from reassuming his masculine authority ("fatherhood").

Chris Columbus's *Mrs. Doubtfire* (1993)[14] complicates matters somewhat by withholding from its father figure this kind of "natural" male authority. At the outset of the film, Daniel Hillard (Robin Williams) has lost both his job and his family. Having failed as a "father" (as breadwinner and responsible parent), he reenters his own house in the guise of a lovable, crotchety sixty-year-old Scottish housekeeper and nanny. Starkly contrasted with his architect/breadwinner wife, Miranda (Sally Field), who assumes power over him by becoming his employer, Daniel acquires "feminine" qualities, from cooking to playfulness to emotive understanding, that Miranda herself does not seem to possess. As Krimmer has pointed out, the obvious solution that the film does *not* offer is that of a simple role reversal: "Daniel as a house-husband and loving father with no professional ambitions could be the ideal complement to his work-oriented wife." This is not presented as an option, however, because it would require Daniel to take permanent "refuge in the female realm of domesticity" (33–34). Although, paradoxically, Daniel's fatherhood is initiated by his assumption of a "feminine" persona, it is undermined by his lack of masculinity, his inability to pull off Alexander Hess's feat of reverting to his true gender. Once unmasked he is unproblematically accepted by his children as their father, but he is not allowed to reenter his house as a father either by his wife, who merely grants him a subordinate role as babysitter, or by the judge, who upholds the initial decision to award custody of the children to Daniel's wife. In other words, successful fatherhood, even as it incorporates "feminine" qualities, remains an essentially male affair.

Daniel ends the film as a profoundly ambivalent figure. His professional success is tied to his feminine persona (he runs a TV show as Mrs. Doubtfire). As himself, he is allowed to care for his children, but in a role that entails all the work and care of motherhood while being completely bereft of the authority of fatherhood.[15] Rather than validating him as a father, the film shows the hopelessness of Daniel "really shaping up and taking responsibility for the whole fatherhood caper": fatherhood itself is presented as "a joke" (Nicole Matthews 119). Daniel is hardly, as he has often been read, an ideal mix of father and mother;[16] on the contrary, he is an amalgamation of mother and *child*. Even his most earnest protestations of how seriously he takes his role as a father focus simply on spending time with his kids: "I have to be with my children, it's not a question [. . .] I need to be with my children, I'll do anything." The film presents "being with" his children as playtime. Daniel throws riotous parties, dons costumes, provides the voice-over for cartoons, creates little domestic disasters,

and is hardly fazed when one of his children walks in on "Mrs. Doubtfire" urinating while standing up. The potential trauma of this scene (cf. Bruzzi, *Bringing Up Daddy* 179)—the child's discovery of kindly nanny's male member—is partly mitigated through the simultaneous discovery of Dad's identity, but partly also through the childishness of the situation itself (catching a glimpse of another kid peeing).

Compared with the cool distance of the film's "real man" Stu (Pierce Brosnan) toward Miranda's children, Daniel's childishness is warm and caring, and it is of course expressive of the old adage that to understand children you have to become one yourself.[17] But it is also, in the end, what disqualifies him from fatherhood, because both woman and child, the roles he is able to play, fall woefully short of the masculine persona that is the real foundation of responsible fatherhood. Even if this conflation of masculinity and fatherhood is identified with the film's traditionalists (mainly Miranda and the judge who refuses to reverse the custody decision), Daniel's acceptance of his subordinate role as babysitter, his willingness to settle for less than full-fledged fatherhood, underlines his lack of masculine resolve.

Although they "cross" the line into the feminine realm quite ostentatiously, the mother-impersonators of *Junior* and *Mrs. Doubtfire* do not endorse the feminization of men or sexual ambiguity of any kind. Alexander, even after he has stopped taking hormones, continues to gush about his pregnancy as one of the most important experiences of his life, and *Mrs. Doubtfire* proclaims that a father is someone who cares for and about his children, even if he has failed in every other way. In Bell-Metereau's optimistic reading, these figures convey "a sense of hidden possibilities, of the potential for change and renewal. [. . .] when we find ourselves identifying with the other sex, we learn more of what it is simply to be human" (*Hollywood Androgyny* 237). Yet neither Alexander nor Daniel comes by this identification honestly; it is thrust upon them in pursuit of other goals (scientific insights in Alexander's case, being near his children in Daniel's). For the audience, moreover, the identification with femininity that both characters enact temporarily, as a means to a different end, is even less direct. Although both films chalk this brief foray into femininity up as a positive learning experience, they expunge it at the end, albeit in diametrically opposed solutions: Alexander's reclamation of his masculinity and Daniel's failure to achieve his.

By stealing the show of motherhood, both Alexander and Daniel indirectly proclaim the centrality of the father in the family. Daniel's children are clearly less than happy in their single-parent mother-led family. Alexander as a father fulfills, in more ways than one, Diana's pursuit of motherhood, which—otherwise why freeze an egg?—is implicitly shown as on the verge of failure. It is no coincidence that both mothers, Diana in *Junior* and Miranda in *Mrs. Doubtfire,* are highly accomplished professionals. In these films, the idea that a woman could successfully combine motherhood and career is more outlandish than the idea that men could become pregnant, or that their wives of fourteen years would fail to recognize them simply because they have donned a skirt, wig, and makeup.

From films that deal so overtly in gender bending, we might expect a certain measure of ambiguity. In the end, though, the family unit is saved not by virtue of ambiguity but ideological promiscuity. Ambiguous films, as defined by Green, leave viewers in a state of doubt, making it difficult for them to accept the film's

readymade solution. Promiscuous films, on the other hand, offer "something for everyone, contriving the story so no potential audience feels left out." Here, the audience is "cheerfully satisfied with either of the interpretations that is being made available" (Philip Green 146-48). Both *Junior* and *Mrs. Doubtfire* can be accused of this kind of promiscuity. We can be "cheerfully satisfied" with the idea that fathers need a bit of character tinkering. But we do not, in exchange, have to let go of the traditional (breadwinner, masculine, authoritative) father or of the Clintonian idea that a family without Father is no family at all.

SAVING THE SON: THE FATHER AS A BUDDY

The Pursuit of Happyness (2006). Dir. Gabriele Muccino. Writer: Steve Conrad. Columbia. Nominated for 1 Academy Award (0 wins). Domestic Total Gross: $163,566,459. Foreign Gross: $143,510,836. Total Box Office: $307,077,295. Production Budget: $55 million.

Road to Perdition (2002). Dir. Sam Mendes. Writer: David Self. Dream Works. 1 Academy Award (6 nominations). Domestic Total Gross: $104,454,762. Foreign Gross: $76,546,716. Total Box Office: $181,001,478. Production Budget: $80 million.

About a Boy (2002). Dir. Chris Weitz and Paul Weitz. Writers: Peter Hedges, Chris Weitz, Paul Weitz. Universal. Nominated for 1 Academy Award (0 wins). Domestic Total Gross: $41,385,278. Foreign Gross: $89,164,177. Total Box Office: $130,549,455. Production Budget: $30 million.

Affliction (1997). Dir. Paul Schrader. Writer: Paul Schrader. Lions Gate. 1 Academy Award (2 nominations). Domestic Total Gross: $6,330,054. Foreign Gross not available. Production Budget: $6 million.

Mother's subsumption into Father's "maternal" personality forms part of a general trend: in many Hollywood "families," mothers and daughters are nowhere in the picture.[18] *Sleepless in Seattle* (1993), a film that reconstitutes the nuclear family by adding Mother to the father-son team, inspired few followers. In fact, cinema of the 1990s inundated viewers with absent or evil mothers.[19] Even as the "normal, stable and consensual family" provided the "dominant narrative driver" (Harwood 7) of social and political discourse, the plot of many Hollywood films did not really get going until the family was stripped down to the essential father-son pairing. "Father-son movies vastly outnumber father-daughter movies and it is usually through a turbulent relationship with his son that a father's role is scrutinized and explained. The sons, in turn, manifest extreme responses towards these fathers, wanting to destroy them, become them (sometimes both at once) or wanting to effect a final reconciliation with an alienated father, often as he lies in bed ill or dying" (Bruzzi, *Bringing up Daddy* xv).

We are now firmly on the trail blazed by Freud and Lacan, a dark all-masculine "world beyond the mother" (Reiter 14) in which human relationships are foiled by fears of abandonment and loss, obsessions with the name of the father, inheritance,

genealogy, and fantasies of sacrifice, castration, and parricide.[20] In this world, the best possible outcome is not life but survival.

Survivalist father-and-son films are concerned less with portraying family life than with reenacting American myths such as rags-to-riches tales (*The Pursuit of Happyness*) or, more literally in *Road to Perdition,* "the last mythic American landscape, the 1930s, when there was still space in which to completely lose yourself in the vastness of America."[21] Triggered by an external circumstance or emergency (poverty in *The Pursuit of Happyness*; the son witnessing a murder in *Road to Perdition*), the plot eliminates the remainder of the family swiftly to buckle down to the actual story: how far a father will go to save his son.

At the outset of *The Pursuit of Happyness*, Chris Gardner (Will Smith) declares that a good relationship with his son is his primary goal in life: "I'm Chris Gardner. I met my father for the first time when I was 28 years old. And I made up my mind as a young kid that when I had children, my children were gonna know who their father was."[22] In contrast, his wife (Thandie Newton) is so worried about the family's economic survival that she is unable to function as wife and mother. She spends much of her screen time near tears, undercutting Chris at every turn, alternately desperate and dejected to the point of apathy, and unable to put on a cheerful face to their five-year-old son Christopher (Jaden Smith), even on his birthday. Once she has left the family, relinquishing the son to the care of the better parent, Chris must serve as both father (breadwinner) and mother (provider of love, care, and security for his son). Like comedic fathers, Chris compensates for Mother's absence by adopting, in part, a "feminine" personality. This manifests itself in his role as loving caregiver for his son, in his immense capacity for self-sacrifice, and also on the job. As the only black intern at a high-powered brokerage firm, he is quickly singled out as the boss's "secretary" and saddled with all sorts of odd jobs, from procuring doughnuts to re-parking the boss's car.

Chris's project is as American as apple pie: he wants to provide "a better life" for his son. For a black man, the main road to this better life is, of course, education. He enrolls in an internship at a brokerage firm, undergoes various hardships related to his race and his abject poverty—the film is essentially composed of a series of devastating setbacks—and successfully beats unbelievable odds. He secures a much-coveted and highly competitive internship, finishes first in his class, gets the one job the firm offers to a member of the graduating class, and ends up a multimillionaire. Throughout all this, he manages to relate to Christopher even in circumstances of extreme deprivation in a way that contrasts harshly with his ex-wife's initial neglect and later abandonment of the child. In one central scene, Chris and Christopher, evicted from their apartment because he did not pay the rent, must sleep in a bathroom in a San Francisco subway station. Chris protects his son from this horrible situation by pretending they are escaping from dinosaurs in a time machine. We see him sitting in the bathroom, Christopher peacefully sleeping on his lap, tears streaming down his face, holding the door closed with his foot while someone outside bangs on the door.

The ultimate goal of Chris's pursuit is less his own "happyness" (the title derives from a misspelling on a wall that Chris, intent on passing on good education to his son, corrects numerous times) than Christopher's. Although the film occasionally takes its eyes off the prize, in brief scenes that feature easily achievable moments

of happiness, such as eating a hamburger or a simple lesson taught to his son, "happyness" in the end simply translates into immeasurable wealth. True to the standard rags-to-riches tale,[23] there is no middle ground between Chris's wretched poverty at the outset and the lush millionaire's lifestyle that he achieves in the end. The film links wealth with personal achievement, although it rejects the coupling of poverty and personal failure, voiced by several characters. Chris understands this clearly and acts on it by making his poverty his best-kept secret, particularly when cultivating contacts with the rich or during job interviews. Ultimately, his triumph is largely predicated on his successful impersonation of a rich man and the wit with which he avoids being unmasked as poor (for example, when he arrives at an all-important interview fresh out of jail and dressed in paint-splattered rags).

Two national father figures frame the pursuit of happiness: the president who originally authored these words and the ruling president at the time the film is set (1981). From the depths of despair, Chris contemplates the relevant passage in the *Declaration of Independence:*

> I started thinking about Thomas Jefferson, the Declaration of Independence, and the part about our right to life, liberty and the pursuit of happiness. And I remember thinking: How did he know to put the "pursuit" part in there? That maybe happiness is something that we can only pursue. And maybe we can actually never have it. No matter what. How did he know that?

The implication here is simultaneously meritocratic and dispiriting: there is no constitutional guarantee of happiness, merely a right to "pursue" it (and, as Chris suspects here, potentially unsuccessfully). This thought is borne out in a scene in which Chris protests angrily when he is turned away from the mission where he tries to secure a mattress for the night: "I was told that we had to be here on time. I got here on time. I was in line." Although he played by the rules and thus deserves a place to sleep, he is rejected, a decision he can do little to influence (he and Christopher are admitted in this scene but turned away on another occasion). There is no guarantee of a mattress, merely the constitutional right to pursue it. The film deserves some credit for showing the consequences of Reagan's social and economic policies: barely affordable and wretched childcare (Christopher's daycare center); homelessness (lines of desperate people clamoring to enter the mission; Chris carrying all of his belongings around with him); mentally impaired people thrown out on the streets rather than receiving proper care (the Time Machine guy); the lack of a social net to fall back on. For nearly two hours, viewers witness the complete failure of the Reaganite American Dream, only to have it reinstated to full glory at the end.

In point of fact, Reagan, the film's second president/father figure, holds out the promise that we will emerge from economic disaster if we "go to work to turn things around. And make no mistake about it, we can turn them around." Compared with Jefferson's elegant prose, this may sound like thoughtless and unsubstantiated drivel, but in the world of the film, Reagan turns out to be right. Chris goes to work to turn things around, and make no mistake, he succeeds, against impossible odds.[24] As the film's trailer suggests, "for his son, one man will reach for the impossible."

Chris triumphs because he keeps up his hot pursuit of happyness; his virtue lies in his determination to overcome hardship and—a clear message to those who hope for a better social system—in his utter self-reliance. This is the message conveyed not only in Reagan's TV address but also in a religious ceremony that Chris attends with his son. The song sung by the congregation as Chris hugs his son tearfully proclaims, "Please don't move that stumbling block, but lead me, Lord, around it. My burdens, they get so heavy, seem so hard to bear. But I won't give up, no no." This is ultimately also the lesson Chris passes on to Christopher. Shooting hoops at an inner-city basketball court, the quintessential site of usually unfulfilled career dreams for poor black kids, he instructs his son: "Don't ever let somebody tell you you can't do something. Not even me. You got a dream, you gotta protect it. People can't do something themselves, they tell you you can't do it. If you want something, go get it. Period." Like *Mrs. Doubtfire* and *Junior*, *Pursuit* can be accused of ideological promiscuity: on the one hand, it suggests that a father's primary duty is to care about (for) his son. On the other, caring is presented simply as getting filthy rich.

Like Chris, the father figure in Sam Mendes's *Road to Perdition* is given a single task that defines his entire life with his son: to ensure the son's survival. Mike (Tom Hanks), employed as a hit man by a (god)father figure, John Rooney (Paul Newman), flees with his son Michael (Tyler Hoechlin) after the child has accidentally observed a hit. Once the remainder of the family, another son, who is mistaken for the witness, and the mother, have been killed by the Mob, father and son embark on the traditional buddy road adventure. The project here is survival, but also—once again—enabling a "better life" for the child, which means in this case to prevent him from following in Father's footsteps as a paid killer. In a dramatic final scene, Mike, fatally wounded on the ground, kills his murderer, thus enabling his son, who had trained his gun on the assassin, to drop the weapon. "I saw then that my father's only fear was that his son would follow the same road. And that was the last time I ever held a gun."

Road to Perdition overflows with angst-ridden father-son relationships. John Rooney is unable to love his biological son Connor (Daniel Craig), who betrays him gruesomely, but is deeply attached to his "adoptive" son Mike. He harbors enough paternal feeling for him to refuse to permit the murder of Mike's son Michael even as he orders Mike's killing. Similarly, Rooney refuses to sacrifice Connor even though he is aware of his betrayal. To Mike, he confesses that "I will mourn the son I lost," although he himself orders him killed. The film features an elaborately staged parricide scene, shot like a traditional 1930s gangland hit, in which Mike, in his overriding concern to protect his son, kills his "father," Rooney. In the dark of night and in the driving rain, visibility further diminished by monochrome colors, Rooney finds his driver dead in his car. He and his bodyguards are clearly visible in the middle of the road as the camera pans back to show what a perfect target they offer. Then machine-gun fire coming seemingly from nowhere mows down all of Rooney's men. Since the soundtrack, a piano score, drowns out the bullets and screams, the audience remains as detached from the slaughter as Rooney, who stands with his back to the shooter, resigned to his fate. Once he is the last man standing, Mike emerges from the shadows. Rooney, turning slowly, utters a final blessing as well as his endorsement

of what is about to happen: "I'm glad it's you," upon which Mike, near tears, commits parricide. The bullets tearing into Rooney are the first the audience is allowed to hear.

We might read this scene as Freud's Oedipus complex in action: according to Freud, the earliest stage of the father-son relationship is marked by the son's desire to kill the father; similarly, in *Road,* the son's survival depends on the father's removal.[25] Of course, in Freud, the endpoint is not the father's death, but the son's identification with the father after the "dissolution of the Oedipus complex"; in contrast, in *Road to Perdition,* the father's death remains paramount for the son's survival to the end, when Mike, in turn, dies to save Michael. In the son's voice-over, which provides the final lines of the film, Mike's entire life is encapsulated by this final paternal act of killing and dying: "When people ask me if Michael Sullivan was a good man or if there was just no good in him at all, I always give the same answer. I just tell them: he was my father."[26]

If the ultimate goal is to save the son, and if this can only be achieved through the father's self-sacrifice, it is little wonder that Father stands absolute and absolutely alone in these films. The pairing of names in both films already indicates that father and son form a symbiotic unit. In both cases, the "kid" version (Chris, Mike) is assigned to the father and the "adult" version (Christopher, Michael) to the son. In sacrificing himself for his son, the father achieves a completion unavailable to himself: Mike saves Michael from becoming what he is—a killer—while Chris spares Christopher his own impoverished upbringing. Moreover, in both films, the narrative perspective underscores this intimacy: *The Pursuit of Happyness* is told from the father's perspective, with frequent voice-overs explaining the action; *Road to Perdition* from the son's perspective, with voice-overs framing the action.

Since other relationships would only intrude upon this intense symbiosis, the complete elimination of other family members, most importantly mothers or aunts, makes sense. *The Pursuit of Happyness* gives no indication that there will ever be a woman to replace Christopher's inept mother and complete the family unit. In *Road to Perdition,* the initial destination at the end of the road—Aunt Sarah's house— offers not sanctuary but (nearly) perdition, for it is here that the assassin sets a trap for father and son. At some point, both sons contest Father's authority, tearfully or stubbornly requesting access to the lost mother/family (Christopher: "I wanna go home"; Michael: "Just take me to Aunt Sarah's"). But the audience already knows that there is no family beyond the father to go home to. Indeed, in *Road to Perdition,* it is Father's main job to protect his son from the family or, in this case, the Family. The fate of the other son, Connor, whose death is authorized by the Family and predicated upon Rooney's failure to protect him, indicates clearly that the Family poses a deadly threat to Michael from which only his father can save him.[27]

Films denying the persistent Hollywood credo that a son's safety lies only in the arms of Father are comparatively rare. Inevitably, such films must take on two well-established cinematic traditions: the centrality of the father figure on the one hand and the irrelevance of the family on the other. Interestingly, the absence of a dominant father in the family drama does not reinstate the family—on the contrary.

About a Boy,[28] based on Nick Hornby's 1998 novel, redefines the idea of family and the role of the father. The film's father figure Will (Hugh Grant) is a

chauvinistic, shallow, and self-absorbed man-about-town—or, in his witty self-flagellation, an "unreliable emotionally stunted arsehole"—who lives comfortably on inherited money and spends his time consuming. Holding fast to the idea that "every man is an island," and proud of the fact that he has reached his late thirties without any meaningful relationship, Will is completely unprepared when twelve-year-old Marcus (Nicholas Hoult) singles him out as a potential father figure. At school, Marcus is a misfit who is tortured for his deeply uncool dress and behavior. At home, he is worried sick about his hippie throwback, clueless and suicidally depressed mother Fiona (Toni Collette). In his attempt to set Will up with Fiona, Marcus is initially out to gain the safety promised by the nuclear family. Will, on the other hand, initially uses Marcus to score single mothers because they are the only women who provide him with the kind of relationship he's interested in: "Passionate sex, a lot of ego massage, and a guilt-free parting."

This less-than-promising pairing—a not-very-hip twelve-year-old going on forty and a trendy thirty-eight-year-old who is emotionally about twelve—turns out to be the recipe for success. The film does away with the traditional one-sided father-son model and allows the two to interact as equals. Marcus dispenses advice on honesty and intimacy, Will on stylishness. Will understands the schoolyard, Marcus real life. Will learns from Marcus how to have a one-on-one relationship; Marcus from Will how to survive in a crowd. The turning point comes when Will understands that you support people you love, even if it means sharing in their public humiliation. He backs up Will, who sings "Killing Me Softly" on the school stage in a high, wavery voice, essentially committing social suicide to please his mom. The turning point for Marcus comes when he stops clutching at the straws provided by the nuclear family: "I don't think couples are the future. You need more than that. You need backup." Will, despite his ulterior motives and repeated rejection of Marcus early in the film, turns out to be every kid's fantasy father: he is cool, hip, and young; he is there when Marcus needs him; he notices when other kids humiliate him; he teaches Fiona a thing or two about parenting; and he is always available because he does not work. And yet the film does not hit upon the usual solution, the idea that the father's presence alone solves all problems. Both Will and Marcus end up in a free-wheeling group composed of family, friends, and potential and actual couples: Will's love interest Rachel and her son Ali; Marcus and his new girlfriend Ellie; Fiona and assorted incidental friends, both gay and straight. The group forms—in the final scene of the film—an island chain: everyone is an island, but beneath the surface, they're all connected.

The main achievement of the film is not that it does away with the nuclear family or the centrality of the father, or that it "displaced biological paternity to focus on the increasingly important *social* role of fathering" (Tincknell, *Mediating the Family* 62). Its central premise, Marcus's island-chain idea, is hardly new. Hillary Rodham Clinton proclaimed six years before the film (and two years before Hornby's novel) that "it takes a village to raise a child," and this is in fact the standard family structure in several non-Western societies (cf. Radcliffe-Brown; Parry; Amoateng and Heaton). *About a Boy* breaks with the standard Hollywood son-survival story in a radical way precisely because it suggests that survival is an ongoing project rather than a once-and-for-all fix. Several of the film's central characters are ill-suited for survival, most

importantly Fiona, whose clothes alone signal how utterly out of place she is in the modern world. Once Will realizes that he cares about Marcus, he also understands that he must do something about Fiona because Marcus's survival is linked to hers. "Marcus. He was the only thing that meant something to me, and Fiona was the only thing that meant something to him, and she was about to fall off the edge." Initially, he hits on the standard solution: looking for a quick fix.

> *Will.* Please don't try and commit suicide again.
> *Fiona.* I can't believe you just said that. That is my private experience.
> *Will.* Yeah, well, that's the thing, isn't it? It's not. Because Marcus is worried about you. And I'm worried about Marcus because he's worried about you, so it's not.
> *Fiona.* Will, I don't have plans to commit suicide.
> *Will.* You don't?
> *Fiona.* Not at the moment, no.
> *Will.* Great. Great! [*embracing her*] Well, good.
> *Fiona.* Will, you know I'm not attracted to you, right?
> *Will.* Huh? What are you on about? No. What are you, nuts? All right. Wrong word completely. But that's, d'you know, something that we should, you know, talk about a bit, this crying in the morning thing, this depression. You know? Let's get that fixed.
> *Fiona.* That's what men think, isn't it?

This may well be the most honest moment of the film, the one that shows up the disingenuousness of son-survival films like *The Pursuit of Happyness* and *Road to Perdition*. Of course, there is no once-and-for all fix for "the crying in the morning thing, the depression." There is no villain to shoot and no epiphanic moment of "happyness" that blots out the past. We (and Marcus) don't even know why Fiona is constantly depressed and crying. We can only assume that the problem is ongoing, and that therefore the solution must also be ongoing, in the form of constantly reenacted support. Even so, the problem cannot be fixed once and for all. In this scene, Fiona merely promises not to kill herself "at the moment"; in the final scene, she does a bit better for Marcus, promising him to "be around for a while." Still, it is clear that with "backup," her chances of survival, and therefore also of Marcus's survival, are considerably greater than they would be in a traditional nuclear family. In fact, the film does not support Marcus's initial impulse to "fix" his mother by providing a father figure for a nuclear family unit with him and Fiona. By stripping the father of his predominance and the nuclear family of its preeminence as the only suitable context for children, *About a Boy* in effect denies the audience the guarantee of the son's survival. Marcus's survival is relatively assured at the end of the film, but only on the condition that it is constantly renegotiated.

Paul Schrader's *Affliction* turns the traditional story of the son's survival through the father's self-sacrifice entirely on its head. The film shows in excruciating detail the devastating influence of an abusive father on his two sons. Rolfe Whitehouse (Willem Dafoe), from whose perspective the film is narrated, manages to extricate himself. He survives to tell the tale of his brother's total erasure: "This is the story of my older brother's strange criminal behavior and disappearance. We who loved him no longer speak of Wade. It's as if he never existed."

Long before Wade Whitehouse (Nick Nolte) exhibits "strange criminal behavior," his failure as a father foreshadows his decline. Following a bitter divorce, he fails to relate to his sullen and uncommunicative daughter Jill (Brigid Tierney), who spends all of her visiting time with him uttering morose requests to be taken home to Mom. These scenes—he full of forced jollity, she the very picture of dejection—are painful in the extreme. We get our first glimpse of Wade's fatally impaired judgment when he decides to go to court to obtain custody of his daughter even though his own lawyer tells him that there is little chance he will prevail. As policeman in a perennially snowed-in, tiny New Hampshire town, Wade exhibits similarly flawed logic when confronted with a case that might be a hunting accident or murder. He embraces every single harebrained conspiracy theory that anyone casually utters about the case, and feverishly pursues several unlikely possibilities without coming any closer to solving the case. Wade's determination to get to the bottom of all these base-less theories remains mysterious until several flashback scenes reveal his motivation. Wade's dogged tenacity is rooted in his experience with his father (James Coburn), who used to call little boy Wade a "quitter." Similarly, the film relates Wade's sense-less outbursts of violence—verbal and legal attacks against his ex-wife Lillian (Mary Beth Hurt), random and unprovoked attacks on various townspeople, and wild and unsupported accusations of murder launched at the suspect of the moment—to his father's verbal and physical abuse of his wife and sons. These flashback scenes are shot home-movie style: a handheld camera shows wildly wavering faded color images that are strongly reminiscent of Wade's imaginings of the next improbable solution of his murder case, visualized in black and white. As the film progresses, the world of eternally snowed-in New Hampshire, with its limited color palette of greys, pale blues, and whites during daytime and grey to black nighttime shadows, increasingly mimics the monochrome world of Wade's mind movies.

This cinematographic equation of awful childhood memories with highly unlikely present-tense scenarios is the most tangible hint that Wade's perspective is profoundly unreliable. The viewer is pushed—or so it initially seems—into a search for clues of a more reliable reality that might balance Wade's fantasies. The one temptingly on offer is that of Wade's brother Rolfe. Rolfe consistently devalues Wade's phone reports on the murder case, the custody case or his childhood memories as "ongoing sagas," "detective stories," and "family melodramas." The film seems to set Rolfe up as a voice of reason, the survivor of domestic abuse, the more successful brother. Rolfe escaped the dire world of his home and hometown and is now a professor of history at Boston University. His calm and reasonable demeanor contrasts favorably with Wade's deepening spiral of insanity. Not least of all, he survives the film physically. But Rolfe's status as role model is undercut by the fact that Wade's perspective is never related directly, but funneled through the limited perspective of Rolfe, whose knowledge is itself largely based on phone conversations with Wade. Furthermore, Rolfe is a highly unreliable witness intent on self-justification. Occasionally, the film confirms Wade's account through additional evidence when his and Rolfe's memories of the same childhood episode differ. At one point Rolfe even tells a blatant lie, claiming that he has remained unaffected by their father's violence. The audience is thus cast adrift between two contradictory and unreliable perspectives, with Wade's dominating visually and Rolfe's controlling the voice-over narration.

In this way, the film turns Wade's and Rolfe's dilemma into that of the audience, without offering a viable solution. Failure to extricate oneself from Wade's perspective—which is in essence his father's—means insanity and death. Wade slowly turns into his father. He sees his father's face in the mirror, drinks heavily, and uses his father's abusive language ("Quitter! Quitter!"), until at the end of the film he accidentally kills him and disappears. Unlike Wade, Rolfe succeeds in distancing himself from his father's perspective, but this is presented as the coward's way out. Rolfe does not attempt to intervene, but merely observes his brother's decline. "You will say that I should have known terrible things were about to happen. You will say that I was responsible. But even so: what could I have done by then? Wade lived on the edge of his emotions. He was always the first to receive the brunt of our father's anger. He had no perspective to retreat to. Even in a crisis." Set against Rolfe's unconvincing justifications, Wade emerges as something of a hero. As a child and an adult, Wade shielded others from his father—he tries to protect his mother and his sister from a beating; in another scene, he takes his drunk father's car keys away. In contrast, Rolfe stands idly by as his father brutalizes his brother and mother and makes no attempt to stand up for them. He himself betrays this in a conversation with Wade in which he pits his memory of events ("history") against Wade's ("stories"): "I became real careful around Pop. I was a careful child, and I became a careful adult. At least I was never afflicted by that man's violence." To which Wade replies, laughing, "That's what you think."

The father's abuse, in other words, has damaged both sons beyond repair. At the end, Rolfe privileges Wade's (and his) "stories" over the inexpressive facts of "history":

> The historical facts are known by everyone. [. . .] Facts do not make history. Our stories, Wade's and mine, describe the lives of the boys and men for thousands of years. Boys who were beaten by their fathers, whose capacity for love and trust was crippled almost at birth. Men whose best hope for connection with other human beings lay in detachment, as if life were over. It's how we keep from destroying in turn our own children and terrorizing the women who have the misfortune to love us. How we absent ourselves from the tradition of male violence. How we decline the seduction of revenge.

In contrast to traditional father-and-son buddy movies, here fathers pass on not heritage but affliction, not the hope of a "better life" but violence unto death or clinical detachment, "as if life were over." The film stages a direct reversal of *Pursuit*'s dictum that the struggle, if fought hard and consistently enough, will be crowned by success. The more Wade struggles to be a good father and to be different from his own father, the more he becomes like him. Rolfe, on the other hand, manages tolerably (but certainly not "happyly") through detachment. In other words, he refuses to struggle. In this scenario, the best possible outcome, and simultaneously the greatest tragedy, is not the son's survival but his death:

> We want to believe Wade died that same November, froze to death on a bench or a sidewalk. You cannot understand how a man, a normal man, a man like you and me, could do such a terrible thing. Unless the police happen to arrest a vagrant who turns out to be Wade Whitehouse, there will be no more mention of him, . . . or our father. This story will be over, except that I continue.

Referring to Wade, who spirals from uncommunicative, paranoid, and irrational to vicious, violent, and insane as "a normal man, a man like you and me," may seem a bit of a stretch. But by calling Wade normal the film, in its final sentence, sneaks in a contemplation of what so many father films comfortably assume as a given: the question of what can be considered "normal." It is certainly a question worth asking. Why should audiences settle for the fairy-tale ending of *The Pursuit of Happyness*, after having been confronted with abject poverty and its effects on the nuclear family, merely because this incredible ending bears the rubber stamp of "history" as in "based on a true story"? Why should we view a son's survival, engineered through the father's simultaneous act of killing and dying (*Road to Perdition*), as a bearable ending? Why should we accept the cinematic pretense that fathers are there for their children when in real life many fathers abandon them or rarely see them because they work all the time?[29] Why, for that matter, should we accept that once fathers adopt some "feminine" qualities, mothers are of secondary importance?

By saddling Father with the sole responsibility for the son's survival, father films imply that the nuclear family is irrelevant. But the alternative idea that Dad can do it all by himself, given sufficient "feminine" emotiveness and "masculine" determination, certainly deserves a question or two. Such questions (in *About a Boy: can* Dad really do it by himself? In *Affliction:* what happens if he does?) are often drowned out by the satisfying contrast between Father's contested position at the film's outset and his stunning success at its end. Daniel's irresponsibility, Chris's poverty, Mike's inability to relate to Michael under normal circumstances, and Will's and Alexander's inability to form a lasting relationship pale beside their achievements: they learn from their experiences, become more responsible parents, and ultimately save their children physically, emotionally, morally, or economically. Perhaps this shows once more the iconic value of the Father. In politics, his absence is often cited as the gravest problem besetting American society, although there is little evidence to suggest that children in single-mother families fare worse in any terms other than financial, and plenty of evidence that they do better than children in families headed by an abusive father.[30] In cinema, the father is as devastatingly efficient in the familial and social realm as Rambo in the jungle. He vanquishes the most acute social (poverty) and personal problems (divorce), an army of angry mobsters, and human biology (Alexander Hess's pregnancy). He also neatly does away with a structure that no American politician would ever dare to question—the nuclear family. Armed with a new arsenal of "feminine" qualities, the father overcomes his initially embattled position and emerges as the most traditional he-man imaginable.

SAVING THE NATION: THE FATHER AS A SYMBOL

Volcano (1997). Dir. Mick Jackson. Writers: Jerome Armstrong, Billy Ray. Twentieth Century Fox. Domestic Total Gross: $49,323,468. Foreign Gross: $73,500,000. Total Box Office: $122,823,468. Production Budget: $90 million.

War of the Worlds (2005). Dir. Steven Spielberg. Writers: Josh Friedman, David Koepp. Paramount. Nominated for 3 Academy Awards (0 wins). Domestic

Total Gross: $234,280,354. Foreign Gross: $357,465,186. Total Box Office: $591,745,540. Production Budget: $132 million.

The Day after Tomorrow (2004). Dir. Roland Emmerich. Writers: Roland Emmerich, Jeffrey Nachmanoff. Twentieth Century Fox. Domestic Total Gross: $186,740,799. Foreign Gross: $357,531,603. Total Box Office: $544,272,402. Production Budget: $125 million.

Signs (2002). Dir. M. Night Shyamalan. Writer: M. Night Shyamalan. Buena Vista. Domestic Total Gross: $227,966,634. Foreign Gross: $180,281,283. Total Box Office: $408,247,917. Production Budget: $72 million.

Gladiator (2000). Dir. Ridley Scott. Writers: David Franzoni, John Logan, William Nicholson. Dream Works. 5 Academy Awards (12 nominations). Domestic Total Gross: $187,705,427. Foreign Gross: $269,935,000. Total Box Office: $457,640,427. Production Budget: $103 million.

The Patriot (2000). Dir. Roland Emmerich. Writer: Robert Rodat. Columbia. Nominated for 3 Academy Awards (0 wins). Domestic Total Gross: $113,330,342. Foreign Gross: $101,964,000. Total Box Office: $215,294,342. Production Budget: $110 million.

As one of the last he-men around, the father is an ideal vehicle for national myths. Hollywood films strictly distinguish between "actual" fathers, who are often diminished or inept, and symbolic fathers, who start out that way but in the end represent the unassailable ideal.[31] As a national symbol, only the awesome primal father will do. He wields his remarkable power in two cinematic genres: the disaster movie set in the recent past, present, or near future and the historical film set in the distant past. In these films, the child's survival, a paradigm already familiar from the father-and-son buddy road movie, gains in importance because it is symbolically linked with the nation's survival, either negatively (the child is sacrificed but the nation is saved) or positively (child and nation are saved). Inevitably, the nation itself—regardless which nation is portrayed in the film—or even the entire human race stands in for the United States of America.

Disaster movies such as *War of the Worlds, Signs, Volcano* or *The Day after Tomorrow* take their cue from fantasy/action or disaster films of the 1980s and 1990s, which were often successful enough to inspire sequels spanning years or even decades (the *Mummy* series, 1999-2008; the *Terminator* franchise, 1984-2009). These films inevitably portray a larger-than-life threat to the "world,"[32] such as volcanic eruptions, climate change (*Volcano; The Day after Tomorrow; 2012*), or alien invasion (*Signs; War of the Worlds*). Forced to face up to this local or global crisis, the film's inept, neglectful, emotionally crippled, or unreliable father turns into a caring, protective, and competent dad (Fig 3.1). The crisis outside enables these fathers to rise to challenges in the personal realm that previously seemed insurmountable: divorce (*War of the Worlds*), widowerhood (*Signs*), or simply overwork that leaves no time for the kid (*Volcano; The Day after Tomorrow*).

In many of these films, the father figure is charged to save the "world" (or what's left of it after disaster has struck) as well as the child. Even if millions of lives are

Figure 3.1 It takes a global crisis: Ray Ferrier (Tom Cruise) is finally close to his son (Justin Chatwin) and daughter (Dakota Fanning). Courtesy of Photofest, Inc.

lost, even if the global threat eventually takes care of itself (*War of the Worlds*[33]), the father figure is instrumental in hitting upon a solution to the crisis. Because of Father, the film's world recovers, restarts, and continues. Who is the first to notice that the shielding on the alien tripods has failed and to point this out to the military (in *War of the Worlds*), the first to understand that the aliens can be killed by exposure to water (in *Signs*), or the first to take the threat of global climate change seriously, in time to save millions of lives (*The Day after Tomorrow*)? More often than not, it is the film's Father. "While mothers may lay claim to giving biological birth to children, these fathers ensure that there will be a world for these children to live in" (Jeffords, "Can Masculinity Be Terminated?" 255).

In many films, saving the diegetic world is a cinch compared with the far greater challenge of saving the child and becoming a good father. But of course this is a false juxtaposition: many films equate saving the world with saving the child (or more to the point, the son, even in films like *Signs* or *War of the Worlds,* which feature daughters and sons). In *The Day after Tomorrow,* the reunion of father and son marks the end of the "disaster" part of the film and the beginning of the recovery phase. In *Signs,* the tale of a reverend who has lost his faith following the traumatic death of his wife, the son's survival restores the father's faith, enabling him to resume his task within the family as father and in his community as Father. And in *War of the Worlds,* in which the father must let go (initially it seems: sacrifice) the son to save the daughter, the highly unlikely restoration of the son (whom we last see running into a blazing inferno) signals that all is well with the human as well as the nuclear family. The final shot of the film shows a neatly gender-divided embrace, daughter in the arms of mother, and father embracing son. Finally, although the initial sacrifice of sons helps to save the world in both *Gladiator* and *The Patriot,* images of saved children herald the peaceful era of rebuilding. Lucilla's son Lucius survives, and *The Patriot's* Benjamin rebuilds his family. His marriage and the rebuilding of his house,

which the film foregrounds in its final scenes, furnish a new protective context for his surviving and any future children.

In film after film, the child's survival symbolizes the continuation of humanity (and by extension, the casting of the father as the savior of the human race). This identification is in turn predicated upon a linkage between global disaster and family crisis. In a scenario in which a large part of humanity is eradicated, the death of every child imperils the future. In *The Day after Tomorrow,* the scientist and failed father Jack Hall (Dennis Quaid) urges immediate action on global warming, warning that "if we do not act soon, our children and grandchildren will have to pay the price." Just as he himself has failed his son (Jake Gyllenhaal), the nation has failed its children. The only solution is to survive the disaster and start over, but a new start can only be realized if we "learn from our mistakes," both in the global arena of humanity and on the more limited playing field of fatherhood. In *The Day after Tomorrow,* this link between the survival of mankind and that of the son is particularly evident in a conversation between Jason (Dash Mihok) and Jack, the father en route to his son:

> *Jason.* What do you think's gonna happen to us? [...] I mean us. Civilization. Everybody.
> *Jack.* Mankind survived the last Ice Age. We're certainly capable of surviving this one. All depends on whether or not we're able to learn from our mistakes. I sure as hell would like a chance to learn from mine. [...] I made my son a promise. I'm going to keep it.

The death of millions does not even rate a mention; the focus shifts immediately and optimistically to the handful of survivors who have, one hopes, profited from these deaths as an object lesson. Jack's casual implication here is somewhat reminiscent of Bob's bitter statement in *He Was a Quiet Man:* "There comes a time when the diseased and weak must be sacrificed in order to save the herd." Diegetically, disaster movies do indeed engage in this kind of "purging."[34] Stupid *people* die in millions (for instance the people in *The Day after Tomorrow,* who, sheeplike, follow the cop out of the New York Public Library to freeze to death outside). Stupid *presidents* (the erstwhile vice president who pooh-poohed Jack's scientific findings and warnings) get to "learn from their mistakes." Having reformed, repented, and survived, they lead the considerably reduced, but presumably now more robust, human race into the next era. "Learning from our mistakes" even holds out the promise of a harmonious equality in the new world that was firmly out of reach in the old. We might think here of the new respect awarded to the homeless black man Luther (Glenn Plummer), the presidential appreciation of Mexico's generosity in opening its borders to U.S. refugees (both in *The Day after Tomorrow*), or the rescued little boy (Jared Thorne/Taylor Thorne) in *Volcano,* who, pointing at whites and blacks covered in volcano ash, exclaims, "Look at their faces. They all look the same!"

In their "globalization" of American concerns as those of the entire world, disaster films echo political attempts made, particularly during the 1990s, to "place the nation at the very center of history" and "redefine 'America' as 'the beacon of freedom

in a searching world.'" (George H. Bush, cited in Savran 241). In his State of the Union address on January 31, 1990, George H. Bush defined America as "not just the nation, but an idea alive in the minds of people everywhere" (cited in Savran 240). As an idea(l), America is identified with the whole world (or the part of it that matters, anyway). Thus what is obviously a film about a key moment in U.S. history, 9/11,[35] can be staged cinematically as a War not only of the World, but the Worlds. Conversely, every single foundational moment in world history—the deposition of a tyrant in ancient Rome (*Gladiator*); the defeat of the British at the hands of U.S. revolutionaries (*The Patriot*)—symbolizes a key moment in American history. Once we are dealing in symbols, the past is not the past but the present. Faraway places are not distant but home. History is not history but myth. And the city, the country, and the planet all stand in for the nation.

Historical father films tend to shrink the variety of father types available to films set in the modern era—the working man in *War of the Worlds,* the faithless priest in *Signs,* the prescient but fatally ignored scientist in *The Day after Tomorrow*—down to one single type: the private citizen and father turned unwilling hero, redeemer, warrior, and savior of the country. In both *Gladiator* and *The Patriot*,[36] the father figure is a "man of the soil," a farmer[37] who, having lost his son, must be persuaded to do his part in saving the nation.[38] Historical films are, in fact, the only father films in which the action is initiated by the *loss* of a son, a sign that we are now firmly in the territory of symbolic rather than actual fatherhood. On this symbolic level, both films rather directly admit to being "about" America, either thematically or allusively. David Fanzoni, the screenwriter for *Gladiator,* put it plainly: "The movie is about us. It's not just about ancient Rome, it's about America" (cited in Cyrino 125). Both films were released in 2000, which could be seen as the end of the age of innocence in U.S. history. Years after the fall of the Communist regimes, one year before the horrors of 9/11 deflated America's supreme self-confidence as the world's only remaining superpower,[39] and at a time when U.S. presidential advisers spoke openly of imposing a "Pax Americana" on the world (Rose 160), *Gladiator*'s Roman Empire recognizably symbolizes America "at the height of its power." On screen as well as off, war is over simply because "there is no one left to fight, Sire." The sole question that remains is what kind of superpower Rome will become: a benevolent patriarchy (a "republic") or a tyrannical one.

Predictably, the political conflict takes the form of a father-son drama. Marcus Aurelius (Richard Harris), portrayed not as a powerful emperor but an ailing father, tries to make up for his admitted "failure as a father" in the final moments of his life. Two father-and-son conversations set the story in motion. In the first, Marcus Aurelius leaves the fate of the fatherland in the hands of an unwilling Maximus (Russell Crowe), "the son that I should have had." In the second, he disinherits his biological son Commodus (Joaquin Phoenix). Both sons have plans of their own that conflict with the father's wishes. Maximus dreams of returning home to his wife and son; Commodus, of succeeding his father as Father of the Country. In both scenes, we are offered visual clues that neither son will achieve his wish. As Maximus begs the emperor to allow him to go home to "a wife, a son, the harvest," a statue of Caesar, positioned right next to him, reminds us of Maximus's past career as "Rome's greatest

general" and hints at his future. Julius Caesar is credited with a massive expansion of gladiatorial games and the foundation of numerous gladiatorial training centers in the first century BC (Sanello; Rupert Matthews). As Maximus will be, Caesar was betrayed and stabbed to death. Similarly, Commodus's desire to become emperor of Rome is undercut as short-lived by his placement, throughout his conversation with his father, beside a statue of Plato, author of *The Republic*.

Although both *Gladiator* and *The Patriot* are painfully obvious in their moral certitudes and simplistic equations (Rome = America = republicanism = freedom[40]), in both, fatherhood is not a symbol for benevolent rule, but a complicated, multifaceted construct. We are given a first glimpse at this when Marcus Aurelius, the more sympathetic character, *denies* the identity of actual and symbolic fatherhood, while Commodus, the film's villain, *insists* on it. Marcus Aurelius's belated acceptance of responsibility ("Your faults as a son is my failure as a father") pales beside Commodus's heartrending listing of those faults. Aurelius's rejection of Commodus as his successor is merely the logical endpoint in a long history of rejection, from childhood on.

> Even then it was as if you didn't want me for your son. I searched the faces of the gods for ways to please you, to make you proud. One kind word, one full hug, where you pressed me to your chest and held me tight would have been like the sun on my heart for a thousand years. What is it in me you hate so much? All I've ever wanted is to live up to you. Caesar. Father.

The father-son embrace that follows is one of the great Oedipal moments of the film. In suffocating his father in the embrace, Commodus fulfills, all too literally, the Freudian paradigm that a son must kill his father to take his place. He also establishes himself as an abusive new father figure whose love finds expression only in murder. That this is a *political* paradigm as well as a personal one is already expressed in his final words to his father: "I would butcher the whole world if you would only love me." Later Commodus's murderous love reappears in his incestuous desire for his sister Lucilla (Connie Nielsen) and his death threats against her and her son Lucius (Spencer Treat Clark). Thus we are forewarned when Commodus refuses to cooperate with the Senate and instead claims sole and absolute power over the people of Rome. "I call it love," he informs the Senate. "I'm their father, the people are my children, and I shall hold them to my bosom and embrace them tightly." The formulation all too clearly evokes the parricide scene, just as it presages Commodus's fatal embrace of his "brother" Maximus, when he stabs him with a poisoned dagger.

If this implies a critique of fatherhood as a model for benevolent rule, the film later takes it all back in spectacular fashion.[41] Like *The Patriot*, *Gladiator*—to the extent that it portrays Republican Rome as template for America—must make adequate noises about "the people" who are ultimately expected to rule. This is initially Marcus Aurelius's charge to Maximus: "I will empower you to one end alone: to give power back to the people of Rome." But neither film actually shows the sovereignty of the people. The people of Rome are presented as a fickle mob entertained by blood sports, cheering for the winner on one day and the underdog the next. They are also

entirely impervious to historical irony: when the Battle of Carthage is staged in the arena, they implicitly cheer for their own defeat. As Senator Gracchus (Derek Jacobi) states, the people of Rome are, throughout much of the film, incapable of seeing through Commodus, accepting his poisoned love *as* love and responding in kind: "He'll bring them death, and they'll love him for it." Clearly, these are children in need of a father rather than self-rule.

Astonishingly, neither *Gladiator* nor *The Patriot* culminates in the rule of the people, even though both masquerade as America's foundational myth. Both do not empower the people to rule, but replace an abusive father figure with a more benevolent one. A history that involves the masses (war, revolution) is essentially stripped down to single combat between two men: Marcus Aurelius's two sons in *Gladiator* and "the ghost" Benjamin Martin (Mel Gibson) versus "the butcher" Colonel Tavington (Jason Isaacs) in *The Patriot*.

In *The Patriot,* the term "butcher" applies to those who do not respect the *sine qua non* of U.S. political discourse, the family. From the outset, Tavington attacks women and children; he murders Martin's son Thomas (Gregory Smith), and later initiates viciously punitive actions against the families of militia men. The traumatic loss of Martin's two sons is elevated to the status of poetic justice when Martin confesses to his oldest son, Gabriel (Heath Ledger), that he himself was guilty of such butchery in an earlier stage of the war. "We took our time. We cut them apart slowly. Piece by piece. I can see their faces. I can still hear their screams. [. . .] Not a day goes by where I don't ask God's forgiveness for what I did." Reminiscing about his sins at the appropriately named "Fort Wilderness," Martin, an erstwhile butcher who has "learned from his mistakes," is a more appropriate founding father for the nation (formerly also a "wilderness") than the unrepentant butcher Tavington.

"Butchery" manifests itself as the slaughter of innocents ("families"), but its root *cause* lies in the refusal to submit to paternal authority. This emerges in a scene in which General Cornwallis (Tom Wilkinson) tries to reign in his unruly "son" Tavington. "We serve the Crown and we must conduct ourselves accordingly. Surrendering troops will be given quarter. These brutal tactics must stop." But Tavington, not unlike Commodus, counters Cornwallis's conjuring of the symbolic father (in this case, the King) with a description of his actual father:

> *Tavington.* My late father squandered any esteem in which we were held, along with my inheritance. I advance myself only through victory.
> *Cornwallis.* You advance yourself only through my good graces.

The lawless brutality of Tavington, who refuses to submit to Cornwallis's paternal authority, parallels Commodus's tyrannical rule. In both cases, the greatest peril for the country consists in the unauthorized rule of the fatherless son. Empowering the people, letting all sons out from under the father's control, would escalate this danger immeasurably. It is a specter raised by Benjamin Martin when he cautions the Assembly against the dangers of democracy: "Why should I trade one tyrant 3000 miles away for 3000 tyrants one mile away? An elected legislature can trample a man's rights as easily as a king can." The film, of course, seems to prove him wrong, adopting his sons' perspective that the fight is both necessary and just. And yet, it appears

that the sons' fight must be tempered by paternal control. Sons who fight without
parental authorization become slaughterers (Tavington) or are slaughtered themselves
(Benjamin's son Thomas). But properly trained and assigned to their father's com-
mand, Benjamin's sons—his younger sons when they help their father rescue their
older brother Gabriel, and later Gabriel himself, when he fights under his father's
command—develop into valiant soldiers (Fig 3.2).[42]

Figure 3.2 Instructed by his father (Mel Gibson), Gabriel (Heath Ledger) fights bravely; freed from his
father's control, he rushes heedlessly into battle and pays with his life. Courtesy of Photofest, Inc.

This logic constitutes an irresolvable quandary for both *Gladiator* and *The Patriot*.
Since the films take on America's foundational myth and lay claim to a considerable
degree of historical veracity,[43] they must champion, as the ultimate "message," the
empowerment of the sons even as their narratives present such empowerment as a
specter of horror. In the end, both films take the easy way out and sidestep the
messy business of democratization. Instead, they offer reassurance through a sym-
bolic father, who functions as guardian and overseer of some future democratization.
In *Gladiator*, it is the kindly Senator Gracchus who is asked to restore the people's
faith in the justifiability of sacrifice: "Is Rome worth one good man's life? We believed
it once. Make us believe it again." Significantly, the question whether Rome is worth
the sacrifice of thousands—in centuries of conquest and gladiatorial games—is not
raised. In *The Patriot*, the film's son offers a vision of the future: "They call this the
New World. It's not. It's the same as the old. But we'll have a chance to build a new
world. A world where all men are created equal under God." God, of course, is the
most symbolic father figure of all: sufficiently removed to "make us believe" in home
rule for the sons, but at the same time powerful enough to prevent mob rule. Despite

all of its talk of "freedom," *The Patriot* admits that the new nation of America did not replace a "monarchy" with "democracy" but merely one symbolic father (the King) with another (God). Leaving its claims to historical "accuracy" aside for the moment, the film does encapsulate a symbolic truth that applies to this day: the United States still defines itself as "one nation under God" and is quite possibly the only Western industrialized nation in which God still rules political discourse with an iron fist.

Although tagged as historical films, neither *Gladiator* nor *The Patriot* has any interest in an accurate portrayal of the past.[44] Rather, like many politicians of the Clinton and Bush eras, they mobilize the past as a symbol of "what the United States can apparently offer the world (that is, freedom, democracy, hope, and so on)" (McCrisken and Pepper 29). The director Roland Emmerich's somewhat inarticulate description of the past purportedly depicted in his film—"It was like, kind of the birth of freedom"—is a carbon copy of Bush's assertion, ten years earlier, of America's presumed present and future ("America stands at the center of a widening circle of freedom, today, tomorrow and into the next century"; cited in Savran 240). The films' families are explicitly "globalized" in much the same way. "What we hope the audience will take away with [*sic*] after seeing *The Patriot* is that, that the only way to protect your family is to protect the family of all men."[45] In the context of this serial symbolization (Roman or Colonial history as a symbol for contemporary America and contemporary America as a symbol for "universal" human values), the films' assertion that the "remasculinization of the nation" (Fradley 248) is the only viable course packs at least as much ideological punch as the rather paradoxical vision of a "democracy" whose safety and endurance can only be guaranteed by paternalistic rule.

Historical films with their symbolic fathers generalize what nonhistorical films and their actual fathers portray in the particular. If history is portrayed not as specific but universal, the future of the entire human race is at stake (or, in the films' innocently revealing formulation, "all men" or "mankind"). Once "family values" become universal values, the father becomes the only possible parent. It is perhaps for this reason that father films, overwhelmingly and without the slightest sign of discomfiture, revalidate the he-man, the self-made man, the authoritarian, the pecs-and-'ceps man, the gunfighter, and the swashbuckling hero. Indeed, few cinematic soldiers or cowboys still stand as tall, proud, muscular, undisputedly male, and devastatingly destructive as the Hollywood father. And an astonishing number of films (*War of the Worlds, Road to Perdition,*[46] *Gladiator, The Patriot*) reclaim killing as a justifiable act, so long as it is done as a father, in defense of one's family.

This is indicative of a quick-fix mentality that manifests itself even more clearly in the films' sins of omission than those of commission. It is not accidental that *The Patriot* is populated exclusively by well-nourished, well-treated, and well-loved blacks working voluntarily for or with their white brethren. Clearly, the representation of slavery would complicate the film's simplistic propagation of American "freedom" as a universal value. Similarly, the confident resurrection of old-style masculinity is made possible only by the elimination of women from the majority of father films. The overriding desire for a quick fix is also the reason why father films favor the portrayal of problems that can be solved through violence, wit, determination, or

simple "musculinity"—say, alien invasion—over the depiction of the monsters that really destroy the world of children, such as absent, workaholic fathers or suicidal mothers prone on the couch, vomiting up an overdose of pills.

More than anything else, then, the "crisis" of fatherhood is one of denial, one that, in the name of the Father, restores traditional masculinity to all of its former glory while disavowing the actual crises that beset families as well as nations.

COWBOYS, MYTHS, AND AUDIENCES

> This is the West... When the legend becomes fact, print the legend.
>
> Newspaper publisher Dutton Peabody in
> *The Man Who Shot Liberty Valance,* 1962

> Deserve's got nothing to do with it.
>
> William Munny in *Unforgiven,* 1992

> "Have you ever killed anyone?"—"Yes, but they were all bad."
>
> Helen and Harry Tasker in *True Lies,* 1994

CLASSIC WESTERNS ARE AMERICA'S MOST ENDURING MYTHICAL GENRE. They show us "a heroically decent America" (Marcus 211), a world whose heroes—cowboys, gunslingers, sheriffs, prospectors, trappers, ranchers, buffalo hunters, bullwhackers, mountain men, rodeo riders, and homesteaders—are white American Protestant males, "a masculine world where men were men and women—on the rare occasions they appeared—seemed to like it that way" (Frayling xiv). All cowboy literature and films refer to and, on occasion, deviate from this blueprint. Not all fictional cowboys are Protestant white males. There are black cowboys,[1] Jewish cowboys (see Raboy; Rischin and Livingston), Native American cowboys (Savage 94-95), and queer cowboys (Packard), even—although considerably more rare—the occasional woman making her way across the Plains.[2] And of course, not all Westerns are American. There are, most famously, Spaghetti Westerns (defiantly called "Macaroni Westerns" in Italy), but also Sauerkraut Westerns from Germany, Paella Westerns from Spain, Camembert Westerns from France, Chop Suey Westerns from Hong Kong, Curry Westerns from India, and "Borscht Westerns" from Russia (Frayling xix). In spite of such foreign interlopers, the American Western still enjoys pride of place as *the* Western. Rare is the critic who, like Christopher Frayling, attempts to integrate it into the international scene (as the "Hamburger Western," with "John Wayne representing the pure beef variety," Frayling xix). The myth of *the* Western does not lend itself to such diversification.

In the Western, the white male embodies America's Manifest Destiny. He is "a kind of nameless Everyman, a symbol of the real or desired courage, independence and triumph of the ordinary American" (Philip Durham and Jones 227). By definition, such a hero exists in a world that presupposes white, Protestant, male, and American to be the norm. Like the "ideal" presidential candidate of the pre-Obama era, he cannot be a Mormon, Catholic or Jew, Swede, Hispanic, black, or female (Philip Durham and Jones 227–30). The Western hero is an archetype, not a person (cf. Frantz and Choate 70–72). He functions almost exclusively on the symbolic level as the "iconic American" (Baur and Bitterli 10), "professional American,"[3] or "quintessential American" (Kitses 13–14). This is why actors who have portrayed this archetype are often identified with it—most notably, of course, John Wayne— and why "a good-guy reputation established in Western films helped Ronald Reagan become one of the most popular politicians in US history" (Lenthan 121). As these examples show, the Western hero's status as symbol and archetype often leads to a conflation of actor and character, who are *both* identified as "iconic Americans": Wayne as the American Everyman, Clint Eastwood as the Man with No Name. The less specific (more symbolic) the actor's role in the film, the easier it is to view him in this way. Audiences do not generally confuse Tom Cruise with a secret agent, Russell Crowe with a gladiator from ancient Rome, or Kevin Spacey with a serial murderer, but in the world of myths and archetypes, the distinction between role and person is less clear cut.

As a mythical genre, the Western does not describe a "real" world, past or present. Westerns "emerged at a time when the West of America as evoked in these narratives had already disappeared. It is possible that it existed in this manner only for a few moments. In other words: [...Westerns are] pseudo-mythical legends in the making" (Koch 57). Some Westerns display considerable awareness of this. Sergio Leone's definition of the Wild West as a fairy tale in *Once Upon a Time in the West* is a case in point (Brehm 143). Self-aware or not, Westerns are not historical or even fictionalized versions of any moment in the American past but rather myths. Their symbolic quality permits the straightforward exportation of Western themes into the real world of U.S. politics. Even today, the frontier and its crossing, key themes of Westerns, serve to justify modern conquests: "The way the politicians declare that Iraq will be brought democracy by occupation and law and order will be established there is directly reminiscent of the themes of the Western films—if in a perverted form."[4] Over and over again, U.S. presidents, particularly those who espouse a tough-guy image, have framed their political and military goals with reference to Western legends and lingo, most recently George W. Bush in his promise to "hunt down terrorists and 'smoke them out of their holes.' "[5]

Because myths are by definition stuck in the past, the Western has become saddled, as it were, with a reputation for being the most backward, traditional, and un-modern of all film genres. For over thirty years now, scholarly consensus has declared Westerns to be a genre in decline. Unable to compete with more sophisticated genres, it survives as self-parody or in "revisionist" form.[6] Several critics have pointed out that very few Westerns have won Academy Awards.[7] Even scholarship on the genre has come in for its share of criticism, described by some of its own practitioners as "a field that is intellectually conservative and, what is worse,

unimaginative [. . .]. [W]estern literature isn't exactly the most theorized field in the world. It's an un-p.c. region where people know more about fur coats than Foucault" (Allmendinger, *Ten Most Wanted* 12–13). The similarity assumed here between subject and method of investigation is reminiscent of the conflation of cast and characters in Westerns.[8] But again, Westerns are mythical stories, and mythmaking relies on such a lack of distinction.

The (con)fusion of actor and character can be traced back to the genre's inception, when many of the last surviving Western heroes participated in the creation of their own legends. Wyatt Earp, Wild Bill Hickok, and Buffalo Bill Cody all played themselves in dramas or films. Henry McCarty, better known as Billy the Kid, was himself the originator of his "21-dead list," which contributed considerably to his legend after his death at the age of 21 ("one murder for each year of his life"), although only three or four killings on the Kid's list could be substantiated (Rasch; Wallis). Emmett Dalton, the last surviving member of the Dalton gang, specialists in train robberies, played himself in the 1918 film *Beyond the Law* and wrote a book titled *When the Daltons Rode* in 1931 (Latta). Jesse James, an expert in self-glamorization, mined Jacobean tragedies for ideas on self-representation (Frayling 192). And his son, Jesse James Jr., played his father in the 1921 film *Jesse James under the Black Flag*.[9]

In light of this history, it is hardly surprising that self-mythification, the standard modus operandi of the classic Western, is still the central theme in modern "historical" Westerns.

HISTORICAL WESTERNS: THE ASSASSINATION OF AN AMERICAN MYTH

Unforgiven (1992). Dir. Clint Eastwood. Writer: David Webb Peoples. Warner Bros. 4 Academy Awards (10 nominations). Domestic Total Gross: $101,157,447. Foreign Gross: $58,000,000. Total Box Office: $159,157,447. Production Budget not available.

The Assassination of Jesse James by the Coward Robert Ford (2007). Dir. Andrew Dominik. Writer: Andrew Dominik. Warner Bros. Nominated for 2 Academy Awards (0 wins). Domestic Total Gross: $3,909,149. Foreign Gross: $11,092,627. Total Box Office: $15,001,776. Production Budget: $30 million.

No Western in recent memory has been more susceptible to the traditional conflation of actor and character than *Unforgiven*. Clint Eastwood, who directed the film and played its lead role, is one of the most popular and iconographic Western heroes of all, second only to John Wayne in number of appearances and name recognition (Hoy 176). Eastwood has acted in eleven Westerns, directed four, and achieved iconic fame as the Man with No Name (Kitses 285–89). *Unforgiven*'s main hero, William Munny, a reformed killer coming out of retirement, has often been interpreted as Eastwood's antithetical resurrection of the mythical killer/hero of his own earlier Westerns such as *High Plains Drifter* (1973), *The Outlaw Josey Wales* (1976), and *Pale Rider* (1985). Munny, according to some critics, is "the heroic horseman— a pose from Eastwood's filmic past—from which Munny/Eastwood turns away."[10]

Based partly on this kind of intertextual identification of actor and character (and in this case, director), *Unforgiven* is commonly interpreted as a "revisionist" Western.[11] In this view, the Classic Western exists "in order to provide a justification for violence" (Tompkins 227), whereas *Unforgiven* critiques the validation of violence as a means to achieve "justice," encapsulated in the oft-repeated tagline "I guess he had it coming."[12] In Allmendinger's short and snide formulation, "Clint Eastwood kills people, but this time he's sorry" (*Ten Most Wanted* 12).

The film begins with a direct attack on masculinity, a prostitute giggling at the size of a man's penis. "All she done when she seen that he had a teensy little pecker is give a giggle, that's all. She didn't know no better." What Delilah (Anna Thomson) should have known is that she is paid not only to have sex but to maintain the man's "fragile self-importance" (Bingham 236). From the very start, *Unforgiven* links sexuality, violence, and masculinity.[13] Quick Mike (David Mucci), the whore's customer whose masculinity is questioned, asserts it violently—by cutting up her face.

The entry of the film's hero, William Munny (Clint Eastwood), is about as inglorious as it gets, the very image of humiliated manhood. Formerly an infamous killer who was reformed through the good influence of his pious but now deceased wife, Munny now writhes in the mud, desperately battling feverish pigs, poverty, and nature (Fig 4.1).

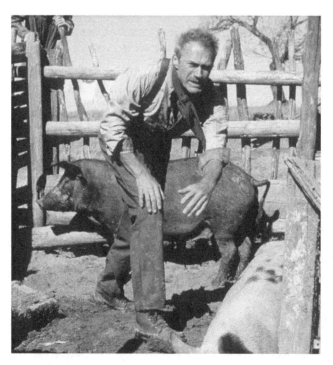

Figure 4.1 William Munny (Clint Eastwood), the pig farmer, an image of emasculation. Courtesy of Photofest, Inc.

From this abject position, he is confronted with his own humiliation by a seem-ingly disembodied voice pointing out the contrast between his former and his present self: "You don't look like no rootin' tootin' sonofabitchin' cold-blooded assassin." Looking up, Munny sees a rider silhouetted against the sky, an icon similar to the Pale Rider or Josey Wales: the Schofield Kid (Jaimz Woolvett) has come to enlist Munny's help in the bounty hunt for the two cowboys held responsible for Delilah's injuries. Already at this point, before the audience hears much about Munny's con-version, it is clear that it won't last. This failure is implied in Munny's abject misery and in the contempt in the eyes of his son (Shane Meier) as he watches his father get thrown off his horse or fail to shoot a can less than 20 yards away. A peaceful, quo-tidian existence signals unmanliness. No longer the lord over life and death, Munny is reduced to the existence of a worm crawling through slime. In fact, Munny in the mud is a recurring image throughout the film. When Little Bill Daggett[14] (Gene Hackman) beats him to a pulp in the saloon, Munny crawls out the door and falls into the mud, with passers-by averting their eyes from his emasculation in much the same way as his son does at the outset of the film.

Munny's participation in the bounty hunt is motivated partly as the hunt for his lost manhood. At the same time, the film suggests that this kind of manhood stands in direct opposition to humanity. On the quest with his best friend Ned (Morgan Freeman) and the Kid, Munny is consistently presented as the lesser man, both sex-ually (compared with Ned) and in terms of his willingness to engage in violence (compared with the Kid). Ned and the Kid avail themselves of the whores' services as soon as they can, but Munny confesses to Ned that he does not miss sex enough even to masturbate. The Kid, extremely short-sighted both literally and figuratively, boasts about his murderous exploits around the campfire. In contrast, Munny answers his insistent questions about how many he has killed with a monotonously recurring and increasingly questionable "I ain't like that no more." When Ned is murdered, Munny briefly reverts to the competent killer of his past, avenges Ned's death, and then dis-appears with his children to San Francisco, where, as the film's closing statement informs us, "it was rumored he prospered in dry goods."

Munny, who wants to be "just a fella [. . .] no different than anyone else no more," battles two demons: one is alcohol, the other his own legend, the myth of Munny the gunslinger and murderer. In this myth, man is in complete control of the violence he inflicts, but under the influence of alcohol, violence is defined as a *loss* of control, and it is this interpretation that Munny embraces. When asked about his murderous past, he explains, "It was whiskey done it as much as anything else. I ain't had a drop in over ten years. My wife, she cured me of that. Cured me of drinkin' and wickedness." Drinking and killing are linked causally, not only in Munny's mind, but also in the film. Ned and the Kid drink steadily to anesthetize the trauma of killing, but Munny, who has steadfastly refused all offers of whiskey, takes his first drink immediately before riding into town (whose name "Big Whiskey" already tells us that it will be the site of a slaughter) to avenge Ned's death. Before Munny enters the local saloon, the camera focuses on the empty whiskey bottle he has flung into the street. Munny has finished the bottle; there will be hell to pay. The following scene in the saloon shows Munny alternately killing and sipping whiskey. His sole comfort for the Kid, traumatized after his first murder, is "Take a drink, kid." When Munny

remorsefully remembers his killing of William Hendershot, whose name he assumes in masochistic identification when introducing himself to Little Bill, he states that he only killed Hendershot because he was drunk. This close connection between drinking and killing explains the otherwise incongruous dialogue between Little Bill and Munny in the saloon, with the whiskey bottle foregrounded on the table:

> *Little Bill.* I says, give me over your pistol.
> *Munny.* I ain't drunk.

At the end, we are told, Munny is "dry" again ("prospered in dry goods"), or at least he is "rumored" to be. Aside from the utter failure of Munny's first conversion, the formulation alone casts doubts on Munny's perseverance in his second attempt. Before the final scene, which validates the myth of Munny the legendary killer, rumors, myths, and legends in *Unforgiven* never stand up to scrutiny. Several characters in the film are identified as mythmakers: the Schofield Kid, the dime-novel writer W. W. Beauchamp (Saul Rubinek), and English Bob (Richard Harris). The Kid, who idolizes Munny because of his past as an indiscriminate killer, "more cold blooded than William Bonney," attempts to join the illustrious club of manly murderers by making up tall tales about people he has shot. English Bob, the self-styled "Duke of Death," glamorizes his killing of Corky "Two Gun" Corcoran with the help of his "biographer," W. W. Beauchamp, transforming it into a chivalrous tale of the defense of a lady's honor followed by a classic fastest-draw-wins fair fight. All of these myths and rumors turn out to be either untrue or wildly exaggerated. In Little Bill's account, for example, the legendary gunfight of English Bob and Corky Corcoran is debunked as the sordid murder of an unarmed man by a drunk and jealous Bob ("the Duck of Death"); this scene is counter-cut with the fireside scene in which the Kid brags about his fictitious victims.

Even Delilah's injuries, the trigger for the cycle of violence portrayed in the film,[15] are inflated every time someone tells the tale. The Kid's version, designed to persuade Munny to participate in the bounty hunt, already adds lurid details: "They cut up her face, cut her eyes out, cut her ears off. Hell, they even cut her teats." When Munny retells the story to Ned, attempting to lure *him* into the hunt, he embellishes still further (see Kitses 307), claiming that the cowboys "[c]ut up a woman. Cut up her face, cut her eyes out, cut her fingers off, cut her tits. Everythin' but her cunny, I suppose." These escalating exaggerations warn the audience to mistrust myths and legends. Inconsistencies also show up, more subtly, in the legend of the gunslinger William Munny, who is rumored to have killed "women and children an' all" as well as a "U.S. Marshall in '70." But in Munny's own feverish nightmares of his victims, he sees neither women nor children but only a man named William Hendershot. Moreover, in a conversation with Ned, which takes place in 1880, Munny claims that he has not fired a gun at anyone in eleven years. Still, Munny is not above using his own legend when he needs to present himself as a "man," in other words, to intimidate or kill others:

> *Munny (a little drunkenly).* I've killed women and children. Killed just about everything
> that walks or crawled at one time or another. And I'm here to kill you, Little Bill, for
> what you did to Ned. *(to the others)* You boys better move away.

Of course, the greatest Western myth of all claims that those who get killed "deserve" it, and those who get killed without "deserving" it are properly avenged. *Unforgiven* both enacts and undermines this myth on various levels. Violence in *Unforgiven* is traumatic, undignified, messy, and indiscriminate. It connotes masculinity, but not courage, as the example of Little Bill Daggett shows. Little Bill, that debunker of masculine myths of killing, is by far the most violent character in the film. But Bill never confronts anyone without his posse of deputies or, for that matter, anyone who is armed (he also uses a whip, which was considered a coward's weapon in the West). In *Unforgiven*, violence is uncoupled from narratives of "justice" or "retribution." The statement that "they had it coming," obsessively repeated throughout the film, is undermined by images of the sordid and senseless deaths of innocents. Cowboy Davey (Rob Campbell), who was not involved in injuring Delilah, is nevertheless shot for it and dies miserably, calling out for help and water. His slow and excruciating death is all the more traumatic because the Kid's false accusation "YOU SHOULDN'T OF CUT UP NO WOMAN, YOU ASSHOLE!" reminds us that he died innocently. Ned, horrified by this scene, gives up the bounty hunt. Ironically, it is he—like Davey, innocent of killing anyone—who is tortured to death by Little Bill. Other deaths—that of Quick Mike, the cowboy actually responsible for Delilah's injuries, who dies messily on the toilet while "taking a shit"; that of Skinny (Anthony James), the proprietor of Greely's Saloon and possibly the least sympathetic character of the film; that of the sadistic and murderous Little Bill—seem more "deserved," but that is hardly the point. Rather, the film questions the distinction, the Western myth that killing is acceptable if the victim "has it coming," the idea that violence can be anything *but* traumatic, undignified, messy, and indiscriminate. Even Munny, who has inflicted so much violence, has to be disabused of the notion that death comes to those who "deserve" it: when informed of Ned's death, he responds with denial. "Nobody killed Ned. He didn't kill anyone, he went South yesterday. Why would anybody kill Ned?" Ned's death causes Munny to revert to his former killer persona and to deny the "they had it coming" myth. "We all have it coming, kid," Munny tells the Kid. To Little Bill, immediately before shooting him in the face: "Deserve's got nothing to do with it."

Some critics consider *Unforgiven* a failed revisionist film, implicated "in the violence it is critiquing" (Kitses 312). Although the film foregrounds the ugliness and traumatic consequences of violence, at the end, when William Munny enters the saloon to avenge Ned, he looks competent and "manly." Thus, the ending provides a satisfying contrast to earlier distressing images of Munny wallowing in the mud. "If it's really an anti-violence picture," Buscombe notes,

> we ought at this point feel that Munny is letting himself down, and that the final bout of killing is a betrayal of his wife's legacy. In fact, it's almost impossible to respond to the film in that way. We do not view him dispassionately through the prism of our awakened feelings of anti-violence. Instead, we are on his side, cheering as single-handed he takes on a whole saloon full of opponents and routs them. [...] If ever a film had its cake and ate it too, surely this is it.
>
> (74–75)

Buscombe's point is a fair one: despite all of its explicit criticism of violence, the film juxtaposes the violent life of a "man" with the humdrum existence of a "human

being." It is peacefulness and sobriety that flung Munny in the mud at the outset; at the end of the film—if he really does "prosper in dry goods"—he becomes a merchant, the least glamorous path a Western hero could possibly take. The implication here is that peacefulness and humanity are *boring*, and this may also be the unstated reason why Ned joins in the bounty hunt. Ned is in a stable marriage, Munny a widower; Ned's picturesque, fertile, and prosperous-looking farm provides the starkest possible contrast to Munny's bare, dusty patch of land, his ramshackle hut, and his muddy pigpen. Clearly, Ned's familial, financial, and psychological situation do not provide sufficient motivation for him to go on the kill (see Knapp 168). It is hardly a great leap to speculate that the life of a peaceful farmer is not enough for a real "man," that Ned is bored with his placid domesticity. After all, the quest for money and adventure are the major motivators in Western films.

The constant contrast between verbal assurances ("I ain't like that no more") and visual images also suggests that *Unforgiven* has its cake and eats it, too. The film's cinematography, in particular lighting, offer tangible hints that Munny has never really reformed. Whenever he is confronted with his past as a killer—in the initial scene with the Schofield Kid, in the campfire scene with Ned and the Kid, in the saloon scene with Little Bill—his face is either in shadow—lit at a noticeably lower level than anyone else's—or covered by his hat. The low lighting or half-shadows on Munny's face make him look furtive and threatening, showing his propensity for violence quite literally as his dark secret. Throughout the final shootout in the saloon, Munny's eyes are shaded by his hat; when he kills Little Bill, the entire left side of his face is in deep shadow; after the carnage, he rides off not into the sunset but into the night. Munny the killer disappearing into darkness, the townspeople's vision of him impeded by deep shadows and pounding rain, is a starkly traumatic image. As a final glimpse of the character, it certainly packs greater emotional punch than the disembodied frame narrative informing us of Munny's future life as a peaceful and prosperous merchant.

Certainly, there is a case to be made that *Unforgiven* fails in its attempt to deglamorize violence, and this strand of criticism is gaining currency alongside the one proclaiming the film's revisionist virtues. Both of these critical traditions, however, argue in purely diegetic terms, querying the film's attitude but not that of its viewers. Every film presumes an audience response to the story, in both emotive and commercial terms. To this, cowboy films add another layer. In a cowboy film, the story shown on screen always implies another, America's foundational myth and the relevance of this myth for national self-representation. Explicitly or metaphorically, cowboy films offer both up to audience inspection. Thus, if a Western breaks genre rules, it raises questions not only about the story but also about the historical, foundational, mythical, and representational stories implicated in the one shown on screen. In the case of *Unforgiven*, the central issue that has polarized critics is violence, on all levels: as the story's central theme; as a direct statement that "Nothing good comes of it ultimately" (Morgan Freeman); as an implied counterargument that something good *did* come of it (America's expansion as a nation); and, not least, as a question to the audience whether they enjoy it or object to it, whether they want it to continue or stop, whether they are rooting for the pig farmer or the sonofabitch assassin.

It would perhaps be a stretch to claim that *Unforgiven* presses its viewers for an answer, but it does beg the question, and it does so in a fairly traditional way: *Unforgiven* breaks the rules of a genre with which its audience is intimately familiar. In the final killing spree in the saloon, Munny violates just about every convention that defines "fair fights" in the Western. He begins by shooting an unarmed man:

Little Bill. You just shot an unarmed man.
Munny (the shotgun pointed right at Little Bill). Well, he shoulda armed himself if he's gonna decorate his saloon with my friend.

In the ensuing scene, Munny kills wounded men lying on the floor, shoots men in the back as well as men who are trying to flee. He kills Little Bill, who is wounded, unarmed, and clearly terrified, by shooting him in the face. These scenes offer a stark contrast to earlier shots of Will Munny, the broken-down pig farmer or the tender, considerate man who interacts with Delilah after his recovery from a fever. They also motivate the question that masquerades as the film's most profound riddle, the question of Munny's character that is superimposed over the sunset scene of Munny at his wife's grave: "And there was nothing on the marker to explain to Mrs. Feathers why her only daughter had married a known thief and murderer, a man of notoriously vicious and intemperate disposition."

This faux-profound question—what makes William Munny a violent man, or what makes men violent—is the film's most elaborate red herring. Mrs. Feathers's puzzlement over Munny's "notoriously vicious and intemperate disposition" is, in fact, not unlike the critics' demand that the film make up its mind on the subject of violence, and not unlike the view that refusing to do so is "having it both ways."[16] Ultimately, the film's views on the subject of violence are of far less consequence than the audience's. Eastwood once indicated as much in an interview on one of his most iconic Western heroes:

Interviewer. The Outlaw Josey Wales ends with Josey riding into the sun. Is he returning to the commune?
Eastwood. The audience is willing him to go back. That's their participation.
(Jousse and Nevers 60)

Arguably, *Unforgiven,* too, asks the audience for their participation. Immediately after his killing spree, Munny (and, of course, the audience) is offered yet another opportunity to turn what has just happened—traumatic, undignified, messy, indiscriminate violence—into a Western myth. W. W. Beauchamp, former biographer of English Bob and Little Bill, has identified a new potential subject: "Who'd you kill first? *(reciting:)* When confronted by superior numbers, an experienced gunfighter will always fire on the best shot first. Little Bill told me that." Does the audience remember at this point that Munny shot an unarmed man first? The preceding dialogue ("Well, he shoulda armed himself...") is certainly memorable enough.[17] But is it memorable enough to counteract the Western myth, which makes violence look attractive and manly? *Unforgiven*'s main question is not that posed by Mrs. Feathers, which is unanswerable and hence a dead end. Rather, the film asks its viewers whether, after

witnessing the gruesome consequences of violence throughout the film, they *want* William Munny to go into the saloon and kill "just about everything that walks or crawls."

The film's stance on violence is not a clear-cut choice between masculinity and humanity, or between having the cake and eating it. True, *Unforgiven* does not make it easy; it does not actively shoot down the Western myth; it can be accused of condemning violence verbally and then taking it all back visually, and of course the final scene in the saloon can be read as a validation of the killer myth. The film offers viewers a choice: they can interpret it as a traditional enactment of the cowboy myth or confront their own simultaneous distaste *and* enjoyment of violence. The first option presents viewers with the mirror images of Munny the broken-down pig farmer and Munny the rootin' tootin' sonofabitch assassin. The second requires a hard look at the untenable middle ground: Munny at Greely's, already feverish, the whiskey bottle temptingly and threateningly foregrounded; Munny refusing sex with prostitutes but in their employ; Munny protesting endlessly that "I ain't like that no more" but nevertheless engaged in a bounty hunt. Munny *thinks* he can deal out "justice" without becoming a murderer. He *thinks* there is such a thing as justifiable violence. He *thinks*, at least until Ned's death, that deserve's got something to do with it. Munny's untenable subject position is, or so the film seems to assume, the same as the audience's. It is, after all, the only position—other than plain sadism—from which violence can be enjoyed. And from this position the film invites the audience to cast its vote—either in favor of adventurous, oversexed, violent, traumatized and traumatizing masculinity or in favor of the sober, sexless, boring and dreary everyday existence of average humanity.

Like *Unforgiven*, *The Assassination of Jesse James* is set in the early 1880s and confronts us with an aging Western legend: "over there in Europe, there's only two Americans they know for certain, Mark Twain and Jesse James." In *Jesse James*, Bob Ford (Casey Affleck) is the Kid and the hero's biographer rolled into one. Jesse (Brad Pitt), retired at thirty-four, has fashioned for himself an underground existence as a family man, "Thomas Howard," a cattleman and commodities investor. "*He was growing into middle age and was living then in a bungalow . . . He installed himself in a rocking chair and smoked a cigar down in the evening as his wife wiped her pink hands on an apron and reported happily on their two children.*"[18] He meets his greatest fan and ultimate assassin, the then nineteen-year-old Bob Ford, on the occasion of the James Gang's last train robbery at Blue Cut. Bob, raised on the legend of the James Boys, attempts to wheedle and cajole his way into the gang. Brutally rejected by Frank James (Sam Shepard), Bob is given permission by an indifferent Jesse to hang around.

Bob's greatest fear is that the myth of the James gang could end. Devastated by Frank's unequivocal statement that the Blue Cut robbery will be their last, he offers his services as a mythmaker. Chummily ensconced with Jesse on the porch and smoking a cigar that makes him sick, he reads him the following excerpt of the legend of Jesse James:

> *Bob.* Jesse James, the youngest, has a face as smooth and innocent as a schoolgirl. The blue eyes, very clear and penetrating, are never at rest. His form is tall and graceful and capable of great endurance and great effort. Jesse is light-hearted, reckless, and devil-may-care. There is always a smile on his lips . . .

Jesse. All right, all right, all right, all right, all right. [. . .]

Bob. You know what I got right next to my bed? It's *The Train Robbers, or, A Story of the James Boys*, by R. W. Stevens. I mean, many's the night I stayed up with my mouth open and my eyes open, just reading about your escapades in the Wide Awake Library.

Jesse (smiling). They're all lies, you know.

Bob (clearly disappointed). Yeah, of course they are.

Jesse does not respond well to his own mythification; in fact, he seems rather downcast by it, perhaps guessing that it implies his death.

Jesse's final months (the action begins in September 1881, seven months before the assassination of the historical Jesse James on April 3, 1882) are blighted by his increasing fear of being betrayed for the reward money. His paranoia is conveyed aesthetically through the constant presence of a narrative voice,[19] which, similar in style to the commentary framing *Unforgiven*, gives lyrical expression to Jesse's terror. *"Jesse was sick, with rheums, and aches, and lung congestions. Insomnia stained his eye sockets like soot. He read auguries in the snarled intestines of chickens or the blow of cat hair released to the wind. And the omens promised bad luck, which moated and dungeoned him."* The second aesthetic reminder of Jesse's fear is the recurring use of pinhole photography, showing us a clear image in the center of the screen (an area that steadily diminishes as the film progresses) surrounded by ever-increasing blurry edges (reminiscent of the Schofield Kid's short-sightedness). Camera angles force the character's paranoid perspective onto the viewer. Frequently, the camera sneaks up behind a character. Because these point-of-view shots are not attributed to a character, the audience is left to assume that whoever it is could easily shoot Jesse in the back.

The relationship between Jesse and Bob is the uneasy one of star and stalker, characterized by the all-too-extreme contrast between Bob's obvious besottedness and Jesse's casual indifference. Unable to give friendship or trust, Jesse stands distant from those who compete for his attention: Bob and his older brother Charley (Sam Rockwell), former gang members Ed Miller (Garret Dillahunt) and Dick Liddil (Paul Schneider), and Jesse's cousin Wood Hite (Jeremy Renner). Nobody, except perhaps Jesse's wife and children, who hardly ever appear on screen, has a normal relationship with Jesse. Everyone is either smitten with or scared to death of him, and for good reason, since Jesse, seeing traitors everywhere, has systematically begun to kill everyone involved in the Blue Cut robbery. The film presents both Jesse's fear and mistrust and Bob's adoration as thoroughly dysfunctional. Bob, a mixture between sidekick and stalker, has moved into the Howard house and follows his hero everywhere. *"If Jesse palavered with another person, Bob secretaried their dialogue, getting each inflection, reading every gesture and tic, as if he wanted to compose a biography of the outlaw, or as if he were preparing an impersonation."* Bob's move from imitation and identification to impersonation is significant, since the latter allows for the removal of the original. Jesse himself notes this in his question to Bob: "I can't figure it out. Do you wanna be like me or do you wanna be me?" In this context, Charley's stories about Bob's idolization of Jesse and Bob's hero stories of Jesse assume an ominous meaning. "Being" Jesse James, impersonating/replacing him, is, in the waning days of the James Boys legend, the only way for Bob to become what he has always wanted to be: a mythical hero. If you can't join him, kill him.

The day before the assassination of Jesse James, a Sunday, we see the "Howard" family—Jesse, his wife, Zee (Mary-Louise Parker), and their two children—strolling to church like good respectable citizens. The scene is shot in characteristic pin-point photography, with about 80 percent of the image blurred. Bob stays home, inventories Jesse's clothes, sips from his water glass, smells his pillowcase, and lies down on his bed.[20] *"His fingers skittered over his ribs to construe the scars where Jesse was twice shot. [. . .] He imagined himself at 34. He imagined himself in a coffin."* Jesse's imminent murder is foreshadowed by the narratorial identification of bed and coffin and by the tremendous intimacy of Bob's impersonation.

Intimacy also defines Jesse's final moments. For the first time in the film, with the exception of one brief scene in which Jesse good-naturedly complains about his wife's cooking, he is presented as a family man. Indirectly, these scenes motivate his suicide. Unable to continue living with the perennial paranoia that a bounty hunter might kill him, Jesse makes an elaborate show of participating in this very scenario. At the same time, in the family scenes at the end, Jesse lives a private existence that his fame has prevented him from enjoying. Immediately before his death, he is horsing around with his son and playing with his little daughter Mary, trying to find her lost shoe. This domestic context—Mary playing in the yard, singing "The Water Is Wide"; sounds of Zee rummaging in the kitchen—frames his assassination. Jesse looks out of the living room window, his back to Bob, who, gun in hand, nerves himself up to use it; Charley is at the door, his gun drawn. Through the window, Jesse sees the shoe Mary had lost earlier. With great deliberation, he takes off his guns: "I guess I'll take my guns off, for fear the neighbors might spy them," echoing Bob's earlier warning not to take his guns to church. He walks over to a picture—"Don't that picture look dusty"—climbs on a chair, and awaits execution. Peaceful piano music underscores the domestic ambience until Bob shoots Jesse in the back of the head, and Charley fires simultaneously into the floor.

Immediately, Jesse's death is cast in two possible ways: as a betrayal, which Bob denies (Zee: "Oh, Bob. Have you done this?"—Bob: "I swear to God that I didn't."), and as an act of heroism, which Bob claims. At the telegraph office, he and Charley compete for the honor of having shot the legendary bandit. Charley: "Put my name."—Bob: "Why, what'd you do? I shot him." The telegram he sends to the governor reads: "Have killed Jesse James. Bob Ford." As he hands it to the telegraph officer, he advises him: "You might wanna keep that." But his hope to place himself at the center of a new myth that might rival that of Jesse James is bitterly disappointed; the Jesse James legend continues to eclipse his own. Jesse's body, placed on ice, is on public display, hundreds crowding around it to be photographed, with the prints selling for $2 apiece. Viewers are shown the photograph of his body on ice, the entire screen blurred, the pin-point center of clarity dwindled to nothing. *"And it was this shot that was most available in sundries stores and apothecaries to be viewed in a stereoscope alongside the sphinx, the Taj Mahal, and the Catacombs of Rome."* Here, Jesse James has completed his transformation into a myth. Jesse, a legend in life, becomes one of the Seven Wonders of the World in death. Simultaneously, Jesse's photograph serves as a rather self-referential reminder of the celebrity theme: the myth created by the camera (*"this shot"*) is at least as lethal as a shot fired from a gun.

And what of the new legend, Bob Ford, the man who killed Jesse James? He does not get to be a legend, but at least he gets to play one in the theater. Together with his brother Charley—Charley playing Jesse and Bob playing himself—they reenact the assassination in New York theaters. "*By his own approximation, Bob assassinated Jesse James over 800 times. He suspected no one in history had ever so often or so publicly recapitulated an act of betrayal.*" Bob, the hero and the narrator of the piece, plays his role in utter seriousness, whereas Charley offers a farcical performance, slouching, muttering, and idiotically dusting the picture in pendulum style, drawing a laugh every time he delivers the line "That picture's awful dusty." The reviews—"*It was widely felt that Bob possessed some acting talent and Charley not a jot*"—indicate clearly which of them is the more accomplished traitor. Over hundreds of performances,

> Something began to change in Charley's stage portrayal of Jesse. His gait seemed more practiced. His voice was spookily similar to the man's. His newly suggested dialogue was analogous to a script Jesse might have originated. He began to look at his younger brother with spite, as if he suspected that in some future performance he might present himself to a live cartridge in Robert Ford's gun.

This is one of the main ways in which Bob's project fails: Charley turns into Jesse, whereas Bob, who always wanted to be Jesse, merely gets to be (play) himself. In the end, Charley, having written a number of letters begging forgiveness of Jesse's wife, none of which he mails, echoes Jesse's death by committing suicide. Bob, his attempt to stage himself as a hero in tatters, leaves the stage to catcalls of "cur," "murderer," and "coward."

Much like *Unforgiven, Jesse James* knows that audience participation is a central prerequisite for the survival of a myth. One of Bob's central mistakes is to confuse legend with fame. He does become famous—"*By October of 1883, Bob Ford could be identified correctly by more citizens than could the president of the United States*"—but he never achieves that which determines mythical status: uneasy fascination, admiration tempered with fear, the audience's horrified and yet *appreciative* response to the violent act. "You know what I expected?" he asks his only friend, Dorothy. "Applause. I was only 20 years old then. I couldn't see how it would look to people. I was surprised by what happened. They didn't applaud." When Bob is killed in revenge for Jesse James, his legend ends with his life. "*There would be no eulogies for Bob, no photographs of his body would be sold in sundries stores, no people would crowd the streets in the rain to see his funeral cortege, no biographies would be written about him, no children named after him. No one would ever pay 25 cents to stand in the rooms he grew up in.*" In pointing to the vastly different audience responses to Jesse and Bob, this passage also unveils how similar they are in every other respect: friendless and paranoid, blighted by guilt and fear, and victims of assassins.

Jesse James defines the Western myth as one of the past, but it also identifies the myth that will replace it: middle-class domesticity, moderate wealth, homeownership, and family life—in a word, "the American Dream." Throughout the film, traditional Western heroism is undercut to the point of farce. Whenever Jesse kills someone, he shoots him in the back, and the great shootout between Dick Liddil and Wood Hite,

in which they fire at each other sixteen times from four feet away without inflicting much damage, speaks for itself. Clearly, in this film, the Western myth is over. And what could replace it? The new myth of the American Dream is presented to us early in the film, in an exchange between Frank James and Charley Ford:

> *Frank.* [. . .] after tonight, there'll be no more shenanigans. You can jot that down in your little diary. Sept. 7th, 1881, the James gang robbed one last train at Blue Cut and gave up their nightriding for good. [. . .]
> *Charley.* Wait. Well, how are you going to make a living?
> *Frank.* Maybe I'll sell shoes (Fig 4.2).

Figure 4.2 Frank James (Sam Shepard) contemplates the American Dream: "Maybe I'll sell shoes." Courtesy of Photofest, Inc.

This last line, whether serious or sarcastic, spells the end of the Western myth, the civilizing of the Wild West, and the integration of the Western hero into society through domesticity, wealth, and commerce ("prospering in dry goods"). What Bob fails to understand is that the Western legend cannot be maintained by substituting one hero for another. It is the Western myth itself that is dying.

One of the clearest signs of this is the facility with which the legend of Jesse James is adapted to these new conditions. While alive, he rarely appears as a family man; posthumously, however, "family values" assume heretofore unsuspected proportions in the Jesse James myth. In a song sung in Bob's bar, Jesse the bandit is turned into Jesse, the devoted husband and father:

> Well, Jesse had a wife to mourn for his life,
> three children, they were brave,
> but that dirty little coward who shot Mr. Howard
> has laid Jesse James in his grave.

Bob, the film's great mythmaker, weakly tries to debunk the new myth—"It was two children, not three"—but only confirms what the film implies all along: that he has wasted his life on the vain attempt to enter a vanished world, or more precisely, one that never existed in the first place. *The Assassination of Jesse James* shows Jesse's murder along with the assassination of an American myth. It depicts an America that has turned away from the Wild West toward law and order, prosperity, family, and the American way of life. In this new world, what was merely an undercover existence for Jesse James becomes middle-class reality: a job that supports the family (something pedestrian, like selling shoes or dry goods), a bungalow, a porch, a rocking chair, a cigar, a wife and two to three (2.2) children, playing with the children in the yard, looking for their lost shoes, complaining about the wife's cooking. Once a legend has outlived itself, it adapts to new historical circumstances. But it is not an easy transition. Bob is universally hated and despised for killing Jesse James. Their contempt, his career as a "coward" rather than a hero, shows that his audience (in the film) falls into the same trap as he did. Both confuse the man with the myth. *The Assassination of Jesse James* shows that legends are difficult to let go of, particularly if the myth that replaces them is as inexpressibly dreary as family values and the American Dream.

MODERN WESTERNS: FRONTIERS NEVER CROSSED

Brokeback Mountain (2005). Dir. Ang Lee. Writers: Larry McMurtry, Diana Ossana. Focus Features. 3 Academy Awards (8 nominations). Domestic Total Gross: $83,043,761. Foreign Gross: $95,018,998. Total Box Office: $178,062,759. Production Budget: $14 million.

The Three Burials of Melquiades Estrada (2005). Dir. Tommy Lee Jones. Writer: Guillermo Arriaga. Sony Classics. Domestic Total Gross: $5,027,684. Foreign Gross: 4,017,680. Total Box Office: $9,045,364. Production Budget: $15 million.

Modern Westerns show us how men (or human beings) survive (or don't survive) in the new environment of family values and middle-class existence. In the historical Western, the West is the whole world. In contrast, the modern Western plays on the popular understanding of the West as the *real* "Land of the Free," separated from society by an invisible yet distinct frontier. *Brokeback Mountain,* at first glance, seems to exemplify the Western tradition that casts modern civilization as problematic and "nature" as a potential respite. The mountain is far more than a scenic backdrop to the love story between Ennis Del Mar (Heath Ledger) and Jack Twist (Jake Gyllenhaal); it is the only place where this love can find safe expression. Nature's serene beauty stands in stark contrast to the poverty and desolation of the society in which Ennis and Jack must survive. The film emphasizes this divide visually through expansive, crisp vista shots infused with stunning greens and blues that contrast with dull, matted shots of tightly restricted indoor settings, often in low lighting and drab pale yellows and browns. Throughout, the film highlights the struggle between "nature" and "civilization." Tellingly, Ennis longs for a rural life, while his wife, Alma (Michelle

Williams), wants to move to town. Several critics have pointed out that the idyllic mountain setting of the love story is indebted to the Hellenistic tradition of Classical writing (for example, Theocritus's Pastorals) in which male-male love unfolds in an Arcadian locale.[21] The contrast between nature, in which Ennis and Jack can be together, and civilization, in which they cannot, is at times read as validating—indeed, naturalizing and universalizing—their love: homosexuality is natural because it happens in nature (Li 107–09). Relying on a cinematography that is "as clear as spring water" (Lamberti), the film appears to be simplicity itself. It outlines stark contrasts between love and hate (crimes), between nature and culture, while renouncing state-of-the-art special effects. There are few jump cuts, no slow dissolves, and only three fades-to-black. While the plot revolves around the necessity to keep the love affair secret, the cinematography "outs" it. *Brokeback Mountain* is one of the rare films that show us "two A-list male heartthrobs [sharing] an onscreen kiss that's not hidden by shadows or side camera angles" (Guerra).

Despite the film's purposeful support for its gay lovers, often viewed as its most progressive and innovative aspect, the setup of its main characters as outsiders fits snugly into the Western tradition. The Western hero is typically excluded from society or at least in a tense relationship with his community. Of course, Western heroes always live in a homosocial world, such as that of the all-male Cartwright clan in *Bonanza,* the most successful Western series of the 1960s. Some generic aspects of this homosociality are reproduced more or less precisely in *Brokeback Mountain:* "Affection for women destroys cowboy *comunitas* and produces children, and both are unwanted hindrances to those who wish to ride the range freely" (Packard 3). But *Brokeback Mountain* diverges from the blueprint in the way in which it takes up traditional Western themes. In the traditional Western, "[t]he community learns to integrate the loner because it needs him [. . .]. And the lonely hero offers his services to the community for a certain time though without being able or wanting to be assimilated by it" (Koch 58). *Brokeback Mountain,* on the other hand, confronts us with two heroes who are unable to live a life outside of the community and deprived of the luxury of making their own laws.

For Ennis and Jack, life off-mountain is determined by the laws of masculinity and economics. While images of masculinity are a staple of the Western tradition, economic misery is less frequently represented. The conventional wisdom that America is a classless society virtually precludes a frank discussion of poverty and its consequences (Garza 199). In *Brokeback Mountain,* though, the topic is at least as prominent as gay-bashing. Both Ennis and Jack, before his marriage to Lureen (Anne Hathaway), live in abject poverty and deprivation. Ennis had to leave high school after one year when "the transmission went on the pick-up." When his brother got married, there was no more room for him in the house. His home with Alma is only a step up from squalor. Off-mountain, Ennis is too busy making a living to think about having a life. He invariably counters Jack's attempts to persuade Ennis to live with him with economic arguments:

> *Jack.* Old Brokeback got us good, didn't it? What are we gonna do now?
> *Ennis.* I doubt there's nothin' we can do. I'm stuck with what I got here. Makin' a living's about all I got time for now.

Economics determine all relationships in the film. The marriage between Ennis and Alma falls apart not just because Ennis is gay but also under the pressure of poverty; they divorce shortly after Alma confronts Ennis with his inability to support their children. Jack, who has married into money, trades his dignity for economic security. His father-in-law (Graham Beckel) subjects him to a steady stream of insults and petty torments.

Concepts of masculinity are also far more rigid off-mountain. On Brokeback Mountain, Ennis and Jack prove adaptable enough to alternate between masculine and "feminine" jobs, like cooking. Once married, however, they turn into bread-winning husbands and fathers who impose rigid gender roles in the household. Jack explosively asserts his "masculinity," defined as the right to raise his son the way he sees fit, against his father-in-law, while his wife contributes nothing to the exchange. Ennis opposes Alma's going to work because "The girls need to be fed. [. . .] No one's eatin' unless you're servin' it," and makes it clear that he'll only have sex with her if she's lying on her back. Finally, although the mountain is the site of romanticized dangers, of attack from wolves or bears, neither Ennis nor Jack is ever seriously in harm's way there. Off-mountain, however, gay lovers are brutally murdered and fathers force their little boys to look at their mutilated corpses as a warning not to stray from the path of straight and narrow masculinity.

Whatever one may think of *Brokeback Mountain*'s representation of male gay love, it can certainly be argued that the film "universalizes" the tragedy of Ennis and Jack. It does this by working with contrasts: the Utopian space of the mountain and the dystopian space of American society; Jack's wealth and Ennis's poverty; Jack's desire for a life together and Ennis's resigned acceptance of the hand fate has dealt him. "If you can't fix it," he tells Jack, "you gotta stand it." Tenderness and longing are expressed not in the vocabulary of love, which is unavailable to both Jack and Ennis.[22] Rather, they are conveyed through the characters' repeated insistence that they "just can't stand this anymore." As Jack tells Ennis, "The truth is, sometimes I miss you so much, I can hardly stand it." But the obvious alternative, "fixing it," is not an option.[23] Jack proposes living with Ennis on his parents' ranch, but his own memories of his prejudiced and abusive father are miserable. Anything, he confesses to Ennis, "beats workin' for my old man. You can't please my old man—no way." Similarly, his dream of "a little ranch somewhere, a little cow-and-calf operation, it'd be a sweet life," is mooted by Ennis's memory of the lynching of a gay man: "They took a tire iron to him, spurred him up, and drug him round by his dick till it pulled off. [. . .] Two guys livin' together? No way. Now, we can get together once in a while, way the hell out in the middle of nowhere, but . . ."

"Way the hell out in the middle of nowhere" indicates that no distance from society is great enough or safe enough to enable two guys to live together. Even on Brokeback Mountain, they are secretly observed by hostile eyes. For Jack and Ennis, there is no right place and time: "The bottom line is, we're around each other and this thing grabs hold of us again in the wrong place, in the wrong time, then we're dead." In its inability to envision a Happy End for Ennis and Jack, the film can perhaps, as some scholars have claimed, be read as "a cautionary tale about homosexuality, not homophobia" (W. C. Harris 121). Yet in withholding a solution, it also counteracts the Western myth of the hero's self-sufficiency and independence. Here, there is no

freedom in wide open spaces, just as there is no life outside of society. Ennis and Jack's dilemma is social, not personal. In that sense, *Brokeback Mountain* is also, for lack of a better word, "pro-gay." "Common mythology understands the closet as an individual's lie about him- or herself. Yet queers understand [...] that the closet was built around them" (Arellano 64). *Brokeback Mountain* appears to endorse this sentiment: the Happy End cannot be manufactured by Ennis vanquishing his fears and riding off with Jack into the sunset.

In pitting traditional expectations of masculinity against the image of two male lovers, the film forces us to consider that "real men" can be gay, and that gay men can be "real men." Ennis and Jack certainly *look* the part of the traditional Western hero, with Ennis's Marlboro Man good looks and Jack's resemblance to a young John Wayne (see Garza 201-02). Neither, however, lives up to expectations. They are not traditional heroes cut in the mold of the old Western myth. Jack, for example, fails to shoot a coyote in plain daylight, and Ennis falls off his horse when it is spooked by a bear (Garza 202). But they also fall short in the context of the new myth of family values and the American Dream, in which they must act as husbands, fathers, and providers. In addition, there are moments, albeit subtle and subliminal, when the film appears to be in perfect alignment with the prejudices it sets out to denounce. Jack's last name, Twist, is both a rodeo term for the thigh muscle strength required for a bull rider to lock onto the bull (Stacy, "Buried" 41) and a 1920s slang term for "girl." The first meaning is a reminder of his father-in-law's disdain for him. He refuses to address Jack by his real name and instead uses the contemptuous nickname "Rodeo." The second meaning seems to assign Jack a stereotypically "feminine" role in his relationship with Ennis, which is echoed in parts of the action: he becomes Ennis's "seductress" in the tent; he is the one being screwed rather than screwing; he is also the one who tries to rope his partner into a long-term relationship. Simple visual clues transmit further subliminal judgments of Jack. Throughout much of the film, Jack wears a black hat (to Ennis's white hat), the easily recognizable accoutrement of the "bad guy" in the traditional Western. Perhaps we cannot conclude from this that Jack is the sexual predator and Ennis his "victim."[24] Clearly, on the surface on which plotlines, characterization, camera angles, lighting, and dialogue move, the film suggests no such thing. Still, we may wonder whether a film that valiantly attempts to combat prejudices is also informed and shaped by them. One thing is for certain: in the Classic Western, the guy in the black hat always gets shot, and this is also, in a way, what happens to Jack.

If *Brokeback Mountain* critiques the notion that "real" men cannot be gay and that gay men cannot be "real men,"[25] its point is analogous to that of *Unforgiven* and *Jesse James*: rigid concepts of masculinity destroy human potential, implying, of course, "that we, too, have been constrained in ways not always immediately apparent" (Garza 214). The "real men" of the film are Aguirre (Randy Quaid), Jack's and Ennis's dishonest, prejudiced, and exploitative employer, and the abusive father-figures of the film: Ennis's father, Jack's father (Peter McRobbie) and father-in-law. Failing to adhere to this model means expulsion from society and possibly death. Adhering to it means suffering, expressed in Ennis and Jack's manly taciturnity and their inability to express their love in anything but the negative. It is this suffering

that packs the film's greatest emotional punch. Surely, in any love story, "I can't stand this anymore" is a pitiable substitute for "I love you."

"One of the fiercest debates about *Brokeback Mountain*," as Stacy has summarized it, "is whether it is a gay story, a gay love story, a gay lust story, or a universal love story, and whether Ennis and Jack should be labeled heterosexual, bisexual, homosexual, gay, queer, or unlabeled" ("Love and Silence" 205-06). Indeed, two basic questions—is the film "pro-gay" or "anti-gay," and does it portray a "gay love story" or a "universal love story" in which the lovers "just happen to be men"?[26]—now form the nucleus of the scholarly discussion on *Brokeback Mountain*. While most critics laud the positive portrayal of a gay couple, others read the absence of a solution to Ennis and Jack's dilemma as an "antigay polemic."[27] "Antigay" is here understood not as an indictment of homosexuality proper. Rather, these critics posit that the gloomy ending documents the filmmaker's inability to "understand these two gay characters as anything *other* than tragic" (W. C. Harris quoting Draz, 127). In other words, Jack and Ennis's failure to realize their love signals a similarly tragic fate for all gay lovers. Curiously, audience responses when the film appeared showed the same divide:

> Moviegoers responded to the film in unpredictable ways. Some saw it as a groundbreaking, Zeitgeist event that would help reshape the nation's perception of homosexuality at a time when the issue of gay marriage had claimed significant political space. [...] others saw it as a disappointing heteronormative cautionary tale, the all-too familiar "one dies, one lives" scenario of the past. Some gays were bored by the film; others wept. [...] Some middle-aged and older heterosexual couples accepted the images of same-gender affection and sex [...] and found themselves deeply moved. Others walked out as the kissing began.[28]

We might conclude with W. C. Harris that *Brokeback Mountain* is an "irreducibly ambivalent work" (120). And yet, so far all ambivalence and controversy have focused on a single theme, gay love. Certainly, it could be argued that the film raises several themes worthy of scholarly or societal attention and emotional investment. As it now stands, poverty does not feature as a disaster in its own right (and one that affects women and children to a greater degree than men) but as one of several problems that keeps our lovers apart. Moreover, although Alma's life could certainly compete in wretchedness with either Ennis's or Jack's, most scholarly treatments of the film do not acknowledge the tragedies experienced by the female characters. Rather, the film's women are seen as hindrances to the love story or as symbols of repressive society expectations, including marriage and fatherhood. John Kitterman, one of the few critics to consider the role of women in the film, poses the question in refreshingly "vulgar" terms: "Do Ennis and Jack flee from Alma and Lureen, from their brand of 'petticoat government,' into each other's arms, or do the women get the short end of the stick, as it were, because the cowboys are already gay?" (51). Kitterman's self-described "vulgarity" ("vulgar" also because it deviates from the *Brokeback Mountain* school of thought?) is useful because it reminds us of all the tricks we have missed. The film confronts us with a series of grave social problems. So far, audiences

and scholars have recognized one of them. Kitterman, with his productive vulgarity, and Teresita Garza, with her statement that "[t]he film is [. . .] much more than a movie about gay cowboys" (198), are, at least to date, fairly lonely voices upon the plains.

Squarely situated in the frontier tradition, *Brokeback Mountain* leads us to frontiers that we as a society have not yet crossed. Like *Unforgiven,* the film relies on audience participation. Its refusal to envision a Happy End for gay lovers suggests that it is society's job to do so. But that is not all: *Brokeback Mountain* shows how firmly the frontiers between gay and straight, between haves and have-nots, between women and men, still hold. The fact that we as a society are willing to engage with some of these themes, but not others, indicates that there is still a lot of open prairie out there.

Tommy Lee Jones's directorial debut *The Three Burials of Melquiades Estrada* strips the "frontier" of its mythical proportions and presents it at its most literal level, as national border and racial divide. Melquiades Estrada (Julio César Cedillo), an illegal immigrant and friend of Pete Perkins (Tommy Lee Jones), is shot to death by the border patrolman Mike Norton (Barry Pepper), who believes erroneously that Melquiades, who was hunting coyote, was aiming at him. In an attempt to cover up his crime, Norton buries the body in a shallow grave. When it resurfaces, Sheriff Belmont (Dwight Yoakam) refuses to investigate because "[h]e was a wetback," automatically assuming that Melquiades was involved in drugs or smuggling. Although Pete shows Belmont a photograph of Melquiades's wife and children, Belmont makes no attempt to notify his family or even to find out his last name. The ramshackle cross on his grave in the town cemetery simply states: "Melquiadis. Mexico." When Pete finds out that Norton killed his friend, he forces him to disinter Melquiades's body and accompany him to Mexico to fulfill Melquiades's wish to be buried at home. The third burial of Melquiades Estrada takes place in an abandoned ruin somewhere in Mexico after Pete and Mike find out that Melquiades has invented both his home village and his family.

Modern American myths, family values and the American way of life, are mercilessly taken to task throughout the film. At the outset, Mike and his wife, Lou Ann (January Jones), the quintessential lower-middle-class couple, settle into their slice of the American Dream: a double-wide trailer, complete with washer, dryer, heat and air conditioning, garbage disposal optional, "strictly top o' the line," with the highest resale value of "mobile residences" in its class. The view out of the window shows a depressing vista of a train yard, a warehouse, cars and asphalt, other trailers, dusty yards with occasional tufts of grass, and a sign reading "Liberty means freedom from high interest rates." Both Mike and Lou Ann are in their late teens or early twenties; she is a blond, stick-thin ditz on a diet; he a crew-cut soldier-type who feels empowered by his uniform and gun. A traditional couple, she stays at home as he brutalizes Mexicans under the heading of "work." Entertainment is TV and the occasional Saturday excursion to the mall. Brief visual and dialogue snippets map out Lou Ann's future: ten years down the road, Lou Ann may well be like her middle-aged overweight neighbor, who suns herself in a bikini and Stetson in front of her trailer. Similarly, the fate of Rachel (Melissa Leo), the local diner waitress and the only person Lou Ann occasionally talks to, whose husband cannot remember how

long they have been married, foreshadows the future development of Lou Ann's own marriage.

Nobody in the film has a functional family life. Mike and Lou Ann do not know how to talk to each other. Mike's casual rape of Lou Ann at the kitchen counter while she is watching a TV soap opera and chopping vegetables for dinner expresses in one succinct scene the nature of the relationship. As he pushes into her from behind, showing as much concern for her as he does for the porn magazines he regularly masturbates over or the toilet that he masturbates into, she endures, rolling her eyes, her gaze fixed on the TV on which another marital drama unfolds. Rachel, although married to Bob (Richard Jones), the short-order cook, for longer than he can remember, has regular trysts with Belmont and Pete. For many characters, fantasy plays a significant role in counterbalancing their dreary reality. Lou Ann is glued to the TV. Although the soap-opera marriages she watches seem no happier than her own, the TV couples nevertheless demonstrate a verbosity and emotionality undreamed of in her reality. Melquiades invents a family life for himself, showing Pete a picture of a woman and three children, whom he describes, with great tenderness and a dreamy look of longing, as his family. His request to Pete to bring him home after his death already indicates that such fantasies cannot be lived in real life: "If I die over here, carry me back to my family and bury me in my hometown. I don't want to be buried on this side among all the fucking billboards." If "home" is where the heart is, it becomes, in this heartless land of pure commercialism, a difficult place to reach:

Realtor. Where y'all from?
Lou Ann. Cincinnati.
Realtor. Oh, long way from home, huh? What line o'work bring you to Texas?
Mike. Border patrolman. We're always a long way from home.

Part of the film's project is to bring Melquiades Estrada "home," "home" being defined as a place where any human being can hope for a basic measure of acceptance and respect. The distance between "home" and "a long way from home" is measured in the three burials of Melquiades Estrada: the hasty and furtive interment in a shallow grave by his killer; the indignity of a loveless bulldozer burial by people who don't know, or want to know, his name; and finally being "laid to rest" by a friend who mourns him. Going "home" means crossing several frontiers: the national border, racial divisions, and the line between masculinity and humanity. The most drastic example of the inhumanity of traditional masculinity is Mike's violence toward others, his sadistic treatment of the Mexicans he catches at the border, and his rape of Lou Ann. Again and again, the film defines "men" as oversexed beings; Mike's rape and his penchant for porn figure as prominently here as the extramarital sex scenes and Belmont's terror of impotence (Melquiades, significantly, is extraordinarily shy around women). Moreover, the representation of masculinity is interlaced with discourses on race. Belmont's refusal to investigate the murder of a "wetback," and the border patrolmen's casual acceptance that they won't be able to keep out illegal immigrants ("Well, somebody's gotta pick strawberries") highlight racial divisions. One of the most notable scenes documenting racism is Pete's failed attempt to make Mike see the Mexican he has killed as a human being by bringing him into Melquiades's

hut: "Melquiades lived here. That was his bed. Kept his clothes right over there. That was his plate. And that was his cup."

Unlike the Americans who are portrayed as dysfunctional, callous, or dejectedly uncaring, all Mexicans are shown as humane, approachable, generous, and hospitable. Accorded equal space with Americans (about half of the film is shot in Spanish), they present not a minority but an alternative to the American "way of life." Their generosity is exemplified by Melquiades in a touching scene in which he gives Pete his favorite horse, but also generalized beyond his character. A group of Mexicans whom Pete and Mike encounter in the mountains share their food and drink with them. Tellingly, though, the Mexicans watch, on a generator-powered TV, the same soap opera episode that provided the backdrop to Mike's rape of Lou Ann. Clearly, Mexicans too are subject to the influence of the same mass-produced media that sicken the heart and soul of their Northern neighbor, but their degradation is less advanced. When Mike breaks down crying in front of the TV (it is not entirely clear whether he cries in sentimental identification with the TV couple's misery or in remorse at his own act of rape), the Mexican who has shared his whiskey with him offers him the entire bottle: "Take it, for your troubles." In another scene, Mike is cured from a rattlesnake bite by Mariana (Vanessa Bauche), a woman he had brutalized earlier. When he caught her trying to cross the border, Mike knocked her down and broke her nose. Mariana saves his life but whacks him hard in the face with a coffee pot as soon as he is sufficiently recovered. Immediately thereafter— "Now we're even, asshole"—both Pete and Mike are seamlessly integrated into family life. Mariana and Mike sit peacefully next to each other, both shucking corn, casting embarrassed glances at each other, looking virtually identical with their broken noses. Mexicans are the film's most successful communicators. The "home" they fashion for themselves centrally relies on their ability to act on human impulses, both positive ones like generosity and supportiveness, and negative ones like Mariana's petty act of vengeance. Even more centrally, it relies on the ability to let go of a festering malice and animosity that, for many of the American characters, is rooted in their firm belief in their own racial superiority.

Melquiades's "home," a nonexistent village he has named "Jiménez," symbolizes these possibilities. As he describes it to Pete, "Jiménez is a beautiful fucking place. It sits between two hills. The air is so clear there you feel you can hug the mountains with your arms. A stream of clear clean fresh water bubbles up right out of the rocks there. If you go to Jiménez, I swear to you your heart will break with so much beauty." After Pete and Mike are told by locals that they don't know of such a place, much of their dialogue focuses on the question whether Jiménez exists, with Pete calmly insisting and Mike hotly denying that it does. When the two arrive at a ruin of a stone house, surrounded by an unspectacular and unvaried landscape of dry hills and dusty rocks, Pete declares, "This is Jiménez. It's just like Mel said it was." Mike, nonplussed but possibly deciding that it's no good arguing with a madman, agrees: "Yeah. This is it. You found it, Pete." In the final scenes of the film, Pete and Mike work together for the first time; they fill in the cracks in the stone with mud, sweep the inside of the house, create a ramshackle roof for it, even make a sign for the village: "Jiménez." What is shown here is more than two overgrown boys building a pile of sticks and rocks and calling it a house. We are witnessing the creation of "home."

After Melquiades is buried for the third time ("laid to rest" rather than flung into a hole in the ground), Pete frogmarches Mike to a tree, pins the photograph of Melquiades's fictitious family to it, and demands that Mike ask for forgiveness. And Mike does, tearfully, in moving and surprisingly credible words (Fig 4.3). The scene is all the more convincing since Pete, who initiated Mike's breakdown by threatening to shoot him, moves off-screen, leaving Mike alone with the photograph. Mike's words, delivered as he looks up at the photograph the way penitent sinners look up to the cross ("It hurts me, and I regret it every single day. Forgive me. Forgive me, Melquiades, for taking your life. Forgive me. Forgive me") are worlds apart from his earlier rationalizations ("I didn't mean to kill your friend, man. He shot at me, all right?"). His (and the film's) final line, shouted after Pete as Pete rides off ("You gonna be all right?"), is the first indication that Mike is capable of showing concern for another human being.

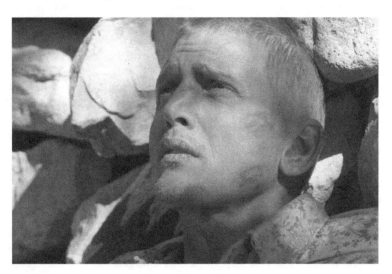

Figure 4.3 Mike Norton (Barry Pepper) in Jiménez, begging forgiveness of Melquiades Estrada. Courtesy of Photofest, Inc.

The Three Burials of Melquiades Estrada debunks several modern American myths, ranging from "family values" to "truth" (Melquiades) and "justice" (Mike). The film showcases the inability to extend the "American Dream" to nonwhites, non-North Americans. We see an America that is both emotionally stunted and physically depressing with its trailer homes and "all the fucking billboards." In this America, the middle class and the poor can only fantasize about a stable home and family life. The film undercuts boasts about technological achievements ("strictly top o' the line") with a stream of images of things that do not actually work: Melquiades's second burial is sped up because the refrigeration unit is broken, as is the heat-seeking radar that would enable the border patrol to spot Pete. In *The Three Burials,* America defines itself largely through separatism ("protecting our borders") and enforces its borders through overkill military prowess. Pete, a single man on horseback, is pursued by eight prowlers, one helicopter, and a dozen border patrolmen. The idealized

portrayal of the Mexican community offers a foil for American society, a replacement myth that is portrayed as both unreal (the search for Jiménez) and real (on the level of human interaction and support). In this way, Pete can be read both as a fool who refuses to let go of the illusion of Jiménez and as a wise man who, through contrition and forgiveness, turns a pile of rubble into a paradise.

This re-mythologization suggests that *Three Burials,* ostensibly an American dystopia, may well be the most Utopian Western yet. It rejects the vengeance enacted at the end of *Unforgiven* and offers, as an alternative, the successful conversion of a "man" into a human being. If this were a traditional Western, one in which deserve's got something to do with it, Mike, the film's most thoughtless, brutal, unsympathetic, and contemptible character, would inevitably die a spectacularly and satisfyingly messy death. Amid all the frontiers that the film puts on display—the national border, racial divisions, male-female relationships, the distance between masculinity and humanity—relinquishing the desire for retributive "justice" may well be the most difficult frontier to cross. The film's portrayal of Mike's conversion as honest and successful is an offer to the audience, asking indirectly whether Mike's escape can be accepted as a gratifying ending, perhaps even a more enjoyable conclusion than mere "justice" can provide.

Most Westerns can easily be related to concrete events in American politics. *Unforgiven* can be read in the context of the brutalization of Rodney King and the death-penalty debate of the late '80s and early '90s. *Brokeback Mountain* has been linked with the issue of gay marriage, much discussed at the time the film was made (cf. Stacy 1–2; Arellano 60). *The Three Burials* comments on America's new separatism in the wake of 9/11, the Patriot Act, the fortifications erected at the Mexican border (see Baur and Bitterli 10), and the everyday racism that motivates such decisions. In a very real political sense, then, Westerns represent "a nation's attempt to assess itself" (Koch 57), and they are ideally suited to do so because, as "the symbol for America per se" (Brehm 143–44), they have a mythological depth unmatched by any other cinematic genre. If "the key to the Western is the phenomenon of the frontier and its crossing," modern filmmakers of the genre and their audiences are forced to negotiate the difficult terrain of "restrictions and excessiveness, inclusions and exclusions, integration and disintegration" (Koch 58). Frontier crossings, moreover, are "experiences in which something is sought: the promised land, home. The prerequisite for such a search is being expelled and driven. It involves something unresolved" (Koch 58). The experience of being expelled and driven. Read in this way, the cowboy, divested of his traditional meaning as a symbol of "law and order" or "freedom and adventure" (Brehm 144), becomes a profoundly ambivalent character, whose "unresolved" status raises questions that can ultimately only be answered by the audience.

REAL MEN?

SUPERHEROES, LEADERSHIP, AND THE WAR ON TERROR

> I'm the commander—see, I don't need to explain—I do not need to explain why I say things. That's the interesting thing about being the president. . . . I don't feel like I owe anybody an explanation.
>
> George W. Bush, qtd. in Ivins and Dubose 277

> There is no doubt in my mind we're doing the right thing. Not one doubt.
>
> George W. Bush, qtd. in Woodward 430

REDEEMER FILMS, THAT IS, films about superheroes and saviors who risk their lives for the sake of a city, a nation, or all of humankind (see Vera and Gordon 34), can easily be read within the context of contemporary terrorism.[1] Several films discussed here contain explicit references to the attacks of 9/11 and the war on terror. Others comment on the events in an indirect fashion. But even films that are not concerned with the specifics of Islamist extremism influence our perception of contemporary politics. Superhero films demonstrate effective and inappropriate responses to a crisis. They model leadership styles and visualize the proper relation between the leader and his people and between the individual and his community. Finally, they define notions of sacrifice and service and explore the possibility of agency against a backdrop of fate and determination.[2]

When the Bush administration coined the phrase "war on terror," it redefined terrorism as a threat that required large-scale military operations rather than police action or diplomacy. As Goldsmith points out, this shift from the language of law enforcement to that of warfare had drastic implications (105–09). In warfare, you may kill your opponent with impunity. In the civil arena of law enforcement, much stricter restrictions apply. Interestingly, all films discussed here—with the exception of *Spider-Man,* which favors the language of law enforcement—opt for a declaration of war in response to situations of crisis. *The Matrix, The Lord of the Rings,* and *Iron Man* are shot through with war rhetoric. Invariably, the films portray characters who seek

to avoid bloodshed as misguided cowards who acquiesce in their own oppression. The good of humankind demands violent engagement; a refusal to fight is tantamount to supporting the forces of evil. There are different kinds of fighting, though. Although all these films are fascinated with weapons and explosions, they also depict inner struggles. The greatest victory of the savior-superhero consists in overcoming his own fears, doubts, and flaws. This inner victory, however, must be complemented by a subsequent triumph in battle.

Bush's much quoted tenet that you are either "with us or you are with the terrorists" (qtd. in Wilentz 440) has come to define the war on terror as a Manichean enterprise. Interestingly, although superhero films embrace the war rhetoric of the Bush presidency, they are marked by a refusal to invest in simple dichotomies of good and evil. In terms of plot and character development, three of the franchises analyzed in this chapter, *The Matrix* (1999), in particular the sequels (2003), *The Lord of the Rings* (2001, 2002, 2003), and *Spider-Man* (2002, 2004, 2007), blur the lines between villainy and heroism. For example, whereas the first *Matrix* film depicted programs as vicious and cruel enemies, its sequels disrupt the binary of man and machine by featuring programs that are capable of love and selfless commitment. Similarly, *The Lord of the Rings* depicts a world in which everybody, high and low, is vulnerable to temptation. In *Spider-Man,* noble motivations often produce villainous outcomes. Norman Osborn (Willem Dafoe) seeks to save his company through the fateful self-experiment that turns him into the Goblin. Dr. Ock (Alfred Molina) wants to invent a clean source of energy and is transformed into a monster in the process. Sandman (Thomas Haden Church) steals because he wants to save his daughter. The only outlier in this crop of recent blockbusters is *Iron Man,* a film that remains comfortable with a world of black and white.

Even though conceptually most of these films steer away from clear-cut dichotomies, they reintroduce binaries when they translate their story into images. All superhero films discussed here succumb to the lure of the spectacular and favor visual stimulation over ideological finesse. Thus, the films' aesthetics, their visual demonization of the enemy, undermines the conceptual preference for a world in shades of grey. Antagonists are presented as subhuman monsters of magnificent proportions and offered up for guilt-free elimination. The visual "Otherness" of Orc, goblin, or robot provides an easy justification for relentless slaughter. The only film that deviates from this pattern is *The Matrix*. Here, the computer programs that are the bane of humanity just happen to look like a bunch of middle-aged white guys.

Superhero films not only show us how to respond in a situation of crisis and how to think about our enemies, they also introduce and evaluate leadership styles. In particular, they are concerned with the relation between the leader and his people, and in this, they bear a direct relation to the politics of our time. Of the two presidents that define our timeframe, Clinton, who was repeatedly criticized for an overreliance on polling data, is generally perceived to be too dependent on popular opinion. To his supporters, Clinton was a president who favored cooperation and inclusiveness. In the eyes of his enemies and critics, he was a pushover. In contrast, Bush is known for his "go-it-alone" approach (Goldsmith 113). In the Bush administration, some executive decisions were not sanctioned by Congress, and even prominent cabinet members who disagreed with proposed policy, such as Secretary of

State Colin Powell, were excluded from the decision-making process. Clearly, Clinton and Bush are at opposite ends of the political spectrum. But the difference between them is not merely a personal one but rather one that defines the American imagination. Countless films weigh the various advantages and downsides of the two types: the leader as primus inter pares who is first and foremost a nimble talker, and the leader as lone fighter and gunslinger who resolves any crisis through silent, decisive action.

Because they are concerned with leadership, redeemer films also explore the troubled relation between the exceptional individual and his community. In *America in the Movies,* Wood speaks of the great "American myth of a fall into social life" (33). Wood claims that Europeans are born entangled whereas Americans celebrate individualism and even selfishness. Since all films discussed in this chapter tell stories in which an exceptional individual saves the world,[3] the tension between freedom and service, between individual happiness and the good of humankind is front and center. Of the different franchises discussed here, *The Lord of the Rings* and *Spider-Man* are most adamant that the talents of the individual, his exceptional strength, courage, loyalty or steadfastness, need to be placed at the service of the community. In contrast, *The Matrix* makes much of the rhetoric of saving humanity, but is mainly concerned with an elite group of enlightened individuals and perfectly willing to sacrifice the complacent masses. *Iron Man,* finally, places all its hopes in the lone fighter, savior of the poor the world over, and evinces great distrust of organizations and government agencies. While three of the franchises feature positive authority figures—Morpheus in *The Matrix,* Aragorn in *The Lord of the Rings,* and Ben Parker in *Spider-Man*—*Iron Man* dismantles all authority figures, paternal and institutional, except, of course, Iron Man himself.

Just as the films' visual choices reintroduce the stark dichotomy of good and evil that their plots and characters would seem to deny, they also undermine the overt support for democratic messages that emphasize the contributions of the little guys. All these films are highly attuned to their status as spectacles and self-consciously invite us to admire the display of excess not as necessary elements of plot and character but as cinematographic achievements. The pervasive all-seeing eye and the seeing stones in *The Lord of the Rings,* the omnipresence of reflected images in *The Matrix,* Peter's camera in *Spider-Man,* and the liberal use of television and satellite images in *Iron Man* are designed to remind us of our status as spectators. Redeemer films position us as admiring viewers, and this positionality threatens to undermine their supposedly empowering message.

GUERRILLA WARS AND BENIGN DICTATORS

The Matrix (1999). Dir. Andy Wachowski and Larry (Lana) Wachowski. Writers: Andy Wachowski and Larry (Lana) Wachowski. Warner Bros. 4 Academy Awards. Domestic Total Gross: $171,479,930. Foreign Gross: $292,037,453. Total Box Office: $463,517,383. Production Budget: $63 million.

The Matrix Reloaded (2003). Dir. Andy Wachowski and Larry (Lana) Wachowski. Writers: Andy Wachowski and Larry (Lana) Wachowski. Warner Bros. Domestic

Total Gross: $281,576,461. Foreign Gross: $460,552,000. Total Box Office: $742,128,461. Production Budget: $150 million.

The Matrix Revolutions (2003). Dir. Andy Wachowski and Larry (Lana) Wachowski. Writers: Andy Wachowski and Larry (Lana) Wachowski. Warner Bros. Domestic Total Gross: $139,259,948. Foreign Gross: $288,029,350. Total Box Office: $427,343,298. Production Budget: $150 million.

Like *The Lord of the Rings*, *The Matrix* trilogy is wildly intertextual and dazzles through meticulous craftsmanship. The films offer a skillful blend of a vast variety of cultural traditions, ranging from Christianity to Buddhism,[4] from Greek mythology to the Western, from science fiction to Hong Kong action flicks, and from fairy tales to Nazi storm troopers. *The Matrix* trilogy draws on high and low culture alike and is equally well versed in philosophy and popular film, citing Descartes and *Superman*, Baudrillard and the *Terminator*. More so than the sequels, the first film impresses through spectacular camerawork supported by a web of subtle allusions and puns all centered on a thematic core. The exploration of identity, for example, has its visual equivalent in the omnipresence of mirror images, faces mirrored in sunglasses and rearview mirrors of vehicles, spoons, and doorknobs. Important themes are conveyed through explicit lectures and casual conversations, through potent names and subtle references. Long before we have any idea what the matrix and Neo (Keanu Reeves) are all about, a minor character insists that Neo needs to unplug and that he is "my savior, my own personal Jesus Christ."[5] Neo, whose name is an anagram of the One and who works for the computer company Metacortex, lives in apartment 101. Conversely, his love interest Trinity (Carrie-Anne Moss) performs her first set of stunts in room 303.

The enormous cultural impact of *The Matrix* is evident in its staggering box-office success and in the multiple book publications and articles dedicated to analyzing the films' science, religion, mythology, and philosophy.[6] Indeed, *The Matrix* has spawned its own academic cottage industry. And yet, while the various interpretations of *The Matrix* draw out its many innovative and revolutionary features, including its "wedding of bullet time and wire fighting" (Clover 17) and its adoption of video-game aesthetics (Clover 25-28), they have overlooked one of its most interesting achievements. Although *The Matrix* portrays a story of remasculinization, the hero is paired with equally powerful female characters and his high-octane masculinity retains feminine elements.

The Matrix splits its hero in two. As Neo, he is a hacker and loner who deals in illegal software and grows to be the savior of the world. As Mr. Anderson, he is an oppressed nobody who has been emasculated by the system. Mr. Anderson is a modern wage slave in a cubicle, an alienated worker in the best Marxist sense of the term, and anything but a traditional hero. He bears a strong resemble to the "Man in the Gray Flannel Suit" (Cohan, *Masked Men* xi) who populated American films of the 1950s—although he does not share the latter's family status of married with kids (see Bruzzi, *Bringing Up Daddy* 38). He is passive, conformist, and obedient, a loser who is put down by his boss the second he shows his last remaining vestige of independent spirit. During the initial pursuit by agents, Mr. Anderson immediately

takes to flight, crawling and crouching his way out of danger, but hesitates as soon as the first bit of action is required.

Although Neo is the hero and Mr. Anderson the conformist, it is Neo who is repeatedly feminized. He is compared to Alice in Wonderland tumbling down the rabbit hole and Dorothy, who must say good-bye to Kansas. When the agents arrest Neo, the interrogation, during which he is undressed and a tracing device inserted into his navel, is framed as a rape. Indeed, the matrix, the computer system that turns all humans into unconscious pods, is itself portrayed as a form of rape. To reenter the matrix, the film's rebel heroes sit on chairs straight out of a gynecologist's practice and are penetrated by rods inserted into their cranium.

Clearly, Mr. Anderson, like the disciples of Robert Bly's *Iron John,* has to bring the inner warrior back to life. To revive his flagging masculinity, he is quite literally reborn (Mercer Schuchardt 7). Bald and naked like a baby, he leaves his womblike pod, where he is suspended in liquid and sustained by an array of umbilical cords, through a birth-canal-like tunnel, and then struggles to catch his first breath. The first task in his new life consists in developing his muscles, which have atrophied because he has never used them. He also has to learn to see for he has never used his eyes. As a new man, Neo wears black leather and marshals an entire arsenal of heavy weaponry. And yet, even though Neo develops into a fearsome fighter who kills without mercy, he never entirely loses his feminine side.

Although Neo is a warrior in the fantasy world of the matrix, in the real world he remains a guy who is immobilized in a chair and who willingly submits to Trinity's authority as ranking officer on the ship. Even in the matrix, Neo wins in the end not because he commands an arsenal and is an expert shot but because he stops bullets. During the showdown, he does not crush his opponents, but dances around them in a ballet of destruction. Right before his final triumph, he is Cinderella, who is brought back to life by the kiss of the princess. Similarly, in *Matrix Revolutions,* Neo, now fully defined as a Christ figure, wins not because he asserts himself, but because he is willing to lose his identity and merge with Smith (Hugo Weaving). Since Smith is defined as his negative, Neo's self-erasure is the only way to defeat Smith.

Neo's masculinity is offset by that of the agents, the evil forces of the matrix. The agents embody a horror vision of masculinity, but they are also presented as Mr. Anderson's doubles. Like Mr. Anderson, the worker bee, the agents are completely interchangeable. They wear the same suits, the same glasses, and all have the same wire behind their ears, the conduit through which they receive their orders and which thus functions as the visible expression of their heteronomy. We may surmise that if Neo had not undergone a dramatic change, in time he too would have become very much like his enemies: an empty suit, if not an ice-cold, sadistic killer. Appropriately enough, in *The Matrix,* humanity's biggest enemy is a powerful group of middle-aged white guys.

Although *The Matrix* features a story of remasculinization, it breaks with traditional gender stereotypes in many and important ways. While the film's hero retains feminine characteristics, its heroine Trinity possesses the kind of courage and strength that is associated with the male gender. As Mellencamp aptly points out, "it will take the entire film before he (Neo, EK) gets up to this woman's speed, fighting skills, awareness, and black-leather fashion" (83). As though to emphasize its investment in

undermining gender dichotomies, the very first scene of the film features a couple of policemen, who hopelessly underestimate Trinity's power. "We can handle one little girl," they declare and are subsequently annihilated by Trinity's feline strength. Trinity is a woman who does a man's job. She welds equipment, drives motorcycles, and wields big guns. Moreover, Trinity is not only androgynous, but looks like the hero. Of similar height and build and adorned with similar, gender-neutral clothing, Neo and Trinity resemble each other to a striking degree (Fig 5.1).

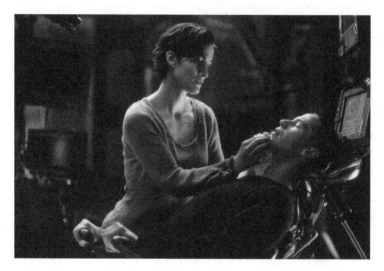

Figure 5.1 Two of a Kind: Gender Blending in *The Matrix*. Courtesy of Photofest, Inc.

Trinity is not the only strong female character. In *The Matrix Revolutions*, Niobe (Jada Pinkett Smith), the captain of the rebel ship *Logos*, steers a hovercraft mechanically through extremely difficult terrain, a feat believed to be impossible by all of her male teammates. In the dystopia of the matrix, humans are born from pods, not wombs, and white men hold all positions of power. In the safe haven of Zion, however, racial and sexual equality have been realized to an impressive degree (see Lawrence 86).[7]

The film's progressive gender politics are intimately related to its exploration of the body-mind split and of our experience of bodily sensations. In the matrix, the human body has been reduced to an insentient source of energy, an extended version of "the brain in a vat"-fantasy. Man is a battery, and the body is imprisoned in a pod without any contact with outside reality. All sensual experience, touch, taste, smell, sound, and sight, is fed directly into the brain. In the matrix, the world is a simulation and the body an illusion, a mental projection of one's digital self. Unsurprisingly, the agents who protect the matrix are completely alienated from their own bodies. In Agent Smith's petty bourgeois rant on why he hates being in the matrix, his disgust with its stench features prominently.

Although the matrix is a world without bodies, the training program Neo submits to before he can emerge as the savior is ostensibly geared toward physical strength and agility. Neo has to jump across rooftops and fight kung fu style. Paradoxically,

though, his real body remains inert in a chair while his mind is doing all the work. As Morpheus (Laurence Fishburne) tells him, "do you believe that my being stronger and faster has anything to do with my muscles in this place?" This emphasis on the irrelevancy of the body finds its complement in the fact that the agents are shape shifters. Like medieval demons who inhabit the bodies of their victims, the agents can control anyone who has not yet been unplugged. Through this gimmick, the matrix is a world of infinite paranoid possibilities in the manner of "trust no one"; it is also a world in which bodily identity is meaningless. In the matrix, the mind, not the body determines who you really are and what you can achieve. Certainly, this is an encouraging concept for women whose physical attributes are thus uncoupled from agency and social status. Still, visually, the world of the matrix revels in the body. Our heroes are stylishly clad and display their attractive bodies in stunning stunts and graceful fights. Although *The Matrix* denounces the simulated world of the matrix, it owes its visual appeal and financial success to the object of its disapproval.

While the matrix offers pleasures that are ideologically questionable but visually seductive, reality, as it is conceived in the film, holds hardly any pleasure at all. Any experience in the matrix is by definition not real, but then again, reality sucks. Since the film posits that the "real" world was destroyed by an atomic blast, the unplugged rebels live in the sewers. They wear gender-neutral grey outfits and eat a cereal that offers plenty of nutrients but whose snotlike consistency is enough to turn you off food forever. If they want tastier fare, nightclubs, or fashion, they have to enter the matrix. Life on the rebel ship *Nebuchadnezzar* is characterized by monkish asceticism and sensory deprivation.[8] It is hardly surprising that Neo's outfits increasingly resemble those of a Catholic monk or that Cypher's (Joe Pantoliano) betrayal of his teammates is motivated by a desire for luxury and riches. Cypher, who does not have an ascetic bone in his body, hates being cold and chowing slop. When he meets with an agent, he eats a juicy steak and demands a life of extreme hedonism in return for his service. Although the film portrays Cypher in extremely negative terms—his name evokes zero as well as Lucifer—it also uses his character to critique the rebel crew and their ideology. Although his is a venal choice, the film hints at a problem inherent in the rebels' willingness to forego pleasure.[9] As Mouse (Matt Doran) tells us, "to deny our own impulses is to deny the very thing that makes us human." Through Cypher, who is given ample screen time to explain his motivations, the film not only problematizes a life without bodily joy but also questions the command structure on the ship. According to Cypher, freedom and truth are ugly and bleak, and, even worse, they are nonexistent on the rebel ship: "You call this free," he yells at Morpheus, "all I do is what you tell me to do." While Morpheus teaches Neo that anarchy is the key to defeating the rule-guided matrix, Cypher suggests that life on the *Nebuchadnezzar* is not guided by a democratic vision. Viewed benignly, its strict hierarchy is a temporary measure due to the need for military efficiency. To less benevolent observers, it is a dictatorship.

The sequels further underline Morpheus's charismatic and authoritarian style of leadership. When Link (Harold Perrineau), the new operator, doubts the wisdom of one of Morpheus's commands in *The Matrix Reloaded,* Morpheus does not offer reasons for his choice, but simply demands unquestioning obedience from his crew. *Revolutions* ultimately redeems Morpheus, but only partially. Although his belief in

the One is justified, his visionary certainty that the machines will never reach Zion is proven wrong. If Morpheus's rival Lock (Harry Lennix) had not prepared the city as meticulously as he did, everyone would have been killed before Neo had time to accomplish his mission.

Like *Lord of the Rings* and *Iron Man*, *The Matrix* is shot through with war rhetoric, but it introduces an unusual perspective in the discourse of the war on terror. Curiously, the first installment of the franchise, which was released before 9/11, shows a distinct affinity with the language and ideology of terrorism. The rebels of the *Nebuchadnezzar* are portrayed as a guerilla force. Faced with an enemy of overwhelming size and power, they rely on surprise, ambush, deception, and sabotage. As Morpheus explains, the agents live in a world that is built on rules. Because of that, they can be defeated, especially by highly disciplined resistance fighters who are organized in small, independent units. Morpheus's crew is willing to die for the cause and prepared to kill every unplugged pod-person who stands in the way. In the matrix, you are either with us or against us. There is no neutrality, since anybody who has not been unplugged can be infiltrated by an agent. Thus, if you have not had the good fortune of being rescued by the rebels, you may be killed with impunity. Moreover, although the human batteries of the matrix would appear to be innocent victims, they are portrayed as somehow complicit in their plight. Viewers are informed that they lack the critical awareness necessary for their liberation: "Most of these people are not ready to be unplugged, and many are so inert, so hopelessly dependent on the system that they will fight to protect it," Morpheus informs Neo. The precise nature of this complicity remains undefined, but the license to kill is not revoked.[10]

The sequels abandon the tight plotting of *The Matrix* in favor of a baroque, episodic structure and complex philosophical musing. The first film of the trilogy names freedom as the ultimate goal of the rebel war. The matrix is a system of control. Its fake sensual pleasures are designed to hide the truth: the cruel exploitation of the human race. In contrast, the sequels do not emphasize freedom, but rather suggest that our choices are predetermined by character and circumstance or, as the Merovingian (Lambert Wilson) puts it, by cause and effect. In other words, you can choose to accept or reject the matrix, but you cannot choose whether you are the kind of person who would accept or reject it. *Reloaded* further problematizes the notion of choice and freedom when it introduces the idea that the last human city, Zion, is controlled by machines, just like the matrix:

> *Councilor.* Have you ever been to the engineering level? [...] Almost no one comes down here, unless, of course, there's a problem. That's how it is with people. Nobody cares how it works as long as it works. [...] I like to be reminded this city survives because of these machines. These machines are keeping us alive while other machines are coming to kill us. Interesting, isn't it. The power to give life and the power to end it.
>
> *Neo.* We have the same power.
>
> *Councilor.* [...] I think about all those people still plugged into the matrix and when I look at these machine, I can't help thinking that in a way we are plugged into them.
>
> *Neo.* But we control these machines, they don't control us.
>
> *Councilor.* [...] What is control?

Neo. If we wanted, we could shut these machines down.

Councilor. [...] If we wanted, we could smash them to bits. Although if we did, we would have to consider what would happen to our lights, our heat, our air.

Neo. So we need machines, and they need us.

In Zion, humans appear to be in control of the machines, but are in fact utterly dependent on them. If they decided to turn them off, their very existence would be threatened. In *Reloaded,* freedom and choice are relative terms, and love is the only variable in the system that truly matters.[11] Here, we learn that Neo is not the first of his kind, but the sixth incarnation of a tolerated anomaly in the system. Neo's determination to save humankind is predictable, but his love for Trinity makes him different from all of his predecessors. As savior, Neo is one of many, but for Trinity, he is the one. Similarly, the thrice repeated lines that "some things in this world never change while some things do" always feature love as the variable in an otherwise constant system.[12]

While *The Matrix Reloaded* portrays love as the quality that separates the real world from the matrix, *Revolutions* undermines this distinction by featuring programs that feel love. Both sequels consistently complicate the idea that the human world and the machine world are fundamentally different. Some programs feel love, others lust, while yet others crave power. However, if there is no choice but only inevitability, and if love exists in both worlds, then the difference between the real world and the matrix has become obscure. Consequently, the Oracle's claim at the end of *Revolutions* that the system has changed must refer to something else. In *Revolutions,* the product of the prolonged war is not freedom, but peace and beauty. Whereas Agent Smith, the embodiment of evil, insists that there is no denying purpose, Sati, the love child of two programs and a program herself, stands for beauty without purpose. After a century of war, peace and a sunrise reward the survivors.

In *Revolutions,* the epic battle between Neo and Smith offers an interesting twist on the Cold War strategy M.A.D. as in "mutually assured destruction." Neo defeats Smith by becoming Smith so that his triumph coincides with their mutual elimination. But the moment of their union is also the moment when the enemies of Zion vanish into thin air. Although *Revolutions* exploits the final battle for Zion for its full visual potential, it depicts peace as the result of our willingness to transcend dichotomies and shed our belief in a world where you are either "with us or against us."

THE WAR TO END ALL WARS

The Lord of the Rings: The Fellowship of the Rings (2001). Dir. Peter Jackson. Writers: Peter Jackson, Fran Walsh, Philippa Boyens. Warner Bros. 4 Academy Awards (13 nominations). Domestic Total Gross: $314,776,170. Foreign Gross: $555,985,574. Total Box Office: $870,761,744. Production Budget: $93 million.

The Lord of the Rings: The Two Towers (2002). Dir. Peter Jackson. Writers: Peter Jackson, Fran Walsh, Philippa Boyens, Stephen Sinclair. Warner Bros. 2 Academy Awards (6 nominations). Domestic Total Gross: $341,784,758. Foreign Gross: $583,495,746. Total Box Office: $925,282,504. Production Budget: $94 million.

The Lord of the Rings: The Return of the King (2003). Dir. Peter Jackson. Writers: Peter Jackson, Fran Walsh, Philippa Boyens. Warner Bros. 11 Academy Awards. Domestic Total Gross: $377,027,325. Foreign Gross: $742,083,616. Total Box Office: $1,119,110,941. Production Budget: $94 million.

Directed by Peter Jackson, who had not previously been in charge of any A-list films, *The Lord of the Rings* is one of the biggest box office successes of all times and won a total of seventeen Oscars. Although released in consecutive years, all three parts of the trilogy were filmed simultaneously in New Zealand, and the circumstances of the production are as epic and oversized as the film itself. All costumes, furniture, and props were made from scratch in specially created facilities including smithies and leather shops (Kristin Thompson 38). In addition to creating an entire artificial world, Jackson also elevated the production of DVDs to an art form and is credited with raising "fantasy from its status as box-office poison to a position at the core of current popular filmmaking" (Kristin Thompson 9). The films' cinematography draws on a vast store of cultural imagery ranging from Gothic architecture to monsters that resemble the elephant man and the dragon in Disney's *Sleeping Beauty,* and from Jugendstil art in the design of the elf houses to panoramic shots of mountains that recall Leni Riefenstahl's visual style.

Although it was first published in 1954–55, Tolkien's *The Lord of the Rings,* the epic novel on which the trilogy is based, was partly written during World War II, and its political landscape maps neatly onto that of 1940s Europe. There is Mordor, the empire of evil led by Sauron, who seeks to obtain the ring, a symbol of cruelty, malice, and the will to dominate; there are those who fight for freedom and justice, such as Gandalf (Ian McKellen), Aragorn (Viggo Mortensen), and the hobbits, and those who, like Saruman (Christopher Lee), believe that fighting is pointless and cooperation one's only chance of survival. And there are the elves, the Swiss of Middle Earth, who would like nothing better than not to get involved.

Designed during the war against totalitarianism, *The Lord of the Rings* is easily transferred to the current political framework of the war on terror. Gigantic battle scenes featuring various stages of the fight for the freedom of Middle Earth against an axis of evil and its barbarian hordes take up the larger part of the movie. Any attempt to avoid war, such as the decision of Rohan's King Theoden (Bernard Hill) to seek shelter in a fortress, proves misguided and ultimately futile. In *The Two Towers,* Aragorn responds to Theoden's refusal to engage in battle and bring further death to his people with the declaration: "Open war is upon you whether you would risk it or not." *The Two Towers* and *The Return of the King* repeat the same theme. Here, the madness of Denethor (John Noble), steward of Gondor, is first evident when he fails to gather armies for the defense of the realm. Even the Ents, stewards of the trees, abandon their century-old reserve and decide to attack Isengard. Throughout the trilogy, courage is a supreme value, and valor in battle the measure of a man's worth. There is not a shred of doubt that war is inevitable and justified. The films evoke the political fantasy of the one chance to destroy evil forever in a final stand-off, but they temper this portrayal by focusing on a hero who, though he triumphs, remains marked for life. There are many glorious military victories, but there are also wounds that time cannot heal.

While most major feature films have no more than three to five main characters, *The Lord of the Rings* works with a large cast of protagonists. Since almost all of them are male, the films offer an unusually varied array of male role models and different types of masculinity. In addition to Aragorn, a traditional romantic hero and exemplar of fortitude, courage, and dignity, there is the wizard Gandalf, a Christ figure and "geriatric superhero" (Kristin Thompson 64). Although he is of advanced age, Gandalf excels through superior wisdom and displays considerable stamina and physical vigor. The stout dwarf Gimli (John Rhys-Davies), a loyal companion whose courage and pride far outmatch his skill in battle, offers a comic foil to the slender, feminine grace of the elf Legolas (Orlando Bloom). The most interesting characters of all, however, are the four hobbits, Frodo (Elijah Wood), Sam (Sean Astin), Merry (Dominic Monaghan), and Pippin (Billy Boyd). Of diminutive size and childlike features, hobbits would at first glance appear to be ill suited to the profession of soldier. And yet, they fight in every battle in the film, and in courage and loyalty no one is their equal. Because hobbits, unlike human men, are pure of heart and do not desire power, Frodo is chosen as the bearer of the ring of evil. The fate of Middle Earth depends on him, and every other character is called upon to support Frodo's mission. Still, Frodo would have failed without the help of his loyal hobbit friend Sam. Sam is perhaps the most intriguing character in the film (Fig 5.2). Pudgy and unattractive, he possesses no special skills and is, at least for the most part, useless as a fighter. But his devotion to Frodo is unparalleled, and because of his unwavering loyalty, evil founders in the end. Through Frodo and Sam and, to a lesser extent, through the

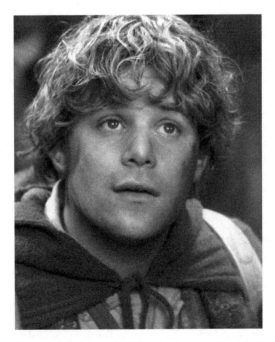

Figure 5.2 An Unlikely Hero: Sam Gamgee (Sean Astin). Courtesy of Photofest, Inc.

fellowship of Aragorn, Gimli, and Legolas, the film offers an ode to friendship. Even the most powerful king is not invincible and requires the help of the meek. Even the wisest wizard can learn and grow, as is evident in Gandalf's progression from Gandalf the Grey to Gandalf the White. And "even the smallest person can change the course of the future," as Galadriel (Cate Blanchett) remarks, but he cannot do so alone. Frodo would not have prevailed without Sam, and both would have been lost without the help of the fellowship. In *The Lord of the Rings,* only a multiracial, cross-class collaboration can save the world.

Frodo and Sam's accomplishments are all the more impressive since they have to transcend the narrowly circumscribed customs of their homeland in order to bring their quest to fruition. The world of *The Lord of the Rings* is a medieval fiefdom of clearly defined hierarchies and strictly demarcated realms that tend to connote class status. The shire, inhabited by the hobbits, is a classic locus amoenus devoid of the trappings of modern technology. The hobbits are farmers and craftsmen who live in harmony with nature and revel in the pleasures of the body. Theirs is a cheerful but highly limited and provincial world. The hobbits lack ambition, never do anything unexpected, and never venture beyond the borders of the shire. The world of *The Lord of the Rings* is not a democracy, but a society of peasants and lords connected through a system of fealty. The film's frequent use of extreme frog and bird perspectives emphasizes these hierarchical differences. There are those who possess strength and wisdom and those who perform manual labor. The true mettle of a ruler is revealed in his behavior toward his inferiors. Gandalf's benevolent paternalism contrasts sharply with Saruman's contempt for the hobbits. While Gandalf shows great concern for their welfare and Aragorn treats them as equals, calling them gentlemen and equipping them with weapons, Saruman considers them despicable halflings and is bent on their destruction.

Although the film's plot elevates the hobbits, its visuals emphasize their inferior status. Hobbits are not the equals of elves, wizards, or kings, and the difference between them is written on the body. In *The Lord of the Rings,* physiognomy reigns supreme and social status is inscribed in the body. Hobbits are set apart through their large, hairy feet and their small size. Wizards are tall and have long beards and noses. Gandalf's superior mind and expansive range of action are visualized through his towering size, which makes it difficult for him to even enter a hobbit's house. Dwarves are small and portly. Elves are tall and have flowing white-blond hair. Kings are easily identifiable through their noble features and tall and dignified bearing. Their soldiers are disciplined and well ordered. The hordes of evil, on the other hand, resemble wild beasts, and Gollum bears the marks of his corruption on his hideous face and slimy fish-white body.

The Lord of the Rings shows a world of immutable class boundaries, in which high and low are determined by birth and legible in physical features. Repeatedly, the film presents the hobbits as infantile and makes fun of their simple desires—their gluttony is a running joke—while it showcases Aragorn's heroic masculinity for our admiration. And yet, although *The Lord of the Rings* is heavily invested in hierarchies and, like the book, naturalizes class distinctions, it does allow for the possibility of transcendence. In their different ways, both Bilbo Baggins (Ian Holm) and Frodo overcome the limitations of their heritage as they turn into adventurers and writers. Bilbo

is the author of *There and Back Again,* and Frodo is credited with the writing of *The Lord of the Rings* itself. Even though the film emphasizes hierarchies, it insists that the lowliest peasant may exceed expectations while great kings do not always live up to the dignity of their positions. In fact, the plot is set in motion because Isildur, a great king, could not control his desire for power. On the other hand, even the most evil and sinful creature retains a trace of good and can redeem himself or, at least, play his part in the bigger scheme. Thus, Boromir (Sean Bean), who succumbed to the temptation of the ring, regains his honor when he fights valiantly to save the lives of the hobbits. Theoden, who was possessed by Saruman and then endangered his people by leading them into a trap, ultimately prevails in battle and is again worthy to join his forebears in the great beyond. And even Gollum proves invaluable when his greed causes the destruction of the ring.

Just as each realm of *Lord of the Rings* connotes a different class status, it is also associated with a particular gender. At first glance, the empire of evil is decidedly masculine; its denizens Sauran and Saruman inhabit phallic towers and favor iron and technology over trees and nature. But Saruman, a latter-day Frankenstein, has also arrogated the female power of giving birth to himself and is in the process of creating an army of repulsive humanoids, the huruk-hai. Saruman's uncanny procreative skills find their complement in the fact that the all-seeing eye, the visible expression of Sauron's pervasive power and source of a blazing fire that threatens to consume anything within its reach, bears a striking resemblance to a vagina. Although the empire of evil is coded as masculine, the ultimate threat may be female after all.

While Sauron is associated with fire, the element of the elves is water and that of the shire earth. The shire connotes femininity, values nature and the body, and its inhabitants live in womblike caves. In contrast, dwarves and elves are portrayed as androgynous. Female dwarves resemble male dwarves to such an extent that some assume dwarves are not born but spring from holes in the ground. Both male and female elves have long hair and wear long flowing white garments. And yet, while androgyny is a prevailing theme, actual female characters are few and far between. Of the three who have any claim to the status of protagonist, two, Galadriel and Arwen (Liv Tyler), are depicted as goddesses, living embodiments of hope rather than fully fleshed-out characters. Galadriel equals Gandalf in wisdom, but she does not take any part in the action. Arwen enjoys a brief moment of glory when she rides roughshod to race the wounded Frodo to safety, but for the rest of the narrative, she remains an inspiring vision in Aragorn's mind. The third important female character, Eowyn (Miranda Otto), is integrated into the ranks of men when she cross-dresses and joins the fight. Eowyn rebels against life in a cage and objects to the notion that five-year-old boys are fit to fight in battle while grown women are not. But her three minutes of glory when she kills the witch king barely make a dent in an epic whose nine-hour playing time is marked by the near absence of female characters. In *The Lord of the Rings,* victory depends on the successful collaboration of different races and classes, but women's contributions to the endeavor are all but negligible.

One of the most fascinating aspects of *The Lord of the Rings* is its conceptualization of agency, best embodied in its master symbol, the ring. Throughout, the status and nature of the ring are highly ambiguous. On the one hand, the ring must obey its

master, the dark Lord Sauron. On the other hand, Sauron's life force is bound to the ring, and the ring possesses a life and will of its own. It wants to return to the master, it wants to be found, and it ensnares every new master. Thus, agency is located both on the inside and on the outside, governed by a complex web of temptation and vulnerability, situation and individuality. In *The Lord of the Rings,* everything is alive and connected to everything else. Because agency is determined by an interplay of multiple factors, there is a degree of chance and freedom. Even though the hearts of men are easily corrupted, they can rise above greed and deception. As the initial voice-over tells us, every once in a while something happens that the ring does not intend.

To emphasize freedom of choice, the film relies heavily on doubling. Boromir, Gondor's heir, is a dead ringer for Aragorn. But he not only resembles Isildur's heir in physical appearance; rather, the fact that he succumbs to the power of the ring serves to highlight his own as well as Aragorn's vulnerability. Saruman, who closely resembles Gandalf, shows that Gandalf too might have chosen a different path. Similarly, Gollum is Frodo's Other and a split personality himself consisting of the black-hearted Gollum and the well-meaning Smeagol. Even Sauron's monstrous servants, the Orcs, were once elves. The potential for good and evil is present in everyone, and salvation lies in inner strength and in the wisdom to remove oneself from temptation.

In *The Lord of the Rings,* everyone has a part to play. Because Pippin is curious, he can show Frodo the way out of the shire. Because he likes to stir up trouble and cannot resist the temptation of a seeing stone, the fellowship learns of Sauron's plans. Because Bilbo showed pity for the Gollum and did not kill him, Gollum shows Frodo the way to Mount Doom and plays his part in the destruction of the ring. There is destiny, but also freedom. Some events are foreordained; others are determined by free will and chance. In *The Lord of Rings,* there is always hope, and death is not the end but another path to a far greener country. Although the trilogy embraces the rhetoric of war, its plot and character development suggest that the enemy is not an Other but a different version of one's own self.

LAW ENFORCEMENT: YOUR FRIENDLY
NEIGHBORHOOD SPIDER-MAN

Spider-Man (2002). Dir. Sam Raimi. Writer: David Koepp. Columbia Pictures. Nominated for 2 Academy Awards (0 wins). Domestic Total Gross: $403,706,375. Foreign Gross: $418,002,176. Total Box Office: $821,708,551. Production Budget: $139 million.

Spider-Man 2 (2004). Dir. Sam Raimi. Writers: Alvin Sergent, Alfred Gough, Miles Millar, Michael Chabon. Columbia Pictures. 1 Academy Award (3 nominations). Domestic Total Gross: $373,585,825. Foreign Gross: $410,180,516. Total Box Office: $783,766,341. Production Budget: $200 million.

Spider-Man 3 (2007). Dir. Sam Raimi. Writers: Sam Raimi, Ivan Raimi, Alvin Sargent. Columbia Pictures. Domestic Total Gross: $336,530,303. Foreign Gross: $554,341,323. Total Box Office: $890,871,626. Production Budget: $258 million.

Spider-Man, the top DVD seller in the year of its release (Kristin Thompson 221), is a nerd's dream come true. Peter Parker (Tobey Maguire), a dorky, clumsy teenager with glasses, derided and mocked by his classmates and too shy to approach the girl he is in love with, possesses a secret identity as a superhero. As Peter Parker, he takes pictures; as Spider-Man, he is in the picture. As Peter Parker, he is tripped up, pushed around, ignored, and excluded. Fingeroth calls him a "Seinfeld with webbing" (75). As Spider-Man, he is the only one who can save the city from imminent doom. *Spider-Man* is a film about the travails of adolescence, about bodies that change in uncanny ways, about the promise and pain of first love, and the conflict between parental expectations and young dreams. Anybody who survives adolescence, it would seem, is by definition a hero. Finally, *Spider-Man* is a film about paternal legacies, father figures, and different models of masculinity.

Spider-Man juxtaposes the post-World War II work environment, with its mainstays of steady employment, occupational loyalty, and male breadwinners, to the postmodern world of mergers and acquisitions and corporate downsizing. The film features two middle-aged white men who are both laid off. Ben Parker (Cliff Robertson), the orphaned hero's uncle, loses his job as senior electrician in a plant where he had worked for thirty-five years. Norman Osborn (Willem Dafoe), the father of Peter Parker's friend Harry (James Franco), is asked to resign from his position as the director of Oscorp, a military supply company that he started and for which he made enormous sacrifices. Ironically, Norman is released at the moment of his greatest success. When he reports to the board that costs are down, revenues are up, and stock has never been higher, he is asked to step down since it has now become lucrative to sell the company. Thus, both Ben and Norman fall victim to the overall imperative to downsize people and upsize profits regardless of individual merit and accomplishments.

Spider-Man paints a bleak picture of the modern world. A decent man and exemplary worker like Ben Parker is fired and then becomes the victim of a random crime. Higher up the social ladder, a brilliant inventor and strong leader like Norman Osborn also gets fired, fights back with all his might, and also ends up dead. Although Ben and Norman respond in diametrically opposed ways, neither strategy is effective. Ben Parker resigns himself to looking for a new job. Since he is killed before he can start the process, we do not know what would have happened to him, but his prospects are not good. The ads in the newspaper all call for computer skills. At sixty-eight and with no expertise in computers, Ben is likely to remain unemployed or work in a low-wage sector. Although he is old enough, retirement does not seem to be an option. In a lifetime of work, Ben, who is portrayed as thrifty and responsible, did not make enough money to be able to provide for himself, his wife, and his one dependant.[13]

Whereas Ben acquiesces, Norman Osborn develops the necessary killer instinct. Under pressure to finish development of a human performance enhancer, Norman, in an attempt to outdo his competitor and avoid losing his funding, experiments on himself. But the experiment goes awry, and Norman is split into his usual self and the Green Goblin, a malicious alter ego of superhuman strength and deviousness. As Green Goblin, Norman kills the members of the board and lashes out against

anybody who stands in his way. In spite of this, the Goblin is destined to lose his company since even a military supplier must ultimately rely on the kind of creative work that Norman was capable of but the Goblin is not. For the next generation, the picture is hardly better. Peter Parker barely manages to secure a tenuous position as a freelance photographer even though he is willing to exploit his own superhero stunts as tabloid fodder. In the new economy, long-term employment of the postwar variety is no longer an option; even precarious jobs now require superhuman ability.

The notion that spectacular stunts are barely enough to keep you competitive in today's rapacious labor marketplace is not only evident in the Goblin's fate, but plays itself out on multiple levels. In *Spider-Man,* nice guys finish last and those who succeed are not happy (see Michael Wood 77–79). When Peter needs money, he signs up for a wrestling competition. As it turns out, the match is hopelessly rigged against him. His opponent, Bone Saw (Randy Savage), a titan of testosterone and master of disaster, is favored by the crowd. He is also handed a chair and a crowbar, while Peter is left to fend for himself. When Peter triumphs against all odds, the manager still refuses to give him the amount promised to the winner. To reap the rewards of his labor, Peter would have to be preternaturally strong and ruthless. Playing by the rules does not get you anywhere in a world without a moral compass. However, adjusting to the ways of the world also proves to be harmful. When the same manager who robbed Peter of his just reward is himself robbed in turn, Peter stands idly by even though he could have stopped the culprit. Peter's decision to repay like with like is his worst choice yet since his uncle is killed by the thug who stole the manager's money. Peter now deeply regrets his behavior and begins to fight crime all over the city. Curiously, though, in portraying a hero who brings thieves and rapists to justice, the film, in a classic bait and switch operation, offers a solution that does not at all correspond to the problem it presented. Initially, viewers are faced with the structural fallout of a profit-driven corporate world. But since Ben is not only fired but also murdered, the punishment of petty thieves and murderers glosses over the structural inequities of corporate capitalism. Similarly, in Norman's case, the elimination of a crazed megalomaniac is designed to efface the character's initial victimization at the hands of corporate players.

In typical Hollywood fashion, *Spider-Man* substitutes individual misbehavior for systemic malfunction. However, the film also stages the return of the repressed when it insists that a commitment to the community at large is at odds with professional success and family obligations. Peter's new vocation conflicts with his ability to hold down a job—he is fired because he is always late—and with his desire to have a girlfriend. Since everyone who is close to him becomes a target, Peter feels he has to protect his loved ones by keeping his distance. While Iron Man is having fun even when he fights terrorists—it is not for nothing that he tells his computer assistant to throw a little hot rod red on his suit—for Spider-Man the fun stops once he accepts his mission.

While *Spider-Man* depicts serving humanity as a job without pay and benefits, *Spider-Man 2* is intent on erasing this dilemma. Here, the pressure of excessive self-renunciation is counterproductive. When Peter flunks his exams and loses his job and his girl because of his heroic obligations, he finds himself unable to perform. His spinnerets malfunction, and he can no longer climb walls or jump from block to block.

Deprived of even the hope of love, he is a superhero no more. The restoration of his superpowers occurs when his fight no longer takes him away from Mary Jane (Kirsten Dunst) but brings him closer to her. Moreover, just as service no longer requires sacrifice in *Spider-Man 2*, the sequel is also not concerned with the structural contradictions of a capitalist economy. Instead of the pressure of corporate competition, viewers are fed the old trope of scientific hubris.

Although *Spider-Man* juggles different social strata, Peter Parker is firmly rooted in a working-class environment. Though the film shies away from dwelling on social problems, it does hint at them. Mary Jane has an alcoholic father and works as a waitress in a burger joint. When Peter invites her out, he has a seven-dollar budget. Peter's uncle is unemployed, and in the sequel, the house of his aunt May (Rosemary Harris) is foreclosed. Indeed, the film's sympathy for its working-class heroes is so large that it becomes an example of "inverse snobbery." Peter experiences the world of the rich through his friend Harry. Harry's father has a fancy penthouse, and Harry, who is taken to school in a Rolls Royce, flunked out of every exclusive private school in the area. In spite of all this wealth, however, Harry's father is fired just like Peter's uncle, and Mary Jane ultimately chooses Peter over his rich friend. Though Harry is in a position to buy everything she wants, Mary Jane prefers Peter's kindness and empathy to Harry's attempts to turn her into a woman his father might approve of. In spite of all the opportunities open to him, Harry lacks talent and character. While Peter wins science medals, Harry is a middling student. Peter is morally upright, Harry is spineless, egotistical, and petty. Wealth connotes greed, loneliness, and ultimately insanity, while the world of Uncle Ben and Aunt May embodies the values that make America great. Aunt May slaps Norman's fingers when he tries to serve himself before the others, and she hits a bank employee with her umbrella when he tries to steal a gold coin in the general chaos caused by Dr. Octopus's robbery. Honesty, courage, and responsibility are at home in Aunt May's house with its embroidered cushions, flowery wallpapers, and cheap furniture. Peter Parker follows his uncle who defines masculinity as service, while Harry seeks to please a father who equates masculinity with success. Ben Parker leaves a legacy of moral uprightness and service, while Harry Osborn is saddled with the burden of revenge.

One of the most attractive features of the Spider-Man franchise is its refusal to trade in easy dichotomies of good and evil. In the first film, this is evident in the many parallels between the hero and his nemesis, the Green Goblin. Both Norman and Peter are science geeks who have benefited from various forms of human performance enhancement. When he first discovers his new powers, Peter too responds with a new taste for irresponsible behavior. He shirks his chores and spends his time frolicking on rooftops and getting into fights with classmates. Even Norman's misogynistic rants, which would seem to be a far cry from Peter's kindness towards his aunt and Mary Jane, find an echo in Spider-Man's noble renunciation of relationships, which is justified as a desire to keep Mary Jane out of harm's way but could also be read as Peter's fear of commitment. Significantly, male spiders are not only predators but in danger of being engulfed and eaten by their female mates. The writers are clearly aware of this dimension and develop it further in *Spider-Man 2*, which treats Peter's reluctance to commit somewhat ironically. When Peter is told to woo MJ with poetry, he picks up Henry Wadsworth Longfellow's "Shawondasee." Peter

quotes: "Day by day he gazed upon her," but wisely does not recite the next few lines: "But he was too fat and lazy to bestir himself to woo her./ Yes, too indolent and easy to pursue her and persuade her." Clearly, what differentiates Norman from Peter is not inclination but choice. Both the Green Goblin and Dr. Ock of *Spider-Man 2* have a gentler, kinder side that succumbs in an internal dialogue with its driven, selfish alter ego. In the *Spider-Man* franchise, villains are not wholly evil but victims of their own ambition, hubris, and even love, as in *Spider-Man 3*, where the villain is motivated by a desire to help his sick daughter.

In both *Spider-Man* and *Spider-Man 2*, the hero, much as he likes to introduce himself as your friendly neighborhood Spider-Man, is initially at odds with his community. At first glance, the reason for the estrangement appears to be the press where Spider-Man's courageous deeds are misrepresented and maligned. The film presents the editor of *The Daily Bugle*, J. Jonah Jameson (J. K. Simmons), as a profit-driven liar and braggart. Again and again, *The Bugle* denounces Spider-Man as a public menace, a criminal, and a vigilante and calls for the "wall-crawler's arrest." But the film also defuses its own critique by portraying Jameson as a comic character. And, of course, Jameson is partially right. Spider-Man is a vigilante. Like all superheroes, he is not bound by the letter of the law (Fingeroth 17). Thus, we might conclude that the problem does not so much lie with the press as with its readers and the fabled fickleness of the crowd, which the film showcases in the wrestling scene. This fickle nature along with the exceptional status of the hero constitutes an antidemocratic threat, a threat that the films defuse by featuring Spider-Man's reconciliation with the crowd.

Both the first and second films of the franchise introduce scenes in which Spider-Man is reconciled with the public and even owes part of his success to the support of the many. In *Spider-Man,* the reconciliation occurs when the Green Goblin forces the hero to choose between saving his girl or a gondola car full of children. Of course, Spider-Man tries to save both Mary Jane and the children, but in doing so, he becomes vulnerable to the Goblin's attacks. In his moment of need, onlookers on the bridge not only cheer him on but start pelting the Goblin with baseballs and anything else they have handy. Their acts are followed by a declaration of solidarity: "you mess with one of us, you mess with all of us." Similarly, *Spider-Man 2* features a sequence of events where Spider-Man is first accused of villainy—"Masked Menace Terrorizes Town," the headline reads—and then reconciled with the public at large when he prevents a train crash and is himself saved from plummeting to his death by the supporting hands of the crowd. As both Peter Parker and as Spider-Man, the hero is one of the crowd, and his triumph is made to represent the triumph of American democracy. Whereas the Goblin proclaims that the masses exist for the sole purpose of lifting the few exceptional people up on their shoulders, Spider-Man has internalized his uncle's credo that "with great power comes great responsibility," a theme that is reiterated in the sequel, when Peter learns that intelligence is a gift to be used for the good of humankind, not a privilege. *Spider-Man 3* continues and expands on the hero's relation to the public at large and also on the problematic role of the press. Here, one of the villains is a photographer who digitally alters pictures in order to scoop his competitor, Peter Parker. As in the two preceding films, the crowd is fickle, capable of extraordinary solidarity but also easily swayed by the media.

Spider-Man 3 contains imagery strongly evocative of 9/11. Toward the beginning, an out-of-control crane crashes into a high-rise demolishing first one office, then several floors. Glass shatters; furniture and a young lady fly out of the gaping hole and hit bystanders in the streets below. Of course, Spidey saves the woman who tumbles down 62 floors. In light of this reference, it is interesting that the rest of the film argues strongly for forgiveness and against revenge. The theme of revenge is played out on two levels. First, Harry still blames Spider-Man for his father's death and seeks revenge. Meanwhile, Peter learns that the man held responsible for his uncle's death was merely an accomplice, while the actual killer is still at large. He too is now bent on revenge. In both cases, the pursuit of vengeance brings out the worst in all involved. When Harry, relieved by temporary amnesia, forgets his bloody mission, he feels free and happy, enjoys life, and is reunited with his friends. When he regains his memory, he is again consumed by hatred and ultimately disfigured in a fight with Peter. In turn, Spider-Man, who had never killed before—previously, his opponents had the good grace to off themselves—attempts to kill his uncle's murderer. When he proudly reports to Aunt May that her husband's killer is no more, May delivers a worthwhile lecture:

> I don't think it's for us to say whether a person deserves to live or die [. . .]. Uncle Ben wouldn't want us living one second with revenge in our hearts. It's like a poison. It can take you over. Before you know it, it turns us into something ugly.

Of all the saviors and superheroes discussed in this chapter, Spider-Man is the only one who does not employ the rhetoric of war but rather relies on the language of law enforcement, to the extent possible in a film that features a vigilante. In *The Lord of the Rings* and *The Matrix* trilogy, the empire of evil is a black wasteland. In *Spider-Man*, evil is situated in isolated spots, dark alleys littered with garbage, but there is a bright and busy city with green parks all around it. Spider-Man rejects the war on terror, but our next superhero, Iron Man, embraces it full core.

HOT ROD RED: LIVING IT UP IN THE WAR ON TERROR

Iron Man (2008). Dir. Jon Favreau. Writers: Mark Fergus, Hawk Ostby. Paramount Pictures. Nominated for 2 Academy Awards (0 wins). Domestic Total Gross: $318,412,101. Foreign Gross: $266,762,121. Total Box Office: $585,174,222. Production Budget: $140 million.

Iron Man, based on the eponymous Marvel comic, is a classic example of a Hollywood film that gets to have its cake and eat it too. The film's plot revolves around a weapons manufacturer, Tony Stark of Stark Industries (Robert Downey Jr.), who undergoes a transformative experience when he is held captive in a cave in Afghanistan. Trying to fight his kidnappers, Tony realizes that his company has been dealing under the table, a fact of which he was completely ignorant, and that his weapons are now in the possession of terrorists. He escapes from the cave because of his ingenious engineering skills and makes it his mission in life to destroy all Stark weapons that have fallen into the wrong hands. To do so, he upgrades the armored

body suit, which he built in the cave using scrap metal. Since the suit is powered by a micro-reactor implanted in Tony's chest, *Iron Man* literalizes the notion of having a change of heart (Fig 5.3).

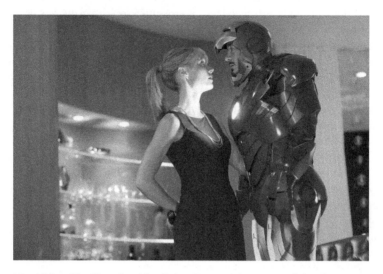

Figure 5.3 A Man with a Heart: Iron Man (Robert Downey Jr.). Courtesy of Photofest, Inc.

As Iron Man, Tony defends the helpless and protects the innocent. And, of course, to help the worthy and disarm the evildoers, Tony needs an arsenal of heavy artillery. Thus, the man who has supposedly realized that he has "more to offer the world than just making things that blow up" spends the rest of the film blowing things up. The bigger part of this film about disarmament features spectacular explosions and lethal force.

With *Iron Man,* Paramount Pictures spruced up a franchise originally devised in the context of anti-Communism to fit the war on terror of the late twentieth and early twenty-first centuries. The film even includes a joking reference to the Office for Homeland Security. In the *Iron Man* comics, the acronym S.H.I.E.L.D. stands for Supreme Headquarters, International Espionage, Law-Enforcement Division. In the film, S.H.I.E.L.D signifies Strategic Homeland Intervention, Enforcement and Logistics Division, represented by the eager, though somewhat ineffectual, agent Coulson (Clark Gregg). As the depiction of Coulson indicates, the film, while embracing the war on terror, evinces a strong dislike of the government and its institutions. Iron Man always gets the job done, while the U.S. military is entangled in a bureaucratic web of restrictive regulations and held back by conflicts between its various branches of service. The only job that the government accomplishes more effectively than Iron Man concerns the deception of the public. Repeatedly, the film cuts from an event to the misrepresentation of said event at a press conference, where official statements ridicule every possible notion of truth.

In spite of its topicality, the film's political message is noncommittal and confused. The only tenet the film endorses without qualifications, the bright idea that

one should not give big guns to bad people, is carefully chosen to be minimally controversial.

Aside from this lowest common denominator, *Iron Man* simultaneously promotes and criticizes the weapons industry. Before his transformation, Tony advises the generals to whom he hawks supremely destructive missiles that they just have to find "an excuse to let one of these off the chain, and [...] the bad guys won't even want to come out of their caves." Finding excuses to invade foreign countries is indeed an apt description of Bush-era foreign policy, and the fact that Tony throws in a portable, fully equipped bar to clinch the deal serves to underline the implied critique. The fact that the chief villain of the film, Obadiah Stane (Jeff Bridges), is also the most vocal advocate of the defense industry does not help matters either. Obadiah argues that Stark weapons keep the world from falling into chaos, but disproves his own claim when he sells military technology to terrorists of all nations.

Still, *Iron Man* would not be a blockbuster if it did not counterbalance its attacks on weapons manufacturers with an equally powerful argument for the indispensability of the weapons industry. First, viewers are informed that we owe much of our progress in medical technology and agriculture to military research. Second, Tony's friend and military liaison, Colonel Rhodes (Terrence Howard), is furious with Tony when the latter declares his intention to shut down the weapons technology division of his company and tells him to "get his mind right." Since Rhodes is consistently portrayed as a highly positive, even admirable character—the majority of the deleted scenes included on the DVD seem to have been taken out to make Rhodes look more competent and upright—viewers are likely to sympathize with his position. His ire is motivated by his belief that terrorists aim to rule the world and must be stopped with lethal force, and the film bears out his opinion. To rid the world of weapons, Tony has to create the most lethal weapon ever. Toward the beginning of the film, Tony quotes his father's definition of peace as "having a bigger stick than the other guy." Since this definition is uttered before Tony undergoes his transformative experience, we expect the film to revise it, but it never does. In circular logic, the film argues that we need to keep manufacturing weapons precisely because we cannot keep our already manufactured weapons out of the hands of terrorists. In *Iron Man,* the possibility of disarmament through negotiations is never explored, and since the success of a film owes much to its visual appeal, the preference for Jericho missiles over conference tables is wise. Politically, however, this is unimaginative and harmful.

Iron Man not only references the current war on terror, it also compares the present situation to America's participation in World War II. To do so, the film uses an Oedipal constellation. Tony inherited his company from his father, who was also an inventor and manufacturer of weapons technology. The film states that the young Tony quickly outshone his father and hints at some unresolved conflicts and unanswered questions—thus setting up the premise for a sequel. While Tony considers his father a hero because he helped defeat the Nazis, a journalist calls him a war profiteer. In addition, Obadiah, who is himself a negative father figure, points out that Howard Stark helped give the world the atomic bomb. The film seems tired of the moral superiority of the World War II generation and suggests that newer and better heroes have arrived.

Like *The Bourne Ultimatum, Iron Man* employs imagery familiar from the war on terror, but effects a role reversal. Instead of terrorists being tortured and waterboarded by American forces, here it is the American hero who is hooded and whose head is repeatedly dunked into water. In *Iron Man,* the Americans do not respond to an attack on their homeland, but rather wage war on Afghanistan in order to protect Afghani peasants, who are threatened by Arab terrorists. But again, the film keeps all ideological options open by depicting the terrorists not as independent agents but as puppets of a Westerner. They did not kidnap Tony on their own account but were hired by Stane, who wanted complete control of Tony's company.

To further muddle the political waters, *Iron Man* does not identify its terrorists with a particular country, but portrays a fictional group, the Ten Rings, who recruit their members from a variety of nations. Tony's captors speak Arabic, Urdu, Mongolian, Farsi, Russian, and, unaccountably, Hungarian. All of them, including their leaders, one potbellied and stupid, the other bald and mean, remain ill-defined except for four facts: they are cowards, they are utterly stupid and incompetent, their victims are innocent farmers, women, and children, and they want to rule the world, starting with Asia. Faced with danger, they either run away or order someone else to lead the way. Technology has always been their Achilles' heel, as Obadiah tells his terrorist minion. And indeed, although Tony is under constant surveillance in a cave, his jailors fail to spot the fact that their prisoner is crafting a body suit and not the missile system they told him to build. "It doesn't look anything like the picture," one of them observes astutely, whereupon another replies, "It's just backwards."

While the terrorists are exemplars of ineptitude, Tony Stark is a quintessential omnipotence fantasy. He is also an embodiment of what Michael Wood calls the American "myth of excess [. . .] only those things that are too big are big enough for American appetites" (174). Tony is excessively rich, his living room alone the size of several airplane hangars. He is a brilliant inventor and innovator. Of superior intellect and muscular build, Tony knows how to use hammer and anvil as well as the fanciest 3D computer simulation. He is also a classic example of a rake reformed. Before his captivity, Tony devoted his time to his work, booze, and sex. After his near-death experience, he embraces a mission and takes the first steps toward building a family by refocusing his amorous attention away from Playboy magazine cover girls toward his trustworthy assistant Pepper Potts (Gwyneth Paltrow). But it is not only the requirements of the sequel that keep Tony from making the commitment. Unlike *The Lord of the Rings,* which emphasizes collaboration, and unlike *Spider-Man* and its nod to the community, *Iron Man* shows a lone fighter. Although Tony relies on the most sophisticated high-tech gadgetry and supercomputers, he never works in a team, but plans and implements every design alone, aided only by his various robotic butlers. Tellingly, it is his robot assistant, not his human helpmeet, who saves Tony's life by handing him his iron heart when he most needs it.

Just as Tony is an omnipotence fantasy, Pepper Potts is a romantic fantasy. As Tony's Girl Friday, Pepper handles all practical matters in the Stark household, including getting rid of his one-night stands, an activity she refers to as "taking the trash out." She is fully devoted to her employer and to him only. Pepper has no problem working for the "most famous mass murderer in the history of America," as his terrorist captor calls Tony. But when Tony decides to fight on the side of good, she

quits. Since the only cause Pepper cares about is Tony's well-being and since Tony's previous job as merchant of death was safer for him, she would much rather have him pursue his first line of employment. Of course, her loyalty demands that she ultimately support Tony in whatever he chooses to do. Pepper's extraordinary skills are completely at Tony's disposal. Anything Tony tells her do, including spying on Obi or overloading a powerful reactor, she accomplishes successfully. The only thing she cannot do is form an agenda of her own.

If *Iron Man* comes across as playful adventure rather than ham-fisted warmongering, this is largely due to the film's pervasive sense of irony. The film's editing, in particular, serves to deflate both its characters' grandstanding and its ideological agenda. For example, the second Obi tells us that Tony is always working, the film cuts to Tony living it up in a casino. Similarly, Rhodes's declaration that he does not drink is followed by a picture of him and Tony completely hammered. Finally, Tony's announcement that he is going to begin his flight practice in his new suit "nice and easy" precedes an image of Tony smashed against the ceiling. Still, much as it tempers its purposeful declarations and heavy-handed explosions with irony, *Iron Man,* more so than any other film discussed in this chapter, peddles an unmitigated ideology of war waged by a hypermasculine American hero.

ENHANCED MASCULINITY

Superhero films are centrally concerned with concepts of masculinity. Of the four fantasy worlds discussed in the chapter, all but *The Matrix* relegate women to the sidelines and expend all their energy on the exploration of different types of masculinity. All these films offer stories of masculinization, of growing up, changing one's life, standing up for one's ideals and beliefs. In so doing, they define what it means to be a man, a hero, and a leader.

It is well known that Presidents Clinton and Bush embody diametrically opposed styles of leadership. Clinton was known to encourage debate to the point of exhaustion. He insisted on exploring all angles of any given problem and would not decide until he had heard all options (John F. Harris 55). In contrast, Bush is commonly described as a president who disdained complexity and nuance and did not seek out opposing viewpoints and expert opinion (Maranto/Redding 24). Clinton has been much criticized for an overreliance on polling data, whereas Bush liked to boast that he relied not on data, but on instincts and gut feelings. Clinton's critics perceive him as a pushover without backbone. But if Clinton is too flexible, Bush is excessively rigid. Known for his stubborn resistance to advice, Bush clung to policies even after they had long been proven ineffective. In other words, Clinton's leadership style relies on traditionally "feminine" virtues while Bush worked hard to project a he-man persona.

While Clinton and Bush embody diametrically opposed models of masculinity, the films discussed here show a clear preference for mixed types. They either depict heroes whose traditional "masculinity" is tempered by feminine or at least softer elements or, alternatively, offer a selection of different types of heroes from which viewers may choose. *The Matrix* idolizes a hero who is repeatedly feminized and who triumphs not through self-assertion but through self-erasure. *The Lord of the*

Rings glorifies a traditional male hero, Aragorn, but also celebrates Frodo and Sam, two inconspicuous boy-men who prevail not because of martial skills but because of their modesty and their dedicated friendship. Similarly, *Spider-Man* shows a muscle man who is bound by his ideal of service and his commitment to his family and the community at large. Even Iron Man's seemingly uncompromised preference for martial he-man masculinity is tempered by the film's strong sense of irony.

If it is true, as Susan Jeffords maintains, that "1991 was the year of the transformed U.S. man [...] the hard-fighting, weapon-wielding, independent, muscular, and heroic men of the eighties [...] have disappeared and are being replaced by the more sensitive, loving, nurturing, protective family men of the nineties" ("Switch" 197), then the first decade of the new millennium insists that men must now be both. The heroes in these films are omnipotence fantasies of the "I don't come to pieces" variety (Easthope 42), but they are somewhat less muscular than they used to be. They are survivors who are smashed about, beaten up, and shot at. They plummet into the abyss and crash against solid brick walls. But they are also devoted lovers and friends, committed to their families, their male companions, and the community at large.

The need for an enhanced masculinity is also visible in the fact that our heroes tend to be either sub- or superhuman. They are humans with machinelike skills, such as Neo, belong to a different race, such as the hobbits, or they are man-animal hybrids, such as Spider-Man. Savior films further highlight the need for enhanced masculinity through their preference for doubling. They are fond of alter egos and tend to split their heroes in two. In *The Matrix,* the hero is Neo and Mr. Anderson. Spider-Man is a superhero and a shy, dorky kid. *Iron Man* is an idle playboy and a man who gives his all to help the poor and weak. Even *The Lord of the Rings* trilogy, whose heroes do not have a secret identity, repeats this pattern through doubling. Boromir and Gollum show us what might have happened to Aragorn and Frodo. Although all these films depict heroes who possess the qualities of traditional he-men, they are also acutely aware that in this new world being a he-man is never enough.

SPIES, PARANOIA, AND TORTURE

We'll have to work sort of the dark side, if you will . . . And, uh, so it's going to be vital for us to use any means at our disposal basically, to achieve our objectives.
 Vice President Cheney, qtd. in *The Dark Side,* 9–10

All you need to know is that there was a "before 9/11" and there was an "after 9/11." After 9/11, the gloves came off.
 Vice President Cheney, qtd. in *The Dark Side,* 43

THE AGE OF PARANOIA

Paranoia is not a Bush-era invention. And yet, the days after September 11, 2001, the constant dread of further attacks, be they hijackings or anthrax poisoning, were a high point of paranoia in American history. It was a time when, as Jane Mayer describes, the armored motorcade that chauffeured Vice President Cheney to his office contained a gas mask along with a biochemical survival suit and was accompanied by a medical doctor (5).[1] The paranoia that gripped the government also affected American citizens, who were called upon to participate in the war on terror through constant vigilance. "Report all suspicious activity" became a refrain that accompanied all public activities. It was a time when everyday objects such as backpacks, phones, or packages could be perceived as potential weapons of terror (see Bratich 142).

In this political and social climate, the spy film, in which paranoia is always justified, was bound to thrive. Its popularity is evident in the revival of the Bond franchise, but also in the enormous success of films such as *Miss Congeniality,* of spy parodies from *Austin Powers* to *True Lies* (see Hagopian 22–25) and television shows such as *Alias* and *24.* Spy stories are perfectly aligned with the paranoid agenda of the post-9/11 era. They are also ideally equipped to deal with another issue that dominated public debates after 9/11, namely the relation between torture and the law. It is now widely known that in its fights against terrorism, the Bush administration felt hampered by existing law. To overcome the restrictions imposed by the

Geneva Conventions, which confer rights on prisoners of war, the U.S. government created a special status for terrorists (Goldsmith 39–41). Now designated enemy combatants, terror suspects could be detained indefinitely without charge, trial, or right to counsel. Habeas corpus no longer applied to them. Both at Abu Ghraib and at Guantanamo,[2] suspected terrorists were subject to what Bush and his advisers referred to as harsh interrogation practices, but critics designate as torture. Because the administration defined torture in the narrowest sense possible, only behavior that results in a "sufficiently serious physical condition or injury such as death, organ failure, or serious impairment of body functions" (Goldsmith 144) qualifies. Sleep deprivation, deprivation of light and sound stimuli, waterboarding, stress positions, hooding, isolation, and the use of dogs were deemed acceptable interrogation techniques (see Pfiffner 66), and torture became "the official law of the land in all but name" (Mayer 8).

The growing interest in torture is evident in film and television. A Human Rights First study found "that acts of torture on prime-time television had gone from fewer than four a year before 9/11 to more than a hundred—and the torturers, who in the past were almost entirely villains, were now often the shows' heroes" (Faludi, *Terror Dream* 139). The obsession with torture is also evident in spy movies. Curiously, though, a peculiar reversal has taken place. In contemporary reality, only one white American prisoner, John Walker Lindh, prisoner 001, the son of an upper-middle-class American family, was subjected to brutal interrogation methods. In contrast, in the fantasy world of the spy film, it is the white American hero who is held prisoner and tortured brutally by a terrorist or criminal "Other."

Spy films not only change the ethnic and political dynamic of the torture scenario, they also seek to come to terms with another tenet of the Bush government, namely the idea that current U.S. law hampers the war on terror. As numerous critics pointed out and as the Supreme Court decisions in *Hamdi v. Rumsfeld* and *Rasul v. Bush* confirmed, key officials of the Bush administration were convinced that the law needed to be bent and even ignored if terrorism was to be fought effectively.[3] The notion of "the law 'handcuffing' the police" (Parenti 116), a favorite in action film ever since *Dirty Harry,* is also evident in spy films of the period. Several films discussed here suggest that only deviation from official protocol and even transgression of the law save the day. The films celebrate the lone fighter in splendid isolation who takes on an entire organized crime syndicate by himself.

It is perhaps worth noting that the approach championed by many of these films, in particular the preference for go-it-alone heroes as opposed to institutional solutions based on cooperation and the exchange of information—is directly at odds with the recommendations of the 9/11 Commission, which produced the most thorough investigation of the terror attacks. The findings of the commission emphasize the necessity of cooperation and shared information. The greatest failure of the intelligence community before 9/11 lay not in the inability to extract relevant information. On the contrary, all relevant information was available. Rather, fatal consequences resulted from the failure to share important findings with other agencies (see John F. Harris 408). Cooperation and communication, not maverick heroics, could have saved the day. During the rescue efforts after the attack on the Twin Towers, a hero

who rapels from a helicopter in James Bond style would not have made much of a difference, but wide availability of effective radio communication could have saved hundreds of lives.

All spy films discussed here are highly topical, but such topicality remains abstract and superficial. Spy films, even though or precisely because they are situated in a context of domestic and international politics, favor generic plots and characters and defuse potentially controversial scenarios. All films in this chapter are shot through with casual nods and allusions to contemporary political events, in particular, terrorism, but these references remain vague. Crucially, whenever the films portray political failure, they frame the problem as personal rather than systemic. As Robin Wood points out, "ideology acknowledges a minor, local, reformable evil in order to divert attention from the fundamental ones" (161). Thus, several films suggest that threats to society are the result of moral failure or madness on the part of one individual in a mid-level position. Both *Mission Impossible* and *Casino Royale*, for example, locate the origin of all evil in personal corruption, greed being an all-time favorite, while *Mission Impossible 3* and *The Bourne Identity* hint at ideological agendas reminiscent of the politics of the Bush White House, but attribute such misguided aspirations to self-aggrandizing fantasies of individual bureaucrats. In contrast, *The Bourne Supremacy* is far more radical in its evaluation of the reach of political corruption, but it defuses the explosive nature of its message by depicting American citizens as the prime victims of a misguided American foreign policy. In spy films from Clinton to Bush, as in Reagan-era action films (see Jeffords, *Hard Bodies* 19), government bureaucracies—but actually only a few bad individuals within these organizations—are an impediment to societal progress.[4]

It is easy to criticize spy films for glamorizing a rather drab profession. As Mayer points out in reference to the CIA, "the Directorate of Operations would like people to think it's a great James Bond operation, but for years it essentially assigned officers undercover as diplomats to attend cocktail parties" (38). But this does not go to the heart of the matter. Rather, it is the films' libidinal investment in individual stunts over cooperation, physical force over communication, and maverick action over law-directed procedure that should give us pause. Clearly, films *must* be free to pursue their own agenda. Politically correct censorship would only exacerbate the problems it seeks to address. And yet, we cannot ignore the fact that these films keep us emotionally invested in stories that champion ineffective and even potentially harmful political strategies.

SPY BALLET

Mission: Impossible (1996). Dir. Brian De Palma. Writers: Bruce Geller, David Koepp. Paramount Pictures. Domestic Total Gross: $180,981,856. Foreign Gross: $276,714,503. Total Box Office: $457,696,359. Production Budget: $80 million.

Mission: Impossible III (2006). Dir. J. J. Abrams. Writers: Alex Kurtzman, Roberto Orci. Paramount Pictures. Domestic Total Gross: $134,029,801. Foreign Gross: $263,820,211. Total Box Office: $397,850,012. Production Budget: $150 million.

Mission: Impossible is inspired by the eponymous television series written by Bruce Geller, who also wrote the script for the film. The film centers on an Oedipal conflict and stars Tom Cruise, an actor whose early reputation was largely built on his convincing performances in Oedipal narratives.[5]

In *Mission: Impossible,* the Oedipal theme is the key to the entire plot. Ethan Hunt has lost his biological father to a disease that killed him slowly and painfully. He found a father substitute in his trusted boss, Jim Phelps (Jon Voight). When Phelps appears to be the victim of a failed undercover operation, Hunt blames himself for his mentor's death. Taking its cue from *Hamlet, Mission: Impossible* even treats its viewers to a vision of the dead father, who, his hands dripping with blood, laments, "I needed you. You weren't there." Of course, the man who wasn't there was Phelps himself, who turns out to be the criminal mastermind behind a plot that threatens to engulf our hero and endanger the lives of all CIA undercover agents.

Like all James Bond films and *The Bourne* trilogy, *Mission: Impossible* pits one man against the world. Total paranoia is the only appropriate response in a situation where everybody, the good and the bad guys, is out to get the hero, whose damnable position is underlined through reference to the story of Job. Appropriately enough, Job 3:14 ("with kings and counselors of the earth, who built for themselves palaces now lying in ruins") is not only a pertinent reminder of the transitoriness of earthly power but also the online name of the film's villain. When Ethan assumes Job's virtual identity, we are reminded of the undeserved nature of his unhappiness and ready to observe how much he can stand without losing faith in the world and his fellow humans. Of course, in the end, Ethan, unlike Job, is redeemed by his own strength and skill. The premise of a hero who cannot trust anybody or rely on anybody's help sets up an all-encompassing omnipotence fantasy.

De Palma highlights the precariousness of trust and the omnipresence of betrayal through the theme of masks and performances. Because deception, supported by technologically sophisticated devices such as facial masks and voice modulators, reigns supreme, personal identity is constantly being interrogated and redefined. The spies of *Mission: Impossible* do not catch their targets through drawn-out surveillance schemes—waiting and watching do not lend themselves to the spectacular displays of the action genre—or through the decoding of messages. Rather, Ethan Hunt and his companions live in a theatrical world, an infinite cycle of playacting and performance, with Phelps as a director who assigns roles. Tellingly, the film opens with a captivating scene in which Claire (Emmanuelle Béart), a member of the team and Phelps's wife, appears to be the victim of a Soviet thug. Several minutes into the scene, however, viewers learn that the entire scenario was staged. The apparent victim is in on this elaborately choreographed ruse designed to draw out information from the thug, who is the actual victim of the plot.

This initial scene, which we see through the eyes of a character who watches it on a video monitor, introduces us to the theme of surveillance and to the use of computer-generated facial masks and voice box decoders, which allow the hero to transform himself into the villain and enter his world. Paradoxically, though, the device of the facial mask facilitates both deception and revelation. It is a crucial instrument in undercover actions, designed to trick one's opponent, but it is also

a medium of truth, for example, when Ethan dons the mask of his former boss to probe the trustworthiness of his love interest Claire.

Mission: Impossible is obsessed with the theme of seeing through somebody else's eyes. When Ethan elicits a confession from Phelps, he is wearing glasses outfitted with a camera that allow his CIA contact to witness the exchange. Similarly, as viewers, we are frequently forced to see the action through the eyes of a character. When Ethan attends a party under cover, viewers do not watch Ethan, but rather, in an unusual first-person shot sequence, see the party through his eyes or share the perspective of Phelps, who himself observes the party through the camera installed in Ethan's glasses. In spite of its investment in voyeurism, however, the film is careful to warn us that images can lie. Indeed, the entire plot is set in motion because the crucial scene, in which Ethan witnessed Phelps's murder through a video feed, was staged.

Because of Phelps's betrayal, Ethan's world is turned upside down, and the film skillfully mirrors its hero's disorientation through its heavy reliance on extreme camera angles. Repeatedly, the dislocation of Ethan's worldview is rendered through Dutch tilts that position Ethan's face diagonally on the screen, while Ethan's CIA contact Kittredge (Henry Czerny) is filmed from below. The themes of disorientation and lack of options are further underlined through the repeated visual motifs of labyrinthian staircases and of tunnels and elevator shafts that restrict the characters' movements. The constant possibility of surveillance is suggested by the fact that the camera repeatedly appears nestled in the ceiling, tracing the actions of an unsuspecting or frantic Ethan from above.

The key to Ethan's ultimate triumph consists in his initiative in directing the show rather than being duped by someone else's performance and in his ability to control his feelings. In particular, Ethan has to resist the fatherly overtures of the newly resurrected Phelps and the sexual allure of Claire, who, although she appears to be on Ethan's side, remains loyal to Phelps until the end. If *Mission: Impossible* is a story of origins and new beginnings, it owes this quality to Ethan's ability to extricate himself from a dysfunctional Oedipal constellation and emerge as a new, independent man.

Ethan's ability to subdue his emotions is epitomized in the big heist that constitutes the film's climax. Through this scene, De Palma showcases balletic discipline rather than the "hard body" credentials that characterized the action hero of the Reagan era (Jeffords, *Hard Bodies* 13).

To steal highly sensitive information required to prove his innocence, Ethan and his team penetrate into the heart of the CIA in Langley, Virginia. The data they require must be retrieved from a high-security environment equipped with sensors that register the slightest change in room temperature, noise level, and pressure. In this ultrasensitive capsule, one drop of sweat would lead to immediate detection and arrest. Thus, it is quite literally Ethan's cool that saves the day. Furthermore, the deviation from the "hard body" model is also evident in the fact that, during the heist and throughout the movie, Ethan insists on a zero-body count. Clearly, *MI* is a pre-9/11 film, and the gloves have not yet come off. Ethan triumphs through planning and attention to detail, quick-wittedness, and supreme self-control, although it would be premature to conclude that the choreography of dance has supplanted the brutality of the fight. Ethan is capable of crude violence, evident in the killing

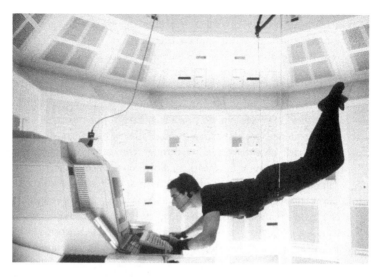

Figure 6.1 A Man with a Light Touch: Ethan Hunt (Tom Cruise). Courtesy of Photofest, Inc.

of Phelps and his helpmate in the end. More importantly, Ethan's rough handling of Claire conflates sexuality and violence—in particular, when he body-searches her in a way that evokes rape—and suggests that this hero has not completely settled into the balletic supremacy that he exhibits for most of the film (Fig 6.1). Ethan is a graceful acrobat, a tough strong-arm, and a troubled lover, and his status as lone survivor in the end serves to elide these contradictions rather than resolve them.

The Oedipal structure of *Mission: Impossible,* that is, the fact that the coveted lover is the wife of Ethan's substitute father, sets up a highly interesting gender dynamic. Since Claire is married to the much older Phelps, she is positioned as a mother figure. Her age, however, marks her as a suitable partner for Ethan. Throughout, the film highlights the sexual tension between Ethan and Claire. But unlike James Bond, who "repositions" his female partners both sexually and ideologically (Bennett and Woollacott, *Bond and Beyond* 116), Ethan must extricate himself from the familial web. In spite of their compatibility, Claire betrays Ethan, supports Phelps's plan, and is finally killed by her partner in crime—though the film corroborates Ethan's superior prowess by hinting that Claire fell for him after all and that Phelps's brutal shooting of his own wife is motivated by jealousy. In the end, Ethan is left unpartnered and thus ideally positioned for a sequel.

Interestingly, the other important female figure in the film is also characterized as an untrustworthy maternal presence. The infamous arms dealer Max (Vanessa Redgrave), shrouded in anonymity and protected by a cleverly chosen male pseudonym, seeks to acquire the highly classified NOC list of all undercover agents in Eastern Europe. Max possesses the style and elocution of an upper-crust socialite and conducts her black market deals as though she were presiding over a tea party. Her professionalism is almost on par with that of Ethan, whom she comes to respect and treats like a favored son. Her outstanding skill level in her chosen métier is proven in

the end when she is caught but extricates herself with an offer to trade information—
"I am sure I have something you need." In *Mission: Impossible,* lovers, mothers, and
fathers all prove untrustworthy, and the hero's black buddy remains the only one
worthy of his trust.

Like the heroes of *The Bourne Identity* and *Casino Royale,* Ethan Hunt experiences
significant emotional turmoil, but does not acquire new skills during the course of the
film. When challenged, Ethan is momentarily shaken but quickly regains his confi-
dence. In spite of his ups and downs, designed to show his emotional responsiveness,
he remains cocky and capable from beginning to end. Tellingly, Ethan's most sig-
nificant insight consists in the realization that the deaths of his team members were
not caused by his incompetence or insubordination—his initial refusal to abort the
mission—but by the utter moral depravity of the team leader Phelps. The only "skill"
Ethan acquires is the ability to separate the wheat from the chaff. Ethan no longer
implicitly trusts everybody on his team. He ferrets out traitors and relies only on those
who deserve his confidence. He quickly disposes of his corrupt new partner Krieger
(Jean Reno), but forms a close bond with the other member of his team, Luther (Ving
Rhames). And the film rewards this transformation with a promotion. In the last
scene, Ethan assumes Phelps's position as the recipient of a mission assignment. The
corrupt father is deposed, the worthy son takes his place. This circular ending, rein-
forced by the dual structure of Claire's fictional (in the beginning) and actual death
(in the end), conveys an ultimately conservative, reassuring message. The structure is
still intact, only the players have changed. Corruption is not systemic but the result
of individual moral failure. Once these individuals are detected and eliminated, order
is restored. There is considerable irony in the fact that at the party in Prague, Ethan
impersonates a Senator named Waltzer, who is introduced as a politician commit-
ted to investigating the Secret Service. In a television interview witnessed by Ethan,
Phelps, and Claire, Waltzer underlines his demand for openness in the Secret Service
with the statement, "Last time I checked we lived in a democracy." The character
of Waltzer is curiously dropped after this interlude, and the film remains undecided
with respect to his politics. Since the Secret Service proves perfectly capable of root-
ing out corruption on its own, viewers may conclude that Waltzer's desire to uncover
the secret workings of the agency is uncalled for and, even worse, likely to endanger
the safety of the country, as his interview partner suggests. On the other hand, we
may also interpret Ethan's impersonation of Waltzer and his subsequent attempts to
capture the mole as the much-needed implementation of Waltzer's ideas. But regard-
less of our interpretation, the problem is not systemic and political but personal and
moral, and the only way to solve it is to rely on Ethan Hunt's exploits.

Mission: Impossible III (MI3) was written by Alex Kurtzman and Roberto Orci,
both highly experienced in the spy genre through their work on the TV series *Alias.*
It is characterized by the same circular structure exhibited in the first film of the
franchise. The opening scene features Ethan tied to a chair unable to prevent the
execution-style murder of his wife. Unlike *MI,* however, which immediately reveals
the staged quality of the scene, director J. J. Abrams, whose TV show *Lost* is known
for its innovative jumbling of chronologies, does not let viewers in on the secret until
the very end, when we learn that, thanks again to the infamous face mask, the villain

is not who we think he is, nor is the woman Ethan's wife. As this scenario suggests, *MI3* is as obsessed with play-acting, roles, and performances as its predecessors. Unlike the first installment of the series, however, number *3* depicts a hero who is about to get married and explores the effects of a performance-based professional identity on Ethan's capacity for intimacy.

The first few scenes of the movie show Ethan interacting with his fiancé, Julia (Michelle Monaghan), and her family and friends. In this private setting, every word out of Ethan's mouth, with the exception of "I love you," is a lie. Still in the service of the agency, Ethan tells everybody, including his future wife, that he works for the Department of Traffic. When he pops out for a quick meeting with his Secret Service contact, he pretends to buy ice. When he is assigned to Berlin to help an agent who has been taken hostage by the evil mastermind of the film, the black market trafficker Owen Davian (Philip Seymour Hoffman), he claims that he is attending a conference on transportation in Houston. As this setup makes amply clear, the central question of *MI3* is no longer in whom one can safely place one's trust, but how to keep the dishonesty and subterfuges of one's profession from destroying the intimacy of one's family. In other words, while *MI1* left the contradictions between Ethan's various identities unresolved, *3* seeks to reconcile the violence of his job with the sensitivity of the new family man. How can Ethan the man and the United States as a nation do what it takes to catch the bad guy and still emerge with his/its humanity intact?

Like *MI1*, number *3* depicts a malfunction in the Secret Service that is not systemic, but rather the responsibility of a single corrupt agent. As in the previous film, the failure of a mission in no way results from an error in judgment on Ethan's part, as Ethan's superior initially believes, but from treachery in the organization. The nature of this corruption, however, differs from that portrayed in the earlier film. Unlike Phelps, who had become unmoored by the agency's loss of power and influence after the end of the Cold War and set his sights on financial gain, Musgrave (Billy Crudup), the villain of *MI3*, is a racist and visionary. Musgrave resents his black superior Theodore Brassel (Laurence Fishburne), whom he derogates as an affirmative action poster boy. The film initially goads viewers to doubt Brassel's integrity, but ultimately vindicates him. By inviting us to assume that Brassel is in cahoots with Davian, the film puts the racial feelings of its audience to the test while establishing its own progressive racial politics.

In portraying a villain who plans to procure intelligence through illegal means in order to start a war, *MI3* alludes to and is critical of the Bush government's infelicitous Iraq War. In spite of his rhetorical flourishes about democracy and the working families of this country, Musgrave's purpose is mostly mercenary since he hopes to gain financially during the process of reconstruction and "nation building" after the war. "When the sand settles, our country will do what it does best, clean up," Musgrave informs Ethan. The double meaning of "cleaning up" as tidying up and making a lot of money is well chosen, and Musgrave's hypocritical proclamations are apt to expose the capitalist underpinnings of the rhetoric of freedom and remind viewers of the highly profitable business ventures of Blackwater and other war entrepreneurs.

Like Musgrave, whose visionary politics evoke the disaster of the Iraq War, the character of Davian is a nod to contemporary politics. Although a Westerner, he is closely associated with Middle Eastern terrorism. Davian not only supplies weapons

and money to Korea and jihad terrorism, but relies on an al Qaeda-style cellular structure to ensure that even those who implement his schemes know next to nothing about his identity and intentions. Still, in spite of these mandatory nods to contemporary threats, *MI3* is ultimately not about foreign terrorists but about corruption at home. In fact, the spies in the film are so busy fighting corruption in their own agency that dealing with actual criminals appears as a mere afterthought. Moreover, even though the film's villain is a mouthpiece of Bush/Rumsfeld ideology, the fictional White House of the film is innocent of all corruption, which remains safely confined to one individual on the lower rungs of the CIA bureaucracy. Unlike the Bush government, the fictional government of *MI3* does not punish whistleblowers, but rewards the fight against corruption, evidenced by the job offer extended to Ethan in honor of his outstanding public service. In the end, the superhuman exploits of our hero save the world and effectively eliminate corruption. Through its idealization of Ethan, the film promotes trust in an exceptional leader at the expense of a more pedestrian system of checks and balances. Paradoxically, though, the superhuman quality of the hero and his far-reaching isolation can also be read as indicative of a larger problem. After all, if it weren't for the fantastic skills of Ethan Hunt, Musgrave would have succeeded in carrying out his evil schemes.

Like its predecessor, *MI3* is fond of literalizing metaphors. Instead of seeing through somebody else's eyes, number *3* explores the concept of voices in your head. In the third installment of the series, friends and enemies are literally in your head. During the failed rescue operation in the beginning, Luther's probing questions about Ethan's impending nuptials are transmitted through a microphone placed in Ethan's ear. When Ethan resents the intrusion, Luther reminds him that, for now, "you are stuck with my voice in your head." Similarly, the explosive device that Davian plants in Ethan's head is both a technological gadget and a metaphor for Davian's ability to exploit Ethan's fears and doubts. Davian's ability to get into Ethan's head is evident when Ethan interrogates the captured Davian and, enraged by Davian's threat to hurt his wife, almost throws his prisoner out of the plane. In the climax of the film, which pits the still wired Ethan against Davian, Ethan's victory depends crucially on his ability to override the alien "voice" in his head.

While *MI2* had already toyed with the potential interchangeability of hero/lover and villain, *MI3* explores this theme in depth.[6] When Ethan confesses to Luther that he is already married to Julia, he is wearing a Davian face mask, which suggests that in marrying Ethan, Julia is insolubly tied to his enemy as well. Consequently, during the climactic rescue scene, the target of the operation shifts from catching the bad guy to saving Ethan's family. In *MI1*, Ethan survives because he can control his feelings. In *MI3*, he is vulnerable because of his feelings—the only way Davian can harm him is through Julia—and he is saved by his feelings. In the end, Julia's love for him and her surprising competence in both caring and killing assure Ethan's survival. The film's facetious answer to the incompatibility of lies and intimacy is to recruit Julia for the war on terror. After she has proven her mettle by competently disposing of Musgrave, the final scene shows Julia at the CIA, hugging Luther and shaking hands with the rest of the team. The hero can be both sensitive and tough, as long as his family is willing to do the same. In this, however, the film suggests a solution that its premise forbids. Ethan loves Julia for her sweetness and innocence. If she joins his

team, she will lose all that he admires in her. It remains to be seen if *MI4* can live up to this ending, or if it will quietly drop the heroine from its roster.

THE WATERBOARDED SPY

The Bourne Identity (2002). Dir. Doug Liman. Writers: Tony Gilroy and W. Blake Heron. Universal Pictures. Domestic Total Gross: $121,661,683. Foreign Gross: $92,372,541. Total Box Office: $214,034,224. Production Budget: $60 million.

The Bourne Ultimatum (2007). Dir. Paul Greengrass. Writers: Tony Gilroy, Scott Z. Burns. Universal Pictures. 3 Academy Awards. Domestic Total Gross: $227,471,070. Foreign Gross: $215,353,068. Total Box Office: $442,824,138. Production Budget: $110 million.

The Bourne Identity explores what happens when you reduce a man to a killing machine. Killing, so the film suggests, is much like riding a bike. Once you've learned how to do it, you never forget. A government special agent trained to assassinate inconvenient political leaders, Jason Bourne has lost all memory of his identity and past life. But even though he lacks the most fundamental self-knowledge, he is extremely skilled at recognizing danger, defending himself, and eliminating potential opponents. Bourne's survival skills are the result of gut reactions, not conscious deliberation. His killing is that of a machine: fast, efficient, practiced. His machinelike status is also evident in the chip implanted under his skin. The only information it contains is an account number and the name of a bank. Jason Bourne is a cipher with money, the ultimate perversion of the corporate man who has to give his all, body and soul, to the company that controls him. As his boss tells him in the final confrontation, he is U.S. government property, a thirty-million-dollar weapon designed to remain invisible: "I send you because you don't exist."

Unlike the 1988 television production of *The Bourne Identity* starring Richard Chamberlain, the big screen version emphasizes the theme of new beginnings and portrays its hero as a martial idiot savant. Unlike Chamberlain's Bourne, who is not only older but also covered with scars and battle wounds, Matt Damon's Bourne is a blank slate in every respect but his fighting skills. Chamberlain's Bourne has a past, and his body is a living testimony to his extensive professional activities. His Bourne has been in the business of killing for quite a while. In contrast, Damon's Jason Bourne is a youngster whose lack of history connotes innocence amid corruption. Damon's star quality based on his portrayal of a similar combination of hypercompetence and arrested development in *Good Will Hunting* (1997) reinforces this image.

Like many other films of the period, *The Bourne Identity* is a story of remasculinization. When we first meet Jason Bourne, he is unconscious, wounded, and helpless. Two bullets are stuck in his back, and his exhaustion is so extreme that he faints during medical treatment. The hero's masculinity has been shattered and is in dire need of being reborn, as the pun in his name and the film's title makes amply clear. To emphasize the theme of rebirth, the film first shows Bourne as a body floating in the ocean, like a baby in the womb. Bourne is pronounced dead by one of the

sailors who fish him out of the water, and the rest of the film is about Bourne's new lease on life.

Through its emphasis on Bourne's amnesia, the film suggests an interesting conceptualization of violence. Violence is a reflex. It is not paired with self-awareness but springs from its lack. As long as Bourne does not know who he is, he has to resort to violence. This is true in the most literal sense when Bourne, who is sleeping on a park bench like a homeless person, is awakened by Swiss policemen. The policemen ask for his papers, and Bourne responds by beating them up. Both the filming and acting style of the fight scenes emphasize that Bourne's conscious mind is not involved.[7] As Robin Wood points out, the editing of these sequences is frenetic. "No shot lasts more than a second or two; we never see even the semblance of a punch actually landing" (xxxi). The absence of intent and deliberation are also conveyed by Matt Damon's acting style. His eyes turn blank, his body becomes autonomous, instincts and training take over. Bourne's expression does not betray emotional involvement of any kind, neither determined courage nor rage. He fights not because he wants to survive, but because he needs to solve the mystery of his identity.

Like *Mission: Impossible, The Bourne Identity* explores the twin fantasies of paranoia and omnipotence. Jason Bourne has the entire world against him. Every time he makes a phone call, uses his credit card, or enters a public building, he risks detection and death. But while the stakes are high, so are the spy's abilities. Jason Bourne climbs like a cat and fights like a super ninja. In the showdown, he shoots one of his opponents while plummeting down a staircase and using another body to cushion his fall. Bourne also has a photographic memory and speaks multiple languages fluently. And he is in dire need of such superhuman qualities since he deals not with a single opponent in the manner of Batman vs. the Joker or James Bond vs. Dr. No, but rather an entire government organization, its infinite technological resources, and its army of henchmen. To take him out, Operation Treadstone, the unit that trained him, sends several assassins and an entire SWAT team. Still, Bourne prevails. However, when asked the simplest question about himself, such as what music he likes, he cannot answer. The film emphasizes the loss of identity through the frequent use of mirrors, reflecting surfaces, and through mise-en-scène. Bourne's apartment lacks the most basic personal touch. A row of near identical suits hangs in the closet in neat two-inch intervals. Everything he owns is expensive and nondescript. Bourne has no friends, not even acquaintances. On the basis of everything we know about him, we assume that it is not only his amnesia that prompts him to tell Marie (Franka Potente) that she is the only person he knows.

In other words, Jason Bourne has suffered the fate that Ethan Hunt seeks to avoid in the third installment of the *Mission: Impossible* franchise. In acquiring his extraordinary professional competence, Bourne has lost his soul and the ability to relate to others—though not completely. Since he is so supremely skilled, the audience must assume that he failed to assassinate his target, the African dictator Wombosi (Adewale Akinnuoye-Agbaje), because of a sudden onset of conscience. Indeed, a flashback, a precious glimpse into Bourne's otherwise opaque internal processes, reveals that our hero hesitated when he saw children in the room with Wombosi. While *MI3* enlists the family in the war on terror, Bourne resigns from the war and opts for family. Tellingly, during the first half of the film, Bourne is constantly given guns, which he

immediately discards. An unwilling executioner, Jason Bourne is a victim himself, a governmental guinea pig. When in training, he was administered drugs to increase alertness. As a result, he now suffers from periodic headaches. *The Bourne Identity* asks us to accept as credible the character of a hit man who has remained innocent at heart. The film never explores Jason's complicity in any depth and never explains why he signed up for an assassination program to begin with. In *MI3,* the war on terror is a jolly family enterprise. In *The Bourne Identity,* those who employ questionable methods to eliminate foreign threats are themselves hapless victims of a nefarious government conspiracy.

Like *Grosse Pointe Blank* (1997), *The Bourne Identity* is a love story involving a hit man and a female ingénue. Unlike *Grosse Pointe Blank,* however, *The Bourne Identity* is not a parody. Rather, the film's celebration of innocence is reinforced through its female lead, Marie, portrayed by Franka Potente, who shot to stardom through her role in *Run Lola Run* (1998). Even more than Jason Bourne himself, the character of Marie deviates from its television predecessor. While Richard Chamberlain's Jason Bourne is paired with a highly educated doctor of economics, who is affiliated with the Canadian treasury and capable of saving her man when he loses a fight, Marie is a female drifter, a wild child, and a huge liability in any fight. But Marie's trusting and open personality also allows Bourne to relax and ultimately recover his identity. Even a killing machine, when paired up with the right girl, is capable of intimacy and commitment. Like Jason's rebirth, the story of Jason and Marie's love is that of a mythical beginning. Utterly cut off from every other human contact, they rely only on each other.

Like most spy thrillers, *The Bourne Identity* is centrally concerned with power and corruption. It develops the traditional theme of a secret service within the secret service designed to take care of missions too criminal in nature to be officially associated with any legitimate form of government. But again, because the abuse can be laid at the door of a rebel agent, whose superiors remain blissfully unaware of his clandestine operations, corruption does not reach into the highest echelons of political power—though the clearance level of the rogue agent in *The Bourne Identity* exceeds that of his *Mission: Impossible* colleague by several pay grades. To the post-9/11 audience, the assassins of *The Bourne Identity* bear an uncanny resemblance to the Special Access Program (SAP) created by former secretary of defense Donald Rumsfeld (Mayer 243). SAP, "Rumsfeld's answer to the CIA death squads envisioned by Cofer Black" (Mayer 243), was run out of a secret office. Its members had aliases, unmarked clothing, and advance authorization to use lethal force. Of course, in the world of *The Bourne Identity* corruption does not go unpunished. As soon as Jason Bourne recognizes the moral abyss embodied by Operation Treadstone, he turns against the system. Still, in its willingness to depict the CIA as an organization that trains killers, Liman's film proves more radical than many popular films of the period, including the earlier treatment for television. In the TV film, Treadstone was created to catch assassins, not to produce them.

Interestingly, *The Bourne Identity* undermines its own happy ending. On the one hand, conscience prevails, corrupt power fails, and Bourne retires to an island paradise. Seen in this light, Bourne's superiority can be read as a testimony to the superiority of the service and the nation that trained him, while his willingness to

fight corrupt authorities speaks to an unbroken belief in the essential goodness of the average American. This rosy outlook, however, is undermined by the fact that the head of Treadstone, portrayed by Chris Cooper, is not killed by Bourne in an act of self-defense—as the genre demands—but ordered assassinated by his superior. Here, corruption is not rooted out, but merely redirected. However, while the film maintains its critical outlook on power, it is also subtended by the fantasy that Jason can develop his moral, tender side without losing any of his competence as a killing machine. Although a trained assassin, all of Jason's acts of violence are motivated either as self-defense or defense of women and children. Unlike *Mission: Impossible, The Bourne Identity* does not even ask whether sensitivity and toughness might be mutually exclusive. Rather, they are two sides of the same coin, different manifestations of the drive to protect one's home, family, and country.

While *The Bourne Identity* focuses on the corrupt actions of several rogue players in the CIA, *The Bourne Ultimatum* portrays corruption as a systemic problem. We are no longer dealing with one section chief who interprets the law too freely, but rather with an entire organization within the CIA. Under the code name Blackbriar, the antiterrorism bureau directs all black ops, including rendition, "experimental interrogation," and lethal action without any red tape or parliamentary supervision. The film emphasizes the wide reach and ruthlessness of *Blackbriar*. The fast-paced change of location, from Moscow to Turin to London to New York and back, conveys the sense of an omnipresent force, whose tentacles reach into every corner of the globe. Similarly, the extensive use of aerial shots of city segments juxtaposed with the corresponding grid on a map as it is viewed in the CIA headquarters, the frequent shots of CCTV cameras in public locations, and the constant references to recordings of intercepted phone calls serve to highlight the agency's omnipotence. The victimization of innocent bystanders and the determination of Noah Vohsen (David Strathairn), Blackbriar's director, to kill anybody who threatens the smooth execution of his black ops underline the agency's lawlessness. The film's critique of these methods is profound and radical. Vohsen, in particular, is portrayed as a semicompetent individual whose unconstitutional power leads to impulsive, split-second decisions over who lives and who dies.

While *The Bourne Identity* does not ask what a nice guy like Bourne is doing in an assassination program, *The Bourne Ultimatum* traces the origin of Treadstone and Bourne's initiation into the program through the extensive use of washed-out flashbacks. The film's representation of the antiterrorism bureau remains one-dimensional since the only threat we see is not external but posed by the agency itself. In contrast, the portrayal of Bourne is contradictory. On the one hand, we are told that Bourne volunteered for service and that he was informed about the specifics of the program for which he eagerly signed up. "We didn't pick you, you picked us," he is told by Dr. Hirsch (Albert Finney), the CIA physician, cast in the mold of a Nazi doctor, who supervised his training. On the other hand, Bourne's files document that he resisted the training, that he was lied to, and that the agency exploited the innocence and patriotism of a young, idealistic soldier from the heartland—originally named David Webb, Bourne is, of course, from Missouri. To the insistently repeated question "Will you commit to this program," Bourne responds, "I can't." "You will save American lives" is the refrain that turns Bourne into an assassin.

While the representation of the assassin as victim is potentially problematic, the film's portrayal of torture is positively deceptive. In flashbacks of his training, Bourne is hooded and waterboarded. The images are clearly designed to evoke the treatment of Iraqi prisoners at Abu Ghraib and of terrorism suspects in general. By substituting a traumatized U.S. soldier for Arab prisoners, the film implies that the real victims of a failed U.S. foreign policy are not situated abroad but at home: well-meaning Americans who were manipulated and tricked into unethical behavior. This impression is reinforced through repeated shots of the Blackbriar documents, which feature multiple files, each containing a mug shot next to the lines "American citizen, terminated."

It would appear that *The Bourne Ultimatum* is able to represent systemic corruption in the U.S. government because it simultaneously suggests that the average American citizen is in no way complicit or responsible, but rather the prime victim of these political machinations. And yet, there is one important narrative feature that troubles such a reading. Tellingly, the flashbacks Bourne experiences focus on his resistance to the program. But when he finally comes face to face with Dr. Hirsch during the climax of the film, Hirsch confronts him with a reminder of his own complicity: "We didn't pick you, you picked us." Here, complicity emerges as the core of Bourne's amnesia. It is his own willingness to participate in Hirsch's criminal operation that Bourne had to erase from his memory. We can read this as an allusion to the forgetfulness of the American people, who voted for Bush not once, but twice. But we can also choose to ignore it and focus on the very last shot of the film, a direct citation of the first shots of *The Bourne Identity*. Again, Bourne is floating in the water; again, he is ready to be reborn to a new identity, an embodiment of the American dream of starting all over again.

COLD WAR DINOSAURS AND KILLERS WITH A SOUL

The World Is Not Enough (1999). Dir. Michael Apted. Writers: Neil Purvis, Robert Wade. MGM, United Artists. Domestic Total Gross: $126,943,684. Foreign Gross: $234,888,716. Total Box Office: $361,832,400. Production Budget: $135 million.

Casino Royale (2006). Dir. Martin Campbell. Writers: Neil Purvis, Robert Wade. MGM. Domestic Total Gross: $167,445,960. Foreign Gross: $426,793,106. Total Box Office: $594,239,066. Production Budget: $150 million.

The World Is Not Enough is the last Bond film of the Clinton presidency and the third to feature Pierce Brosnan as James Bond. Unlike Sean Connery, who was known for hard-edged masculinity and suave snobbery combined with callous violence,[8] and unlike Roger Moore, who is identified with a campy, self-mocking style of performance that undermined the series' derring-do, Pierce Brosnan combined traditional masculinity with hints of a new-man sensibility. Since Timothy Dalton's short-lived departure from the Bond formula proved only moderately successful at the box office, the Brosnan films sought a middle ground.[9] Brosnan's acting style is slicker and more light-hearted than that of Dalton, his character's mastery of technology superior to

that of all his predecessors, and his treatment of the fair sex seeks to shed some of the franchise's chauvinistic heritage.[10] Once more, Eon Productions sought to update a hero who, from his inception, was threatened with obsolescence.

Although the Brosnan Bond films deserve credit for updating a franchise that was no longer in tune with the spirit of the times,[11] they are by no means the first to modify the central character to suit the needs of the present.[12] From the beginning of the series in the 1960s, Bond was denounced as sexist and passé, and the challenge to make him right for his time not only accompanied the franchise from day one but constitutes one of its major attractions. Much as Bond was always already a dinosaur, he was also always already a chameleon, "a floating cultural icon, who is continually reconfigured and repositioned in the face of social change" (Lindner, "Introduction" 3). Several scholars have argued that the Bond of the 1960s was not a throwback, but perfectly in tune with the countercultural, consumerist spirit of the '60s. The series' emphasis on glossy visuals and high production values and its representation of casual sex and conspicuous consumption were more in line with the values of Swinging Britain than many other genres, including the war film and the Western (see Chapman, *License* 71).

While Bond has always functioned as an icon of masculinity—in Kingsley Amis's words, "We don't want to have Bond to dinner or go golfing with Bond or talk to Bond. We want to be Bond" (qtd. in *The James Bond Phenomenon* 169)—he has also held considerable attraction for women. Scholars have claimed that the 1960s female audience saw in Bond's sexual license a welcome alternative to the restrictive gender roles of their time. Bond promises sexual fulfillment and freedom. Some have even suggested that Bond occupies a place outside of patriarchy. According to Toby Miller, "Bond offers transcendence from the bonds of origin via a form of life that uses commodities and sex to go beyond, to another place, and then moves on, without any drive toward accumulating power and authority . . . He is the drifter in a tux . . . who never stays in one place long enough to adopt the mantle of patriarchy through its trappings of soil, blood, and home" (239). Though any reading of Bond as a proponent of women's lib seems highly inflated, Bond films strive to remain attuned to the cultural mood of their time, and the Brosnan films are no exception. They deliberately cite stereotypes associated with the brand—Bond's male chauvinism and the Cold War heritage of the franchise—in order to refute them.

One of the most conspicuous changes implemented in the Brosnan era is the concerted effort to modernize the series' gender politics. Bond now has a female boss (Judi Dench) who calls him a "sexist, misogynist dinosaur" to his face, and an assistant who discusses sexual harassment. When he joined the Bond franchise, Brosnan was known through his starring role on *Remington Steele* (1982–87), a television series built on a feminist plotline, namely the premise that a talented female PI has to invent a male figurehead in order to get work. As the Brosnan character comes to impersonate this fictional boss, his female partner constantly finds herself in a situation where she does all the work and he gets all the credit. The Bond franchise banks on Brosnan's proven screen compatibility with strong female leads by pairing him with a Bond girl who is not an unknown starlet, but a major star in her own right.[13] From Hong Kong action star Michelle Yeoh to Academy Award winner Halle Berry,

Bond heroines now hold their own. Moreover, as the casting of a black and Asian female lead indicates, Brosnan's Bond films also seek to distance themselves from the series' (and the novels') xenophobic and even racist past.

In spite of all these changes, however, Bond still remains Mr. Kiss Kiss Bang Bang. Brosnan's Bond is fond of gadgets and he never refrains from a quip. The films are overloaded with fast-paced chase scenes and explosions, whose "kinetic style ... disguises the absence of narrative logic" (Chapman, *License* 58). They continue the tradition of visual excess and high production values, elaborate sets, and fondness for exotic locales and for the display of luxury items associated with the franchise. During Brosnan's tenure, the practice of product placements was carried to such extremes that *Die Another Day* was mocked as *Buy Another Day* (Hagopian 41): "BMW received 10,000 advance orders for the Z3 roadster when *GoldenEye* was released" (Stock 220). Finally, like Connery and Moore's funny one-liners, Brosnan's relentless punning provided the Bond audience with the familiar self-parodic, tongue-in-cheek style that allows for the suspension of disbelief required by Bond's outrageous stunts and superhuman exploits.[14] Bond films possess what Spicer refers to as "self-protective irony. Audiences are invited to recognize the fabrication, but also to emotionally endorse the sentiment, to 'love the lie'" ("Reluctance to Commit" 78). Thus, in *Goldfinger*, Sean Connery takes off his diving suit and emerges fully clothed in elegant evening attire, while in *The World Is Not Enough*, Brosnan adjusts his tie while submerged under water and lands perfectly coiffed in an unwrinkled suit after a daredevil descent from the twentieth floor.

Designed to reconcile contradictory demands, the Brosnan Bond emerges as a curious mixture of the traditional and the modern. Bond's effort at politically correct gender politics does not prevent him from liberally dispensing sexually suggestive double entendres, from sleeping with a female doctor to secure medical clearance, or from using his X-ray glasses to inspect both concealed guns and girdles. The film simultaneously endorses and undermines his bravado. When Bond answers the query of a female accountant, "Would you like to check my figures," with "I'm sure they're perfectly rounded," viewers see her raise an eyebrow in disgusted disapproval. Similarly, when he hands out a cigar to Moneypenny in coy imitation of the then scandal-plagued leader of the free world, Moneypenny tosses this little phallic symbol straight into the trashcan.

The uneasy blend of old and new produces narrative inconsistencies, which, however, are easily ignored amid a wealth of explosions and chase scenes. Unsurprisingly, the most blatant paradox concerns the hero's love affairs. On the one hand, the film insists that Bond is a man of deep feelings, both tender and caring, and uses the female lead to prove its point. Deviating from the Bond girl mold, Elektra King, played by the French star Sophie Marceau, is rich, strong, daring, even foolhardy, and given to vaguely feminist proclamations about reclaiming the kingdom that her father took away from her mother.[15] The film uses the Bond/Elektra pairing to prove Bond's capacity for intimacy and his compatibility with strong women. To drive home the point, the film contrasts Bond, a man of feeling, with the villain Renard (Robert Carlyle), who, because of a brain injury, literally cannot feel anything. Given the suggested depth of commitment on Bond's part, one might reasonably wonder why Bond, upon learning that Elektra is not the vulnerable victim of a kidnapping

but a conniving criminal and Renard's lover, has so little trouble in dispatching her with a gun and a pun. "You'll miss me," she says. "I never miss," he replies as he pulls the trigger and moves on to the next Bond girl, a nuclear physicist with the captivating name of Christmas Jones (Denise Richards). Though the film makes an effort to portray an emotional struggle, the fact that Bond makes out with Dr. Jones some ten minutes after killing Elektra renders the pretense of a deep emotional connection rather unconvincing. Clearly, *The World Is Not Enough* tries to have it both ways. It seeks to portray true love and to present Bond as a great lover, but it also refuses to implement significant changes to the proven three-girl formula of the typical Bond vehicle. As the producer Cubby Broccoli instructed Roald Dahl in 1967, when the latter wrote the script for *You Only Live Twice,*

> So you put in three girls. No more and no less. Girl number one is violently pro-Bond... Girl number two is anti-Bond. She works for the enemy and stays around throughout the middle third of the picture... The girl should also be bumped off, preferably in an original fashion.... Girl number three is violently pro-Bond. She occupies the final third of the picture, and she must on no account be killed.
>
> (qtd. in Bennett and Woollacott, *Beyond Bond* 157–8)

If we count the female doctor who provides medical clearance for sex as girl number one, then *The World Is Not Enough* still works with the traditional Bond formula. Moreover, continuing this muddle of old and new, girl number three is herself a walking paradox. To be fair, her name, Dr. Christmas Jones, constitutes a distinct improvement over Pussy Galore and Kissy Suzuki, although it hardly connotes experience in nuclear physics. However, any budding notion of her professional competence is immediately doused by her playboy bunny looks and skimpy T-shirt.[16]

The film's uneasy combination of modernization and traditionalism is also evident in its treatment of M. In some respects, M is portrayed as a no-nonsense, we-do-not-negotiate-with-terrorists leader, and Judi Dench's dignified screen presence assures that we take the character seriously. And yet, the narrative is set up to undermine her authority. M is a dupe who, unlike Bond, falls for Elektra's charade of the innocent victim. She is also hopelessly inept in the field, where she, too clumsy to effect her own release, finds herself a captive in a cage.[17] One is almost grateful that Bond has the good grace to rebel against her authority since this provides a welcome reminder that she has got any.

It should come as no surprise that the film's political messages are as muddled as its gender politics. Renard, the arch villain, is a former KGB agent turned freelance terrorist. Truly committed to his chosen profession, Renard opts for an ambitious, nondiscriminating approach to his field of action. He has been active in Korea, Iran, Iraq, Bosnia, and Afghanistan. Renard's "only goal is chaos," we are told, and his politics are vaguely anticapitalist. Renard is the quintessential catch-all terrorist. He is not beholden to any particular philosophy, nor is he associated with any specific organization. Rather, his ideology might simply be summarized as "very bad."[18]

In spite of its ostensible nod to modern gender roles and new male sensitivity, the Bond of *The World Is Not Enough* is essentially static. He knows who he is, and though it may take him some time to sort out the evidence, he also knows whom to trust.

He does not possess the martyred body of the 1980s action heroes, but emerges from all his adventures with nary a scratch. Essentially, this Bond is stirred, not shaken. Tellingly, the next and last of the Brosnan Bonds, *Die Another Day* (2002), exhibited a keen awareness that further changes were needed. But even the new and improved Bond of *Die Another Day* is plagued with the same contradictions that afflicted his predecessors. *Die Another Day* prefigures many of the changes that were fully implemented in *Casino Royale,* but it tries to do so without upsetting the formula. The film updates its politics by shifting the action from the former Soviet Union to the "axis of evil," in this case North Korea. In *Die Another Day,* Bond has to prove his brawn in an extended process of de- and remasculinization. *The World Is Not Enough* shows Bond in a perfectly tailored suit for about 90 percent of the film, whereas *Die Another Day* partially undresses its hero and features a torture scene. Bond is beaten, waterboarded, and abandoned by his own people. When he is returned to his country, his double-O status is rescinded. Furthermore, Bond is paired with Halle Berry, who is not just a strong woman but a Bondette, a female version of Bond, who accompanies her kills with puns and whose relationships do not seem to last. And yet, in spite of its attempt to respond to the politics of its day and to revamp its gender roles even more radically than before, *Die Another Day* obsessively revisits the threatening obsolescence of its hero. Repeatedly and explicitly, the film asks whether Bond is still useful to anybody, only to confirm that, yes, of course, he is. Like *The World Is Not Enough, Die Another Day* ultimately fails to break free from the Bond format. Bond may undergo torture, but he still orders a Bollinger the minute he is released from captivity. The Bond girl may be a Bondette, but the film still presents her in the traditional bikini sequence. A drastic reconfiguration of the Bond heritage was not effected until the arrival of the next Bond, Daniel Craig.

 Casino Royale and *Quantum of Solace* (2008) are the latest products of what has been referred to as "the most enduring and successful film franchise in history" (Black xi). *Casino Royale,* in particular, marked a spectacular box-office success. Adjusted for inflation, the film outearned every Bond movie since *Moonraker* (1979; see Packer, "Many Beyonds" 6). It also constitutes the most intriguing attempt to redefine and lend emotional urgency to the Bond character since Timothy Dalton's short-lived tenure as Bond. Whereas all previous incarnations of Bond killed their opponents without explanation or remorse, *Casino Royale* psychologizes and contextualizes its hero's casual attitude toward sex and violence. While Sean Connery, Roger Moore, and Pierce Brosnan followed their kills with one-liners instead of moral deliberations, *Casino Royale* makes tentative forays into introspection and ethics. While most Bond films flaunt their excess and lend an ironic dimension to their heroes' exploits, *Casino Royale* strives for realism and does not shy away from showing the grueling demands on its hero's body and endurance. Unlike Brosnan's Bond, this Bond bleeds. Craig's Bond is closer to the Byronic hero of the original Fleming books (see Bennett and Woollacott, *Beyond Bond* 57) than most of his predecessors, although he is less of a melancholy loner than a grim avenger.

 Casino Royale is based on Ian Fleming's first Bond book (1952)[19] and bore the appropriate working title *Bond Begins.* The film introduces us to a Bond who is about to acquire double-O status and highlights the emotional scars he suffers in the process. In other words, this Bond has to acquire his license to kill, and since this

is Daniel Craig's introduction to the franchise, he also has to acquire his license to thrill. Interestingly, the first kill of the Craig Bond is fundamentally different from the agent's usual modus operandi. In this scene of initiation, Bond has no gadgets, no weapons, and no quips at his disposal. Rather, killing is manual labor of the most sordid type. To drive the point home, the scene is shot in stark black and white, takes place in a toilet in view of the urinals, and, most importantly, is presented as flashback. Daniel Craig is the first Bond who is granted flashbacks, and all that is associated with this cinematic device: an inner life, memory, and even self-reflective capacities.[20] Instead of, or rather in addition to, the traditional but greatly reduced one-liners and wisecracks, we are treated to rare moments of introspection. As the flashback indicates and the movie bears out, this Bond has a soul, and his soul forms the prerequisite for a plotline in which Bond learns to love and to regret having loved.

Historically, the need to modify the parameters of Bond's world has often played out as a simple political update. Conceived by Ian Fleming at a time when Britain still had an empire and the defeat of the Nazis was not yet a distant memory, Bond soon developed into a Cold War hero. Later, in keeping with the times, Communism was abandoned in favor of independent terrorist agents, and SPECTRE, an international terrorist organization, replaced SMERSH, Fleming's Soviet counterintelligence agency. In *Casino Royale,* the film's arch villain Le Chiffre, whom Fleming conceived as a Soviet agent who embezzled funds of the French Communist party, has become an international financier and private banker to the world's terrorists. Conversely, his executioner is no longer an agent of SMERSH but a shadowy figure who might as well be working for SPECTRE. In keeping with Fleming's tradition of featuring disfigured or ethnically marked villains (see Eco 38–39), the criminal players of *Casino Royale* bear the physical emblems of their moral corruption—Le Chiffre has a malfunction of the tear ducts and Le Chiffre's helper, an African terrorist, has facial burns—and they still traffic in weapons, drugs, or diamonds. But the geographical focus of the action has now moved away from the successor states of the Soviet Union to developing countries. *Casino Royale* not only partakes of this shift in scenery but highlights it. Its first few scenes are set in Prague and evoke film noir aesthetics and a Cold War atmosphere, a nostalgic reminder of Bond's past. The subsequent assignment takes him to Uganda, where he is paired off with third world villains for hire. And yet, although the film updates Fleming's politics, it does little to revamp the racist and xenophobic underpinnings of his stories. Le Chiffre has an Albanian background, his right-hand man is Alex Dimitrios (Simon Abkarian), a shady Greek, and viewers are treated to a scene with machete-wielding African gangsters who threaten to cut off the arm of a blond, white woman.

The film's initial sequence in Uganda, which features a confrontation between Bond and an African scoundrel, speaks directly to our current debates on terrorism. After a spellbinding chase sequence, in which Bond climbs cranes, bulldozers entire buildings, and jumps impossible distances, our man finally catches up with his opponent on the grounds of an embassy. Defying all rules of international diplomacy, Bond shoots his opponent execution-style and destroys the entire embassy in the process. In a manner reminiscent of the proverbial ticking-bomb dilemma, the film then shows that the villain carried a bomb in his backpack and thus suggests that Bond's actions are justified. After all, Bond gets the job done. Viewers are led to assume

that the terrorist would have gone free if Bond had followed acknowledged rules of engagement. Thus, *Casino Royale* embraces the freedom from "red tape" that *The Bourne Ultimatum* goes out of its way to denigrate. And yet, *Casino Royale* is anything but ideologically consistent. The film abounds with allusions to terrorism. The driver of a truck loaded with a bomb is vaguely Arab-looking; there are sequences with panicking crowds, and we are informed that the organization Bond is fighting had a hand in the shorting of stock on the day before 9/11. In spite of such topicality, however, Le Chiffre and his consorts are not Muslim fanatics but mercenaries. *Casino Royale* erases the political dimension of terrorism and replaces ideological conflicts with one simple signifier: money. Characteristically, Le Chiffre's goal is the manipulation of the stock markets. He engaged the henchman whom Bond fights in the initial scenes in Africa to blow up the prototype of a new plane so he could make a killing when the aircraft company's stock plummets. Similarly, in the absence of any information to the contrary, viewers assume that the African and Arab terrorists who work for Le Chiffre are also motivated by greed. Even the mysterious organization behind Le Chiffre is directed by a mastermind who is clearly a Westerner and displays all the trappings of economic success. In sum, *Casino Royale* traces all terrorist ideologies and motivations to one original source, greed, and suggests that Bond's extralegal actions provide an ideal tool for dealing with terrorist threats.

While the political stance of this latest Bond venture is somewhat confused, its portrayal of masculinity is well thought out and highly consistent. Above all, *Casino Royale* is a story of remasculinization. Surprisingly, although the popular notion of Bond suggests otherwise, Craig's Bond is ideally suited for such a narrative. The new Bond is a paradoxical hero who embodies both hypermasculinity and vulnerability. In keeping with tradition, Craig's Bond is all but omnipotent. He anticipates his enemies' every move and excels physically and intellectually. He is a computer wiz, a master of technology, and highly knowledgeable in affairs of the world. Like every Bond before him, Craig's Bond is a male fantasy, a hero who defeats all opponents and beds every attractive woman in sight. The axiom "Any time, James. Any place," in the memorable words of the blonde physiotherapist in *Thunderball* (1965), still holds true for Craig's Bond.

At first glance, Bond, who, in a scathing review of *Dr. No* by Paul Johnson written for the *New Statesman,* was once described as possessing "the sadism of a school-boy bully, the mechanical, two-dimensional sex-longings of a frustrated adolescent, and the crude snob-cravings of a suburban adult" (qtd. in Black 30), is not an obvious candidate for effeminacy. And yet, as one of many double-O agents, Bond is a hero whose singularity is highly contested. While M still appeared to appreciate the rare value of Brosnan's Bond, whom she repeatedly calls our best man, she tells Craig's Bond in no uncertain terms that he is expendable. Moreover, while Bond the character is being reminded of his status as one of many, the publicity surrounding Brosnan's replacement showed that the Bond-actor is nearly as expendable as Bond girls number one and two. If he grows too old, too difficult, and does not perform at the box office, he is likely to be replaced by a younger model. In a clever marketing move, the plot of *Casino Royale* exploits the heated public debate whether the new guy was right for the part that preceded the release of the film. In the film itself as well as in the publicity surrounding it, viewers are introduced to a Bond who has to prove that he has

the balls to play the part. Since the casting and box-office performance of Bond are greatly influenced by youth and looks, the modern Bond has become a sex symbol, much like the Bond girl, and is subject to the objectification implied by this status. Tellingly, one of the most prominent film stills used to advertise *Casino Royale* showed Craig in swim trunks, his body glistening as he emerges from the ocean (Fig 6.2).

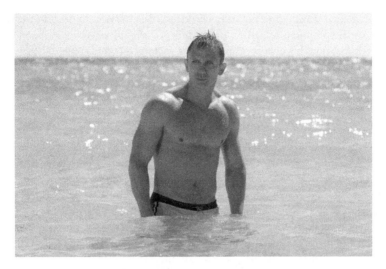

Figure 6.2 Who's the Bond Girl Now? James Bond (Daniel Craig). Courtesy of Photofest, Inc.

Finally, Bond's masculinity is also undermined by his fondness for conspicuous consumption, which threatens to reduce the character to an accessory of his own gadgets. It is not accidental that Craig's Bond, whose status appears much more unstable than that of his immediate predecessor, does not rely on gadgets but makes use of whatever is lying around. While Brosnan's Bond combined clever improvisation with high-tech gadgetry, the Craig Bond underlines his manliness through raw spontaneity. While Pierce Brosnan developed lucrative sidelines selling watches, cars, and other high-end consumer products, Craig's Bond, who also sports an omega watch, takes swipes at his own accessories to avoid any misgivings.

In the course of the film, Bond goes from being hit in the balls in an excruciating torture scene to carrying the phallus proudly. Although the Bond series is no stranger to castration anxiety (Chapman, *License* 104)—one need only think of Sean Connery's close encounter with a laser in *Goldfinger* (1964)—*Casino Royale* is the first to undress its hero completely and explicitly address the threat to his genitals. The scene of abjection is fully recuperated in the final shot of the film, which shows Bond holding up an outsized gun while introducing himself with the classic lines: "The name is Bond, James Bond." Craig's Bond, who is the most sensitive of the lot and the one with the biggest gun, is a classic example of the "eminently heroic and eminently vulnerable man of the post 9–11 era" (Malin, "American Masculinity" 146). A full-fledged proponent of Bush's war on terror and its extralegal methods, this Bond has arrived in the new era in a way that Brosnan's Bond, to his credit, never could.

While the scenes of torture and triumph are particularly apt to highlight Bond's remasculinization,[21] the theme is played out on many different levels. Bond starts out as "a blunt instrument," M's designation for her subordinate, but emerges as a powerful, independent agent. Continuing the tradition of the Brosnan films, *Casino Royale* gives Bond a female boss to modernize his status as a Cold War relic. But like its predecessors, the film then proceeds to undermine the agent-director hierarchy in fundamental ways. Bond not only breaks into M's apartment, he also hacks into her personal computer. When M orders him to take an extended vacation, Bond effectively becomes his own boss and pursues his mission on his own. He determines the course of action and M follows his lead. Furthermore, Craig's Bond is no longer a sophisticated connoisseur of wine and food who dresses stylishly and combines snobbery with violence. Instead of suits, Craig's Bond wears polo shirts. Instead of posing as a nuclear physicist, he pretends to be a valet. While Brosnan's Bond exhibited the classlessness associated with all previous Bond incarnations, *Casino Royale* avoids any association with the effete upper classes. This Bond is characterized not by casual superiority but by carefully controlled resentment. He is an upstart with a rough edge who wears the wrong dinner jacket and does not give a damn whether his Martini is stirred or shaken. In fact, he invents his own drink. Unlike Sean Connery, Roger Moore, and Pierce Brosnan, who hardly ever broke a sweat while killing and only rarely shed a drop of blood, Craig's Bond suffers significant physical abuse. It is not only the torture scene that highlights the vulnerability of his body. Throughout the film, Bond's stunts are not smooth and elegant but rough and noticeably painful. Repeatedly, Bond's face is covered in blood. When he jumps from a crane onto a building in the initial Parkour-style chase scene, the viewer is made to feel the impact through crushing sound effects. Tellingly, the setting for one of Bond's kills is Gunther van Hagen's *Body World,* an exhibition that features corpses donated to the artist and prepared in formaldehyde to provide visitors with sensational lessons in anatomy. Like von Hagen's exhibits, Craig's Bond is marked by the mortality of his body. But this vulnerability only serves to underscore his ultimate triumph.

Like *Mission: Impossible, Casino Royale* defines masculinity as the ability to hide emotions. The story of how Bond begins is the story of how Bond lost his feelings. Unlike the Brosnan films, *Casino Royale* effects a decisive break with the Bond girl formula. The credit sequence features no women in various states of undress. There is no girl number one, and Bond does not sleep with girl number two. His interest in her is motivated solely by his dedication to the job at hand, and he abandons her without consummating the act the minute he has the required information. Finally, and most importantly, Bond's relation to girl number three (Eva Green) is convincing in its portrayal of deeply felt emotion, but she betrays him and has the good grace to commit suicide in careful consideration of the need for a sequel. *Casino Royale* tells the story of Bond as a novel of development. First Bond learns to kill without emotion, then he learns to love, and, finally, he learns to live without love. Appropriately enough, the central metaphor of the film, introduced in the title sequence, is the game of poker in which bluffing, that is, hiding your true feelings, is the crucial skill. You play or your opponent plays you. If you show emotions, you lose.

A true blockbuster, *Casino Royale* knows how to have its cake and eat it too. By presenting Bond as a man who longs to live his feelings and preserve his soul, it makes

the character likable and relatable. Bond has all it takes to be a sensitive new man, but the times are out of joint and call for a more traditional type. In the end, Bond proudly holds a big gun ready to fight organized crime and Bush's war on terror. The Bond franchise has arrived in the post-9/11 era.

KILLING ME SOFTLY

The spy film of the 1990s and 2000s represents a subgenre of the action movie, which rose to prominence during the 1980s (Powrie/Davies/Babington 3). As such, it shares the genre's penchant for blatant omnipotence fantasies and allows its (male) viewers the pleasure of "substitute mastery" (Jeffords, *Hard Bodies* 26). As these readings show, the action heroes of the Clinton and Bush era have lost none of the prowess of their Reagan era predecessors, even though they differ from their filmic relatives in significant ways. Ethan Hunt, Jason Bourne, and James Bond do not show any of the signs of the "hysterical" excess that marked the action hero of the *Lethal Weapon* series or of the status deprivation that powered the angry white man of the *Die Hard* films. This, however, is not to say that masculinity remains uncontested in this newer crop of films. Rather, in the spy film of the last two decades, threats to a hero's masculinity are external, not internal/psychological. Unlike Mel Gibson's Sergeant Riggs, who grieves for his dead wife, and Bruce Willis's John McClane, whose marriage is threatened by his wife's career, the heroes of these films are stabbed in the back by traitors on their own team as they struggle to fight organized crime, government corruption, and terrorism. Here, successful masculinity is defined as a workable balance between the tent poles of paranoia and omnipotence.

As these films attest, the dream of starting all over again holds great power over the American imagination. In the 2000 presidential election, George W. Bush's path from alcoholism to political office was marketed to great effect, while Clinton had been touted as the comeback kid and *The Survivor* (John F. Harris). As this chapter shows, the time around 2000 was rife with narratives of origins and new beginnings. Several films discussed here obsessively show characters who hit rock bottom only to emerge stronger than ever. They investigate what remains when everything you believed in, everything you knew about yourself, and everything you valued and loved is taken away from you. They are not only concerned with the nature of identity, but also ideally equipped to tell stories of emasculation and remasculinization. Again and again, the spy hero is brought low by treachery and betrayal. Spy narratives are stories about trustworthiness, and they often rely on Oedipal constellations, on evil father figures and treacherous lovers. Of course, the hero eventually overcomes all obstacles and rises again by virtue of his own strength and smarts so that the depth of his fall merely indicates the greatness of his triumph when he finally reasserts himself. Like their action relatives, spy heroes partake of what Cohan and Rae Hark refer to as the paradox of masculinity: they derive power from being castrated, wounded, and lacking ("Introduction" 2).

As this narrative arc indicates, the heroes of the spy film are both vulnerable and impregnable. They are sensitive lovers and cold killers. In other words, they embody the contradictions of Clinton- and Bush-era masculinity. As Malin explains, "Clinton was the model of a conflicted masculinity characteristic of the '90s. Sensitive to our

pain, but tough on crime; wealthy graduate of Yale, but down-home Arkansas boy"
(*American Masculinities* 7). A similar contradiction might be said to characterize
George W. Bush. Although toward the end of his presidency, Bush was mostly iden-
tified as the "dead or alive"-style fighter of terrorism, he started out with a project
of "compassionate conservatism." The rapid changes from tenderness to toughness,
from deep empathy to crude violence, from protective care to callous slaughter, evi-
dent in all the heroes of this chapter, exemplify the continued struggle to come to
terms with the challenges to conventional notions of masculinity originating in the
1960s and prolonged far into the new millennium. Indeed, one might claim that the
impossibility to come to terms with these contradictory mandates is directly related
to the fact that, in all but one film discussed in this chapter, the secret agent remains a
figure in splendid isolation. Even though the hero, be he Ethan Hunt, Jason Bourne,
or James Bond, is represented as the answer to all political, criminal, and terrorist
problems, the contradictory demands on his masculinity—the simultaneous quest
for tenderness and toughness—present a challenge that remains largely unresolved.
The world is saved; the hero remains conflicted and alone.

SOLDIERS FROM WORLD WAR II TO IRAQ

> There is no war, then, without representation, no sophisticated weaponry without psychological mystification.
>
> Virilio 6

> We're kicking ass.
>
> George W. Bush, September 4, 2007, qtd. in Finkel 139

> Well, and how many did we kill?
>
> George W. Bush, qtd. in Woodward 370

WAR FILMS ARE HISTORY FILMS. They shape our understanding of the past and are a vivid testimony to the politics of the present. In other words, every era has the war films it needs and deserves. For example, *Platoon* (1986), *Full Metal Jacket* (1987) and *Casualties of War* (1989), all products of the 1980s, are marked by the American defeat in Vietnam. In contrast, the 1990s initiated a revival of good-war narratives evidenced by the renewed popularity of World War II topics in films such as *Saving Private Ryan* (1998), *Pearl Harbor* (2001), *The Windtalkers* (2002), *Flags of Our Fathers* (2006), and *Letters from Iwo Jima* (2006).

Critics have linked the resurgence of the World War II epic to the First Gulf War (August 1990–February 1991). Daniel C. Hallin, for example, claims that the "short and successful war in the Persian Gulf predictably brought back to the screen the positive image of war that prevailed in the mid-1960s" (45). The media coverage that preceded the First Gulf War certainly strengthened the association with World War II by portraying Saddam Hussein as a Hitler stand-in (Boggs 127) and by emphasizing the potentially catastrophic effects of appeasement. Of course, this is not an isolated case. War rhetoric thrives on jumbled chronologies, and the U.S. media routinely employ comparisons with Hitler and the Nazis. *Saving Private Ryan,* for example, owes much of its success to the fact that it "permits a displacement from the temporal period of actual and inconclusive wars in the 1990s to the triumphal epoch of World War II" (Eberwein, "Introduction" 14). In Spielberg's epic, war is an

appropriate means of handling international conflicts, and America is portrayed as a country that works toward the greater good of mankind. A more jaded form of such optimism informs *Black Hawk Down* and *Three Kings*. Both films suggest that, even if the American government is incompetent, as in *Black Hawk Down*, or corrupt, as in *Three Kings*, the American people will step up and do right by other nations.[1]

Saving Private Ryan is without doubt the most important war film of the Clinton era, which constituted a relatively peaceful period in U.S. history. According to the official listing of the Pentagon, one American soldier was killed by hostile fire in the eight years of Clinton's presidency, though another seventy-six are listed as killed by terrorists, a number that presumably includes the victims of the botched mission in Somalia in 1993 (Ivins/Dubose 248). This relative absence of war is partly due to circumstances and partly to the president himself, who is "by talent and temperament a peacemaker" (John F. Harris 410). When Clinton did initiate military action, it was mostly for humanitarian reasons. After having failed to prevent the slaughter of 800,000 in Ruanda in 1994, Clinton intervened in the former Yugoslavia to prevent extended campaigns of ethnic cleansing. In the 1990s, Yugoslavia was embroiled in savage ethnic fighting that claimed the lives of nearly a quarter million people (Finlan 7). To stop the conflicts between the various ethnic groups, including Kosovo Albanians, Bosnian Muslims, Bosnian Croatians, Croatian Serbs, and Serbs, Clinton ordered air strikes in 1999. Operation Deliberate Force, Clinton's response to the Serbian ethnic cleansing campaign against Bosnian Muslims, resulted in 18 days of saturation bombing.

While the war in the former Yugoslavia did not receive much public attention, a fact evident in the relative lack of films on the subject,[2] Iraq has been on the American mind for the past twenty years. In the wake of the First Gulf War, George Herbert Walker Bush encouraged the Shiites and Kurds to rebel against Saddam Hussein. When they did, though, he failed to offer support, essentially leaving the population victim to Saddam's brutal retaliation. Unlike Bush 41, Clinton pursued a strategy of containment in Iraq that relied on the policing of no-fly zones and bombing of chemical factories in 1998 (Ricks 19). Bush 43, however, picked up where his father had left off and launched Operation Iraqi Freedom, the invasion of Iraq, on March 20, 2003. Bush's war garnered little international support, was based on faulty intelligence, and did not include planning for a postwar Iraq. The rationale to defend "the signature initiative of the Bush administration" (Reedy/Johnson 6) shifted from securing weapons of mass destruction, which were never found, to regime change to spreading democracy in the Middle East. In all three respects, however, the war was a failure. As Finkel explains, "the strategy of winning an enduring peace had failed. The strategy of ending terrorism had failed. The strategy of spreading democracy throughout the Middle East had failed" (10; see also Robert G. Kaufman 223). Amis calls the Second Iraq War "a misadventure in search of an exit strategy" (82).[3]

The Iraq War foiled U.S. expectations in profound ways. Although the United States spends $398 billion a year on its military ($300 million per day), while Iraq spends $1.4 billion (Ivins/Dubose 271), it was unable to win the war. Casualty rates among U.S. soldiers are alarmingly high—though low in comparison with Iraqi victims. As the war developed into a counterinsurgency, Iraqi insurgents used improvised explosive devices (IEDs) that cost about $100 to destroy humvees that

cost about $150,000 a piece (Finkel 21). Moreover, the problematics of counterin-surgency warfare are exacerbated by cultural misunderstandings ranging from the inability to communicate to the infelicitous acronym NIC (New Iraqi Corps) for the American-sponsored Iraqi army, NIC being Arab slang for "fuck" (Ricks 155). And yet, communication and cultural sensitivity are all important since soldiers who were trained to win battles are now called upon to win the population, and generals who are trained in strategy must now drink tea with Shia and Sunni leaders, shake hands, and organize radio broadcasts. In addition to dealing with raging sectarian violence, the U.S. Army is tasked to set up functioning schools and sewer systems in a society that, from the point of view of the average soldier, is impenetrable to reform.

The development from a period of relative peace to a replay of Vietnam in the desert is mirrored in the flagging enthusiasm in war films of the past two decades. A growing sense of discomfort is traceable in the transition from *Saving Private Ryan* to *Flags of Our Fathers*, from *Black Hawk Down* to *In the Valley of Elah* (2007), and from *Pearl Harbor* to *Jarhead* (2005) and *The Hurt Locker*. The most recent crop of war films is far less sanguine in its evaluation of past and present wars and tends to depict "places of collapse" (Baudrillard 307) rather than "historical events." Here, war is a quagmire, and the morality of the mission is either impossible to implement or questionable to begin with. At the end of the First Gulf War, President George H. W. Bush declared that "we have finally kicked the Vietnam syndrome" (qtd. in Wiegman 174). As we approach the withdrawal of troops from the Second Gulf War, however, the Vietnam syndrome is back in full swing.

Still, even the most critical film discussed here is not as trenchant as many Vietnam war films, some of which cast "war as the symptom of male psychosis" (Greven 53) or portray the much vaunted camaraderie of war as "essentially fascist in nature and design: it is slavish collective worship, along class and racial lines, of the authoritar-ian and autocratic" (Greven 67). In comparison, the critique expressed in *The Hurt Locker* is limited in scope. The film does not expose the "lies, errors, and impotence" of the leaders or highlight the "futile sacrifice and glaring inequalities" that form the legacy of the Vietnam War (see Dittmar and Michaud 6). Rather, the films discussed in this chapter depict masculinity as essentially intact and express a consensus that war is an effective tool of conflict resolution if it is planned and executed properly.

It is possible that the relative lack of critique in these films is simply a factor of time. After all, many of the most incisive Vietnam-era films were released in the 1980s. But, of course, there is also the fact of indirect censorship. Unlike genres that are generally assumed to be apolitical, such as romantic comedies, war films are subject to a form of government control. As Boggs and Pollard point out, there is an "intimate historical connection between the U.S. military and the film industry [. . .] the studios have furnished the military with continuous, free, highly effective adver-tising and marketing that has often done wonders for recruiting" (53). To be sure, the Pentagon does not censor these films, but it can make them prohibitively expensive to produce by withholding vital resources, such as helicopters and tanks. In a detailed study of the interaction between the Pentagon and the directors and producers of war films, Robb shows that the military routinely "uses access to military units, bases, and even stock military footage and open areas such as the Presidio to force prepublica-tion review and script changes" (17). Clearly, war films are not the only films with an

ideological agenda, but they differ from other films in that the influence exerted by the government is particularly direct and forceful. Perhaps because of this intimate connection many war films are imbued with pride in a national mission that frequently crosses over into a colonizing agenda and a modernized version of Manifest Destiny (see Boggs and Pollard 23).

Even if we discount the controlling influence of the Pentagon, the war film as a genre remains fraught with contradictions. War films are history films with a strong claim to authenticity, but they are also an important subcategory of the action-adventure genre. As such, they favor thrilling action, spectacular explosions, and eye-catching stunts over the humdrum of military routine, including drinking chai with tribal leaders, hauling equipment, and filling out paperwork. Since war is "intolerable as experience and irresistible as spectacle" (Doherty 92), war films are drawn to heroes and uplifting narratives. But, as Basinger suggests, "a film that says war is hell, but makes it thrilling to watch, denies its own message" (*Anatomy* 87). Given their reliance on Pentagon support and box office friendly stunts, war films are unlikely vehicles of pacifist messages, prone to portray war as an arena of male maturation. In particular, the picture of the army in recent war films is somewhat different from the actual U.S. Army today. While films show us young men in their twenties and thirties, the average soldier today is but nineteen years old. Moreover, casting decisions and narrative denouement do not necessarily reflect the fact that to meet recruitments goals, the army increasingly relies on soldiers who need a waiver for medical problems, have low scores on aptitude tests, and are guilty of criminal offenses ranging from misdemeanor to felony convictions. Furthermore, films tend to ignore the soldiers' life after their deployment. According to Finkel, 20 percent experience forms of combat stress (206), exacerbated by the routine practice of extending deployments. Many soldiers who would have succumbed to their injuries in previous wars now survive with multiple amputations, missing one or several body parts, including legs, arms, nose, lips, and ears. These mutilated bodies remain invisible in most war films. Finally, films also tend to ignore or downplay the crucial role of private security companies in favor of the portrayal of the regular army. Blackwater, for example, has become indispensable to the Iraq War and holds one billion in government contracts (Scahill 2), but is never more than a bit player in film if it is shown at all.

The following interpretations are attuned to the political context in which these films were made and released and to the concepts of masculinity they seek to promote. Wars tend to masculinize leaders and boost their approval ratings (Ducat 108), and they are often portrayed as an arena of male maturation.[4] This intimate link between war and masculinity is crucial. If war is an ineluctable part of becoming a man, the willingness to engage in war is considerably higher. But war films address us on both a personal and a national level. They boost national morale and provide a template for the perception of future conflicts. It should not surprise us that some Marines played Wagner's *Ride of the Valkyries* during the invasion of Grenada in imitation of *Apocalypse Now* (Chapman, *War and Film* 89-90) or that the administration decided to replay *Saving Private Ryan* as *Saving Private Lynch* (Mirzoeff 67) when the war in Iraq veered off course. The war films we watch now reflect the wars of our past and shape the wars of our future. They deserve the utmost critical attention.

THE GOOD WAR: G.I. JOE ON D-DAY

Saving Private Ryan (1998). Dir. Steven Spielberg. Writer: Robert Rodat. Amblin Entertainment. 5 Academy Awards (11 nominations). Domestic Total Gross: $216,540,909. Foreign Gross: $265,300,000. Total Box Office: $481,840,909. Production Budget: $70 million.

Saving Private Ryan, a successful modernization of the classic World War II combat film, strives for verisimilitude in the depiction of war's savagery even as it confirms the moral legitimacy of World War II. The film conveys an uplifting vision of American society in which "community is healed [. . .] and established social and political life more or less restored" (Boggs and Pollard 153). Spielberg's war epic is rife with dramatic ironies and moral lessons.[5] It is drenched in sentimentality and patriotism, both opening and concluding on a shot of the American flag fluttering in the wind.[6] The film highlights the American belief in individualism and the willingness of ordinary American families to risk the lives of their men in the pursuit of freedom. Most importantly, *Saving Private Ryan* is a film about fathers, a son's nostalgic homage to the men of the greatest generation (Fig 7.1), who, as the film instructs us, "laid so costly a sacrifice upon the altar of freedom." According to Doherty, it is "best understood as a kind of sacramental rite, the baby boomer sons kneeling before their World War II fathers in a final act of generational genuflection" (301).[7]

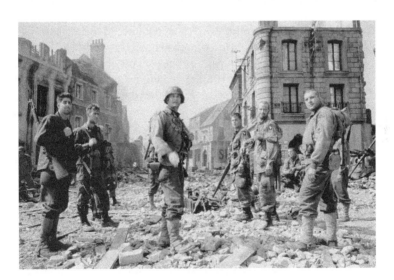

Figure 7.1 The Great Generation. Courtesy of Photofest, Inc.

Saving Private Ryan explores the meaning of American individualism in the midst of mass slaughter. When three brothers are killed, the American Chief of Staff, George C. Marshall (Harve Presnell), orders that the fourth brother, Private James Ryan, be located and sent home to his mother.[8] Since Ryan's exact whereabouts are unknown—he was dropped somewhere in Normandy behind enemy lines—Captain Miller (Tom Hanks) and his men are sent on a mission to find him. Throughout, the

rescue mission is hotly contested. One of Miller's men, Private Reiben (Edward Burns), calls it FUBAR (fucked up beyond all recognition): "Where is the sense of risking eight of us to save one guy?" Reiben wonders. As Miller's men embark on the mission, they know that Ryan may already be dead and that anyone sent to find him may very well be killed in the process. Spielberg uses this plot device to illustrate the logic of war. Military life requires decisions that are based not on the value inherent in any one person but on numerical advantage. As Miller explains, "when you end up killing one of your men, you tell yourself it happened so you could save the lives of two or three." However, since in this case, the mission is the man, the numerical logic used to justify the sacrifice of individual lives is turned on its head.

The film employs mise-en-scène and camerawork to underscore the tendency of war to erase individuality. The conversation in which Miller first informs Horvarth (Ton Sizemore) of the rescue mission is presented as voice-over while we see hundreds of soldiers milling about. As Horvath responds that finding one soldier in France is like finding a needle in a stack of needles, we realize that Miller and Hovarth were in our field of vision all the time, only we were not able to identify them in the crowd. Later on, the erasure of individuality is poignantly visualized when Jackson (Barry Pepper) and Reiben go through a pile of dog tags to see if Ryan's is among them. They start to play poker with the tags, completely oblivious of the fact that every tag represents a life lost in the war. The soldiers who pass them respond with disgust and horror to this scene that illustrates so vividly what their lives are worth in the gamble of war.

In the end, however, *Saving Private Ryan* does not force us to decide between man and mission but rather reconciles the two. When Miller and his men finally find Ryan, he refuses to abandon his company for the comfort of his family claiming that these are "the only brothers I have left." Miller and his men then agree to stay on and help Ryan's company defend a position that is of the utmost importance for the outcome of the war. In saving Private Ryan, Miller and his men also save a bridge across the Merder River, one of only two left, that will allow the winner to advance toward Cherbourg and ultimately toward Paris and Berlin. Thus, *Saving Private Ryan* offers the classical Hollywood "have and eat the cake" ending, where both objectives, the accomplishment of the mission and the survival of the man, are realized.

In her book on the genre of war film, Basinger claims that "World War II seems to be the combat that speaks to the American soul. Perhaps it is our total victory, or the sense of our righteousness, or the conviction that it wasn't our fault" (*Anatomy* 75). Certainly, *Saving Private Ryan* leaves no doubt that this is a war worth fighting. The prominent presence of Mellish (Adam Goldberg), a Jewish soldier, continually reminds us of the moral justification of World War II. At the time, of course, the United States did not justify its participation in the war with a reference to the Holocaust—a subject that may not have motivated the population to fight—but rather with the need to oppose tyranny in Europe and in the pacific theater.

In addition to the reference to the Holocaust, Spielberg further underscores the moral value of America's participation in World War II through an analogy to the American Civil War. In justifying his decision to save Private Ryan, Marshall cites from a letter written by President Lincoln.[9] The same letter is mentioned again in

his missive to the mother of Private Ryan. These references are placed strategically toward the beginning and at the end of the film so that the World War II narrative is embedded in a Civil War frame.

Spielberg tempers this emphasis on the legitimacy of the war with subtle reminders of war's moral turpitude. *Saving Private Ryan* does not demonize the enemy; rather, the film suggests that cruelty is not a quality of any one side but a constant feature in warfare. For example, during the long sequence of the Omaha Beach landing, two German-Czech soldiers approach two American soldiers with their hands up in the air. Yelling "I can't understand what they're saying," one of the Americans shoots them even though they have already surrendered. When the other explains that the Czech phrase meant "I was only washing for supper," they share a laugh. Later on, during street fighting in Neuville, Private Caparzo (Vin Diesel) is horrified that the Germans keep shooting at a messenger who lies helplessly on the ground between enemy lines, but Miller explains "as long as his lungs still have breath in them, he still carries the message, we do the same thing." Miller, who provides the emotional and dramatic center of the story, also tries to stop Private Caparzo when the latter insists on helping a little French girl. "We are not here to do the decent thing," Miller yells at Caparzo, who promptly gets shot as a result of his well-meaning folly. In war, spontaneous kindness is not only potentially ineffectual but dangerous. To drive the point home, Spielberg confirms the potentially lethal consequences of decency through the portrayal of Miller's death at the end of the film. Miller is shot by a German soldier whom he and his men took prisoner early on. Since Miller could not take him along on the mission and was unwilling to violate the moral codex that offers protection to prisoners, he blindfolded him and told him to turn himself in to the first Americans he comes across. The German obviously did not share Miller's moral codex, and Miller becomes the victim of his own generosity. We may read this as a depiction of the moral complexity of war or as an excuse to ignore regulations in favor of wanton cruelty.

Although *Saving Private Ryan* was often lauded for its realistic portrayal of war[10]— Doherty speaks of an "aesthetic of realism that served as a red badge of pure motives and high purpose" (302)—one might with equal right fault it for its pretense at realism. When asked about realism in war films, the director Sam Fuller, himself a veteran of Omaha Beach, famously responded, "You can never do it. The only way . . . is to fire live ammo over the heads of the people in the movie theater" (qtd. in Basinger, *Anatomy* 257). While Fuller is acutely aware of the ineluctable conceit of the war film—the fact that by definition a film is a representation of war, not war itself—Spielberg would have us believe that his film transcends such concerns.

A similar contradiction characterizes the portrayal of death in *Saving Private Ryan*. Although the film purports to portray the randomness of death and survival in war— "it doesn't make any sense, why do I deserve to go?" asks Private Ryan—it actually plots and stages the deaths of the soldiers in Captain Miller's squad with the utmost care. First of all, the randomness of death in warfare is disrupted by the star system. A Hollywood director does not usually hire an actor of Tom Hanks's caliber only to have him killed during the first 15 minutes of the film. Thus, viewers can be sure that Captain Miller will die last. Secondly, both Captain Miller's death and that of

Private Caparzo are rife with moral lessons about the problematic consequences of decency in warfare. Although this serves to acknowledge an ethical dilemma, "the costs of nonviolence" (Burgoyne, *Hollywood Historical Film* 52), it is also a troubling narrative device. Since decent behavior will inevitably get you killed, the moral logic of these deaths encourages viewers to excuse barbarous acts, such as the killing of POWs. If decency is dangerous, it cannot serve as a standard of behavior in war. Secondly, because death is presented as an element in a distinct chain of cause and consequence, it can potentially be controlled and avoided.

The contradictions that adhere to the film's portrayal of death in combat are also evident in the clash between the film's clarity of purpose and its aesthetics, in particular its effort to visualize the fog of war through a variety of techniques. For example, the camera is frequently positioned at ground level and obscured by dirt, dust, or blood.[11] A sense of speed is created through rapid camera movements rather than editing. This gives the impression "that the cinematic technology is unable to keep up with the pace and violence of the events" (King, *Narratives* 121). Repeatedly, disorientation is expressed through an unsteady handheld camera and through sound effects. Both stop-motion cinematography and muffled soundtrack are intended to convey traumatization (see Burgoyne, *Hollywood Historical Film* 54), and desaturated colors are used to simulate a documentary sensibility. However, although all these devices strive for authenticity, such "authenticity remains itself a special effect" (Geoff King, "War Epic" 290). Finally, Spielberg's aesthetics of destabilization is integrated and sublated in the overall trajectory of moral purpose, which is mirrored in the film's form, in particular its well-ordered linearity. Here, innovative aesthetics and homeopathically administered moral pinpricks are absorbed by a cushion of moral purpose and narrative linearity. Spielberg's epic is a film in which "ease of style, naturalness of narrativity matches an ease of worldview, a naturalness of mission and meaning" (Polan 55).

The naturalness of the soldiers' mission is complemented by the naturalness of their masculinity. Captain Miller is a paragon of the traditional male virtues associated with the great generation. Although he is courageous and capable in combat, the film does not celebrate his courage under fire, but focuses on his sense of responsibility, his fatherly concern for his men, and his strong ethics. This eulogy to the great men is paired with the near absence of women. Although the entire mission is undertaken to comfort a mother, mothers and women are well nigh erased from the surface of the film. In an article on the Vietnam film, Tania Modleski points out that women are generally not only absent in war film, but downright lethal: "whenever a soldier displays a photograph of his girlfriend, wife, or family, he is doomed to die by the end of the film" (155). *Saving Private Ryan* upholds this pattern as the mere mention of his wife and rose garden is followed by Captain Miller's death.

Even as *Saving Private Ryan* erases women from history, it celebrates the glory of the American melting pot. Captain Miller's men represent the ethnic medley familiar from many war films: the innocent farm boy from Iowa, America's heartland; the loud-mouth cynic from Brooklyn; the Jew; the Irish Catholic; the Italian; the tough sergeant with an Eastern European background; the peace-loving intellectual from the East Coast, and the Anglo-Saxon hero, "a man of experience and intuition" and "the last to die" (Basinger, "Definition" 33).[12] The film depicts a model society in

which men bond across lines of class and ethnicity and work together harmoniously toward a common cause.

In its emphasis on social harmony, *Saving Private Ryan* is far more optimistic that Clint Eastwood's *Flags of Our Fathers*. Both films are celebrations of the "great generation," both depict the savagery of war, and both are confident in their "faith in benevolent male authority" (Marilyn Young 317).[13] But *Saving Private Ryan* offers the bond between soldiers as "a basis for the regeneration of society as a whole" (Jeffords, *Remasculinization* 74), while *Flags of Our Fathers* shows that bonds forged in combat do not necessarily transcend color lines or class barriers. Eastwood's movie portrays a society rife with corruption, racism, propaganda, and manipulation.[14] In contrast, Spielberg's film, in spite of a few critical asides, adheres to the general script of "a nation called to bring progress and enlightenment to the rest of the world" (Boggs and Pollard 129). Although *Saving Private Ryan* asks questions, it does not sow doubt. Its nostalgic evocation of D-Day is meant for a peacetime population susceptible to the glory of war. The film was much lauded for its realistic depiction of blood and gore-combat during its famous landing scene, but it also portrays war as a time when men were still men and society was characterized by a common mission and moral purpose. An audience that is initiated into warfare by *Saving Private Ryan* is ready for its next mission.

VIETNAM REDUX

Black Hawk Down (2001). Dir. Ridley Scott. Writer: Ken Nolan. Columbia Pictures. 2 Academy Awards. Total US Gross: $108,638,745. Foreign Gross: $64,350,906. Total Box Office: $172,989,651. Production Budget: $92 million.

Black Hawk Down, directed by Ridley Scott and produced by Jerry Bruckheimer, focuses on a military enterprise that has become identified with the Clinton administration. In 1993, the U.S. Army attempted to extract the local warlord Mohamed Farrah Aidid and his close associates from a hideout in Mogadishu. The failure of this mission led to the subsequent withdrawal of troops from Somalia. As Boggs points out, this episode contains "all the requirements of the good-war paradigm: a vital strategic goal, superhuman efforts of a small combat group against impossible odds, male bonding, solidarity won in the midst of unbearable psychological pressures, the struggle to vanquish a bestial enemy" (Boggs and Pollard 137). To be sure, the Mogadishu mission makes an excellent subject for a thrilling story, but there is a cost. *Black Hawk Down* simplifies a complex subject matter, demonizes Africans, and portrays military action rather than diplomacy as an appropriate solution to the problems of the developing world.

Black Hawk Down, which did well at the box office, leaves no doubt that the U.S. Army was not enjoying a "taxpayer-funded safari," but was fighting a just and necessary war in Somalia. Because he wanted "to disabuse the public of the notion that the military had messed up in Somalia" (Marilyn Young 319), Ridley Scott directs his critique not at the mission, but at the supposed lack of government support for the troops on the ground and at the decision to withdraw (see McAlister 334). In its presentation of the story, *Black Hawk Down* employs several strategies, including "the

shift from means to ends [...] the valorization of performance [...] and the blurring of fact and fiction" that are familiar from representations of the Vietnam War (Jeffords, *Remasculinization* 1).

The film's opening establishes the legitimacy of the U.S. presence in Somalia. Years of warfare have caused a famine so grave that 300,000 civilians have died of starvation. Next, viewers are informed that Aidid is responsible for the famine because his men seize food shipments, a criminal practice that is later designated as genocide. In response, the U.S. sends Delta Force, Army Rangers and the 160th SOAR with the express mission to remove Aidid.

Black Hawk Down depicts the United Nations as a paper tiger and ridicules the policy of nonengagement. Viewers witness an attack on a Red Cross food distribution center by Aidid's men. Declaring this food the property of Aidid, Aidid's henchmen randomly fire their machine guns at the crowd. The U.S. soldiers who observe the slaughter from a helicopter request permission to engage, but UN regulations forbid direct interventions. The next shot shows Aidid's man raising a fist and laughing at the helicopter. The use of aerial shots juxtaposed with close-ups of the slaughter on the ground highlight the soldiers' inability to prevent bloodshed. Throughout, the film is critical of rules and regulations and champions Delta forces, who are characterized as "undisciplined cowboys." The extremely competent Delta Ranger Hoot (Eric Bana), for example, constantly flaunts procedure. Hoot jumps the line for lunch and does not put the safety on his gun when he is required to. In combat, however, this cowboy always comes through.

Black Hawk Down enacts a pattern that Jeffords has identified as typical of Vietnam War movies. The film associates "the loss of the war with the government and the honor of the war with the soldier" (Jeffords, *Remasculinization* 5). From the very beginning, the extraction mission is compromised because Washington felt that gunships and armor are too high profile and cannot be used to support the operation. The fact that General Garrison (Sam Shepard) watches the crashing chopper on his video feed but cannot help because he lacks gunships further serves to assign blame to the government. The film's frequent use of long shot and aerial shots presents the dangers of this battle as knowable. Thus, it implies that defeat could have been prevented if proper equipment had been available, that is, if the government had not abandoned these men. Unlike *The Hurt Locker,* which conveys a sense of disorientation through its shaky, handheld camera, *Black Hawk Down* guides its viewers with a firm hand. Appropriately, titles before the credits inform us that General Garrison retired one day after Aidid was killed. Clearly, this soldier was committed to finishing a job that his government left undone.

While the government fails to provide proper support, the soldiers in the field never abandon one of their own. *Black Hawk Down* repeats the motto "leave no man behind" over and over again and portrays all soldiers as deeply committed to the mission and their fellow soldiers. For example, two snipers, Gordon (Nikolaj Coster-Waldau) and Shughart (Johnny Strong), volunteer to defend the crash site of a chopper even though they know that they will have to face an overwhelming number of enemies without any hope of relief. Both are killed in the process. Similarly, Lieutenant Colonel McKnight (Tom Sizemore) insists on going back in even though he is wounded, and Private Sizemore (Matthew Marsden) threatens to tear off his

cast when he is denied permission to go on the rescue mission because of it. Even on his deathbed, Private Ruiz (Enrique Murciano) begs his Captain not to go out there without him.

In light of the extremely positive portrayal of the U.S. military, it is hardly surprising that the Pentagon lent full cooperation to the producers of *Black Hawk Down*. Still, even a flattering portrayal of the U.S. military has room for improvement. To secure the loan of several army helicopters, the director and producers had to agree to several changes. As Robb points out (91-92), while most of the characters in the film are based on real-life soldiers, one character's name is fictional. Because Ranger Specialist John Stebbins, who won the Silver Star for his conduct in Mogadishu, was sentenced to serve thirty years in a military prison for raping a twelve-year-old boy, his name in the film is Danny Grimes (Ewan McGregor). This fusion of fact and fiction in a film that prides itself on its authenticity suggests not only an investment in moral dichotomies, but also the desire to avoid the fog of war and the messiness of heroism.

Black Hawk Down employs a large number of stock characters familiar from countless war films. There is the desk clerk who finally gets to see some action and proves himself worthy, and the greenhorn leader who emerges triumphant in his very first assignment. There is the tough-talking Captain with a Southern drawl who, underneath his rough behavior, cares deeply about his men, and the lieutenant colonel who joins a rescue mission in spite of his own wounds. But this wealth of interesting personalities contrasts sharply with the absence of individualized Somali characters. Although the film establishes the humanitarian mission of the U.S. Army through its opening titles and the concluding remarks of Sergeant Eversmann (Josh Hartnett), it fails to portray the plight of ordinary Somalis. Their suffering is a given, and the film does not attempt to visualize it beyond the opening sequence. Instead, *Black Hawk Down* focuses all its narrative energy on the heroism of individual American soldiers, independently of any overriding political purpose. As Hoot instructs the young Eversmann, "when I go back home and people ask me why do you do it, you are some kind of war junkie, I won't say a goddam word, why? They won't understand, it's about the men next to you." Of course, this explanation conveniently sidesteps the obvious question: what are both of them doing there?

Black Hawk Down illustrates the differences between branches of the service in great detail, but the Somalis appear as a mysterious nation of starving victims and beastly gunslingers. There is no attempt to explain the clan rivalries and internal conflicts that led to civil war and are themselves legacies of the colonial period in which the Somali territory was carved up into incoherent units by the British, French, and Italians. As a consequence, Somalia is portrayed as a dark continent in which out-of-control warlords attack each other without rhyme or reason.[15] The only way to take care of a situation of this type is to send even more U.S. soldiers with more tanks and bigger guns.[16] *Black Hawk Down* suggests that Africa needs "courageous, selfless whites who risk everything to bring justice to long-suffering tribes" (Boggs and Pollard 64). The film reinforces any number of problematic stereotypes about race and Africa—even more so as there are hardly any black soldiers among the U.S. troops. Africa remains the land of crazed warlords, of rampant, unmotivated violence, incapable of governing itself and of providing the most basic necessities for its people.

Through the character of Mr. Atto (George Harris), a Somali who sells weapons to Aidid, the film portrays black leaders as devious and cunning. Atto, who is captured by the Americans in preparation for the mission, reveals no information, but waits patiently like a spider in its web, confident that the Americans will fail. His knowing superiority contrasts sharply with the young soldiers' innocence.

The representation of Atto also resonates with the film's overall emphasis on the contrast between experienced leaders and young recruits. The young soldiers grossly underestimate the danger to which they are exposed. They believe that Somalis "can't shoot for shit," and do not bring night vision or other valuable equipment for the raid because they think it is going to be easy. We might conclude that, like *The Hurt Locker,* this film draws attention to the dangerous lack of cultural understanding. But *Black Hawk Down* does not so much as hint that there is a Somali culture beyond violence, venality, and cunning. If the American soldiers fail to comprehend what they are getting themselves into, it is only because, in their innocence, they cannot even imagine a society so infested with criminal behavior. Unlike the soldiers in *The Hurt Locker,* these innocent youngsters do not have issues with intimacy, but are good citizens and family men. They call their girlfriends and leave long messages, draw children's books in their spare time, and cling to the picture of their family under enemy fire.

As the problematic representation of race indicates, *Black Hawk Down* forecloses an analysis of the problems that did occur in the political handling of this humanitarian crisis. Somalia, never high on the list of geostrategic interests of the United States to begin with, got lost in the shuffle of the transition from President G. H. W. Bush to President Clinton. While it is true that the deaths in the battle of Mogadishu could have been prevented, the problem did not consist in a lack of firepower and armor but in a lack of communication. When the U.S. troops in Somalia set out to capture Aidid, the U.S. government had already decided that arresting Aidid would not solve any problems in a society without any effective government and ridden by civil strife. This change in strategy, however, was never communicated to the troops.[17]

In a comment on *Black Hawk Down,* screenwriter Eric Roth declared that the film is apolitical: "it's a study of heroism under fire" (Boggs and Pollard 188). Because the film highlights the extraordinary accomplishment of individual soldiers, its effect is uplifting. Its soundtrack amplifies the heroic and the sublime nature of war. Heavy beats signal the arrival of the cavalry and underline turning points in the action. The use of slow motion, the fading of sound as well as soaring and melancholy scores lend an air of dignity to the fight and signal triumph in adversity. *Black Hawk Down* marshals an extensive aesthetic arsenal in defense of an ideological prize. The film helps its audience forget that the U.S. mission in Mogadishu was a failure and suggests that warfare was and is the best way to resolve a humanitarian crisis.

BUSH WARS: IRAQ I AND II

Three Kings (1999). Dir. David O. Russell. Writers: David O. Russell, John Ridley. Warner Bros. Domestic Total Gross: $60,652,036. Foreign Gross: $47,100,000. Total Box Office: $107,752,036. Production Budget: $75 million.

Three Kings, directed by David O. Russell, who also cowrote the script with John Ridley, combines two genres, the war film and the caper. After the end of the first Gulf War, a group of soldiers finds a treasure map, literally pulled out of an Iraqi soldier's ass, that contains the location of Kuwaiti bullion, secreted away by Saddam Hussein. Under the leadership of Archie Gates, played by George Clooney, an icon of the heist movie since *Ocean's Eleven* (2001), Troy (Mark Wahlberg), Elgin (Ice Cube) and Conrad (Spike Jonze) set out to steal the gold, but end up rescuing political opponents of Saddam Hussein's regime. As this synopsis indicates, *Three Kings* not only mixes genres, the war film and the heist movie, it is also confused about its political agenda. The film is steadfast in its bleak assessment of the Bush government, but it abandons its critique of the average soldier midway. At the beginning, the film portrays the soldier protagonists as clueless, callous, and incompetent. In the end they emerge as moral heroes.[18] Instead of the quagmire of the Iraq War, viewers are presented with the fairy tale of the average American Joe defying his own government and fighting alongside the Iraqi rebels in their uprising against Saddam Hussein.

The first lines of dialogue in the film—"Are we shooting people, or what?"—introduce their speaker, Troy Barlow, as clueless and cavalier with the lives of others. Shouting "I think this guy has a weapon," Troy kills an Iraqi, who is both brandishing a gun and waving a white flag in surrender. Troy's comrades, who had been immersed in a lively discussion concerning the weighty subject of bubble gum, promptly applaud him—"Congratulations, my man, you just shot yourself a rag head," and take pictures of themselves with the "dead guy." The next scene shows soldiers dancing to "I just want to celebrate," sunbathing, weightlifting, posing with big metal pipes as ersatz penises and yelling "We liberated Kuwait." Based on this highly eloquent introduction, viewers are led to expect a trenchant critique of the First Iraq War and the troops who fought it.

Like *Saving Private Ryan, Three Kings* relies on slow motion and desaturated colors to portray the drastic impact of violence. Unlike *Saving Private Ryan,* however, *Three Kings* does not use these devices to convey the traumatization of soldiers. The film does not strive for realism, but rather uses sound, in particular incongruously deployed music ranging from the Beach Boys to Johann Sebastian Bach, and camerawork, such as freeze-frames, to allow viewers a critical perspective on the war and its personnel. The film's reliance on a quasi Brechtian alienation effect is also evidenced by the shots of human tissue evocative of anatomy lessons and designed to illustrate the damage done by bullets.

Three Kings contains many comedic scenes and even some slapstick elements. The film's humor conveys its critique, but it also makes light of its own political agenda and thus potentially undermines its critical impact. One the one hand, humor deflates the warrior ethos, for example, when a quick cut reveals that the admiring shouts of "brave warrior, Major Gates" are spoken not in praise of courage under fire but during sexual climax. Similarly, the film lampoons the pervasiveness of racial stereotypes in spite of and amidst a discourse of political correctness. In a conversation about the impropriety of racial epithets, Troy explicates that one should refrain from calling Iraqis desert niggers since this is insulting to black American soldiers. Towel head and camel jockey, on the other hand, are perfectly acceptable.[19]

While these jokes support the political agenda, others take the sting out of its critique. Although the first scene suggests that these clueless dupes are capable of lethal actions, much of the film milks their incompetence and general ignorance for fun. When Archie tells Conrad that the map they found leads to Kuwaiti bullion, Conrad believes he is talking about the cubes you put in hot water to make soup. Conrad also believes that he was trained to kill every Arab until one of his comrades breaks the news that the United States has Arab allies.

The film's humor is not the only device that tempers its political critique. Rather, the plot itself takes an abrupt turn, in which critique gives way to feel-good humanitarianism. The basic plot line of the film is constructed as a thinly veiled indictment of American imperialism. The theft of gold functions as a metaphor for the invasion itself: the Americans are in Iraq to steal from the Iraqis (Fig 7.2).

Figure 7.2 U.S. foreign policy in action: Archie Gates (George Clooney), Chief Elgin (Ice Cube), Troy Barlow (Mark Wahlberg). Courtesy of Photofest, Inc.

The leap from gold to black gold, a common moniker for oil, is not a big one, and the fact that the soldiers repeatedly talk about converting this gold into cars—Troy wants to buy a Lexus convertible with his share of the loot—further underlines the link. A sense of divine entitlement is also seen to conspire in this scheme as Elgin, the proud owner of a ring of Jesus fire, declares that he takes "care of whatever God puts in front of me. He put that gold in front of me and I took it." The critique of the soldiers' venal intentions and of U.S. foreign policy in general is further underlined by the soldiers' self-serving rhetoric with its empty references to patriotism and human rights. For example, when Archie and his men enter the village where the gold is hidden, they proclaim that they are here "for your protection and safety." As they break and enter, they show a letter that reads "orders from the United States."

The gold heist represents the climax of the film's political critique and its turning point. The film sets up a sharp contrast between the Iraqi villagers, who beg for food and medicine, and the American soldiers, who load their gold into Louis

Vuitton bags. There is a fundamental conflict, so the film suggests, between exploiting a country's resources and protecting its people. This jarring contrast is further underlined by the fact that the bunker where the bullion is hidden also contains a prison, where Iraqi rebels are being tortured by Saddam's troops. Although somewhat disturbed by this, Archie's men ignore the rebels and focus on their loot. Soon, however, indifference progresses to complicity. In exchange for not interfering with the Republican guards' treatment of the prisoners, Saddam's soldiers help carry the gold to the American truck. Surprisingly, though, at this point, the film's critical trajectory is interrupted and replaced by a moral one in which Archie's motley crew emerge as human rights heroes. When the wife of one of the tortured prisoners is shot, Archie can no longer bear to collaborate with Saddam's men. He feels compassion for the Iraqi rebels and agrees to transport them to safety. The remainder of the film then completes the transformation of the heist into a humanitarian mission.

As a result of Archie's spontaneous reaction to the murder of an Iraqi woman, Saddam's soldiers turn against him and take Troy prisoner. Archie now needs help to discover Troy's whereabouts and strikes a new bargain, this time with Saddam's enemies. They will lead him to Troy; in exchange, he will accompany them to a refugee camp at the Iranian border, and they will share the gold. From here on, the film highlights the moral potential of the hapless soldiers of fortune. Troy rescues two Iraqi children who are running towards land mines, and Archie and Elgin give their gas masks to Iraqi women and children during an attack. Occasionally, these feats are interrupted by the soldiers' hypocritical humanitarian blabber and hankering for Iraqi wealth. Archie, for example, who needs the rebels' fleet of pricey vehicles for the Troy rescue mission, tries to dupe the resistance leaders into surrendering the vehicles in exchange for the promise of American support for their uprising against Saddam. This time, however, the rebels do not fall for empty promises and Archie ends up buying the cars. In the end, the moral education of Archie and his men is completed during a climactic rescue scene. When the prisoners and their American protectors arrive at the Iranian border, they are stopped by the U.S. military. To save the refugees, Archie has to reveal the location of the gold, which he and his men have buried, to his superior. He and his men have finally understood that exploitation and humanitarianism are not compatible. While the government happily claims the loot, Archie and his men emerge as "good guys" after all.

Unlike many war films, *Three Kings* includes a storyline about the relation between war and the media. This is highly pertinent since the Persian Gulf War has come to be identified with government control of the media and censorship. As H. Bruce Franklin explains, in order to control images of the war, "the U.S. government set up pools of selected reporters and photographers, confined them to certain locations, required them to have military escorts when gathering news, set up stringent guidelines limiting what could be reported or photographed, and subjected all written copy, photographs, and videotape to strict censorship" (40). The film portrays these practices, but it adds an uplifting, humanitarian twist by introducing a plucky reporter heroine (Nora Dunn) whose story parallels that of Archie and his men. Originally motivated by venal interests—the desire to sell stories and get famous—the journalist heroine ends up supporting the soldiers' rescue mission while the U.S. government is again painted as the main villain.

The film starts out with a portrayal of press censorship. Adriana Cruz, a five-time Emmy runner-up, believes that her assigned military escort, Archie Gates, is supposed to protect her. But Archie's real job, defined by his superior, is to make her "feel good about the stories we want." As it turns out, Archie, who enrages Adriana by having sex with her competitor, accomplishes neither. When his superior finds out, he yells at Archie: "This is a media-war, and you better get on board." At this point, Adriana, who will not be "handled," deviates from the military script, and the film deviates from the historical record to offer a feel-good narrative. During the first Gulf War, most U.S. reporters proved compliant and happily sold the government talking points. In contrast, the fictional representation of the war features a journalist who successfully eschews military control.[20] Where "the approximately sixteen hundred reporters mainly camped out in high-tech hotel lounges and makeshift press centers in Dhahran and Riyadh, Saudi Arabia, watching the war on TV just like viewers at home" (Engelhardt 87), *Three Kings* features an investigative girl wonder par excellence, who tricks her handlers and sets out on a journalistic tour de force.

At first, Adriana's defiance is motivated by ambition. When her new escort, instructed to lead her on a wild goose chase, takes her to the site of an environmental disaster with thousands of dead birds covered in oil, Adriana sheds a couple of tears, but then gets back to business since the bird story has already been done. Adriana is outraged at the attempt to control her stories, not because she cares about accuracy or moral standards in reporting but because she needs original stories that she can sell. The actual impact of the event described is of secondary importance. As the film progresses, however, Adriana's venal motivations fade into the background. Because of her willingness to broadcast life from the Iranian border, the soldiers succeed in rescuing the refugees, and Adriana emerges as a do-gooder heroine after all—though, unlike Archie who must forfeit the gold, she might yet be rewarded with an Emmy for her humanitarianism.

Throughout, *Three Kings* presents the American army and government in an extremely unflattering light. Archie instructs his men (and the viewers) that the Bush government encouraged the Iraqi rebels to rise up against Hussein but then abandoned them to their fate. In an ironic twist, the film uses the torture of an American soldier to effect the political education of its viewers. When Troy is taken prisoner, his Iraqi captor, trained in interrogation by the CIA, enlightens Troy about the evils of American imperialism and dependence on oil. The film does not demonize the torturer, but rather presents him as a victimized victimizer. He hates Americans because he lost his baby son to American bombing. When Troy emerges from this experience, he is a changed man. Either under shock or newly enlightened, he insists on helping all Iraqi rebels. Like Archie and Elgin, he now understands the plight of the refugees and emerges as a valiant fighter for human rights. *Three Kings* is a desert fairy tale in which the average American soldier comes through in the end. As Marilyn Young points out, "individual Americans, like Clooney, through their honesty, virility, and disregard for authority, redeem the country's honor, but only in opposition to, or apart from, the government, never in support of its stated aims" (316).

To comprehend this more fully, it is helpful to compare *Three Kings* to an earlier film that also mixes the genres of war film and heist, namely *Kelly's Heroes* (1970). In *Kelly's Heroes*, a group of World War II soldiers in German-occupied France set out

to steal German gold. Although the Second World War offers manifold opportunities for moral heroism, *Kelly's Heroes* does not even mention the Holocaust. Here, the American GIs do not happen upon a group of Jewish prisoners and they certainly do not trade their loot for a humanitarian purpose. Rather, they simply pull of the heist and ride off into the sunshine with their gold. In 1970 not even the Second World War offered a venue for the moral glorification of G.I. Joe. In 1999, even the First Gulf War is an arena where the American soldier shines.

The Hurt Locker (2008). Dir. Kathryn Bigelow. Writer: Mark Boal. Summit Entertainment. 6 Academy Awards (9 nominations). Domestic Total Gross: $17,017,811. Foreign Gross: $32,212,961. Total Box Office: $49,230,772. Production Budget: $15 million.

The Hurt Locker, directed by Kathryn Bigelow, one of Hollywood's very few female directors of testosterone-driven action flicks, was filmed in Jordan. It is based on the experiences of Mark Boal, who worked as an embedded journalist with an American bomb squad in Iraq. In keeping with the reality of the Iraq war—a war that is not played out in large-scale battles but dominated by IEDs, improvised explosive devices, and EFPs, explosively formed penetrators—*The Hurt Locker* follows the work of a U.S. Army Explosive Ordinance Disposal (EOD) team. The film, which received the Academy Award for Best Picture in 2010, includes many of the traditional elements of the war film, but it combines these with innovative and unusual features. As a result, it is both multifaceted and open to a variety of different, even conflicting interpretations.

Unlike many war films, *The Hurt Locker* portrays its soldier protagonists neither as victims nor as perpetrators. Although they risk their lives for UN employees and Iraqi civilians, they are not portrayed as particularly noble. Rather, they are average guys, who sometimes live up to the challenge of a situation and sometimes fail to perform. In their minds, the technology they use is aligned with male prowess—"think of it as my dick," Thompson (Guy Pearce) says as Sergeant Sanborn (Anthony Mackie) tries to position a bomb detection robot in its proper place—and they relish intimacy with danger more than familiarity with women. "Hello, baby," says Sergeant Will James (Jeremy Renner) as he discovers a bomb and begins to caress it. James's excellence in war is the flip side of his discomfort in civil life. A box filled with prized possessions contains parts of bombs he defused but also his wedding ring. To him, it is all united under the general rubric of "stuff that almost killed me." Will, who lives with his ex-wife (Evangeline Lilly) although he is divorced, calls her but then is unable to say anything. Although he cannot understand his Iraqi environment, Will never looks as disoriented in Iraq as he does in the aisles of a supermarket back home.

The Hurt Locker does much to demythologize its soldiers. They smoke, play bloodthirsty videogames, and listen to heavy metal music. They curse and swear at Iraqis and treat them and each other disrespectfully. Their banter in the midst of danger does not signal their courageous defiance of death, but the intrusion of the everyday in the reality of war and sometimes their failure or refusal to acknowledge the seriousness of the situation. Right before their team leader is shot, Sanborn and Specialist Owen Eldridge (Brian Geraghty) joke about starting a business growing

and selling grass in Iraq. When Sanborn kills an enemy sniper, James comments "thanks for playing." Unlike *Black Hawk Down*, *The Hurt Locker* never portrays its soldiers as duped and abandoned by their political and military leaders. It also does not celebrate their camaraderie. On the contrary, Eldridge and Sanborn resent James's recklessness to the point of wanting to kill him. "These detonators misfire all the time," Sanborn remarks suggestively. Even when they party together, they end up punching each other. Dependence does not foster trust but breeds aggression, so this film suggests.

Many war films portray the death of one or several of their protagonists, but few war films foreground the experience and perception of death and even fewer feature death as the main subject of conversation. In contrast, the opening sequence of *The Hurt Locker* casts the death of team leader Sergeant Matthew Thompson as the point of origin for the subsequent story. Thompson dies because a robotic vehicle malfunctions. His death is not heroic, but accidental and sudden. One minute, Thompson eats and makes jokes. The next minute he is blown up. The remainder of the film depicts how Specialist Owen Eldridge and Sergeant J. T. Sanborn cope with his death by focusing on their relation with the new team leader, Sergeant Will James. The individual episodes after Thompson's death are framed by titles that give the number of days left in Bravo Company's Rotation. These titles function as a countdown and ironic measure of the likelihood of survival.

Death underlies all of Sanborn's and Eldridge's experiences and features prominently in the soldiers' conversations. Our understanding of the soldiers' characters is based largely on their attitudes toward death. Eldridge and J. T. Sanborn are afraid of death. In a cynical take on the infamous army commercial, Eldridge asks, "What if all I can be is dead on the side of an Iraqi road?" And Sanborn swears: "I fucking hate this place, I'm not ready to die." Eldridge even receives help from an army psychologist, Colonel Cambridge (Christian Camargo). Cambridge, who repeatedly seeks to engage him in conversations after Thompson's death, advises Eldridge to stop obsessing and start thinking about other things. The representation of Cambridge taps into a number of clichés, familiar from other staples of the genre. Cambridge, who hails from New York, is an intellectual who lacks combat experience and spouts empty slogans such as "going to war is a once in a lifetime experience." When he joins Eldridge in the field, he is clueless. His well-meaning attempts to engage with locals are not only ineffectual but actually get him killed.

While Cambridge is not afraid of death because he fails to grasp the reality of war, Sergeant Will James is not afraid of death and war because he understands them so deeply. James is the only character to whom the film's epitaph, "the rush of battle is often a potent and lethal addiction, for war is a drug," a citation from Chris Hedges's *War Is a Force That Gives Us Meaning*, can properly be said to apply. Unlike Eldridge and Sanborn, who seek to avoid unnecessary risks by following procedure and whose main concern is to get out of Iraq alive, James courts risks to the point of recklessness. Repeatedly, James chooses dangerous options over safe ones and even violates protocol. Instead of sending a robot to explore an explosive, he suits up and inspects the bomb himself. Instead of communicating with Sanborn while he dismantles bombs, he throws his headpiece away. Instead of wearing a protective suit, he approaches the bomb in fatigues.

Sanborn and Eldridge disapprove of his behavior and believe that their new team leader will get them all killed. From James's perspective, however, Sanborn and Eldridge's clinging to procedure is useless at best if not downright harmful, and the film appears to side with him. Because James accepts the omnipresence of death in combat, he is better equipped to deal with it. When James first joins Bravo Company, he tears the plywood covers from the windows although Sanborn advises against it. When Sanborn points out that the covers protect from mortars, James replies that they cannot protect him from mortars coming through the roof. Similarly, when he removes his headgear, he is shielding himself from Sanborn's nervous comments, which interrupt his concentration and make a wrong move more likely. Finally, when he removes his protective suit, he is aware that its bulk cannot protect him in such close quarters with the bomb, but will impede his ability to move swiftly. After all, Sanborn and Eldridge's previous team leader Thompson died in an explosion even though he followed procedure and was wearing the suit. To be sure, James is an adrenaline junkie. He keeps bomb parts as prized possessions because he is intrigued with danger. But he also chooses the method most likely to guarantee his survival. When asked what is the best way to defuse a bomb, he responds: "the way you don't die."

If *The Hurt Locker* portrays war positively, or even glorifies it, as Kamber maintains, it conveys this message through its protagonist Will. Will embodies an omnipotence fantasy of extreme competence and utter calm amidst danger. He disarms bombs, 873 of them so far, and he de-escalates potentially lethal confrontations with Iraqis through his calm, respectful, and determined behavior. Unlike Sanborn and Eldridge, he engages with Iraqis and even seeks to befriend them. He also takes care of his teammates and comforts them. Thus, we may conclude that *The Hurt Locker* celebrates its omnipotent protagonist and insinuates that one can control and survive war if one possesses the proper skills and talents. However, the film also allows for a different reading in which James only appears to understand the complexities of the war in Iraq. In effect, he is as clueless as the others.

On one of their missions to defuse a bomb, James and company search an empty building for explosives and find a body bomb: the corpse of a boy whose stomach has been stuffed with explosives. Sergeant James is convinced that this is Beckham (Christopher Sayegh), a boy who peddled bootlegged DVDs at the local market and with whom he played soccer. James has taken a liking to the young boy, feels beholden to him and seeks to honor his friend by treating his corpse with the utmost respect. Although the best way to dispose of the explosives is to blow up the evacuated building along with the body, James removes the bombs from the body at great danger to himself, wraps the dead boy in white linen and carries him out of the building. He then goes on a wild goose chase to find the boy's family, invades the house of an Iraqi professor, followed by a botched conversation and a physical attack. The episode contains in a nutshell the essence of the American presence in Iraq. James climbs over a wall and breaks into the house. Inside, he points his gun at its owner, who calls him guest and invites him to sit. As James sits down, the wife enters and starts hitting him. James runs away without learning anything about his involuntary hosts or Beckham. A little later, James runs into Beckham, who, as it turns out, was not the victim of bombers but is alive and well.

The film uses the episode to illustrate James's disorientation. Initially, James appears to distinguish himself from Eldrige and Sanborn, who wonder how he was able to recognize the boy since they all look the same to them. But as it turns out, James too cannot tell one haji from another. Moreover, James's failure to identify the boy causes a second error in judgment, which in turns leads to the capture and wounding of Eldridge.

At the scene of a major blast caused by an explosive on an oil truck, James is determined to ferret out the bombers himself. Convinced that the Iraqis are laughing at them, he pursues them into back alleys where Eldridge promptly gets caught and is injured when James and Sanborn free him. The film offers different ways of reading this episode. Before the wounded Elridge is flown back home, he holds James responsible for his injury: "we didn't have to go out looking for trouble to get your fucking adrenaline fix." But since James' desire to find the perpetrators is linked to his anger about the body bomb, it is not simply motivated by recklessness. Rather, it can be attributed to a quest for justice gone astray because of James's inability to comprehend the war he fights or the society in which it is fought.

The Hurt Locker consistently highlights the American soldiers' inability to communicate with Iraqis or understand Iraqi culture. The film's first few minutes are shot from the perspective of a remote-control robotic vehicle sent to investigate explosive devices. Because we share the robot's perspective, we are as "down on the ground" as it gets, and yet, in spite of this proximity, we are utterly disoriented. We observe Iraqi civilians running away or being herded away by U.S. soldiers, but understand neither the cause nor the precise nature of the threat. Like the soldiers, we fail to identify the enemy amidst the crowd of onlookers. This inability to comprehend the nature of the war in Iraq or to tell friend from foe evolves as the most important theme of *The Hurt Locker*. Throughout the entire film, the lack of firm focus and the relative infrequency of tracking shots convey the lack of intelligibility while the shaky, handheld camera continually foils our attempts to gain an overview of the situation. Bigelow is acutely aware of the fact that time moves differently in war. Frequently, the action is fast-paced, the cuts frenetic. But there are also moments when time slows down. When the soldiers are exposed to sniper fire in the desert, for example, time stretches out interminably, sun and shade progress slowly, and bullet shells fall in slow motion.

The Hurt Locker emphasizes the enormous cultural rift that separates the U.S. soldiers from their environment and portrays their isolation as a classic double-bind. If the soldiers engage with the locals, they may make friends and gain valuable information or they may put their lives in danger. Before Thompson is blown up, an Iraqi man approaches Sanborn, asking him where he is from. This may be a friendly hello, but it may also be a scheme to distract Sanborn. Either way, it prevents Sanborn from doing his job, namely from keeping a lookout for suspicious Iraqis who may detonate the bomb. Thus, regardless of his behavior, Sanborn is set up to fail. If they alienate the local population, they are unlikely to receive vital intelligence and may even fuel the resistance. "If he wasn't an insurgent, he sure the hell is now," James mutters as soldiers handcuff an Iraqi who either could not understand him or deliberately defied orders. But attempts to fraternize and befriend Iraqis are potentially lethal and frequently fail to bear fruit. Often soldiers resort to force because they lack words. This is illustrated in a scene in which an Iraqi driver breaks through the road barrier and

stops his car right in front of James. James tells him to back up but as he says it in English we cannot know if the driver understands what he wants. Finally, James fires a shot next to the vehicle and then at the windshield and the driver backs up. His intentions remain as unclear to us as they are to James.

The film reserves its most scathing treatment for a group of mercenaries who specialize in a highly lucrative business. They capture Iraqis who feature on the American most wanted list and sell them to the authorities. The mercenaries, whom James and company first mistake for enemy fighters because they wear "haji gear," are portrayed as bickering, incompetent, cursing headhunters. They are the only ones in the film who kill with relish. When their prisoners run away during an ambush, the team leader (Ralph Fiennes) shoots them, smirking: "I forgot it's 500,000 dead or alive." They are stranded in the desert because of a flat tire, which they cannot fix because they lost the wrench. Unlike the rest of the film, the mercenary episode identifies moral superiority with the ability to survive, a staple of the traditional war film. All mercenaries are shot by Iraqi snipers, who remain faceless, while our heroes survive and finish off the snipers.

While the mercenaries' violation of moral laws is particularly blatant, they are not the only ones who engage in illegal conduct. Army personnel are seen to mistreat prisoners, only here the violation is shown almost in passing. When James arrives at a bomb site, the commander in charge, Colonel Reed (David Morse), has taken an injured Arab prisoner. He knows that the captive is not going to survive unless he is immediately taken to a medical facility. "He's not going to make it," Reed smiles as he delays his departure.

One of the most intriguing accomplishments of *The Hurt Locker* consists in its refusal to offer pat explanations. The film eschews psychological explanations for James' derring-do, and it does not parse the complexities of Iraqi society. In a conversation with Sanborn, James challenges him to explain why he is the way he is. The question is left unanswered. The film also does not attempt to portray the point of view of Iraqi civilians or insurgents, but focuses all its narrative energy on the small group of American EOD specialists. And yet, it is precisely this reserve that allows revealing insights. In *The Hurt Locker*, the experience of war is what you make of it, a force that gives life meaning or a terrifying threat. But the war in Iraq is a losing proposition no matter what you do.

WAR GAMES

It should be evident by now that the concept of masculinity in recent war films differs from that in most other action-adventure spectacles. First, unlike the typical action-adventure thriller, war films do not celebrate the male body. Instead of highlighting physical feats, they praise traditional manly virtues, such as courage, a sense of civic responsibility, and loyalty. The men in *Saving Private Ryan* and *Black Hawk Down* are selfless heroes, James in *The Hurt Locker* is an omnipotent war machine, and even the hapless heroes of *Three Kings* come through in the end. Because of its emphasis on service, some critics have characterized the war film as "male melodrama," a genre in which the denial of self and self-sacrifice are presented as forms of empowerment (Burgoyne, *The Hollywood Historical Film* 86). Secondly, *Saving Private Ryan*

and *Black Hawk Down,* in particular, are comfortable with patriarchal authority. All films, with the possible exception of *The Hurt Locker,* foster an ethos of cooperation, celebrate bonds between men, and emphasize community and nation. Men in these films are citizens first and killers second. In *Saving Private Ryan, Black Hawk Down,* and *Three Kings,* masculinity is surprisingly intact. However, if *The Hurt Locker* is not an outlier but indicative of a trend, motivated by the development of the Iraq War, then masculinity in the war film is likely to unravel in the near future. On the other hand, there may not be any war films in our future.

While *The Hurt Locker* grossed $15 million in theaters, the video game *Modern Warfare 2* earned $310 million during the first 24 hours after its release (Suellentrop 62). In terms of financial viability, war films hardly ever reach the potential of their action-adventure cousins and threaten to become an extinct genre. War films have always been different from the action adventure genre, partly because they fail to appeal to the female demographic[21] and partly because they do not allow for sequels and franchising in the same way that, for example, films based on comic book heroes do. And now, war films are being displaced by war games. In these games, "fidelity" and "authenticity" are interpreted as lifelike characters and environments, not as accurate representations of political and historical contexts. Games aim to recreate the visceral experience of combat, not the documentary reality of war. They highlight action, not empathy. The fact that *Six Days in Fallujah,* a game that added a layer of moral ambiguity, was withdrawn is hardly encouraging. Most importantly, though, war games are built on the illusion that gamers are participants, not spectators. In a conversation with journalist Suellentrop, a military consultant to the video game industry speaks to this problematic:

> Nearly 80,000 Americans are deployed in Afghanistan, Exum said, while 2.2 million played *Xbox Live* during a single day last fall. "There's something annoying that most of America experiences the wars in Iraq and Afghanistan, which are actually taking place, through a video game," he said. Would he feel similarly, I later asked, if Americans were heading to a movie entitled "Medal of Honor" about Operation Anaconda. "I think there is a difference between being a participant and an observer," Exum replied.

Clearly, the ability of war films to convey the "reality" of war is limited, but in light of the growing profitability of war games, even the relative complexity of war films may soon be a thing of the past.

New Men?

ROGUES, RACE, AND HEGEMONY

> I am no less a historian than those who are paid to keep the two essential facts of our condition from the people at large: the American class system (there is no such thing we are flatly told) and the nature of the U.S. empire (no such thing, either).
>
> Gore Vidal 159

PIRATES, MUMMIES, AND OTHER MINORITIES

Adventure films project colonial fantasies and offer models of how to relate to other races, other classes, and the other gender.[1] Traditionally set in foreign lands or in the distant past, adventure films are ideally positioned to negotiate contemporary problems in veiled form. In other words, they use the relation of the hero to his many "Others" to speak to the concerns of a multiethnic society fraught with racial and class conflict. As Waller points out, "today, at least one-third of Americans do not trace their origins to Europe... non-white minority groups are projected to surpass whites to become, collectively, the numerical majority of the U.S. population by the middle of the twenty-first century" (7). This situation is even more pronounced in LA, home of the Hollywood dream machine. Here, 100 languages are spoken in the public school system, and the four major racial minorities make up more than 60 percent of the population (Waller 44).

As this chapter will show, the adventure films' approach to difference both addresses and elides the reality of racism and class hierarchies today. To be sure, the freedom of minorities is of central concern in the action-adventure genre. *Zorro* (1998) features Hispanics, *The Mummy* (1999) deals with the Arab world, and *Pirates* (2003, 2006, 2007) uses the world of pirates as a catch-all category for an Other in terms of both class and race. This focus on minorities, however, does not necessarily imply a progressive agenda. Rogue films are first and foremost feel-good vehicles. They may hint at, even depict the "forbidden opportunities, unfulfilled dreams, inner guilt, tension, fear, societal strife, and diminished productivity" that define racism today (Waller xvi), but all such conflicts are happily resolved by the end of the

movie, usually through the agency of the male hero aided by a coalition of multiracial helpers.

Secondly, rogue films are equal-opportunity offenders who pair classic racial and class stereotypes with open attacks on Anglo-Saxons as perpetrators of colonial violence. On the one hand, a lack of impulse control, often defined as overindulgence of food, alcohol, and sex, is typically the vice of the group that is coded as lower class and ethnic Other. *The Mummy*, in particular, contains numerous deplorable Arab stereotypes. Of all the films discussed in this chapter, it is most beholden to the "messiah complex," depicting a white American as a savior figure and various "Others" who all need saving. Clearly, adventure films are ridden with ethnic stereotypes, but there is also an earnest striving for balanced portrayals of different nationalities and ethnicities. Greed and sadism are shown to be universal evils that afflict both the lower ranks, such as the pirates in the *Pirates* franchise, and upper-class villains, such as Don Rafael Montero (Stuart Wilson) in *Zorro*, who kills random peasants for sport. In *Zorro*, the most striking exemplar of pathological brutality is an American, Captain Love, and in *The Mummy*, American treasure-hunters are the prime embodiments of greed and trigger-happy violence.

While the pairing of traditional stereotypes with efforts at political correctness produces uneven results, the blurring of racial and ethnic boundaries represents perhaps the most intriguing feature of these films. Unlike the villains, the rogue heroes frequently straddle different classes and ethnicities. Zorro, for example, is a Mexican polished by a European education and played by a Hispanic actor. *The Mummy*'s heroine Eve has an English father and an Egyptian mother. Will Turner of *Pirates* is an overly well-adjusted craftsman, but also the son of a pirate. And Jack Sparrow, the hero of the franchise, is a pirate with dreadlocks, played by a white American.

Because rogue films are set in a colonial context, they not only represent America's "Others" but also depict the dynamic of colonizer and colonized. In this too, rogue films are highly pertinent. Even if we do not agree with Noam Chomsky, who calls the United States a hegemonic power intent on achieving global dominance (*Hegemony or Survival*), it remains true that after 9/11, the United States embarked on two wars with the declared goal of bringing democracy to foreign lands. Interestingly, all films discussed in this chapter revolve around colonial fantasies in which oppression inevitably gives way to freedom.[2] To portray this conceit credibly, they are set in the past. *The Mask of Zorro* depicts the Viceroyalty of Spain in California. Here, a white Spanish nobleman, portrayed by an English actor, and a Hispanic hero, portrayed by a Spanish actor, work together to free California from oppression by a corrupt Spaniard and a cruel U.S. officer. *Pirates of the Caribbean* builds on the Spanish conquest of the Americas and the fight of the English fleet against buccaneers and pirates in late seventeenth-century Port Royal. *The Mummy* integrates a backstory in ancient Egypt but is set in 1923, one year after Egypt gained independence from British rule. As this brief summary shows, none of the oppressive powers featured in these films is the United States.

It is tempting to trace the decline of the *Zorro* franchise and the rise of *Pirates* to changes in American politics after 9/11. In *Zorro*, the fight for freedom is represented as a struggle against colonization. During the Bush presidency, when Americans became acutely aware that they themselves are a most unwelcome occupational force

in Iraq, the theme of national independence was no longer easily available for light entertainment. In *Pirates of the Caribbean: The Curse of the Black Pearl* (2003), on the other hand, treasure is all that matters, whereas questions of territory and state-hood are elided. While all three *Pirates* films—a fourth one is in production—were spectacular box-office successes, the *Zorro* sequel *The Legend of Zorro* (2005) did not meet expectations and remains the second and last film of the franchise. Certainly, the film's focus on how to reconcile mundane family obligations with civic responsi-bilities, rather than grand passion with heroism, makes it harder to market the film to the youth audience that is crucial to any commercial success. Still, it would appear that *Zorro*'s earnest portrayal of electoral fraud and of a struggle for an independent state was out of step with its time. In contrast, the ironic and postmodern stance of the *Pirates* franchise struck a chord. To an audience that had become accustomed to Bush's axis of evil rhetoric, a hero who is not affiliated with either one of two equally undesirable regimes but successfully navigates his way between them holds great appeal. Similarly, the ironic stance of *Black Pearl* toward its own protagonist, the visual deflation of his claims to heroism, may offer some relief to viewers. Jack is a classic example of a rogue who frees "audiences from shame about human frailties, weaknesses, and failures" and removes "through laughter, the moral burden of behav-ing responsibly and heroically" (Spicer, *Typical Men* 19). The ability of the rogue to crack jokes about the threats he faces—"four of you tried to kill me, one of you succeeded," complains Jack Sparrow in *At World's End* (2007)—and his self-reflexive awareness of the absurdity of his plight—"I hate mummies," laments Rick O'Connell in *The Mummy Returns*—contribute to the enduring appeal of this type.

PRIMUS INTER PARES?

The Mask of Zorro (1998). Dir. Martin Campbell. Writers: John McCulley, Ted Elliott. Amblin Entertainment, Tristar, Sony Pictures, Distribution Columbia Pictures. Nominated for 2 Academy Awards (0 wins). Domestic Total Gross: $94,095,523. Foreign Gross: $156,193,000. Total Box Office: $250,288,523. Pro-duction Budget: $95 million.

The character of *Zorro* is a classic example of a presold commodity, much valued in a blockbuster-driven marketplace always on the lookout for favorable risk-investment ratios. Originally a pulp fiction figure created by Johnston McCulley in 1919, Zorro soon transitioned to the movies, where he was first portrayed by Douglas Fairbanks in *The Mark of Zorro* (1920). The character has not lost its popularity since. There are numerous film versions starring, among others, Tyrone Power in *The Mark of Zorro* (1940), Alain Delon in *Zorro* (1975), and George Hamilton in *Zorro, The Gay Blade* (1981), which introduces Zorro's flamboyantly gay brother Bunny and pokes relentless fun at Zorro's Spanish accent in a manner rivaled only by the faux French of Peter Sellers's Inspector Clouseau. The most recent incarnation of Zorro, Antonio Banderas, is the first Spanish actor to take on the part in a major Hollywood production. Banderas plays a second-generation Zorro next to Anthony Hopkins's "paternal" Zorro.

The Mask of Zorro shares with *Pirates of the Caribbean* its writer, Ted Elliott and several important themes, in particular an investment in freedom and a fondness for loaded symbols, such as the medallion that signifies heritage and commitment. Like *Pirates, Zorro* splits its hero into two, but unlike in *Pirates*, here one person is made to play both parts. Out of the raw material of the unkempt, ill-mannered, and shabbily dressed Alejandro emerge both Zorro, a strong and graceful fighter and passionate lover, and Don Alejandro, Zorro's cover identity as an effete aristocrat. Both *Pirates* and *Zorro* depict the genesis of a hero, and in both, heroism is defined as the proper balance of emotion and self-control.

In *Pirates*, freedom remains largely undefined. It is symbolized by the open horizon toward which Jack sails in the final scene of the first film. In *Zorro*, on the other hand, freedom takes on a distinctly political and clearly circumscribed form linked to the colonial history of the state of California. In the beginning of the film, we witness the rebellion of the people of California against Spanish rule in 1821. The departure of the Spanish governor, Don Rafael Montero, provides the background for the actual story, which takes place twenty years later when California is under Mexican rule. Don Rafael returns and seeks to set himself up as the leader of a free California. As it turns out, Don Rafael's rhetoric of freedom disguises a sinister agenda: the creation of an oppressive and exploitative regime ruled by a capitalist oligarchy of dons, a group of rich landowners with extensive holdings, under Rafael's leadership. Don Rafael's means to this end is money. He hopes to buy California from Mexico in exchange for gold, which, ironically, belongs to the Mexican government to begin with.

To highlight the absolute evil of Don Rafael's rule, the film relies on concentration camp imagery. The funds for the desired purchase stem from a place called El Dorado, which turns out to be a gold mine and labor camp. Here, slave laborers, including women and children, work in harsh conditions, exposed to the elements, deprived of food, and decimated by hazardous accidents. As mastermind of this operation, Don Rafael is guilty of the plunder of the land and the rape of the people. He is aided by Captain Love (Matt Letscher), a U.S. officer, who keeps body parts of his victims in jars on his desk. In line with the camp metaphor, Love's "hobby" conveys the absolute heinousness of this character. However, while *The Mask of Zorro* makes much of the villain's penchant for arbitrary cruelty, it is oblivious to the injustice of imposing crushing tax burdens that functioned as an important plot element in the 1940s *The Mark of Zorro*. In erasing the mundane but equally lethal aspects of oppression—inordinate taxes caused starvation—*The Mask of Zorro* opts for the spectacular, but fails to denounce the structural injustice of an exploitative economic system.

Much like classical narratives of tyrants, such as the Roman narrative of the rape of Lucretia, *Zorro* links political oppression with the violation of home and family. Before he left California for Spain, Governor Don Rafael not only deprived the people of California of their innate political rights, but also invaded Diego de la Vega's/Zorro's (Anthony Hopkins) private sphere. He killed his wife, stole his daughter, burnt down his home, and imprisoned de la Vega. When Rafael returns to California twenty years later, Diego escapes from prison and recruits a successor, Alejandro Murrieta (Antonio Banderas), whose brother was cruelly murdered by

none other than Capitan Love. Thus, for both the old and the young Zorro, heroism is linked to trauma. The hero must fight against the oppressor because he has no home left to return to.

Through the visual signifiers of the mask and the medallion, the film democratizes the notion of heroism. Because nobody knows who is under the mask, Zorro could be anybody. Zorro's anonymity is a protective shield, but it also symbolizes his connection to the people.[3] A hero, the film suggests, can hail from the humblest background. When Diego tells Don Rafael that "there are many who would proudly wear the mask of Zorro," he casts Zorro as a mass movement rather than an individual fighter. While previous *Zorro* films featured an aristocrat with a double identity, *The Mask of Zorro* selects its young hero from the peasant class. In giving his medallion to two little orphans who helped him, later revealed to be Alejandro and his brother, Diego chooses his own successor based on performance and character.[4] Zorro is not defined by a particular class status or blood ties but by his courage and commitment to the cause.

In spite of its efforts to democratize heroism, the film's political stance is riddled with contradictions. On the one hand, *The Mask of Zorro* derogates elitism and the exploitation of the lower classes, derides nobility as a romantic illusion, and advocates self-government of the people. On the other hand, the film embraces and promotes the cult of the exceptional, charismatic leader. The narrative and visual emphasis on Zorro's superhuman stunts and the numerous fight scenes that pit Zorro against dozens of opponents contrast sharply with the recurring scenes of amorphous crowds (Fig 8.1). Even though the film suggests that Zorro could emerge from any peasant's hut, it also continually emphasizes the helplessness and servitude of the average peasant and worker. In the 1940s Tyrone Power vehicle, Zorro begins as a lonely rebel but he ends up leading a revolution of peasants and dons, who all join his fight against the corrupt Alcalde. In the 1998 *Zorro*, heroism and leadership are not the privilege of

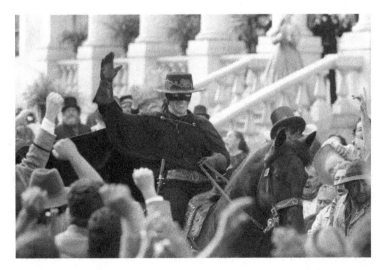

Figure 8.1 Primus inter Pares: Is the hero really one of us? Zorro (Antonia Banderas). Courtesy of Photofest, Inc.

the aristocracy, but they remain the purview of the select few. The people, though they voice their desire for freedom, never take their destiny into their own hands and never join the fight. When Don Alejandro, Zorro's pompous alter ego, declares contemptuously that sheep will always need a shepherd, we are meant to recognize that this statement contradicts everything Zorro stands for. And yet, the film does little to discredit the notion that Zorro is ultimately nothing but a good shepherd to Don Rafael's bad one.

The film seeks to reconcile its promotion of democracy and simultaneous celebration of the great and exceptional individual by portraying a leader who is both of the people and different from them, who knows how to blend in and how to stand out. This holds true for both Zorros. Although a friend of the people, Diego de la Vega is not one of them. A Spanish nobleman, he defines himself as a servant of the people. The film visualizes his straddling of two social strata through a change in costume. Diego is variously clad in his black Zorro outfit and in white peasants' garb. When the situation calls for it, he is able to perform lower class status.

In contrast to Diego, Alejandro's initial problem consists in the fact that he is too much like the people. When the old Zorro recruits his eventual successor, Alejandro is a drunken mess. Much like Errol Flynn's Robin Hood, another friend of the people whose table manners left much to be desired, Alejandro is a wild man in looks and behavior. Unlike Will Turner, the diffident lover of the first *Pirates* film who must learn to let go, Alejandro needs to be schooled in the art of repression. To become a real man and effective fighter, Zorro must be able to control his anger, curb his impulses and wait for the opportune moment. In essence, Zorro has to learn to perform upper-class masculinity. For, as Diego instructs his disciple, a nobleman is a man who says one thing and thinks another. Consequently, Alejandro has to hide his true feelings behind a mask. Clearly, in *The Mask of Zorro,* class is the result of a skillful performance. Nonetheless, when the young Zorro has proven himself, he is united with Diego's daughter Elena (Catherine Zeta-Jones). Thus, a status acquired through performance is confirmed by blood ties, and Zorro's aristocracy of the mind is rewarded with the trappings of an elevated status as he assumes Diego de la Vega's legacy.

In keeping with the spirit of the 1990s, the young Zorro is not only a proponent of political freedom, but also of gender equality. Repeatedly, Alejandro's fraught attempt to tame a wild horse is used not only to great comical effect but also as a metaphor for his relation to the other sex, in particular, his unwillingness to subdue through force and his appreciation of the free will of another.[5] Aiming for an ideal of consensual riding, Alejandro introduces himself to the horse but finds his advances rejected. When he jumps from a rooftop, he learns the hard way that his horse will not wait for him. When he relies on his horse's compliance in a fight, he has trouble just staying in the saddle. And yet, far from disciplining or resenting the strong-willed creature, Alejandro keeps trying until he and his horse make a perfectly synchronized duo.

Like horse and rider, Alejandro and his love interest Elena are portrayed as equal in passion and spirit. Elena too is a friend of the people and supports self-government. Although Alejandro retains the upper hand in his tussles with Elena, for example, when he undresses her in a sword fight, his status as a buffoon deflates his claim to supremacy. To the end, Zorro remains a bit of a stooge and clown. His fights

are bloodless, playful dances rather than violent encounters—Captain Love is the only person he kills. Invariably, Zorro, armed with nothing but a foil, triumphs over opponents with guns. Tellingly, the choreography of the foil differs from that of the gun in significant ways. Fencing is a sport of parry and riposte, not of unidirectional discharge. Zorro dominates through skill, athleticism and speed rather than muscle. Instead of killing, he mocks and taunts. His sin is vanity, not cruelty.

Zorro is not only a fighter and dancer, he is also a storyteller. Zorro's world, like that of the pirates in *Pirates of the Caribbean,* is filled with tall tales. The film is framed by the mirror images of Diego de la Vega and Alejandro telling stories that mythologize their own deeds to their infant children. Zorro is intimately linked to tradition, memory, myth, and the continuity from one generation to another. Interestingly, both *Pirates* and *Zorro* feature a narrative gap of twenty years, in which the lovers, Elizabeth Swann (Keira Knightley) and Will Turner (Orlando Bloom) of *Pirates* as well as Elena and Zorro, are shown to have aged, whereas their opponents Commodore Norrington (Jack Davenport) and Don Rafael are completely unchanged. Even more crucial than their calcification is Norrington's and Don Rafael's lack of family. Zorro lives on in his successor and in the people's myth of Zorro. And perhaps it is this aspect of his existence that democratizes the exceptional figure of Zorro after all. It is precisely because Zorro's feats are so extraordinary, because he is so exceptional, that he is a myth rather than a person. The film highlights Zorro's mythical status through the recurring image of the shadow of Zorro on his rising horse in the sunset. Zorro is not a historical hero who bails out a helpless crowd, but an ideal that inspires the people to believe in a better future; an ideal that may incite them to fight courageously or, conversely, a myth designed to make them endure oppression more willingly. After all, heroism, as Don Alejandro tells Elena, is a romantic illusion.

EX OCCIDENTE LUX

The Mummy (1999). Dir. Stephen Sommers. Writers: Stephen Sommers, Lloyd Fonvielle. Universal Pictures. Nominated for 1 Academy Award (0 wins). Domestic Total Gross: $155,385,488. Foreign Gross: $260,547,918. Total Box Office: $415,933,406. Production Budget: $80 million.

Like *Pirates, The Mummy* situates the uncanny and irrational in another culture. Like *Zorro, The Mummy* deals with treasure and greed. But unlike *Pirates* and *Zorro, The Mummy* portrays greed as a minor affliction whereas hypertrophic erotic passion has the power to destroy the world. In the ethnocentric discourse of *The Mummy,* such violent passion is housed in the Orient, while the quest for knowledge is a Western attribute. And even though the West's single-minded pursuit of knowledge also calls forth destruction and chaos, it ultimately provides the tools to contain the threat it has unleashed.

Unlike the heroines of *Zorro* and *Pirates,* whose professional aspirations remain uncertain, Evy (Rachel Weisz), the female love interest of *The Mummy,* is trained in the most glamorous of professions: she is a librarian and closet scholar. The film plays with and debunks the image of the librarian as bespectacled spinster. A victim

of gender discrimination, whose application to the Bembridge scholars was rejected multiple times, Evy takes her destiny into her own hands. Determined to find the fabled city of Hamunaptra, she literally steps over her brother's (not dead) body in pursuit of valuable hints. As it turns out, her best ticket to success is the adventurer Rick O'Connell (Brendan Fraser), who knows the location of Hamunaptra because he has been there. When Rick cannot offer his help since he is about to be executed, Evy buys his release. She does so with considerable cool, haggling tenaciously for a better price while Rick is already dangling from the noose.

When Evy first meets our hero, Rick is filthy, rude, and a complete scoundrel. In short, he is a true rogue. The adventure film, as Chapman points out, really does like its heroes "scruffy and crumpled rather than suave and sophisticated, relying on a bullwhip rather than technological gadgetry" (*License* 22). Evy is not far off the mark when she claims that the only thing that frightens her is Rick's manners. Paradoxically, the secret to his charm lies in his unwillingness to treat Evy like a lady. In the course of their acquaintance, he throws her into the river, makes her carry his guns, and half-jokingly considers trading her for a bunch of camels. In other words, he treats her like a fellow adventurer, not like a damsel in distress. Like Zorro and Jack Sparrow, Rick appreciates freedom in every form and is generous enough to extend that privilege to women as well as men. He admires Evy's spunk and is particularly taken with her refusal to obey his orders.

Unlike Zorro, who loves to quip, and Jack Sparrow, who never fights when he can palaver his way out of a situation, Rick is not a talker. He has more balls and brawn than brain. Although a buffoon like Zorro and Jack, Rick has a brutal side that neither of the other two rogues possesses. He knows how to handle a sword, but his preferred weapon is the gun. Rick is a master of cynical understatement and defiant in the face of death. While Evy is guided by a passion for knowledge, Rick follows his instincts. Together, they make an invincible pair. She understands history; he can smell danger. In essence, Rick is a bodyguard who provides physical protection so Eve can get the job done. Interestingly, the fact that Rick is the brawn to Eve's brain casts the hero in a subaltern position. Although he dominates over all opponents through his superior fighting skills, he willingly submits to Evy's intellectual leadership. When he does assert his authority, for example, when he locks Evy up in a room to protect her from the mummy, enforced confinement proves less than effective. The monster is perfectly capable of entering the room, but is scared off by a cat. Clearly, adaptability to another culture, knowledge of its fears and desires, is a necessary complement to Rick's alpha dog credentials. Just as Rick is able to appreciate Evy's talents, he is also capable of understanding other beliefs and customs.

Repeatedly, Rick's confidence in Evy makes his triumphs possible. In their pursuit of Hamunaptra Rick and Evy are trailed by a group of American treasure hunters. Like Rick, the Americans lack the requisite knowledge to locate the treasure, but unlike Rick, they make the crucial mistake of underestimating the skills of a woman. More importantly, the Americans, like the small-time Hungarian crook Beni (Kevin J. O'Connor), are driven by greed. Rick, on the other hand, does not care for gold and silver but is motivated by his affection for Evy and a general love of adventure. To Rick, Evy is the treasure.

Rick's masculinity is offset by a variety of male types including the couple's American rivals, Evy's brother Jonathan (John Hannah), Rick's sidekick Beni, and the daredevil British pilot Winston (Bernard Fox). In this lineup, the Americans are the machos. Their ultramasculinity, however, is revealed to be utterly dysfunctional. Sexism, ignorance of Egyptian culture, and trigger-happy pleasure in violence lead to their speedy demise. Whereas the Americans are too masculine, Jonathan is somewhat effeminate. His unstoppable verbalizations contrast with Rick's manly taciturnity. Jonathan is a whiner, miser, and gambler, whose career is at a low point when we first encounter him. He is smug and fearful, and his occasional successes tend to be the result of dumb luck rather than actual skill. His ethics too are somewhat problematic. Whenever it suits his purpose, he cheats, lies, and steals. Jonathan lacks a moral compass, but the absence of ideals is compensated for by his ability to feel affection for others, in particular his sister.

While Jonathan lacks ideals, the Royal Air Force pilot Winston has too many. Winston loves nothing better than an opportunity to die for a worthy cause and gain glory in doing so. Rick, on the other hand, is a modern cynic who falls short where Winston excels, namely in his commitment to the community at large. When the careless treasure hunt unleashes an ancient mummy along with the ten plagues of Egypt, Evy feels responsible and wants to stop the creature. Rick, however, cares only about his and Evy's well-being. Saving the world, as he points out, is not in his contract. While the heroes of savior films tend to doubt their ability to save the world, Rick never questions his skills but lacks motivation. Zorro would have liberated California even if Elena had turned him down, and Jack lifts the Aztec curse even though he and the heroine are not destined to be together. Rick O'Connell, in contrast, might not have saved the world if it had not been for Evy's steady guidance.

In *Guilty: Hollywood's Verdict on Arabs after 9/11,* Jack G. Shaheen writes that "Arabs remain the most maligned group in the history of Hollywood" (xi). Certainly, *The Mummy* does little to better the situation. The 1999 reworking of the mummy theme owes much to its eponymous Hammer Studio predecessor released in 1959. In the Hammer Studio version, the mummy also owes its existence to the illicit love of a priest, who attempts to resurrect his beloved and is buried alive as punishment for his presumption. In both versions, the Westerners embark on a quest for knowledge while Arab characters want to keep the past buried. The difference consists in the fact that, in the 1959 film, the Arabs perceive the Westerners as blasphemous and resent the disrespect with which the Western archeologists treat a God in whom they still believe. In 1999, the Medjai, descendants of the Pharaoh's bodyguards who keep watch at the mummy's grave, are not portrayed as religious, but simply want to protect the world from the grave threat of a resurrected mummy. In the 1959 film, a nefarious Arab fanatic directs the actions of the mummy, while the 1999 version features the Medjai and, in particular, their leader (Oded Fehr) as valiant fighters who contribute significantly to the final defeat of the mummy. Still, in the end, it is Rick's leadership and Evy's expertise that win the day, and the Medjai are left to express their eternal gratitude and respect.

Probably aiming for balance (and comic effect), *The Mummy* presents a starkly polarized picture of the Arab world, a racial equivalent of the whore-saint dichotomy.

On the one hand, there is the buffoonish and greedy Arab prison warden (Omid Djalili), who accompanies our heroes to the City of the Dead. Hungry for treasure and not too bright, he collects scarab gems that turn into flesh-eating bugs and penetrate through his skin to his brain. Although somewhat more individualized, the prison warden is but one of many dispensable Arabs, quintessential red shirts, ranging from the Arab helpers at the gravesite, the first victims of the booby-trapped grave, to the Arab followers of the resurrected mummy, who walk like zombies and are killed at random. On the positive end of the spectrum, there are the Medjai, princes of the desert, who excel in beauty, strength, and wisdom. They are presented as asexual—they have no family ties, and, as a desert people, are at a remove from the community at large—and their proud demeanor expresses great dignity. The Medjai are remnants of Egypt's glorious past. Unlike the other Arabs in the film, they are not corrupted by modernity. But even Ardeth, the leader of the Medjai, remains a subordinate character, second fiddle to Rick's grand hero.

At first glance, it would appear that American and Arab characters are prone to the same human failures and capable of the same accomplishments. Some, like Rick and the Medjai, display courage, others, such as the prison warden and Jonathan, succumb to greed. This equality, however, is undermined by the contrast between the two pairs of lovers: Imhotep (Arnold Vosloo) and the Pharaoh's mistress Anck Su Namun (Patricia Velasquez) versus Rick and Eve. The resurrected priest Imhotep, the protagonist of an ancient tale of passion that functions as a preface to the story of Rick and Eve, cares only for his own desires and those of his beloved. To be united with his lover, he is willing to defy the Pharaoh and commit murder. Not even the punishment he incurs for his crime, the Hom-Dai, an ancient form of torture, can diminish his passion. Once he is de-mummified, Imhotep immediately sets his sights on resurrecting his beloved and cares little about destroying the world in the process. Clearly, the biggest possible threat is presented by the man who sets his own satisfaction above all.

In *The Mummy,* the Western model of love proves to be far superior to the Arab one. While Imhotep gives free reign to his passion and shows no regards for others, Rick, reluctantly, and Evy, eagerly, subordinate their personal desires to a shared moral code. In the Arab world, passion is irrational and asocial. The opening scenes set in ancient Egypt depict a world of sexual excess and murder. There are eunuchs, a mistress whose nakedness is highlighted by revealing body paint, and a gruesome torture scene. If Imhotep's passion is to be prevented from wreaking havoc, it must be buried and carefully guarded for eternity. In the West, in contrast, love is tempered by morality and becomes socially productive.

In the Arab world, carnage results from lust. In the West, disaster is courted by uncontained curiosity and passion for knowledge. While the mummy unleashes the seven plagues, Evy is, in the words of the director of the Museum of Antiquities (Erick Avari), herself a plague. Endowed with an extensive background in history, anthropology, and linguistics—she reads and writes ancient Egyptian—Evy is also exceptionally courageous as well as singularly determined in her pursuit of knowledge. In one of the first scenes, her determination to put every book in its correct place causes a minor disaster in the ancient library. While she is blissfully unaware of the hazardous consequences of her curiosity, the Medjai are attuned to the dangers

of the invisible world. In this, the film reiterates the age-old cliché of the Orient as uncanny and irrational, but it also validates the Arab worldview, not least through its investment in dazzling special effects.

At first glance, it would seem that believing in the reality of ghosts is a sign of superior insight while the pursuit of knowledge is a dangerous enterprise. In the end, however, it is knowledge that carries the day. Even though Evy's overdeveloped curiosity awakens the sleeping mummy, her skill and erudition, aided by Rick's courage and strength, also lead to the final defeat of the mummy. The Westerners tame the forces they have raised and earn the gratitude of the Arab people, and the Western pursuit of knowledge along with its support for equal rights for women triumph over the Oriental effort to keep the past hidden. Although the film includes an attractive Arab role model, the freedom it is concerned with is not that of a former colony—after all, the film is set in 1923, one year after Egypt had gained formal independence—but that of the Western lifestyle.[6]

POSTREALISM: THE WORLD ACCORDING TO JACK

Pirates of the Caribbean: The Curse of the Black Pearl (2003). Dir. Gore Verbinski. Writers: Ted Elliott, Terry Rossio. Walt Disney Production. Nominated for 5 Academy Awards (0 wins). Domestic Total Gross: $305,413,918. Foreign Gross: $348,850,097. Total Box Office: $654,264,015. Production Budget: $140 million.

Pirates of the Caribbean: Dead Man's Chest (2006). Dir. Gore Verbinski. Writers: Ted Elliott, Terry Rossio. Walt Disney Production. 1 Academy Award. Domestic Total Gross: $423,315,812. Foreign Gross: $642,863,913. Total Box Office: $1,066,179,725. Production Budget: $225 million.

Pirates of the Caribbean: At World's End (2007). Dir. Gore Verbinski. Writers: Ted Elliott, Terry Rossio. Walt Disney Production. Nominated for 2 Academy Awards (0 wins). Domestic Total Gross: $309,420,425. Foreign Gross: $651,576,067. Total Box Office: $960,996,492. Production Budget: $300 million.

In the traditional swashbuckler movie, the hero is a pirate and outlaw, but also committed to freedom and justice. If he is Errol Flynn, he owes his existence as a pirate to a blatant miscarriage of justice (*Captain Blood*, 1935), to his patriotic fervor for his country (*The Sea Hawk*, 1940), or his determination to defeat the pirates by spying on them (*Against All Flags*, 1952). In any case, he is not a pirate because of his flair for the criminal, but because of an unusually bad fortune or outstanding courage and patriotism. Thus, the dashing hero gets to live a sparkling life of adventure while possessing all the qualities required in a good husband and citizen. Once justice is restored and his services are no longer needed, the pirate hero willingly returns to the peace and quiet of a settled life—at least until further notice.

Pirates of the Caribbean: The Curse of the Black Pearl departs from this pattern in important ways. First of all, it no longer features one hero but splits the swashbuckler into two, the dashing, but morally unsound outlaw, portrayed by Johnny Depp, and the loyal but slightly boring model citizen (Orlando Bloom). Although the latter gets the girl—he marries her in the third installment of the franchise—it is the

pirate of rather questionable character who holds his audience spellbound. Tellingly, Will does not qualify as a lover until he too is revealed to be part pirate. The film remains ambiguous about which of the two it favors, an ambiguity that is particularly pronounced in the second film *Pirates of the Caribbean: Dead Man's Chest.*

Secondly, unlike the traditional Errol Flynn vehicle, which restores justice in the end, Gore Verbinski's pirate saga does not end with the reinstatement of the rightful sovereign or the reaffirmation of social rules. Rather, *The Curse of the Black Pearl* is marked by a distinctly postmodern agenda. The two opposing forms of social organization presented in the film—the pirate societies in Tortuga and on Barbossa's ship and the British military regime in Port Royal—do not constitute a dichotomy of good and evil, but differ merely in the specific ways in which they fall short of allowing their citizens meaningful lives. In the traditional mold, the hero sets out to punish and correct a violation of the social order and overrides personal needs in pursuit of a higher ideal of justice. In *The Curse of the Black Pearl,* in contrast, Johnny Depp's Captain Jack Sparrow fascinates not because of his idealistic commitment to a cause but because of his ability successfully to circumnavigate society's obstacles in pursuit of his own needs. In essence, the film celebrates a pirate who has always ignored rules, and rewards a citizen who has learned how to bend them.

When we first meet Jack Sparrow, the highly entertaining pirate hero of questionable morals and unsalutary drinking habits, he stands poised against the horizon gazing into the distance while the camera circles around him (Fig 8.2). His posture and the camera work create the impression that Jack is the captain of a mighty ship. A wide-angle shot, however, reveals that he commandeers a boat that is not only tiny but in the process of sinking.

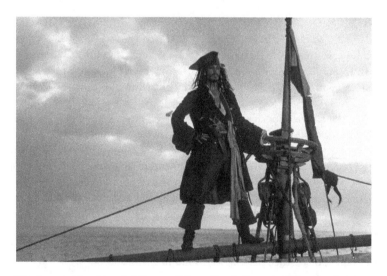

Figure 8.2 A man with a vision: Jack Sparrow (Johnny Depp). Courtesy of Photofest, Inc.

This ironic treatment accompanies Jack throughout the film and the franchise. In another scene in *The Curse of the Black Pearl,* for example, Jack inspects his crew of newly hired sailors. The viewer perceives a pitiable crowd of miscreants, but Jack,

waving a banana, acts as though he is dealing with King Arthur's knights. Clearly, to Jack, masculinity is all about performance, and the world is what you choose to make of it. If we recall that 2003, the year when *The Curse of the Black Pearl* was released, is also the year in which George W. Bush dressed up as G.I. Joe and unilaterally declared victory in Iraq from the deck of the USS *Abraham Lincoln,* then Jack's comical distortion of reality appears in a new light. As the Bush government sold propaganda as truth, *The Curse* invited viewers to laugh at the preposterousness of Jack's attempts to convert blatant failure into spectacular triumph.[7]

Although the film uses the contrast between Jack's actual and his self-proclaimed status to great comical effect in a manner that undermines any claim to heroic stature, it also celebrates his panache and the transformative power of the imagination. In one of the introductory scenes, Jack has no ship, no crew, no gunpowder, and a compass that does not point north, but he still insists on being addressed with the respectful moniker Captain. Surprisingly though, as viewers are still chuckling at his daring but ill-founded presumption, Jack promptly hijacks the fastest ship of the British navy. It is no accident that the concept of "parlay" plays such a prominent role in the film. Throughout, Jack shows the most amazing ability to parlay nothing into something. Jack is not only a testimony to the superiority of performance over essence but also an embodiment of the most crucial Hollywood tenet: the power of dreams, even of the most ridiculous and impossible dreams, to transform an unsatisfactory reality into a world of delight.

While Jack is all performance, Will Turner, his civilian counterpart and the heroine's love interest, is all substance, but, at least initially, does not know how to perform. Jack is too much in touch with his wild side, while Will is too servile and a bit boring. In spite of their respective shortcomings, both Jack and Will represent desirable forms of masculinity. Although Will is still a boy and suffers from overly pronounced impulse control, he rises to the occasion and displays courage and skill when the situation calls for it. Similarly, although Jack's rings and ornamental clothing, flailing gestures, and dainty way of walking, famously modeled on Keith Richards, should render him effeminate, his masculinity remains unquestioned. Jack's slurred speech creates the impression of chronic inebriation, and his stunts and bravado, accompanied by much grimacing and eye-rolling, often take an embarrassing turn. Jack is a bumbling fool, but he is also a hero who fights valiantly, at least when it is too late to run away, and who faces danger head-on—occasionally. Jack is a new kind of action hero, a composite of masculine idol, swashbuckler, stooge, and flaming queen.

What distinguishes Jack and Will from all other characters in the film is their status as outsiders in their own communities, a status that is all the more appealing as both societies are portrayed in a negative light. The pirate community in Tortuga is characterized by lawless anarchy, while the British society of Port Royal is one of systematic oppression and violence. The film narrates the difference between these two forms of social order as a difference between emotional regimes. The pirates of Tortuga are slaves to their desires. Their lives are given to sensual overindulgence, an endless cycle of drinking, eating, bar brawls, and sex. "Violent, dissolute creatures the lot of them," as Norrington claims, pirates have a criminal bent and are greedy and incapable of controlling their impulses. Their guiding maxims are "take what you

can, give nothing back" and "any man who falls behind is left behind." Moreover, in addition to the pirates of Tortuga, there are the pirates on Captain Barbossa's ship, cursed and condemned to eternal life without being able to experience any feelings or earthly pleasures, including food and drink. Dead to joy and pain, they do not represent the antithesis of life in Tortuga, but its logical consequence: a dulling of the senses that results from a lifetime of excess.

While the pirates are defined by either the overwhelming dominance or the complete absence of sensual experience, the British of Port Royal repress all feelings. Unlike pirates, who live their sexuality freely, the men of Port Royal master theirs by channeling their erotic impulses into destruction.[8] It is tempting to read the pirates as the id to the British superego; drives can be repressed, but, like Barbossa's men, they cannot be killed. The British of Port Royal appear to have no other purpose or goal in life but to make war, execute offenders, and march in straight lines. Particularly Commodore Norrington, the commander of the British garrison in Port Royal, has one overarching ambition: securing "a short stop and sudden drop" for as many pirates as he can possibly catch. Even Will is tainted with this particular British malaise. Too timid to woo his beloved Elizabeth, he spends his days welding swords. When he boasts to Jack that he practices sword fighting three hours every day, Jack quips: "You need to find yourself a girl, mate."

While the film need not expand any particular effort to highlight the undesirability of life in Tortuga—the occasional shot of a drunken sailor lying in pig shit is more than sufficient—it uses the characters of Will and Elizabeth to illustrate the destructive nature of British society. Unsurprisingly, in the British outpost, the repression of one's feelings is played out as a subjugation of the subaltern, namely women and the lower classes. In spite of his many talents, Will is repeatedly passed over because of his social standing. Subordinate to an alcoholic blacksmith, Will does all the work and gets none of the credit. Clearly, the American dream that talent will be rewarded with success does not apply in Port Royal. Secondly, in addition to the exploitation of the lower classes, the film also depicts the oppression of women. When we first encounter the heroine Elizabeth, Governor Swann's daughter, she is fitted a fishbone corset and cannot breathe. Her dress and, as viewers understand, her environment are so stifling that she ends up fainting and falls into the ocean. Significantly, she is saved by Jack, who volunteers reluctantly when he realizes that no other rescuers are forthcoming. While fishing her out of the water does not revive her, tearing open her corset does. It is because Jack refuses gallantry that women can breathe in his company.

The film uses Elizabeth's three potential lovers to present us with a choice of different kinds of masculinity: the stolid Commodore Norrington, who locks Elizabeth up to protect her and, were he to marry her, would most likely stage a gruesome execution in honor of their nuptials; Jack, who offers freedom but lacks reliability—the episode in which Jack and Elizabeth are stranded on an island, uncover a secret stash of rum, and dance the night away in a drunken stupor aptly prefigures what the future would look like should Elizabeth choose him. And finally Will, who possesses Norrington's reliability and devotion, but lacks Jack's sparkle. Of these three, only Norrington is dismissed outright while the film keeps both Jack and Will in play. The fact that both have their moments prolongs Elizabeth's inability to settle and

keeps the suspense alive. But it also questions the fantasmatic investment in the one and only lover who fulfills all desires and suggests that there is a compromise in either choice.[9]

While *The Curse of the Black Pearl* portrays the difference between two societies as a difference in emotional regimes, it also frames the battle with one's own emotions as an encounter with another culture. The pirates who work for Barbossa are a motley crew of lower-class and racially diverse characters. Through them, drives and lack of impulse control are visualized as the province of a social and racial Other. The encounter with this "Other" is crucial to the plot, the consolidation of the British Empire, and to the myth that undergirds the plot. Tellingly, the act that sets everything in motion is a crime of colonial exploitation. Captain Barbossa's pirate crew raids the fortress of Port Royal because they seek to recover a piece of gold currently in the possession of the film's heroine. This medallion is one of many pieces of Aztec gold, given to Cortes to prevent him from killing the Aztecs during the colonization of the Americas by the Spanish in the sixteenth century. Because the gift did not stem Cortes's slaughter, the heathen gods avenged the insult to their people by placing a curse upon the gold. When Barbossa and his men stole what had already been stolen, they too fell under the sway of the curse.

Because the plot is motivated by the theft of the Aztec gold, *Pirates* deals with two different groups of colonizers, the Spanish who subjugated and slaughtered the Aztecs and the English who conquered Jamaica. Historically, the pirates of Port Royal functioned as a lynchpin between the two. When England did not yet dare to attack Spain directly, they sponsored buccaneers to rob Spanish ships on their behalf, many of whom were operating out of Port Royal. When the pirates had outlived their usefulness, the British sought to quell piracy, and Port Royal acquired a reputation as a place of execution.[10] Of course, historically, the crimes of the New World went unpunished, whereas in the fantasy world of *The Curse* colonial crimes come back to haunt those who commit them.

Although viewers might expect that the British, unlike their pirate counterparts, abide by legal and moral guidelines, the film, in fact, undermines this notion. In *The Curse of the Black Pearl,* the operative distinction is not one between moral and immoral or selfish and altruistic behavior, but between honesty and hypocrisy. As Jack tells us, "a dishonest man you can always trust to be dishonest, it's the honest ones you have to watch out for." It is not only the pirates who violate their own code, but also the British. The main difference consists in the fact that the pirates, unlike the British, do not pretend to abide by rules. The film abounds with promises that are broken and rules that are being violated. Norrington promises not to kill Elizabeth's rescuer and promptly has him arrested for hanging. He refuses to save Will out of respect for the law, but changes his mind a moment later when Elizabeth promises to marry him in exchange for his help. Needless to add that Elizabeth's promise to Norrington is also made to be broken as soon as Will declares his love for her. And it is this last example that should tip us off to the fact that, though the two lovers appear to be the exception to this habit of selfish rule-breaking, their devotion to each other simply represents a happy coincidence of selfishness and altruism. After all, when Will claims that, unlike pirates, he is not obsessed with treasure, Jack points out that "not all treasure is silver and gold, mate."

In the sequel *The Dead Man's Chest* (2006), the difference between selfish actions and those guided by moral precepts is blurred even further. In the showdown, when the Kraken, a formidable sea monster, attacks Jack's ship, Jack uses an opportune moment to remove himself from the action. However, once he is safely removed, he glances at his compass, a device that points in the direction of its owner's most ardent desire, and returns to the ship to fight the beast. Although in helping his crew and friends Jack is finally doing the right thing, he is also following his desire for Elizabeth, to which the audience has been alerted through numerous allusions. Conversely, when Elizabeth then shackles Jack to the mast to effect her own rescue and that of the entire crew, leaving Jack to be devoured by the monster, her seemingly selfish act may in fact be an altruistic sacrifice. Throughout the film, Elizabeth has been shown to have feelings for Jack and when she kisses him and then leaves him, she may well be acting against her own heart to save those to whom she feels responsible. In both *The Curse of the Black Pearl* and *Dead Man's Chest,* there are selfless acts of devotion, such as Will's commitment to his father, but, for the most part, doing the right thing is simply the result of a fortuitous coincidence of desire and morals. Being a pirate and being a good man are not contradictory categories but integral parts of an inseparable mesh. In the postmodern world of the *Pirates,* idealism is defunct, irony is thriving, and the ending is eternally postponed.

It would appear that the postmodern skepticism of *The Curse of the Black Pearl* speaks to the contradictions and cynicism that defined political life during the Bush presidency. The conflict in the film is not one between an empire of evil and an empire of good, but between two societies that are both deeply flawed. In the end, Will does not replace the inept authority figure, as does Errol Flynn in *Captain Blood,* but engages in an act of defiance. When he frees Jack from the hangman's grip, Will performs what is most likely the only truly selfless act in *Black Pearl*. But it is not just the altruistic impulse that viewers admire. Rather, instead of restoring order, Will demonstrates that, like Jack, he now knows how to navigate the system. *The Curse of the Black Pearl* has given up on society. Instead, it teaches its heroes how to satisfy their needs and maintain a modicum of morality in a society that is essentially beyond reform. What is required is not a set of firm guidelines but a constant negotiation of conflicting needs. And while this may be an apt depiction of our postmodern condition, it is also a perfect prerequisite for a sequel. After all, at the end of *Pirates,* Norrington does not release Jack. He merely allows him a head start.

Dead Man's Chest and *At World's End* were filmed simultaneously and share one continuing plot line. In spite of this continuity, they differ greatly in mood and outlook. *Dead Man's Chest* exhibits the lightheartedness of *The Curse* while *At World's End* introduces a somber tone and effects a radical redefinition of the terms of the franchise. In the third film, the moral ambiguity of the first film gives way to a clearly defined dichotomy of good and evil, and ham-fisted rhetoric replaces playful irony. Pirates are no longer morally questionable characters, but mankind's last hope for freedom, and the pirate code is no longer interpreted as a guideline that can be willfully ignored or reinterpreted, but is obeyed to the letter. Will is no longer an upstanding, idealistic citizen and goody-two shoes, but a driven character who embraces betrayal and cuts deals with the enemy to accomplish his ends. And Jack,

though internally divided and quite possibly insane, repeatedly engages in selfless actions to benefit the larger good.

The Curse of the Black Pearl takes place at a time when the British no longer derived any benefit from condoning buccaneering, but took to hanging pirates instead. Because of this, the film revolves around discipline and punishment, but does not investigate the economical consequences of this change in policy. Historically, the extermination of piracy produced an economic crisis since Port Royal was sustained by the riches gained through high sea robbery, a crisis that was soon relieved by the windfalls of a new British venture, the slave trade.[11] The second film of the *Pirates* franchise elides human trafficking, but is centrally concerned with the transition from casual robbery to systematic capitalist exploitation. In *Pirates of the Caribbean: Dead Man's Chest,* dissolute pirates and uptight British are both obsolete. Instead, we witness a stand-off between the representatives of a formidable capitalist enterprise, the East India Trading Company (EITC), a fictionalized version of the British East India Company, against Davy Jones (Bill Nighy), a character who embodies the elemental power of the sea itself.

In the third installment of the series, Davy Jones has been hamstrung into service to the EITC, but a multicultural confederacy of pirates takes up the fight against the evil corporation. Since pirates are now the sole champions of freedom and since *At World's End* can hardly champion the right to random robbery and lack of impulse control that characterized the pirates in *The Curse,* the film clandestinely and nonsensically redefines pirates as solid citizens and hard workers. The pirates of the future will rule the sea by the sweat of their brow and defend the freedom and civil rights of their fellow citizens.

Dead Man's Chest portrays the East India Trading Company, led by Lord Cutler Beckett (Tom Hollander), as a vicious global enterprise intent on empire building and on expanding its reach into the farthest corners of the globe. Even the Pelagostas, a cannibalistic tribe of natives on a far-off island, who, for reasons that remain mercifully unexplained, have taken Jack captive, season their prospective pirate dinner with spices provided by EITC. The EITC controls every port and crushes its competition through fees and tariffs. At the beginning of *At World's End,* its powerful monopoly appears incontestable since the company now possesses Davy Jones's heart, which allows its owner to control the sea itself.

At World's End begins with a somber scene, in which EITC is cast as a murderous organization responsible for the abrogation of civil rights. On a mission to eradicate piracy, the corporate giant oversees the mass execution of anyone suspected of piracy or associating with pirates. While suspected pirates line up for the noose, an agent of EITC proclaims the terms of an emergency decree that revokes the right to assemble, the right to legal counsel and to trial by jury. The grim declaration is accompanied by shots of large piles of corpses, evocative of Holocaust imagery. Through this scene, the fight against the EITC is defined as a fight for civil liberties and freedom. Peculiarly, however, the political context established in this scene is completely dropped thereafter. There is not a single further reference to civil rights, and the relations between EITC and the British government remain undefined. The only trait that is established beyond any doubt is the company's overriding goal of profit maximization. "Loyalty

is no longer the currency of the realm," Beckett informs Governor Swann (Jonathan Pryce), "currency is the currency of the realm." Thus, the brief introductory nod to political topicality remains an isolated episode, utterly disconnected from the rest of the film, which quickly returns to the tried and true trope of greed. While *The Curse of the Black Pearl* connected to the contemporary political situation by showcasing absurdity, *At World's End* undermines the grandness of its declared political purpose through narrative vacuity.

In *The Curse of the Black Pearl*, all characters are engaged in selfish pursuits. In contrast, *Dead Man's Chest* features characters who are at a loss as to what their true desires are. In *At World's End*, the characters reconnect to their purpose, but in the process, trust is eroded and betrayals abound. In *The Curse*, happiness is open to all who pursue it single-mindedly. In *At World's End*, every minute of happiness comes at a price. "For what we want most, there is a cost must be paid in the end." *The Curse* delights its audience by suggesting that there are third terms beyond the dichotomy of good and evil. In *At World's End*, necessity limits one's options. As Jack tells us, "the world is still the same, only there's less in it."

NARCISSUS TRIUMPHANT

In her article on *Spartacus*, Ina Rae Hark submits that the conflict between a rebel hero and a tyrannous political regime is frequently featured as a dichotomy between narcissism and the Law (163). Rae Hark's observation also describes the films discussed here since in all of them politics is transposed into psychology and the reality of oppression is transformed into the rhetoric of repression. Again and again, discourses of race and class are overlaid with a politics of emotions and the dichotomy of tyranny and democracy is recast as a difference in emotional regimes.[12] Freedom and democracy, according to this vision, do not require structural components such as a functional bureaucracy and an independent legal system; rather, they are the result of proper impulse control. Overindulgence of one's senses and being cut off from one's feelings are the extremes that the hero must learn to navigate in order to succeed in his fight for freedom.

Although rogue heroes inevitably learn to make concessions to the law, they manage to retain a good deal of their originary narcissism. Jack Sparrow, in particular, would seem to be an ideal example of Greven's theory that "narcissism is a potentially radical mode of male sexuality that can defy normative codes and categories of gender whereas masochism, far from being radical, has emerged as the default mode of a traditional, normative masculinity" (19).[13] Rogue heroes are decidedly masculine, but they occupy the fringes of traditional manhood, inches away from the threat of effeminacy. Tellingly, both Zorro and Jack Sparrow of *Pirates* are associated with the sword, not the gun. Zorro's fights are like dances, and his exploits athletic and graceful, not brutal or lethal. Jack's stunts lack Zorro's carefully calibrated grace but impress through their tottering and wobbling defiance of gravity. Both Zorro and Jack Sparrow exhibit typical character traits of the classic rogue. They are talkers and charmers. Their style is tongue-in-cheek, and their heroics are reminiscent of buffoonery rather than mastery. Rick O'Connell of *The Mummy* is closer to the traditional hero of the shoot-'em-up action film, but he too lacks the cold efficiency and determination of

the typical action hero. A true cavalier, Rick's devotion is to his lady while his actual mission is secondary. Rick, like Zorro and Will of *Pirates,* is a male Cinderella whose courage and strength allow him to marry far above his social station.

Because the films are set in the past, the heroes in this chapter are, as Tony Thomas suggests, *Cads and Cavaliers.* And yet, although the films discussed here portray colonial settings, the freedom they celebrate is not necessarily that of a country. Rather, it is the freedom of a lifestyle (including the free pursuit of knowledge), of a social class or the female gender. To be sure, there is a gender imbalance. While the films are studded with male stars, there is never more than one lead actress. And yet, the female leads in these films enjoy a great deal of freedom and equality even if they pay for this with splendid isolation. In the adventure genre, heroines thrive because the heroes themselves view the demands of traditional masculinity with a good deal of ironic detachment.

LOVERS: MEN, WOMEN, AND GENDER EQUALITY

ROMEO REDUX?

Romantic comedies are ideally positioned to explore changes in the relation between the sexes. Amid an atmosphere of laughter and gaiety, they test the flexibility of traditional gender hierarchies, ponder the compatibility of professional success and emotional fulfillment, and seek to police the boundary between intimacy and violence.

During the presidencies of Clinton and Bush, gender relations underwent significant changes. Feminists greeted Clinton's presidency with sentiments of hope. Unlike all presidents before him, Clinton had framed his bid for the highest office as a joint enterprise (John F. Harris xviii). In a two-for-one gamble, both he and Hillary were going to work for the common good.[1] The Clinton administration placed several women in prominent positions, including Madeleine Albright as secretary of state, Janet Reno as attorney general, and Ruth Bader Ginsburg, a lawyer with a proven record of women's rights cases, as a Supreme Court judge. This record paled, however, as Clinton's legacy became identified with his extramarital affair with the White House intern Monica Lewinsky.

While Hillary Clinton never conformed to the traditional notion of the First Lady, Laura Bush played the part to perfection. She distanced herself from the political arena and assured voters that "my life really began when I married my husband [. . .] I give my husband some counsel, but I actually think counsel or advice from a spouse ends up being nagging" (qtd. in Ducat 19). Laura Bush never exhibited any of the political ambitions that so clearly inspired Hillary Clinton. And her decidedly conservative approach to her role as First Lady was in tune with a general conservative realignment of gender roles after 9/11. In her book *The Terror Dream,* Susan Faludi claims that the collapse of the twin towers was seen as a "symbol of the nation's emasculation" (9), which resulted in the desire for a "reconstituted Cold Warrior manhood [. . .] A new John Wayne masculinity was ascendant" (4). We have already seen that this trend to reverse the assumed feminization of men is clearly visible in a number

of male-dominated genres. But it also had an impact on romantic comedies, albeit in a more subtle form.

Traditionally, romantic comedy is a genre that caters to women. Thus, male romantic leads are allowed to, even required to, possess "feminine" qualities. In her study of popular romance novels and their readers, Janice Radway claims that although romantic heroes are often rich, intelligent, and powerful, there is another quality that matters more: "The romantic fantasy is [. . .] not a fantasy about discovering a uniquely interesting life partner, but a ritual wish to be cared for, loved, and validated" (83). Even if the romantic hero is a man's man, as is Nick in *What Women Want,* he cannot be a desirable lover until he becomes capable of emotionally nurturing his mate. This "feminine" quality differentiates the lover from other screen versions of masculinity and situates him in close proximity to the figure of the loser. To prove his worthiness, the lover must be willing to throw his dignity to the wind and make a fool of himself. Conversely, the unsuitable lover is always defined as the one who seeks to control and command the heroine. While a 1930s screwball comedy icon such as Clark Gable was able to combine sex appeal with a touch of physical violence (see Trice/Holland, *Heroes* 19–27), in recent films such as *Titanic* and *Wedding Crashers,* it is the soon-to-be-discarded fiancé who is identified with violence and mastery.[2]

Clearly, the only kind of violence permissible in the ideal lover is the one necessary to defend women and children. Thus, at first glance, Faludi's claim that 9/11 ended the days of "the vaguely feminized, rakish man-child of the 1990s (Leonardo DiCaprio)" (*Terror* 74) does not appear to apply to romantic comedies.[3] In the romantic comedy, male machismo remains a problematic concept that must be handled with care. And yet, although lovers are decidedly more feminine and empathic than the average hero of the spy or superhero film, violence and he-manship did gain in importance in romantic comedies of the post-9/11 period.[4] After all, *Mr. & Mrs. Smith* introduces a professional assassin as love interest, even if the film relentlessly ironizes its use of violence. It is also not accidental that Gerard Butler, the star of the bloodfest *300* (2007) and of a mini series on Attila the Hun (2001), became eligible as romantic comedy material, evidenced by the success of films such as *The Ugly Truth* (2009) and *The Bounty Hunter* (2010).

Interestingly, Bush-era movies not only flirt with male machismo, but also ironize the New Man. In *Titanic* and *What Women Want,* both products of the Clinton era, the he-man is presented as dated goods. If the rogue does not reform, he will land on history's trash pile. In contrast, in the two comedies from the Bush era, new-style masculinity is subjected to relentless parody and irony. While the first two films are characterized by their earnest desire to propagate a new kind of man, the latter playfully reintroduce machos and poke fun at new male sensitivity. Finally, while *What Women Want* relates the hero's individual transformation to larger social changes (women's increasing importance as consumers), and while *Titanic,* however spuriously, pretends to attack class barriers, both *Wedding Crashers* and *Mr. & Mrs. Smith* lack comedy's traditional "movement toward social renewal" (Rowe 180). Here, change is confined to the romantic protagonists, who are cut off from society at large.[5] Aside from the couple, everything is one big joke.

BOY HEROES AND REFORMED ROGUES

Titanic (1997). Dir. James Cameron. Writer: James Cameron. Twentieth Century Fox. 11 Academy Awards (14 nominations). Domestic Total Gross: $600,788,188. Foreign Gross: $1,242,413,080. Total Box Office: $1,843,201,268. Production Budget: $200 million.

What Women Want (2000), Dir. Nancy Meyers. Writers: Josh Goldsmith, Cathy Yuspa. Paramount Pictures. Domestic Total Gross: $182,811,707. Foreign Gross: $191,300,000. Total Box Office: $374,111,707. Production Budget: $70 million.

James Cameron's *Titanic* swept the Oscars and continues to top lists of the biggest box-office successes of all times.[6] The film owes its blockbuster status to its impressive special effects, its proudly displayed financial excess,[7] exquisite cinematography, and a canny mix of genres, including romance, historical epic, disaster, and adventure film. Its appeal derives from its depiction of star-crossed lovers—"Romeo and Juliet on the Titanic," as Cameron described it (qtd. in Bernstein 17)[8]—and its idealizing portrait of America as the land of opportunity, where social success is based on individual achievement, not heritage (Sakeris 220).

James Cameron, who wrote and directed the film, embeds the love story aboard the *Titanic* in a story set in the contemporary United States. Brock Lovett (Bill Paxton), a treasure hunter, charters Russian equipment to search the wreck of the *Titanic* for an invaluable diamond, the heart of the ocean, which once belonged to Louis XVI. The diamond is assumed to have sunk with the infamous ship because one of the passengers, the multimillionaire Cal Hockley (Billy Zane), presented it to his fiancée Rose DeWitt Bukater (Kate Winslet) as an engagement gift. When reports of Brock's mission to locate the missing diamond are broadcast on national television, the 101-year old Rose contacts Brock and tells him the story of her engagement to Cal, her love affair with a working-class lad, Jack Dawson (Leonardo DiCaprio), and her survival. Rose had been forced into a marriage of convenience by her mother, Ruth (Frances Fisher), because the family was impoverished and had nothing left but its good name. Through her encounter with Jack and her experience of the calamity, Rose realizes that wealth is transitory and chooses to abandon her fiancé. Unsurprisingly, the old Rose's narration of love and death has a cathartic effect on her contemporary audience, who also learn to reject mammon in favor of life. "Three years I thought of nothing but *Titanic*, but I never got it, never let it in," declares Brock, who finally understands that the shipwreck of the luxury liner is not about treasure but about the irrecoverable loss of life.

In her study of screen romance, Nochimson refers to the complicated and often contradictory relationship "between simplistic plot and highly indeterminate image" (23). Though Nochimson does not discuss Cameron's movie, *Titanic* is a prime example of this dynamic. The film is rife with contradictions, the most egregious of which is the contrast between the purported repudiation of mammon and the visual love affair with excessive wealth.[9] *Titanic* obsessively details every luxurious feature of the outsize ship and revels in the costly jewelry and clothing of its first-class passengers. The camera lovingly outlines the splendor of the grand staircase and

dining hall, the ornate wood paneling, and exquisite furniture and dwells on the pristine, sparkling newness of the ship's decks and corridors. The contradiction between the supposed rejection of wealth and its adoring celebration culminates in the last two scenes of the film. First, the old Rose tosses the diamond, which had been in her possession all along, in the ocean. This ending corresponds to the beginning, in which the riches of the ship are presented as elements of a vast vanitas vanitatum scene. As Brock's submersible floats through the wreck, we see a broken chandelier and a doll buried in sand, all reminding us of the impermanent nature of earthly possessions. The second ending, in contrast, does not build on this motif but transposes the obsession with wealth into a heavenly beyond. The scene begins with an image of Rose in her bed. Either dreaming of her death or dying, Rose, adorned with a diamond necklace, reenters the grand staircase on the ship where all who died in the disaster await her arrival. Rose and Jack are reunited in a vision of divine luxury.

Titanic is a classic example of what Philip Green calls the "American version of class transcendence as inverse snobbery: Who needs equality since lower is better anyhow?" (21).[10] The film celebrates its working-class hero Jack and denigrates his multimillionaire opponent Cal Hockley. Cameron's characterization of the romantic rivals is truly one-dimensional. Jack is a carefree, happy fellow, an artist who has no money, nor does he need any.[11] Courageous, smart, and altruistic, Jacks asks for nothing but air in his lungs and a few sheets of paper. Like the biblical lilies in the field that do not toil nor spin, Jack trusts that each day will take care of itself and he is proven right. He wins his ticket for the ship in a Poker game and the love of the heroine simply by being himself. "Life's a gift and I don't intend on wasting it," Jack declares, and through him, Rose comes to realize that she needs to make every day count. Unlike many comedies, *Titanic* does not use "transgressive romance as a vehicle for social critique" (Wartenberg 3). The film's message is existential, not political. In spite of its seeming critique of class hierarchies, *Titanic* does not argue for a redistribution of wealth, but offers a quasi-religious, baroque reminder of the transitory nature of all earthly possessions.[12]

While Jack is everything one wants in a lover, Cal is selfish, snobbish, and unfeeling, a character without any redeeming qualities whatsoever. Jack is a talented artist, whereas Cal thinks buying art, including that of Picasso, who Cal predicts will not amount to anything, is a waste of money. When Rose is sad, he gives her jewelry, and when she does not obey his commands, he hits her in the face. Cal is not interested in Rose as a person, but considers her part of his property. He orders dinner for her and wants to control what she reads and with whom she converses. Life with Cal is life in a gilded cage. Though even the dumbest of viewers should have made out Cal's character after the first scene, the film tops it off by contrasting Jack and Cal's behavior during the catastrophe. Jack endangers his own life when he tries to save a little boy, while Cal first ignores and then grabs an abandoned little girl, pretending to be "all she's got" in order to be allowed onto one of the rescue boats. Cal survives, not because of his money—though he does attempt bribery—but because of his ruthlessness, while Jack dies because of his inner nobility and capacity for love.

Like Jack, the unsinkable Molly Brown (Kathy Bates) is an example of the film's romanticization of the lower classes. Although she is one of the first-class passengers, Molly is "new money," graced with what the film codes as a working-class-specific

lack of pretension and hypocrisy. As an upstart, Molly is constantly subjected to the condescension of her peers. But when thousands are dying in the water, Molly is the only one willing to turn around her half-empty rescue boat to pick up survivors.

It is not only the film's representation of social class that is rife with contradictions, but also its portrayal of Jack and Rose's love. Obviously, the film idolizes Jack and condemns Cal. And yet, Cal survives while Jack dies in the icy water, and the reunion of the lovers is relegated to the great beyond. Thus, the film appears to suggest that a love like that of Jack and Rose is not meant for this world. This interpretation is supported by the fact that Cameron equates Jack and Rose's love to a natural force that is destructive of social conventions and ultimately of life itself. When Jack takes Rose to a party in the third-class quarters, the film regales its viewers with the "romanticized expression of working-class joviality" (Malin, "Classified" 84), but also with a good deal of drinking and violence. Jack teaches Rose how to spit, guzzle beer, and curse. To defend her love, Rose gives people the finger, tells them to "shut up," and punches them in the face. Encouraging her to abandon the niceties of civilization, Jack not only teaches Rose how to survive, he also restores her to a "natural state," one that precedes both the norms and deformations inflicted by society. But even though the film celebrates this natural state and buys into "the American myth of a fall into social life" (Michael Wood 33), it also acknowledges the dangers involved. Tellingly, the iceberg, another force of nature, hits the ship immediately after Rose and Jack have sex.[13] In fact, the sailors in the lookout first watch Jack and Rose kissing on deck after their secret tryst and then turn around to face the iceberg. The ensuing catastrophe shows that once society's rules have been dissolved, protection from violence and ruthlessness disappears along with stifling restrictions. Jack's death in the icy water is a captivating example of male self-sacrifice—the piece of wood paneling that saves Rose's life cannot support both of them—but it also puts a convenient end to a love that is destructive of all social conventions and safeguards. The film celebrates the "redemptive power of erotic love" (Trice/Holland, *Heroes* 207), but it also presents great love as incompatible with everyday life. The only appropriate mediums for Rose and Jack's love are the vastness of the ocean and the infinity of heaven.

Titanic has often been praised for its convincing portrayal of a female heroine, who starts out as a kept woman and develops into a tough survivor.[14] Trice and Holland, for example, speak of a "power inequity in favor of the female protagonist" (*Heroes* 208). Indeed, Rose, who is a spoilt brat when we first meet her, ends up wading through water, wielding an ax, yelling at people, and even punching them in the face. In spite of these impressive images of female strength and resourcefulness, though, the film adheres to a traditional pattern that defines romantic love as the site where female identity is constructed (Evans/Deleyto, "Introduction" 3).[15] In other words, Rose's toughness and fighting spirit are justified because she defends her love.

A similar paradox informs the reference to Rose' future life. Although viewers are told that Rose learns to make every day count, visually her 101-year life consists of her few days with Jack, while the remaining 84 years are reduced to a couple of snapshots, none of which include her husband and four children. All of these photos, which show Rose on horseback and as a pilot, illustrate her future freedom and independence. But they also indicate an important contradiction. Although the film purports to show a character who learns how to shun false compromises, it also

asks us to believe that Rose spent several decades of her life married to a man who does not even merit inclusion in her photo collection. On the one hand, *Titanic* asks viewers to accept loss as an inescapable fact of life or rather to embrace life precisely because it is so fragile. And Rose's happy and fulfilled life after the calamity is offered as proof of the feasibility of this imperative. On the other hand, it visually denies the reality of this life in favor of a promise of heavenly transcendence. Finally, in spite of its proclaimed celebration of life, the film does not shrink from the sentimentalized and sensationalist exploitation of images of death and dying during the sinking of the infamous ship.

As the figure of the old woman (Gloria Stuart) as narrator indicates, *Titanic* emphasizes the superiority of experience and memory over science. When one of Brock's employees shows off a computer simulation of the sinking ship, the old Rose responds dryly, "Thank you for the forensic analysis; of course, the experience of it was somewhat different." Even after 84 years, Rose's recollection of the event proves superior to every scientific reconstruction. Of course, in James Cameron's capable hands, memories become pictures, including, as we might extrapolate, moving pictures. Although Rose is presented as narrator, her voice is subordinated to the visual representation of events. Tellingly, Rose laments that she does not have a picture of Jack, but the film makes up for her lack. Ultimately, it is not Rose's memory, but the movie itself that offers a counterweight to the overwhelming experience of death.[16]

Like *Titanic* and unlike *Wedding Crashers,* which offers a romantic comedy from the male point of view, *What Women Want* revolves around female fantasies. Its director, Nancy Meyers, made her name as an expert at female wish fulfillment. Her film *Something's Gotta Give* (2003) responds to the plethora of media images of old men dating young women with a narrative of an older woman (Diane Keaton) who has her pick between a young lover (Keanu Reeves) and an old one (Jack Nicholson). *What Women Want* caters to two female fantasies: the working girl's dream to have it all, career and love, and the fantasy of the rake's reformation. It achieves this by telling the story of a rather unusual cross-dresser. Although Nick Marshall (Mel Gibson) remains male in appearance, he can hear women's thoughts and gradually develops the ability to impersonate the female psyche. In this, *What Women Want* offers a variation on an established stock character of romantic comedy: the "apparently misogynistic man [who] possesses a latent capacity to be another kind of lover, one who combines strength and tenderness" (Studlar 31).

Although it caters to female fantasies, the plot of *What Women Wants* focuses on its hero, Nick. Whereas traditional romantic comedies are the arena of the unruly woman (King, *Comedy* 131), Nancy Meyers's film sets the stage for an out-of-control guy. When we first meet him, Nick Marshall is an avatar of male chauvinism, a true man's man, whom the film defines as "the leader of the pack, a man other men look up to" and "the kind of man who just doesn't get what women are about." To make its point, the film presents Nick in relation to a number of different women, including his daughter, his ex-wife, his housekeeper, his door woman, and several of his assistants and colleagues at the office, thus establishing that Nick is offensive to women in every context, romantically and professionally. Charming but ruthless, he beds every passing stranger, expects to be waited on hand and foot, uses his Ivy League-educated assistant to get his clothes from the dry cleaner, and freely dispenses

his dirty, sexist jokes to all his female coworkers. Nick does not know how old his daughter is and forgets her birthday along with her boyfriend's name. In short, he is unfeeling, smug, and unduly proud of his male equipment—"Grande, or at least I like to think so," he quips when he orders a cappuccino. Although, as Philip Green points out, in Hollywood film, "there is no such thing as a male slut" (92), Nick comes pretty close. Appropriately, the film uses "Mack, the Knife" as Nick's theme song and underlines its interest in hierarchies of power through frequent low- and high-angle shots.

Although Nick's chauvinism is more pronounced than that of his coworkers, the film insists that it is by no means exceptional. Nick's colleague Morgan (Mark Feuerstein) is blithely uninterested in women's inner lives since he does not think they have any. Nick's boss Dan Wanamaker (Alan Alda) is the type of man who offers cigars to reward employees, and the boyfriend of Nick's daughter has only one goal in this relationship: to get into her pants. The film also does little to exonerate Nick. His behavior does not cover up some vulnerability motivated by a previous romantic disappointment. Nor is Nick an unwilling participant in a rat race of male competition in a brutal marketplace. The film holds Nick fully responsible for his behavior, but it also explores female complicity in male chauvinism.

While the film's interest in female complicity adds to its complexity, the nod to the age-old cliché of blaming the mother is less than intriguing. We are told that Nick's mother "just about killed it for every woman Nick would ever meet." As the only son of a Vegas showgirl and the beloved pet and mascot of the entire female cast of a strip show, Nick grew used to being pampered by a horde of doting women. While this bit of Freudian trivia rehashes conventional sexist narratives, the film's presentation of everyday female complicity in male machismo is well worth our attention. Repeatedly, the film shows that although every woman in his life resents Nick's behavior, few of them actually voice their opinions and stand up for themselves. His female colleagues pretend to be amused by his jokes, his assistant smiles when she runs his personal errands, and his dates fall for his insipid pickup lines.

When Nick finally does change, his transformation is presented as the result of magical intervention: he electrocutes himself with a hairdryer in the bathtub. Clearly, nothing short of accidental electrocution and a near-death experience can turn an insensitive macho into an understanding father, lover, and colleague. And yet, the circumstances in which this accident occurs and Nick's journey from initial shock to gradual enlightenment suggest that no such miracle is required to effect change. Interestingly, the electrocution occurs when Nick seeks insights into the female psyche through a variety of female consumer products. To come up with convincing, female-oriented advertisement strategies, Nick experiments on himself. He volumizes his hair, waxes his legs, applies mascara, and puts on panty hose and a wonderbra. As this scenario indicates, Nick's willingness to explore the Freudian dark continent of female sexuality and its accoutrements triggers his change.

It is not accidental that the film casts Mel Gibson, a paragon of high-octane masculinity, in the role of Nick. Only a true hero would dare to go where no man has gone before, the uncharted territory of female thoughts. And only a true hero of Mel Gibson's muscular build would get away with wearing lipstick and panty hose without appearing effeminate and weak (Fig 9.1). Nick's transformation has already begun

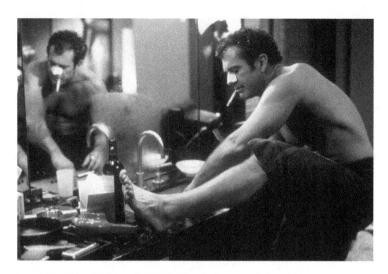

Figure 9.1 A New Man? Nick Marshall (Mel Gibson). Courtesy of Photofest, Inc.

before the actual miracle occurs. Magic may have jumpstarted Nick's makeover, but it was triggered by his courageous determination, and most importantly, it remains incomplete until he progresses from simply hearing women's thoughts to actually listening to them. Moreover, the film suggests that Nick could have arrived at some of his insights without the benefit of magic. In his daughter's case, for example, the problem lies not with Nick's inability to divine her thoughts but with his unwillingness to listen to what she is saying loud and clear (including her boyfriend's name). Nick's real education begins when he stops eavesdropping on women's thoughts and makes an effort to understand their fears and dreams. Gradually, his behavior changes, he stands up for female interests, and takes the woman's side in arguments. In this, the film again combines a feminist message with a rather sexist assumption. Although Nick's advocacy of women's interests is helpful, it also implies that it takes a man to turn a woman's life around. Nick teaches his female colleagues to stand up for themselves and changes all their lives for the better. What they have not accomplished in years, Nick achieves in a couple of days.[17]

While Nick embodies a female fantasy, his love interest, Darcy McGuire (Helen Hunt), is a female role model. Darcy is beautiful, smart, successful, and morally flawless. Ungrudgingly, she gives credit where credit is due (and even where it is not—as in Nick's case) and rejoices in Nick's success. Unlike most other women in the film, Darcy always says what she thinks, and the film celebrates her honesty. While traditional romantic comedies often present a model of male heroism that "requires the sacrifice of female autonomy, a kind of obsessive, automatic, Hollywood taming-of-the-shrew reflex" (Nochimson 109), *What Women Want* introduces a heroine who is independent, ambitious, and competitive. In the end, Nick and Darcy are reunited romantically even though she has just fired him. Moreover, while traditional romantic comedies are built on a model of "mutual transformation" (Wartenberg 57), Meyers's film charges its male hero with the sole burden of change. And even though this causes a narrative focus on the male protagonist, it also conveys the message that

Darcy is fine the way she is. Rather, it is the world and men like Nick who need to adjust to her needs. One of the most intriguing scenes in this context is the response of the pre-transformation Nick and his colleague Morgan to Darcy's welcome address to the team. Nick and Morgan, who label Darcy a man-eater and bitch on wheels before they have even met her, frown, grimace, and roll their eyes during her inspiring and competent speech. Although this scene is rather short, it does provide an insight into what life is like for women like Darcy in a world that has not benefitted from magical intervention.

Interestingly, *What Women Want* presents an economic argument for the need to take women's desires and needs into account. "In the '90s men stopped dominating how our dollars were spent. Women between the ages of 16 and 24 are the fastest growing consumer group in the country," Wanamaker informs his bored employee Nick. He concludes that "if we don't evolve and think beyond our natural ability, we're gonna go down." It is not a stretch to assume by implication that a film industry that ignores its female audiences is doomed to founder. In *What Women Want,* the macho is yesterday's model. An outdated version of masculinity, he will be discarded unless he learns to change.

NEW MEN?

Wedding Crashers (2005). Dir. Dave Dobkin. Writers: Steve Faber, Bob Fisher. New Line Cinema. Domestic Total Gross: $209,255,921. Foreign Gross: $75,920,820. Total Box Office: $285,176,741. Production Budget: $40 million.

Mr. & Mrs. Smith (2005). Dir. Doug Liman. Writer: Simon Kinberg. Regency Enterprises, Twentieth Century Fox. Domestic Total Gross: $186,336,279. Foreign Gross: $291,871,241. Total Box Office: $478,207,520. Production Budget: $110 million.

Wedding Crashers combines the plot of a classic novel of maturation with the romantic comedy motif of "transformation-through-love" (King, *Comedy* 51). In the course of the film, John Beckwith (Owen Wilson) and Jeremy Grey (Vince Vaughn), two freeloaders who like to crash weddings, bed every female available, and procure purple hearts so they will not have to pay for drinks, turn into emotionally responsible and committed individuals. Theirs is a Peter Pan problem. They are growing older, but they are not growing up. John and Jeremy are philanderers and unreconstructed bachelors in the manner of Rock Hudson, but the film departs from the model of *Pillow Talk* (1959) in important ways. Unlike Rock Hudson's Brad Allan in *Pillow Talk* or his Jerry Webster in *Lover Come Back* (1961), John and Jeremy are not high-powered professionals surrounded by the trappings of material success. But then again, unlike the Rock Hudson characters, they are exceptionally well developed in other ways.

Traditionally, the genre of romantic comedy focuses on the development and desire of the female heroine, but in *Wedding Crashers* the male protagonists occupy center stage. This reversal both reifies male dominance and upsets established gender roles. While the "nervous romance" of the 1970s and '80s focused on the "melodramatised male" (Krutnik 22), *Wedding Crashers* introduces the hysterical male.

Here, John's love interest Claire (Rachel McAdams) lacks insight in people and can neither understand nor articulate her desires, whereas John and Jeremy are highly attuned to the mechanics of human emotions and constantly verbalize their feelings toward each other. In one of its most innovative moves, *Wedding Crashers* sheds the heritage of the buddy movie and of the Western and its silently bonding men (Wexman 86) and celebrates a verbal and emotional male friendship.

While John and Jeremy embody a new model of masculinity, Claire is a rather traditional character, the quintessential heroine of a comedy of remarriage (Cavell 56) who has "to learn the positive content of her own desire" (Wartenberg 52). Rich, sheltered, and engaged to the wrong man, her situation resembles that of the female lead Ellie in *It Happened One Night* (1934), but unlike Ellie, Claire is all sweetness and lacks spunk. Although she enchants with her captivating smile and her willingness to speak the truth, Claire remains an underdeveloped character who is not situated in any professional setting or shown to have any aspirations beyond the family context. John, on the other hand, could not be more different from the alternately brooding and smug he-man hero of the Clark Gable variety. He is a master of empathy with clear insights into the complex web of human emotions and social expectations.

Both John and Jeremy possess many qualities identified with the sensitive man of the 1990s. Their profession itself is a testimony to their capacity for empathy. They excel as mediators in divorce proceedings because they know and can verbalize what others feel and want. A far cry from the traditional man who cannot express his feelings, Jeremy, in particular, is expert at parsing and analyzing his own emotional responses. His lengthy description of the awkwardness of the first date is Proustian in its detailed and accurate evocation of every minute sensation. It is also a showcase of rampant insecurity.

Janice. I've got the perfect girl for you.
Jeremy. Janice, I apologize if I don't seem really eager to jump into a forced awkward intimate situation that people like to call dating. I don't like the feeling. You're sitting there, you're wondering do I have food on my face, am I eating, am I talking too much, are they talking enough, am I interested, I'm not really interested, are they interested, should I play like I'm interested, but I'm not that interested, but do I wanna be interested, but now she's not that interested, so all of a sudden I'm starting to get interested. When should I kiss her, should I wait for the door 'cause then it's awkward, it's like good night, you do like the ass-out hug, we hug each other like this and your ass sticks out because you're trying not to get too close or you go right in and kiss 'em on the lips or don't kiss 'em at all. It's very difficult to try and read the situation. And all the while, you're really just wondering are we gonna get humped up enough to make some really bad decisions. [. . .] Hey, Janice, great talk!

Jeremy is that rarest of creatures, a male hysteric, and it is largely due to his presence that, from beginning to end, *Wedding Crashers* is filled with psychobabble.

While Jeremy's unstoppable verbalization is borderline psychopathic, John's emotional competence expresses itself in the socially acceptable form of understanding and kindness. John is a good listener who takes a genuine interest in his fellow men and women. Repeatedly, he is shown to comfort and encourage others. He offers

valuable advice without hurting people's feelings. His and Jeremy's emotional intelligence also shapes their relationship with each other. They are committed to each other, openly declare their love for each other, and engage in lengthy discussions about their relationship. Because they are attuned to the unspoken, they are also effortlessly capable of adapting to another culture. They crash Jewish, Indian, Irish, Italian, Chinese, and Wasp weddings and always manage to blend in. At the Jewish wedding, they shout Mazeltov, dance the Hava Nagila, and toast l'Chaim; at the Irish wedding, they drink excessively; at the Wasp wedding, they bring a tastefully wrapped gift of "fresh Wyoming air."

It is not only John and Jeremy's unusual emotional and verbal competence that serves to feminize the characters. In the thrall of his sexually adventurous love interest Gloria (Isla Fisher) and her gay brother, Jeremy is a victim of rape, not once but twice, an experience that he summarizes as "I felt like Jody Foster in *The Accused*." First Gloria comes to his room at night, gags him, ties him to the bed, and proceeds to have sex with him. Then her brother Todd (Keir O'Donnell) appears and intends the same, albeit with less fortuitous results. Interestingly, this feminization does not render John and Jeremy any less attractive. On the contrary, because they are in touch with their feelings and know how to express them, John and Jeremy are ideal romantic partners. To be good husbands, they do not have to acquire new skills. They merely have to apply what they already know to one woman instead of the entire gender. Moreover, what keeps them from committing is in itself a desirable character trait: their enormous capacity to have fun, to enjoy life, food, alcohol, dancing, and sex. Thus, once John falls for Claire and Jeremy for Gloria, the ending is a foregone conclusion. Indeed, the love story itself offers little suspense. Rather, it is the film's skillfully staged conflict between old- and new-style masculinity that keeps viewers interested.

Wedding Crashers introduces a stark contrast between John and Jeremy's new masculinity and the old-style macho attitude of Claire's fiancé, Sack (Bradley Cooper). Sack is abusive, insensitive, violent, and smug. Twice, he brutally beats John up and is unfaithful to Claire even before the wedding. While John goes for a bike ride with his girl, Sack goes quail hunting and plays touch football. In spite of his machismo, even Sack has caught on to the fact that times are changing and seeks to brush up his image with a veneer of new masculinity. To this end, Sack, who worked for "Habitat for Humanity" and was involved in an organic scallop farm project, is now seeing a Buddhist about his competitive streak. Sack is poised to follow in the footsteps of Claire's father, a successful politician, and his union with Claire embodies the traditional "dynastic marriage," associated with the conservation of property and power—"two great American families, the Clearies and the Lodges will finally unite," as Claire's father puts it—while John stands for the "companionate ideal" (Wexman 76).

Clearly, the film has no sympathy for Sack's machismo. And yet, it also exhibits a certain discomfort with the New Man that is wholly absent in *Titanic* and *What Women Want*. The problematic potential of the New Man is particularly visible in the character of the legendary Chaz (Will Ferrell), John and Jeremy's role model. Chaz not only mirrors and magnifies the theme of arrested development, he is also an epitome of empathy gone awry. Chaz lives with his mother and spends his days

on the sofa watching cartoons in his pajamas. In spite of this, he attracts an endless succession of female bedfellows. Instead of weddings, Chaz now crashes funerals and uses his empathic skills to prey on widows. Chaz demonstrates what the future holds in store for John and Jeremy. Both Chaz and his disciples not only embody a new type of masculinity, they also exploit the image of the new man shamelessly.

The film's interrogation of the new man's viability is also evident in John and Jeremy's skillful impersonation of traditional he-men, which comes in handy when they try to seduce women. In their pursuit of female bedfellows, the wedding crashers claim to be bankers, bullfighters, soldiers in the French Foreign Legion, venture capitalists, football professionals who played with the Yankees, and adventurers who climbed Mount Everest. Since this approach works, we must assume that machismo is newly fashionable. Still, the film does not validate the old ideal of tough masculinity, but rather identifies it as a bad habit that the heroes must shed once they meet the right girl. Moreover, even as they perform ultramasculinity, John and Jeremy make a show of dancing with children and old ladies, making balloon animals, engaging in lively conversation, telling jokes, and enjoying the food. Although *Wedding Crashers* pokes fun at both new and old men, it ultimately stages the "triumph of wimp power" (Spicer, "Reluctance" 80) that is associated with the new romantic comedy. It is the "nice, fundamentally decent, easy-going and sensitive" guy who wins the day (Spicer, "Reluctance" 83).

Although *Wedding Crashers* rejects Sack's old-style masculinity, it tempers its portrayal of male sensitivity with strategically placed reminders that we are not dealing with sissies. To begin with, both John and Jeremy are hypersexualized. Wherever they go, exceptionally beautiful women vie for their attention and sexually insatiable predators seek them out for their pleasure. It is not only Vince Vaughn's physical stature that re-masculinizes his character, but also the nature of his psychobabble. Jeremy may be a male hysteric, but when his subconscious speaks, it does not only obsess about personal insecurities but voices wildly inappropriate sexual fantasies usually revolving around being a cocksman, getting some strange ass, and "eye-fucking" (whatever that is). Secondly, even as party crashers, John and Jeremy adhere to a strict code of military ethics whose foremost rule demands that one never leave a fellow crasher behind. When Claire's fiancé shoots Jeremy in the butt in the course of John's pursuit of Claire, he complains, "You leave me in the trenches taking grenades." Of course, the film pokes fun at the use of military references in a decidedly unmilitary context, but in doing so, it still situates its male protagonists in a martial framework.

In sum, *Wedding Crashers* is committed to the model of the New Man, but it remains aware of the viability of he-men and of the problematic aspects of the new model. Moreover, the film's tendency to ironize both old- and new-style masculinity parallels its self-contradictory muddle of political ideologies. The film pokes fun not only at homosexuality but also at Claire's outrageously homophobic grandmother. When Todd, Claire's gay brother who looks and acts like Frankenstein's nephew, climbs into Jeremy's bed in a misguided attempt at seduction, he is told in no uncertain terms to get back into the closet. In spite of this rebuff, however, Jeremy shows respect for Todd's desire when he insists on keeping a picture of himself in the nude that Todd had painted for him. Here, as throughout the film, it is difficult

to tell whether we are dealing with critique, parody, or a "simple re-enactment of stereotypes" (King, *Comedy* 152). The film lambastes liberal politics, in particular, environmentalism, which is consistently portrayed as a glib tool for the seduction of eligible females. Sack is the president of the environmental defense league because it is an ideal hunting ground for one-night stands. To impress Claire and her family, Sack claims to have rescued otters exposed to an oil spill, while John and Jeremy pretend to invest in a company called Holy Shirts and Pants that "takes the wool from the fur of sheep and turns it into thread for the homeless people to sew." This might be read as a rejection of liberal politics, but it could also be seen as a critique of a party culture that takes nothing seriously and subordinates everything to the greater goal of having fun and "getting some ass."

Still, the film remains blithely evasive even when it explicitly references politics. Although Claire's father is secretary of the Treasury, we never know which political party he works for, nor do we learn anything about his politics aside from the crucial fact that John really enjoyed his position paper on economic expansion in Micronesia. Tellingly, the hero's conversion from promiscuity to monogamy is not accompanied by renewed professional zeal or political commitment. Rather, in *Wedding Crashers*, "reconciliation at the individual level implies, or sidesteps, the reconciliation of broader thematic issues" (King, *Comedy* 55). Even though the film sets it sights on maturity, it ends as it began. The final scene shows John, Jeremy, Claire, and Gloria in a cabriolet planning to crash their next wedding as folk singers from Salt Lake City. In the absence of worthier pursuits, the party must go on.

Mr. & Mrs. Smith shares its title with the 1941 Hitchcock comedy starring Carole Lombard and Robert Montgomery as a married couple who reevaluate their relationship when they learn that because of an administrative fluke, their marriage is not legally valid. As the provenance of its namesake indicates, the 2005 *Mr. & Mrs. Smith* fits the mold of the classic remarriage comedy of the screwball era with its fast-paced, witty dialogue. The film's excessive display of violence, however, and its pairing of violence and humor mark it as a product of the postmodern era.[18]

Although the star personas of Brad Pitt and Angelina Jolie signal anything but everyman qualities, the film introduces its romantic leads as an average American couple. Both their last name, Smith, and their first names, John and Jane as in John and Jane Doe, signal exchangeability. John and Jane struggle with the typical problems of a marriage that longs for a union of equals but remains stuck in traditional gender stereotypes and the stifling routines of suburban life. The Smiths have all the trappings of the American dream. They live in a beautiful colonial house, have two posh cars, and pick up their newspaper in their bathrobe holding a mug of coffee. Underneath this façade, however, there is much hostility and unhappiness.

In a delightful but also disturbing twist, *Mr. & Mrs. Smith* uses the figure of the professional assassin as a metaphor for marital troubles. As John's colleague Eddie (Vince Vaughn), a fount of wisdom on relationships, points out when Jane runs over John with her car, "they all want to kill you. At least, she's upfront about it." *Mr. & Mrs. Smith* bears some resemblance to *Grosse Pointe Blank* (1997), which lambastes the moral vacuity of the modern professional through its contract killer protagonist. But whereas *Grosse Pointe Blank* focuses on the period of courtship, John and Jane Smith have progressed from romance to couple therapy. In a most skillful way, the

film uses its central conceit as a means to literalize, visualize, and ironize emotional clichés. Since John and Jane are undercover agents, their marriage is, of course, a sham. When they try to shoot each other, the meaning of the colloquial insult "you're killing me" becomes laughingly obvious. When they lie to each other about their basic identity and profession, we realize what it means to lead separate lives. In their jobs, they have exciting experiences and get to shine. At home, they are miserable and always at their worst. When they stand on the rubble of their house, which they have just blown to smithereens, we understand that theirs truly is a broken home (Fig 9.2).

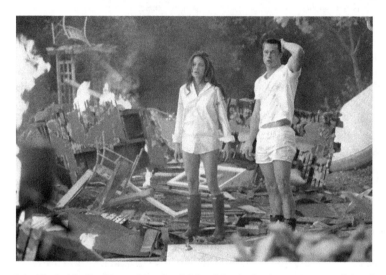

Figure 9.2 The Smiths (Brad Pitt and Angelina Jolie) and their broken home. Courtesy of Photofest, Inc.

Moreover, home and family are not the only dangerous terrains. You also have to "make a killing" in your job. When John comes home from work, he has blood on his shirt; when he discusses finance with his neighbors, they call the stock market a bloodbath where your assets get butchered.

In her study of screen chemistry, Nochimson differentiates between "star power that rocks old ways of thinking and star power that gilds tired old clichés" (10). Banking on Brad Pitt's boyish charm and Angelina Jolie's sex appeal and superhero credentials as *Lara Croft: Tomb Raider* (2001), *Mr. & Mrs. Smith* undermines traditional gender roles by seeming to confirm them. Although John Smith is obviously a killer, he is not a macho. To begin with, John studied art history in college, not exactly a subject that signals ultramasculinity. He is a boy with big toys, not an agent in the mode of James Bond. Depending on one's perspective, he is either unreliable or spontaneous. He forgets commitments, does not plan, and is prone to juvenile gestures. While Jane plans every mission down to the last detail, John relies on improvisation, buffoonery, and bluffing. And yet, he is not only Jane's equal, but a veritable female fantasy. While Nick's transformation progresses from exploitation to empathy, John sheds his seeming indifference and rekindles the passion that characterized the beginning of the relationship. In spite of all this, however, and his art history degree notwithstanding, John is not an exemplar of the New Man. He is a female fantasy not

because he is an exceptionally good listener, but because he truly cares and because he is exceptionally competent at protecting his wife.

Like Nick, John loves his mate even though she is superior to him in many ways. Tellingly, his cover identity is a contractor while Jane is "batwoman for computers." Whereas Jane's headquarters are downtown and equipped with the latest high-tech gadgets, John's shabby office is in an industrial district. While Jane has an entire fleet of highly educated young women at her beck and call, John employs one old woman as secretary. Jane is always five steps ahead of John. She has bigger guns, killed more people, and cheated in more sophisticated ways. After all, John brought his real parents to their wedding, whereas Jane hired actors. Their relationship is fiercely competitive, but when it comes down to it, John is happy about Jane's success and proud when she exceeds expectations. When his friends mock him that he has got "his ass handed to [him] by a girl," John shakes it off. He loves Jane precisely because she is not a Stepford wife. John has staying power. Even though Jane tries to kill him, he yells back at her, "I'm not going anywhere." Unsurprisingly, in the final confrontation with his wife, John is the one who gives in. But he is also the one who saves Jane's life in spite of her demonstrated superiority. Although Jane is the dominant partner and John the one who has to swallow his masculine pride and do her bidding, the film emphasizes that when it really counts, John prevails. After all, John could have killed Jane if he had wanted to, whereas Jane, who actually does try to kill John, fails to do so because of his cunning. John has a clear shot at Jane when she rappels out of her building, but does not take it. Jane, on the other hand, detonates a bomb convinced that it will kill him, but is foiled because John anticipated her every move. In *What Women Want*, Nick's willingness to put on panty hose and mascara signals his qualification as a lover. In *Mr. & Mrs. Smith*, John's skill with his gun and his willingness to share his weapons with his wife prove that he is an ideal partner.

Still, the film does not simply glorify the male protector, but depicts a union of equals that is based on love. John and Jane's difficulties do not stem from a basic incompatibility. Rather, the couple is stuck in unhealthy routines and equally unhealthy gender roles. *Mr. & Mrs. Smith* describes the difficulty of creating a part-nership of equals in an environment that encourages and rewards traditional gender divisions. Again, the film relies on the metaphor of contract killing to turn gender into a running joke. Jane keeps her mortal instruments behind the oven, while John stores his cache of weapons in the tool shed. Jane works in a team; John works solo. When John makes a hit, he pretends to be drunk and plays poker in a backroom. When Jane gets ready for the kill, she dresses up as a dominatrix. In keeping with this basic premise, the film also frames the failure of John and Jane's marriage in gendered terms. Jane is the typical female control freak who approaches her "marriage like a job, something to be re-conned, planned, and executed," while John handles conflict through avoidance. She wants somebody she can count on while he needs more air to breathe, room for mistakes and spontaneity. Repeatedly, the film shows that both protagonists are stuck in gender roles that do not suit their personalities or desires. Characteristically, Jane's cover identity says that she was in the Peace Corps, whereas John pretends to have attended MIT. Jane feels responsible for putting dinner on the table even though we later learn that she has never cooked a day in her life. When the couple visit a fair and stop at a sharp shooter booth, Jane pretends that she does

not know how to use a gun, until John's excellent marksmanship provokes her to reveal her true talents. John, on the other hand, is continually mocked by his male friends and coworkers because he is not the boss in his house. When Jane and John go to a party at their neighbor's house, they are immediately separated along gender lines. "Let's go see the girls," the hostess shouts and directs Jane toward a roomful of women with babies who discuss their husbands' promotions and additions to the kitchen. John is offered a cigar and invited to share his insights into the stock market. Clearly, it is not only John and Jane's own internalized gender roles that pose a problem but also their environment.

Because John and Jane's unhappiness is caused by the much praised suburban lifestyle and everything that it carries in its wake, it is the total destruction of the suburban home that makes it possible for them to reconnect. Once they have completely demolished their entire furniture and all appliances, they can finally allow the other a glimpse of their real past life and experiences. For added emphasis, the destruction of the ideal home happens not once but twice. The demolition of their colonial is followed by the final shootout, which takes place at HomeMade, a store that sells kitchen appliances and furniture. The destruction of the fantasy of suburban happiness along with its mannequin inhabitants makes a final reconciliation possible. Appropriately, while the destruction of their own home has the couple stripped down to their underwear, John and Jane wear identical suits in this scene, a sign perhaps that they have finally found a way to coexist as true equals. They have certainly found a way to deal with their most pressing problems. When Jane is in a jam in the shootout, John proves that he is there for her when she really needs him. Jane's predicament highlights female vulnerability, but it also shows that John can be dependable when it matters. Similarly, Jane stops putting John down and expresses his appreciation for him when she tells him that there is nowhere she would rather be than right here with him. Like many romantic comedies, *Mr. & Mrs. Smith* defines female empowerment emotionally, not professionally. Jane does not need to find her identity and gain confidence in the workplace. Rather, like Darcy McGuire, she is faced with the far more difficult task of finding someone who can accept her extraordinary talents and skills. Thus, the fact that John consents to exchange the girlie gun he gave her for a bigger one is a good sign.

Although *Mr. & Mrs. Smith* fully exploits the spectacle of big guns and big bombs, its violence is designed as a metaphor. John and Jane's victims are faceless, anonymous dummies in their war of roses. The film uses violence to signal that in a marriage, you have to be willing to fight it out. As John says, you have to battle through, take your best shot. The way in which John and Jane bicker reveals their intimate familiarity and makes it clear to us that they are meant to be together. In the final shootout, their determination to stay and engage rather than run allows for a happy ending.

Clearly, the use of violence in this film is meant to be playful and ironic. Still, the question remains why the film relies on violence to signify passion. In the 1941 Hitchcock comedy, jealousy and increasing wretchedness, not murderous rage, signal that the protagonists still care for each other. In the 1941 version, the couple's mutual love puts them on an equal footing, and Robert Montgomery's Mr. Smith is ridiculed and emasculated *after* the separation from his wife. In the 2005 version, in contrast,

violence is an equal opportunity arena, while marriage itself is emasculating. It is to the great credit of the 2005 film that the remasculinization of John is not paired with the humiliation of his wife. But the price to be paid for this is not only a reenactment of the old stereotype of violence as rejuvenating but also a portrayal of martial prowess as the last pillar to uphold an otherwise crumbling masculinity. In *Mr. & Mrs. Smith,* a slightly retooled he-man has found his home in the genre of romantic comedy.

ENLIGHTENED SEXISM?

As Stanley Cavell reminds us, all "tales of romance are inherently feats of cony catching, of conning, making gulls or suckers of their audience" (48). As such they thrive on the topos of mistaken or unrevealed identities (see King, *Comedy* 51). More often than not, the couple's romance is based on a lie. Inevitably, though, as Krutnik points out, "the false basis for union facilitates the learning process that will transform them into a genuine couple" (31). As the initial lie becomes the eventual truth, it opens up a space for the performance of different styles of masculinity: the performance of upper-class masculinity in *Titanic,* of the new sensitive man in *What Women Want,* of the he-man purple heart winner in *Wedding Crashers,* and of the suburban husband/contract killer in *Mr. & Mrs. Smith.*

Since women are identified as the primary audience for romance, lovers are designed as female fantasies, but they also cater to male fantasies. Jack Dawson of *Titanic* is not only an empathic companion, but also represents the triumph of personality over status and wealth. Similarly, John Beckwith of *Wedding Crashers* appeals to female viewers through his capacity for understanding and kindness and to male viewers because he is an average guy who wins the girl even though he lacks his rival's connections and puffed-up CV. The fantasy of the "domestication of the male" (Trice/Holland, *Heroes* 27) responds to the female desire that an emotionally indifferent or sexually promiscuous man can be transformed into a committed husband. The depiction of sexual promiscuity before this transformation occurs, however, is designed to keep male viewers interested.

Even though all lovers discussed in this chapter possess both male and female traits, there is a significant shift in emphasis. Both Clinton-era films celebrate the new empathic man, while the two Bush-era films hedge their bets carefully. In *Wedding Crashers,* the new man emerges triumphant in the end, but is subjected to relentless ridicule throughout. *Mr. & Mrs. Smith* contains occasional nods to the new man, but ultimately celebrates the male protector who knows how to defend his gal against evildoers.

Finally, while he-men have regained their footing in romantic comedy, strong female leads have trouble holding on. In a recent study, Susan Douglas has drawn attention to a phenomenon she labels *Enlightened Sexism.* The central illusion propagated by enlightened sexism consists in the suggestion "that equality for girls and women is an accomplished fact when it isn't" (4). To prove her point, Douglas lists a discrepancy between portrayals of female power in the media and the absence of such power in the political and economic life of contemporary reality. Television shows are populated with female detectives, female lawyers, female politicians, and female

surgeons. In real life, however, only 17 percent of Congress was female in 2009. 17 percent of the partners at major American law firms were women. 14 percent of all police officers and 1 percent of all police chiefs are female. There are 15 female CEOs at Fortune magazine's top 500 companies, and 20 percent of new surgeons were women (Douglas 279). Clearly, the messages implied by the cinematic overrepresentation of female power are manifold. On the one hand, we might claim that the media point the way to a promised land and accustom viewers to the desired professional equality of the future. On the other hand, we might also be concerned that the media create the impression that feminism has long achieved its goals, and that only incorrigible throwbacks to the '60s still voice the—now unfounded—complaint that it has not.

To be sure, the overrepresentation of female economic and professional success on television is problematic, but the situation in film is hardly better. The figure of the Überwoman is no stranger to Hollywood blockbuster—although it is a market niche that has largely been cornered by Angelina Jolie through characters such as Evelyn Salt, Lara Croft, and Mrs. Smith. But for every Überwoman, there are multiple Claires, who are defined first and foremost through their romantic relationships. Clearly, while enlightened sexism is problematic, it is even more problematic that, for the most part, Hollywood's sexism has yet to become enlightened.

LOSERS, MERITOCRACY, AND IDENTIFICATION

> It's very easy—everyone falls neatly into one of two categories: winners and losers. People on the up and people on the down. The winners are "fucking cunts" and the losers are, well, "fucking losers."
>
> John Niven, *Kill Your Friends* (2009)

DURING THE CLINTON AND BUSH ERA, there has been considerable cinematic interest in the most hopeless, wretched, and pathetic type of male: the loser. Some actors (Adam Sandler, William H. Macy, Christian Slater, Will Ferrell, Steve Carell) have made their careers playing the type. Renowned writers and filmmakers, most notably Judd Apatow and the Coen brothers, have created a series of dolts, from the lead character in *Barton Fink* (1991, John Turturro) and the Dude in *The Big Lebowski* (1998, Jeff Bridges) to Everett McGill (George Clooney in *O Brother, Where Art Thou?* 2000) and Ed Crane (Billy Bob Thornton) in the aptly named *The Man Who Wasn't There* (2001). The Coen brothers' Academy Award-winning *Fargo* (1996) practically teems with useless men (Jerry Lundegaard, Carl Showalter, and the father-in-law Wade, played by Macy, Steve Buscemi, and Harve Presnell, respectively; see Tyree and Walters 63–65). The loser may be a "niche"-character rather than a dominant type. But he certainly does get noticed, partly because he stands in the greatest imaginable contrast to the dominant film hero of earlier ages, such as the Reaganite tough-guy warrior heroes Rambo, Rocky, Indiana Jones, Robocop, Dirty Harry, and virtually every role Schwarzenegger ever played (Jeffords, *Hard Bodies* 19).

It is tempting to link this new interest in pathetic men with major policy changes of the Clinton and Bush era. One example that readily springs to mind is the elimination of, to quote ex-president Clinton, "welfare as we know it," which, as policy experts on both sides of the House and many commentators have argued,[1] created an entire new class of losers. Yet the link between what is now loosely (and inaccurately) known as the "welfare reform" of the 1990s and the era's celluloid losers is tenuous at best. The Personal Responsibility and Work Opportunity Reconciliation Act (PRWORA) of 1996 did not, in fact, reform the welfare system as a whole but merely eliminated one of its programs, "Aid to Families with Dependent Children" (AFDC),

which had provided support for single mothers since the 1930s. The replacement program, "Temporary Assistance for Needy Families" (TANF), ended welfare as an entitlement program, requiring recipients to begin working after two years of receiving benefits, with some additional support for the working poor in the form of an expanded Earned Income Tax Credit (EITC). The bill also placed a lifetime limit of five years on benefits paid by federal funds, and expended considerable rhetoric on promoting two-parent families and discouraging out-of-wedlock births.[2] The decision to award federal block grants to states, which effectively moved the administration of the program from the federal to the state level, meant that there was now "no federal definition of who is eligible and therefore no guarantee of assistance to anyone" (Edelman): both had gone with the AFDC.

To claim, however, that this legislation and its unquestionably profound effect on American society "inspired" the cinematic loser type of the late 1990s and early 2000s would be overstating the case. For one thing, there is an obvious racial and gender disparity between celluloid losers and the economic losers of the 1996 welfare "reform." Welfare recipients were, and are, disproportionately black (Schram, Soss, and Fording) and female (AFDC was, in fact, written specifically for single mothers; see Jencks). Some studies have claimed that 30 percent of welfare recipients are women who are either disabled or caring for disabled children,[3] and this is the group—mothers unable to work regularly—that is most significantly affected by the new bill because of its work requirement (see Jencks; Ron Haskins, *Work over Welfare*). Book-length studies on the consequences of the new legislation have invariably focused on women or single mothers (see Ehrenreich; DeParle; Blank and Haskins; Bane and Ellwood), documenting on a case-by-case basis what critics of the bill have pointed out since its passage: that the new legislation, while moving millions of people off the welfare rolls,[4] has done nothing to increase their income or standard of living, alleviate poverty, or address wealth disparities in America (see Schram and Soss; Kaus). But women and blacks, the groups primarily affected by the welfare cuts enacted by Clinton in 1996, and again by George W. Bush in 2006,[5] have not attracted the attention of Hollywood filmmakers. In the movies, losers are white males, and they are not, as a rule, on the dole.

Film, then, does not simply "absorb" what is "secreted" from legislative theory and social practice; art does not imitate life. This is not to say, however, that no link exists between the two. After all, a cause-and-effect relation is not the only possible link between the two realms. If we take the connection between life and art to be less straightforward, searching for the ideas that can be identified as the "common roots" of both policy decisions and the world of the movies, we will readily encounter two that have substantially shaped both welfare reform and celluloid losers. One is the idea that a heterosexual monogamous relationship is the basis for wealth and happiness. The other is America's self-definition as a meritocracy.

THE LAND OF UNLIMITED OBLIGATION: ALL WE NEED IS LOVE

If you truly decide to, you can do almost anything.
 Anthony Robbins, *Awaken the Giant Within* (1992)

At its most basic, meritocracy denotes a system in which advancement is based on individual ability or achievement. In the context of American capitalism and individualism, meritocracy has come to imply that wealth equals happiness, that success equals virtue, and that each individual has the capacity to overcome any obstacle, given sufficient grit and determination (commonly known as "pulling yourself up by your bootstraps").[6] The idea of meritocracy is perhaps the most significant psychological by-product of democracy. Alexis de Tocqueville, one of the earliest observers of American society, already noted the devastating effects of democratic expectations in the absence of the material wherewithal to turn them into reality. The dismantling of barriers to expectation in democracies saddled the new democratic citizen with the moral responsibility to achieve the materially unachievable: equality. Because subjects of monarchic societies experienced the same inequality as divinely ordained, it did not induce feelings of guilt. In monarchies, "one found inequality in society, but men's souls were not degraded thereby" (de Tocqueville, cited in Botton 53). The loser, in other words, is a quintessentially modern and democratic character.[7]

Since the eighteenth century, the equation of material success with personal happiness has gained considerable currency in Western thought. As Michael North has shown, the categories of "material delight" and "the joy of living" (North) became practically interchangeable; at its most basic, the stuff of happiness is just *stuff*. Achieving material success (and therefore personal happiness) soon came to be seen as far more than a pleasing prospect; it became a measure of human worth. The subtitle of one of the earliest treatises on the subject, Thomas Hunt's 1836 bestseller *The Book of Wealth: In Which It Is Proved from the Bible That It Is the Duty of Every Man to Become Rich,* already points to the basic problem, namely that citizens of meritocracies are faced not with an opportunity but with an obligation. If you can succeed—and the principle of meritocracy claims that everyone can—you must. Otherwise, you are a loser. Every self-help book, every rags-to-riches tale, every human interest story of someone who lost both legs and went on to win a marathon on artificial limbs makes essentially the same point: if you don't succeed, it's nobody's fault but your own.[8] Others' success elicits admiration but also, and more importantly, an awareness of one's duty to emulate that success or stop complaining. As Michael Young put it sarcastically, 120 years after Hunt:

> Today all persons, however humble, know they have had every chance ... If they have been labelled "dunce" repeatedly they cannot any longer pretend ... Are they not bound to recognize that they have an inferior status, not as in the past because they were denied opportunity, but because they *are* inferior?
>
> (*The Rise of the Meritocracy,* cited in de Botton 91)

Such absolute reliance on self-help precludes the expectation of help from anyone else, either private persons or the state. This is also the main point of the 1996 welfare bill, tellingly named the Personal Responsibility Act. The personalization of the responsibility for one's own happiness shifts the onus from the state to the individual. The assumption is that the state neither helps nor hinders the pursuit of happiness for whose success or failure the individual alone is accountable. Anthony Robbins's

Awaken the Giant Within, a manual detailing *How to Take Immediate Control of Your Mental, Emotional, Physical and Financial Destiny!* (1992), offers the standard success story of a fat and lonely janitor who, following the discovery of a mental "power" to turn his life around, transformed himself into a slender, happily married multimillionaire in record time. And why, he adds, shouldn't the rest of us be able to do the same, living, as we do, in a free society in which "we all have the capability to carry out our dreams" (Robbins, cited in Botton 60)?

If there is a flawless equation between success and human worth, poverty is a personal failure, not a social problem. The ultimate loser is defined as someone who fails to understand this and refuses to forge his own success, instead riding on the coattails of others or applying to the state for a "handout." Consequently, whatever feelings of inadequacy accompany such failure are personal, not political. This theory is upheld even by writers who have recognized the damaging effects of the idea of meritocracy. Alain de Botton, for example, defines the distress caused by social failure in psychological terms, as "status anxiety," the main problem being "the challenge that low status poses to a sense of self-respect" (Botton 12). Above subsistence level, all of the trimmings of "status"—money, success, fame, influence, and so forth—are merely means to an end.

The end, of course, is love.[9]

SAVED BY THE WEDDING BELL: LOVABLE LOSERS

Punch-Drunk Love (2002). Dir. Paul Thomas Anderson. Writer: Paul Thomas Anderson. Columbia Pictures. Domestic Total Gross: $17,844,216. Foreign Gross: $6,821,433. Total Box Office: $24,665,649. Production Budget not available.

The 40-Year-Old Virgin (2005). Dir. Judd Apatow. Writers: Judd Apatow, Steve Carell. Universal Pictures. Domestic Total Gross: $109,449,237. Foreign Gross: $67,929,408. Total Box Office: $177,378,645. Production Budget: $26 million.

The Cooler (2003). Dir. Wayne Kramer. Writers: Frank Hannah, Wayne Kramer. Columbia TriStar. Nominated for 1 Academy Award (0 wins). Domestic Total Gross: $8,291,572. Foreign Gross: $2,173,216. Total Box Office: $10,464,788. Production Budget not available.

> The problem most men have is that they don't know how to talk to women.
>
> Cal in *The 40-Year-Old Virgin*

Lovable loser movies offer a simple recipe for happiness: once a man's love life is sorted out, everything else will fall into place. Casual sex is seen as a mandatory, but temporary, rite of male passage that is harmful if not overcome. The ultimate goal of the film is to turn the loser into a responsible male adult ready for true love, which is defined as heterosexual, permanent, and monogamous—incidentally very much in line with the 1996 welfare bill, whose first sentence reads, "Marriage is the foundation of a successful society."[10]

Invariably, the lovable loser falls short in the social and financial sense. He often works in jobs that can barely be considered white-collar, for example, as technical

support in an electronics store (*The 40-Year-Old Virgin*), or as a salesman for bathroom accessories (*Punch-Drunk Love*). But as it turns out, his relatively subordinate social status and lack of wealth are not the primary reasons for his inadequacy. Rather, the problem is that he is caught in an arrested stage of sexual development. Geeky, shy, and inept around women, he does not, as "normal" males do, sow his wild oats and brag to other men about his sexual exploits. Because he has skipped this stage of "development," it does not occur to him—and in this he turns out to be very much mistaken—that he is eligible for or capable of a loving, intimate relationship. The lovable loser falls short because he is not a man in the sexual sense, but he is, of course, a man in the chronological sense. Films about teenage boys faced with the dilemmas of sexuality—for example, *Superbad* (2007)—never present the protagonists as losers. Diminutive and boyish-sounding names—*The Cooler*'s Bernie, *Punch-Drunk Love*'s Barry, and the 40-year old virgin Andy—are symptoms of a disease we might term the Peter Pan syndrome. Lovable losers are never called anything harsh or masculine, such as Dick or Jack (as Andy's drunken date points out: "Dan rhymes with man, and men jerk off"). Moreover, the losers' lack of masculinity extends to realms beyond the sexual as well. Their purchasing habits, for instance, either infantilize or feminize them. Like any little boy, Andy (Steve Carell) has a large collection of G.I. Joes and other action figures; his girly side emerges in a scene in which he endures a salon waxing, surrounded by his hysterically giggling male friends (Fig 10.1).

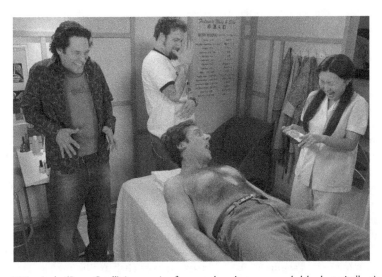

Figure 10.1 Andy (Steve Carell) in pursuit of a smoother chest, surrounded by hysterically giggling friends. Courtesy of Photofest, Inc.

Barry (Adam Sandler) buys Healthy Choice puddings by the carload in pursuit of frequent flier miles and clips coupons like a housewife (Fig 10.2). But when it comes to things that "real" men buy, they are helpless. During his only attempt at phone sex, Barry answers Latisha's question whether his cock is hard—as if we needed further

proof of how utterly disconnected he is from his own sexuality—by saying, "I don't know what it's doing right now."

Figure 10.2 Barry (Adam Sandler) as the Pudding Boy. Supermarkets and other consumer temples play a significant role in many loser films. Courtesy of Photofest, Inc.

The lovable loser film's ostentatious goal is to bring men and women together. Consequently, the hero often starts out in a context dominated by one gender and must struggle free from its pernicious influence. In *Punch-Drunk Love,* Barry is socialized, undermined, and emasculated by his seven sisters. The 40-year old virgin Andy is beset and plagued by advice on how to "get pussy," offered by an all-male crowd of seemingly oversexed but in reality juvenile, painfully average, and—in love relationships—completely dysfunctional coworkers. In both films, it is not the loser but his true love who takes the initiative. The loser's main contribution to the relationship consists of emancipating himself from his one-sided gender surroundings. When Barry stands up to his overbearing sister, screaming at her on the phone ("I'm sick of this fucking shit! You're killing me with the way you are towards me. Stop fucking treating me this way!"), when Andy begins to reject his coworkers' sex advice,[11] true love finds a way.

And once true love enters the stage, everything else falls magically into place. We may have sniggered at Andy's obsession with G.I. Joes, who, in their muscled military rigidity, represent miniature versions of everything Andy is not, but in the end they turn out to be a genius business investment worth half a million dollars, enabling him and his new wife, Trish (Catherine Keener), to set up their own business. We may have pitied Andy's inability to stand up to his colleagues and his sexually forward female boss, and yet, he gets an unexpected promotion at work. Having found true love (and True Love Waits[12]), Andy can explore his new-found sexuality in a safe and sanctioned way.[13] As the priest at their wedding instructs them: "And for God's sake, consummate the thing!" Finally, Trish's children provide the family context without which, according to the American Dream dogma, no marriage is complete. Andy

is, in other words, "promoted" in every way—to floor manager and fatherhood, to happy family life and business success—all this with minimal to nonexistent character development. His only virtue is that he just said no until the time was right to say yes.

Punch-Drunk Love's Barry experiences a similar drastic change without actual development. Following his success in love, he turns into a superhero, proving his new prowess by beating up four professional thugs sent after him by Latisha's pimp (Philip Seymour Hoffman) when he refused to give in to her attempts at extortion. The scene is all the more significant because these are the same thugs who confronted Barry in a traumatic earlier scene, in which he was robbed, beaten, and chased down an alleyway until he wept and grunted in anguish while running away. Post transformation, however, he sets his jaw in a grim determination worthy of Bruce Willis, punches out three of the thugs, and cows the fourth into submission, all without sustaining a single wound or even messing up his suit. In a follow-up scene in which he faces down the pimp, he explains his miracle transformation: "I have so much strength in me, you have no idea. I have a love in my life. It makes me stronger than anything you can imagine."[14]

A good woman's love, in other words, is enough to transform even the most pathetic loser into a business genius or swashbuckling hero. It is not necessary to be Mr. Right to find Mrs. Right since her kiss can turn any frog into a prince. To some extent, this mirrors the centuries-old idea that it is the woman's job to turn a man into a human being, an idea that came into vogue during the late eighteenth century, around the same time that love became the commonly accepted basis for middle-class marriages.[15] In the loser film, of course, the idea has mutated slightly: it is the woman's job to turn the loser into a man. The focus is very much on his well-being rather than hers or society's. Lovable losers tend to have a benign relationship with the world, but lack of (self-)esteem causes them considerable suffering, much as they try to deny it. When Andy, having given up his quest for sex after years of failed attempts, states, "I'm a virgin, it's a choice," we know that the purpose of this lie is to deny his failures not only to the outside, but also to himself. And Barry, having confessed to his decidedly unsympathetic brother-in-law that "I sometimes cry a lot, for no reason," proceeds to do precisely that: he buries his face in his hands and breaks into agonized sobs. The woman's job, then, is the same it ever was: to fix the man's self-esteem issues, to provide him with the sense of self-worth that will enable him to go out and conquer the world.

But what, we might ask, does she get out of the deal? What would attract a good (and in all three cases beautiful) woman to a loser? To that, the films provide a simple answer: women who require any measure of equality and respect in a sexual relationship find real men unbearable. In *The 40-Year Old Virgin*, Andy would not get anywhere with Trish if he followed the advice of his coworkers. In *Punch-Drunk Love*, Lena (Emily Watson) falls in love with Barry because she saw a photo of him surrounded by his seven sisters: here is a man who can live with women, she concludes. In other words, women love losers *because* they are less masculine and more human. Because the relationship will presumably (secretly) contain their humanity—their ineptness, their flaws, their weaknesses, their quirkiness, their emotional openness, and, most importantly, their inability to conceive of themselves as superior to anyone, even women—former losers can be "men" outside of it. In the meantime, what she

gets out of it is a man she can live with. In this sense, the tagline on the movie poster for *The Cooler*—"Even a loser can get lucky in love"—has it exactly wrong. *Especially* a loser can get lucky in love.

This is one of the most interesting unresolved idiosyncracies in lovable loser films. On the one hand, they promote conservative visions of male-female interaction and social integration (marriage, monogamy, family, and success, with the emotional work that enables all of this falling squarely on female shoulders). The films' advocacy of waiting for Mrs. Right can easily be read in the context of the contemporary American abstinence debate, the massive investment of federal monies, under George W. Bush, into abstinence programs,[16] and new projects such as virginity clubs (which tend to represent virginity in the same way that Andy misrepresents it: as a "choice"). On the other hand, these films also show some awareness of an irresolvable quandary, a dilemma expressed not only in the obvious preposterousness of the "true love conquers all" recipe, but also in the awkwardness of the suggested solution. Having demonstrated that men are more problematic than losers, the films turn the loser into a man, for only as such can he survive in society.

The Cooler presents us with some notable variations on the theme. Set not in the context of middle-class respectability but in the corrupt world of Mafiosi, thugs, whores, and gamblers, the film features a loser whose unhappiness is not internal and largely fabricated but deliberately engineered from the outside.[17] Bernie (William H. Macy) is part loser and part slave; his problem is not merely low self-esteem but the coercive relationship with his boss, Shelly (Alec Baldwin), who has extorted his services as repayment of a debt. When Bernie meets Natalie (Maria Bello), the two must learn how to function in a relationship and also defend that relationship against Shelly, who does everything in his considerable power to break them up.

Although Bernie's job is to "cool" tables at the Shangri-La Casino, guaranteeing that gamblers lose and the house wins, he fits the lovable loser type—the guy who hurts only himself and, if he must, the bad guys—perfectly. His bad luck, which rubs off on gamblers at the casino—where losses must, after all, be expected because the game is always fixed—does not harm anyone outside the casino. He does not, for example, cause mass suicides or car accidents when walking the streets of Las Vegas. He himself, however, is clearly miserable. Limping, his wrinkly face set in a grimace of pain, he ambles through the casino in his second-rate shoes and ill-fitting suit, dealing instant death to every lucky streak, ordering white coffee from a bar that has always just run out of cream whenever he asks for it. As his six-year-long indentured servitude to Shelly nears its end—Bernie is only five days away from freedom—Shelly desperately tries to keep Bernie at work, tempting him with all the enticements to which a real man would be susceptible (more money, high-class whores) but to which Bernie is completely indifferent. In paying Natalie to keep Bernie company, Shelly unintentionally hits upon the one thing that presents a temptation, true love. When Bernie's lady love comes accompanied by Lady Luck, his happy love life paradoxically results in his complete failure at his job. Grinning like a schoolboy, Bernie saunters through the casino with a spring in his step as the music plays "It's almost like being in love." The new Bernie turns everyone he walks past into a winner and transforms the casino into what its name proclaims it to be: Paradise.

Unlike other lovable loser films, *The Cooler* directly addresses the mixed messages to men on the subject of sex: the directive to be both oversexed studs ("get pussy") and faithful, monogamous, or celibate men ("Just say no"). The dilemma is on display in a scene in which Bernie, in bed in his cheap motel room, watches TV evangelists while a couple in the next room have sex rough enough to make his bed shake. The guttural screams from both ends of the room (on TV: "Hallelujah! Let the crutches go! Let the spirit come into you!!"; from next door: "You gonna cum all over me??") reveal marked similarities between these seeming opposites, even as they show us a Bernie battered and torn between two societal mandates, both presented as coercive, violent, and profoundly cheerless.

In *The Cooler*, defeating obstacles from the outside is more important and more difficult than overcoming low self-esteem. Bernie relatively easily vanquishes his initial doubts that someone as beautiful as Natalie would want to have sex with him without pay; and although he does not know this, this disbelief is, at that point in the film, far from paranoid, since Shelly is in fact paying Natalie to sleep with Bernie. While his own (justified) suspicions and his low self-esteem evaporate quickly, the hostility of others who try to separate the lovers and ridicule their love is far more demeaning and dangerous. Bernie's miscreant son Mikey (Shawn Hatosy), for example, automatically assumes that Natalie is with Bernie for the money: "My old man, is he rentin' your ass? Because otherwise I just don't get it, a loser like my pops, in the company of some primo tits'n ass—it don't compute." And when Natalie confesses to Shelly that she has fallen in love with Bernie, Shelly exclaims in contemptuous disbelief: "What the fuck is there to love? He's a loser, always has been, always will be." In a follow-up scene, Shelly beats her to a pulp and throws her into a mirror in an attempt to force her to renounce Bernie. She picks herself up, cut and bleeding, and issues the ultimate statement of defiance: "I love him."

In the end, the film elects quite deliberately not to solve the dilemmas it presents. In an indirect admission that violence and external coercion are more difficult to address than low self-esteem, the happy end is brought about—appropriately for a film that deals extensively with gambling—by an absurdly exaggerated stroke of good luck. Bernie wins millions at the tables, and the mafia bosses who run the casino kill Shelly for the only decent thing he has ever done for Bernie, namely allowing him to walk out with his winnings. A false cop sent to murder Bernie and Natalie stops them on their way out of town, pulls his gun, and—not a moment too soon—is run over by a car. The near-execution scene is a ludicrous overstatement of the lovable loser film's credo that true love conquers all. Bernie and Natalie are forced to kneel before the cop, their backs to him, as he points his gun at the backs of their heads. Trembling, they smile at each other beatifically, professing their love one last time. Suddenly their faces are lit with a golden glow. Is it love? Is it the gates of paradise opening? Is it a hint that Bernie and Natalie, caught up in mutual adoration, do not feel death, that they simply float off together on a gilded cloud? None of the above. It is the headlights of the car that kills the cop before he has a chance to shoot them. Love, once again, conquers all.

The Cooler fits the bill of the standard lovable loser film in two ways. The film understands, rather progressively, what all women in loser films know instinctively: that real men are insufferable jerks and that therefore, loving the loser

is the only sensible choice. But it also embraces the (rather conservative) idea that true love (the one that waits) has the power to cure all ills. The two tenets stand in considerable tension with each other, for true love, in the end, mainly cures the loser, who is the least of the films' problems. In essence, the audience is offered a solution to something that is manifestly not the problem, leaving the actual problem untouched. The films offer the gratification of seeing the underdog come out on top, the pleasure of seeing the loser saved by the wedding bell. What they withhold is an honest answer. For if the old macho is unbearable and the lovable loser not viable, it is unclear what or who could constitute the new role model for men and a tolerable sexual partner for women. By forcing us to identify with the least manly man and recoil in horror or disgust from the "real" man, the films leave us with two questions: why is it necessary to "fix" the loser? And, as a corollary, can masculinity be "fixed"?

AND NOW FOR SOMETHING COMPLETELY DIFFERENT (I)

The Big Lebowski (1998). Dir. Joel Coen. Writers: Ethan Coen, Joel Coen. Gramercy Pictures. Domestic Total Gross: $17,451,873. Foreign Gross not available. Production Budget: $15 million.

> With no attempt there can be no failure; with no failure, no humiliation.
> William James, *The Principles of Psychology* (1950)

> What's great about that is how it says it all without really saying anything.
> Jeff Bridges on *The Big Lebowski*

In terms of initial commercial success, *The Big Lebowski,* the loser film to epitomize all loser films, is itself a loser. Dismissed by critics as a "forgettable mess," it tanked at the box office, barely making back its production costs.[18] Two years after its release, however, it became one of the most wildly popular cult-films of the decade. Fans worldwide have recorded instances in which they quote a *Lebowski* line to a friend, only to have a complete stranger at the same restaurant or street corner finish the sentence or deliver the follow-up line (Green et al., 3). Lebowski signage, often in biblical format ("Lebowski 7:19"), has been spotted at tourist destinations from the Empire State Building to Tiananmen Square (Tyree and Walters 9). Since 2002, there have been Lebowski fests held in bowling alleys around the globe, where thousands of fans, often dressed up as characters from the film, assemble to bowl, watch the film, drink White Russians, and "celebrate all things Lebowski" (Green et al. 3–4; Tyree and Walters 7–9). Like bowling, these festivals are, to cite Ethan Coen, "a decidedly male sport, which is right, because *The Big Lebowski* [...] is [...] kind of a weird buddy movie" (cited in Robertson 44). There is good anecdotal evidence that the film is more attractive to male than female viewers. At a 2006 academic conference on *The Big Lebowski,* which featured a call for papers addressed to "academic brethren," only three papers out of a total of 26 were offered by women, with two further papers coauthored by a woman.[19] John Goodman, commenting on the film's popularity, made a similar point: "It just touches me that people come

up to me today, especially younger guys—rarely chicks—and tell me how much they dig it" (cited in Green et al. 34). Apparently, women have yet to discover the determined, proactive, go-getter Maude as a role model, whereas the film's male protagonist, the pot-smoking, potbellied slacker Dude, has become an idol of men worldwide.

Implicit in this global outbreak of Dudeism is a large-scale rejection of the "real man," embodied in the tough guy and in what the film calls the "achiever." The Dude (Jeff Bridges) is loosely based on two models, one taken from real life and the other from pop culture. The Dude's real-life original, Jeff Dowd, self-styled "Pope of Dope" and commonly known as "the Dude," was a member of the Seattle Seven, a group of Vietnam protesters charged with conspiracy to incite a riot during a violent courthouse demonstration in February 1970.[20] In the film, the link is made explicit in the pillow-talk scene with Maude, in which the Dude confesses to his past involvement in the anti-Vietnam protest movement. The Dude's fictional predecessor is one of the toughest guys ever to grace the silver screen, Philip Marlowe, played by Humphrey Bogart in Howard Hawks's *The Big Sleep* (1946). Detective Marlowe, immaculately dressed, competent, eloquent, and hard as nails, provides the foil and reverse inspiration for the scruffy, inept, and inarticulate softie Jeffrey Lebowski—like Dowd, known simply as "the Dude"—who is haphazardly recruited as a money carrier in a kidnapping scheme because he has been confused with a racketeer of the same name.

Although *The Big Lebowski* cheerfully rips off scenes, setups, lines, and characters from Hawks's film,[21] the Coens have placed greater emphasis on the links to Raymond Chandler, the creator of the Marlowe character (Tyree and Walters 51–61). The first scene of *The Big Lebowski,* in which a tumbleweed rolls across the sand to the strains of "Tumbling Tumbleweed," evokes yet another instance of iconic masculinity, namely the cowboy. A quintessential cowboy type, "The Stranger," played by Sam Elliott, an actor who is famous for his cowboy roles, also provides the voice-over introduction of the Dude. His words are culled directly from a story in which Chandler lays down the law of manhood:

> Down these mean streets a man must go who is not himself mean, who is neither tarnished nor afraid. The detective in this kind of story must be such a man. He is the hero, he is everything. He must be a complete man and a common man and yet an unusual man. He must be, to use a rather weathered phrase, a man of honor, by instinct, by inevitability, without thought of it, and certainly without saying it. He must be the best man in this world and a good enough man for any world.
>
> (Chandler 991–92)

And here is how, in the Stranger's introduction, a man is transformed into a dude:

> sometimes there's a man—I won't say a hee-ro, 'cause what's a hee-ro?—but sometimes there's a man . . . and I'm talkin' about the Dude here—sometimes there's a man who, wal, he's the man for his time 'n place, he fits right in there—and that's the Dude, in Los Angeles . . . [. . .] . . . and even if he's a lazy man, and the Dude was certainly that—quite

possibly the laziest in Los Angeles County [. . .] . . . which would place him high in the runnin' for laziest worldwide—but sometimes there's a man . . . Sometimes there's a man . . . [22]

This introduction of the film's "hee-ro" is about as articulate as the Dude himself, establishing only, as Tyree and Walters have put it, that "a) the Dude is not any kind of recognisable hero; b) the Dude is a [sic] basically a wreck of a human being; c) the Dude is, at least biologically speaking, a man; and, finally, d) 'sometimes there's a man' " (50). What the narrator does establish beyond doubt is that the Dude is not comprehensible from the viewpoint of Chandlerian manhood. The Dude is not a man in any sense, neither a hero nor an achiever. He is equally indifferent to sexual threats or offers. The German nihilists' threat to cut off his "chonson," and maybe "stamp on it and skvush it," gets as low a rise out of him as Maude (Julianne Moore) standing over him, wearing only his robe, which she drops to the floor with the words "Love me" (his stupefied response: "That's my robe"). He does not mind that Maude, the only real go-getter of the film, uses him as a free sperm bank because she wants to conceive but not be bothered with a man who would take an interest in the child. The Dude is unimpressed by his namesake's mansion or the many citations and certificates adorning the walls, merely telling Lebowski's assistant Brandt (Philip Seymour Hoffman) that he might drop in again "if I'm ever in the neighborhood and I need to use the john." He does not mind the loss of $1 million, stating, as he sips one in an endless series of White Russians, that "I can't be worrying about that shit." And he is cheerfully indifferent to Lebowski's catalogue of his sins, which amounts to an enumeration of the principal differences between meritocracies and freeloading, between manhood and Dudeness:[23]

> *Lebowski.* You're just looking for a handout like every other—Are you employed, Mr. Lebowski?
> *Dude.* Look, let me explain something. I'm not Mr. Lebowski; *you're* Mr. Lebowski. I'm the Dude. So that's what you call me. That, or Duder. His Dudeness. Or El Duderino, if, you know, you're not into the whole brevity thing—
> *Lebowski.* Are you employed, sir?
> *Dude.* . . . Employed?
> *Lebowski.* You don't go out and make a living dressed like *that* in the middle of a weekday.
> *Dude.* Is this a—what day is this?
> *Lebowski.* But I *do* work, if you don't mind—[. . .] every *bum's* lot in life is his own responsibility regardless of whom he chooses to blame. I didn't blame anyone for the loss of my legs, some Chinaman in Korea took them from me, but I went out and achieved anyway. I can't solve your problems, sir, only you can.
> *The Dude rises.*
> *Dude.* Ah, fuck it.
> *Lebowski.* Sure! Fuck it! That's your answer! Tattoo it on your forehead! Your answer to everything!
> *The Dude is heading for the door.*
> . . . Your "revolution" is over, Mr. Lebowski! Condolences! The bums lost!
> *As the Dude opens the door.*

... My advice is, do what your parents did! Get a job, sir! The bums will always
 lose—do you hear me, Lebowski? THE BUMS WILL ALWAYS—
The Dude shuts the door on the old man's bellowing.

In this scene, Lebowski (David Huddleston) articulates the meritocratic credo of
the self-made man who "achieves" without help from anybody. Part of the fun of
the film is that these male achievers inevitably turn out to be fakes. Lebowski, a
self-described go-getter ("I can look back on a life of achievement, on challenges
met, competitors bested, obstacles overcome . . . I've accomplished more than most
men"), is exposed as a corrupt and incompetent businessman who did not earn his
wealth but married into it and had to be forcibly retired by his daughter before he
squandered it all. In essence, the film describes the contrast not between losers and
real men, but between losers who simulate real men and losers who don't. We are
given a taste of this in the very first scene, where George H. Bush, bespectacled
and stuttering, utters rambling threats against Saddam Hussein for his "unchecked
aggression" against Kuwait.[24]

The representation of politics in the film is as indirect and inconsequential as the
Dude's own political past. Both the Dude and his best friend, Walter Sobchak (John
Goodman), are based on real-life Vietnam-related characters.[25] But neither Vietnam
nor Iraq is more than incidental here. If the Coen brothers are to be believed, the
timeframe of the first Iraq war was chosen mainly to give Walter, who is "forever
finding ways to work the subject of Vietnam bitterly into conversations" (Robertson
36), an overseas war to gripe about (Tyree and Walters 17). Politics is reduced to
moments of "unchecked aggression," the prime playing fields of "hee-roes" and other
real men. Much as Walter tries to be a hero, he too manages, in the Dude's descrip-
tion, only to be an "asshole," forever lamenting the Vietnam dead and cursing "that
camelfucker in Iraq." In any other world, the curious friendship between a long-
haired laidback hippie ex-Vietnam protester and a hotheaded, perennially pissed-off,
and clearly damaged Vietnam vet would have to be motivated by feelings profound
enough to overcome their differences. Not so in Dudeland: where politics and polit-
ical convictions are part of the shit we can't be worrying about too much, something
as incidental as a passion for bowling can really tie the two together.

Politics is just one of many ideologies and doctrines that make an appearance
in the film. There are snippets of Judaism, nihilism, pacifism, fascism, hedonism,
feminism, Buddhism, and existentialism. Even the Stranger can be read not only
as the quintessential American hero, the cowboy, but also as an allusion to a cen-
tral figure of existentialist literature, Albert Camus' *The Stranger*. In one scene, the
camera briefly pans over a copy of Sartre's *Being and Nothingness*, perhaps the most
famous vindication of human freedom against determinism, on the Dude's bedside
table (see Green et al. 15). And the Stranger, who has the first word of the film,
also has the last. In the final scene, the Stranger and the Dude share the following
exchange:

The Stranger. How things been goin'?
Dude. Ahh, you know. Strikes and gutters, ups and downs.
The Stranger's eyes crinkle merrily.

The Stranger. Sure, I gotcha.
The bartender has put two gleaming beers on the counter.
Dude. Thanks, Gary . . . Take care, man, I gotta get back.
The Stranger. Sure. Take it easy, Dude—I know that you will.
The Dude, leaving, nods.
Dude. Yeah man. Well, you know, the Dude abides.
Gazing after him, the Stranger drawls, savoring the words:
The Stranger. The Dude abides.
He gives his head a shake of appreciation, then looks into the camera.
The Stranger. I don't know about you, but I take comfort in that. It's good knowin'
 he's out there, the Dude, takin' her easy for all us sinners.

This conversation, although practically content-free, is nevertheless one of the most loaded in the film: as Bridges has put it, it says it all without really saying anything. In establishing the Dude as a religious figure (life has imitated art: he has, indeed, become a cult figure), the film goes far beyond suggesting that the loser need not be fixed. On the contrary, he is a role model, takin' her easy for all us sinners when we are as uptight as Walter, as dishonest and corrupt as Lebowski, or as vicious as the film's nihilists. A slightly hairier, slightly less chubby Buddha, the Dude proclaims, without saying anything, the central tenets of Buddhism: suffering is caused by craving or attachment to worldly pleasures of all kinds (see Devasthan).[26]

To be fair, attacks on consumerism are relatively routine in loser films. They are commonly expressed in the depressing portrayal of consumer emporia, the super-markets of *The 40-Year-Old Virgin, Punch-Drunk Love,* and *One Hour Photo,* aisles upon aisles filled with identical-looking products proclaiming the emptiness of the consumerist lifestyle. *The Cooler*'s glittering casino, a pleasure market falsely promising Shangri-La (paradise), fulfills a similar function. In other loser films, losers (and, for that matter, "winners") fatally succumb to consumerist ideology, as shown by the contrasting consumer behavior of executives and office workers in *He Was a Quiet Man,* or (in *The Assassination of Richard Nixon*) Sam's desperate attempts to become a good salesman by learning how to deceive or cajole others into buying things they do not need. Not so the Dude. Small and unassuming scenes throughout *Lebowski* (the Dude opening a carton of milk to sniff it before he decides to buy, paying for it with a 62 cent check, or stashing his friend's ashes in a coffee can) document how nonchalantly and yet categorically he manages to put consumer culture in its place. In avoiding the consumerist trap, he also avoids suffering, for—according to the tenets of Buddhism—suffering only ends when the craving for worldly pleasures, goods, or success ends. It ends when we develop the ability not to worry about losing a million dollars, when we have learned to say, "Ah, fuck it, let's go bowling."

Outside of the context of U.S.-style meritocracy, then, the Dude is not a loser but Duddha. He does not need to achieve anything; he merely needs to be a good person. Having failed to change America through protest, he changes himself, refusing to be part of the American rat race ("This aggression will not stand, man!"). The film's "message"—if we can, for the moment, worry about shit like that—has been aptly summarized by Tyree and Walters: "why get yourself all twisted up in knots trying to scramble for money, status, fame, power and so forth? Why not enjoy yourself, why

not enjoy your life, since it's the only one you have anyway?" (106). In encouraging us to become losers rather than achievers, the film flatly contradicts the assumption that losers must be "fixed" to achieve success in society. It also denies the validity and necessity of that success by attacking the most basic assumption of U.S.-style meritocratic thinking: that success equals happiness.

INVISIBLE MEN: IRREDEEMABLE LOSERS

One Hour Photo (2002). Dir. Mark Romanek. Writer: Mark Romanek. Twentieth Century Fox. Domestic Total Gross: $31,597,131. Foreign Gross: $20,626,175. Total Box Office: $52,626,175. Production Budget: $12 million.

The Assassination of Richard Nixon (2004). Dir. Niels Mueller. Writers: Kevin Kennedy, Niels Mueller. Senator International. Domestic Total Gross: $708,776. Foreign Gross: $3,699,038. Total Box Office: $4,407,814. Production Budget not available.

The Man Who Wasn't There (2001). Dir. Joel Coen. Writers: Joel Coen, Ethan Coen. Good Machine International. 1 Academy Award (4 nominations). Domestic Total Gross: $7,504,257. Foreign Gross: $11,412,366. Total Box Office: $18,916,623. Production Budget not available.

He Was a Quiet Man (2007). Dir. Frank A. Cappello. Writer: Frank A. Cappello. Mitropoulos Films. Domestic Total Gross: $2,431. Foreign Gross: $81,009. Total Box Office: $83,440. Production Budget not available.

Irredeemable losers differ from lovable losers in one central respect: they reject the meritocratic principle that that they are solely responsible for their success or failure. To some extent the films endorse their refusal: they portray a society so dysfunctional that only the most ruthless and contemptible can achieve success. The basic problem portrayed in these films is that the loser strives for a success that is neither achievable nor indeed desirable, for success, invariably embodied by the film's most revolting characters, requires integration in a profoundly corrupt society. Big Dave, the alpha male in *The Man Who Wasn't There,* is an embezzler and adulterer who lies about his war record; the losers of *One Hour Photo, Assassination,* and *Quiet Man* are exploited and tormented by ruthless, cruel, and mendacious bosses—"winners" who are far less eligible as models of identification than the film's losers. Workplaces, too, are presented as dystopian: Bob's bleak office in *Quiet Man* with its tiny hula doll ornament, a symbol of dreams of a better life cut down to size; Sam's furniture store in *Assassination,* in which salesmen are terrorized and customers lied to; and supermarkets in several films (the dark Nirdlinger's store of *The Man Who Wasn't There,* which becomes the site of a murder; the aseptically clean and blindingly overlit SavMart in *One Hour Photo*). Clearly, this world is very different from that of lovable loser films, which fix the loser's problem by integrating him into an essentially benign world. The world of the irredeemable loser, in contrast, is itself irredeemable, the loser's integration into it inconceivable, either as a worthwhile goal or as a "happy" ending. Of course, this setup implies a considerable amount of societal critique, conveyed

through the ambiguous portrayal of the loser's search for "success." On the one hand, success means emulating contemptible men and joining their ranks; on the other, success means pursuing goals that meritocracies define as admirable—accomplishments at work, a happy family life, being remembered after death. These simultaneously despicable and commendable desires are reflected in the loser's contradictory relationship with his world. His remonstrations and sometimes rebellion contrast starkly with his thirst for acknowledgment and inclusion. Irredeemable loser films show how an invisible man struggles to become visible to a world that despises him.

Irredeemable losers work in subordinate jobs. They are Sy "the photo-guy" at a SavMart (Robin Williams in *One Hour Photo*), Sam the furniture salesman (Sean Penn in *The Assassination of Richard Nixon*), Ed the barber (Billy Bob Thornton in *The Man Who Wasn't There*), or Bob the office drone (Christian Slater in *He Was a Quiet Man*). Without exception, they are humiliated by a "he-man," very often their boss, who delights in subjecting them to petty torments and, in the case of Sy and Sam, adds injury to a steady stream of insults by firing them. None of the losers have caring partners or happy families. Barber Ed is in an indifferent and childless marriage with Doris (Frances McDormand), who cheats on him with a "winner"; the other losers live alone, eating prepackaged dinners in front of the TV in depressingly drab apartments. Their closest relationships are with pets. Sy the photo guy has a hamster. Bob the office drone has an aquarium full of fish that, in the imaginary conversations he has with them at feeding time, encourage him to go into the office and shoot all of his coworkers before killing himself. Sam the furniture salesman, separated from and despised by his wife and children, is loved only by his dog, which he shoots dead before going off on his mission to assassinate Richard Nixon.

All of these films show a man's failed attempt to anchor himself in a world defined by lies, corruption, bullying, and empty consumerism. At times the losers try to ennoble their substandard jobs, but this desire to self-validate is as pathetic as it is idealistic. Sy, who works at the photographic version of a fast food restaurant, insists on providing high-quality prints, even though in his work context profit is the only object and quality counts for nothing. Until Sam understands that his work context is defined entirely by lies (his boss tells a customer that vinyl is a fancy kind of leather), he tries to become a good salesman with the help of a taped mantra: "The salesman who believes is the salesman who receives. Remember, power is a state of mind. You have as much as you think you have. [...] The salesman must see himself as a winner."

To uphold the tenuous link with the world, losers often subordinate their own existence to someone else's, which can, again, be read as noble idealism or as the hallmark of inferiority, hinting, as it does, that the loser does not have a life of his own. Both are implied in Ed's attempts to fashion a career as a concert pianist for Birdy (Scarlett Johansson), who herself has no such ambition; in Sy's obsession with Will (Michael Vartan) and his family; or in Bob's dedication to Venessa (Elisha Cuthbert), who is wheelchair-bound following the shooting at the office. Strangely, these sometimes selfless motives do not endow the loser with the nobility of character that turns a character into an object of viewer identification, however tenuously. On the contrary, the losers' dedication to the success and happiness of others documents that they have committed the gravest sin possible in a meritocracy: failing to be successful

and happy themselves. Sy's attack on Will and his mistress (Erin Daniels) at the end of *One Hour Photo* speaks volumes in this regard. While Sy has not achieved what Will has—a good job, a grand house, a beautiful wife, a son, and a somewhat more interactive pet—Will has it all but does not appreciate it (hence his illicit affair). The thwarted logic that drives Sy to the hotel room, forcing Will and his lover at knife-point to pose naked in sexual positions, is psychologically motivated;[27] as a child, Sy was forced to pose for child pornography (hence his obsession with photos). At the same time, however, the scene enacts Will's punishment for adultery, more concretely, for having failed in his duty to be happy. In this, the scene is profoundly indebted to the meritocratic idea that happiness is not an opportunity but an obligation.

The resistance against or the longing for the meritocratic world of everyone-for-himself also inform other irredeemable loser films. Quiet Man Bob, for example, is alienated from a world in which men are no longer self-sufficient ("It was easier in the past. A man knew what it was to be a man. Stood up for things") but have to cooperate with others: "Man could no longer stand up against evil himself, he had to go through courts now. Woman demanded equality and she got it. Not by getting everything that the man had but by man being castrated." Like Bob, Sam is caught in the classic conundrum identified by de Tocqueville: the expectation of success in the absence of the material wherewithal to reach it. Although he is constantly told that "power is a state of mind," he experiences work as a state of powerlessness: "I'm telling you, slavery never really ended in this country. It is given another name. Employee." In another scene, watching Nixon intone sagely that "a nation, like a person, has to have a certain inner drive in order to succeed," Sam screams hysterically at the TV: "It's about money, Dick. It's about money, Dick. It's about money! It's about money! It's about money, Dick! Money!!"

The consistent presentation of these losers as invisible constitutes the most trau-matic aspect of these films. Sam's self-definition as "a grain of sand," Ed's toneless awareness that "I was a ghost. I didn't see anyone. No one saw me. I was the bar-ber" put the finger directly on the wound: a human being unacknowledged by others ceases to exist. Like meritocratic thinking, this is a modern malaise. Tellingly, in his defense of Ed, the pompous-ass lawyer Freddy Riedenschneider (Tony Shalhoub) sees in Ed, the Man Who Wasn't There, a product of his time: "He talked about how I'd lost my place in the universe [...] He said I was Modern Man." Similarly, Ed's philo-sophical musings on hair speak to a belief in the intrinsic worthlessness of humans: "How it keeps on coming. It just keeps growing. It keeps growing, it's part of us. And we cut it off and throw it away. [...] I'm gonna take this hair and throw it out in the dirt. I'm gonna mingle it with common house dirt." Only loving acknowledgment can lift humans above dirt, which explains Sy's obsession with photos. "And if these pictures have anything to say to future generations, it's this: I was here. I existed. I was young, I was happy, and someone cared enough about me in this world to take my picture."

The struggle to be acknowledged by society mandates conformity with its ide-ology. Thus, rebellion and acknowledgement are mutually exclusive. Sam fails to understand this. Even in rebellion, he adheres to one of the fundamental ideas of meritocracy, namely that sufficient self-esteem enables great deeds: "The salesman who believes is the salesman who receives." In his taped confession to Leonard

Bernstein, he describes his entire existence as justified by one political act that he views as simultaneously self-defining and self-sacrificial: "Tell them why I did this, Maestro. History needs to be clear on this. They can rebuild the White House but they will never forget me. Not ever. I was here. I was here, Maestro. I did this. And a man is only remembered for his work. Just tell them that." Sam's problem, then, is not lack of self-esteem; he insists throughout the film that he deserves better and believes himself capable of "work" that changes the world. Rather, the problem is that the world refuses to be changed.[28] Sam's historic act, the assassination of Richard Nixon, never takes place, rendering his life meaningless and himself nonmemorable (invisible) to posterity.

The invisibility theme suggests that the loser and the cancerous world he lives in contribute to his despair in equal measure. His invisibility implies that there is someone (everyone) who refuses to see him. If the pursuit of happiness transcends the self and extends to the world beyond it, it requires a reaction from the outside. Indeed, many of these films portray a one-sided dialogue, in which the loser asks and the world refuses to respond. Or rather, the "answer" it offers, consumption of things and financial or business success, is a false path, one that ultimately exacerbates the loser's alienation and despair. Ed's statement that he owns a built-in garbage disposal and therefore "you could say I had it made" is clearly meant to be sarcastic, and yet he later pins his hopes for escape on a partnership in a dry-cleaning business. Sy's and Sam's attempts to be good employees are as misguided and illusory as Bob's meteoric rise to the top floor. Similarly, the emptiness of Sy's life in the SavMart with its cheap plastic crap parallels the emptiness of his fondest dream, his obsession with Will's model home with its expensive plastic crap. The promise of family happiness expressed by a picture of Will's home is as meaningless as the consumer happiness promised by SavMart, since neither reflects reality. As if the reality portrayed in these societies were not dreadful enough, even the illusions through which the loser tries to escape his reality are hopelessly pedestrian. The ultimate dystopia, and the crassest societal critique imaginable, is the depiction of a society in which even a person's wildest dreams are merely consumer dreams.

There are only two possible reactions to such a society: resistance or submission, alienation or self-alienation, aggression directed at society or at the self, murder or suicide. Sam, the failed assassin, encapsulates one possibility: "I am just trying to keep my family together. And the little guy can't do it anymore, he just can't do it anymore. Because there's a cancer in the system, the whole system has a cancer and I'm being punished because I resist. But somebody has to resist, just somebody has to resist." The other option is showcased by Bob, the worker drone, who admits that "There comes a time when the diseased and weak must be sacrificed in order to save the herd."[29] Once awoken from his daydreams of promotion and true love—"Do you really think someone like you would have a job like this? [...] Do you really think that a woman like that is gonna choose a man like you? I mean honestly now"—he thinks of himself as diseased and weak and commits suicide. "You may ask why I did what I did. But what choice did you give me? How else could I get your attention? All I wanted was to exist in your world. If just one person would take the time to actually see me and help me find a way out."

Despite this pitiful cry for help, and despite the films' consistently dystopian portrayal of the loser's surroundings, the person who sees Bob is unlikely to be sitting in the audience, since the film—deliberately—alienates viewers from the loser as well as from his world. At times it is difficult to see, let alone identify with, the main character. Repeatedly, we see only fragments of the loser's face or body: shots of Quiet Man Bob's glasses or mouth or fragments of Sam's face in the mirror. True to the film's title, the barber Ed is rarely fully "there" on screen; he is either overexposed in blinding white lighting, shadows so deep that his face is invisible, or in gray-in-gray tones that make him appear strangely two-dimensional, like a photograph in an old newspaper. The decision to shoot *The Man Who Wasn't There* in black and white reflects the fact that it is a period piece, but it also produces an alienation effect.[30] Other films subject the audience to extreme contrasts between the loser's private surroundings—compressed and stiflingly claustrophobic in their dark lighting—and starkly lit exteriors shot with wide-angle lenses designed to have "a distancing effect on the viewer" (see Robertson 81–85). Particularly Sy's SavMart, a dazzlingly bright and overstocked American emporium that provides the setting for one-third of the film, is oppressive in its garish and generic abundance. The film's attention to the loser's history and feelings conveys his suffering, but cinematography, the staging of the loser's world, makes it difficult to respond to his pain with any sympathy. The films do their best to preclude audience identification with the loser, even as they portray his despair. Whether the audience is confined in the gloomy burrow that serves as the loser's private space or made to share his bleak workspace, both settings compel maximal distance between character and audience.

Reading irredeemable loser films as a critique of meritocracy is a complex affair. On the one hand, these films express a view that is otherwise sternly banished from the American screen: the oppression of the worker exists; there is a class system; the difference between winners and losers is social rather than personal. Part of this critique is implied in the negative portrayal of successful men such as Sam's boss, Big Dave, Freddy Riedenschneider, or the *Cooler*'s ruthless killers. And yet, it is also difficult to identify with the film's loser, although he verbalizes and exemplifies the film's societal critique. Who would want to be someone who submits to bullying, who pretends to derive contentment from a consumer lifestyle or meaning from meaningless jobs? Again and again, irredeemable losers humiliate themselves only to become someone whom the audience is destined to despise. The loser's anguish is inarguably real and harrowing, and his suffering and criticism of his society impossible to dismiss. And yet the distance between audience and character imposed by the cinematography encourages the audience to adopt the same indifference toward the loser that destroys him in the film.

AND NOW FOR SOMETHING COMPLETELY DIFFERENT (II)

Reign Over Me (2007). Dir. Mike Binder. Writer: Mike Binder. Columbia Pictures. Domestic Total Gross: $19,661,987. Foreign Gross: $2,560,321. Total Box Office: $22,222,308. Production Budget: $20 million.

Charlie Fineman (Adam Sandler), the protagonist of *Reign Over Me,* is just close enough to a traditional loser to highlight the difference. For one thing—and this is relatively unusual in loser films—we know what turned him into a loser.[31] The blame lies not with his character but with a cataclysmic event. Following the loss of his wife and daughters in the September 11 attacks, "he just shut down. Quit work. He stopped wanting to talk about her. Then he acted like he didn't remember them." Unable to deal with the most traumatic event of his adult life, Charlie rejects adulthood altogether and reverts to his boyhood persona of the 1970s. He rides around New York City in a scooter, plays video games, collects vinyl LPs, offers memorized trivia instead of actual conversation, and adopts a teenager's attitude toward women. His college roommate Alan Johnson (Don Cheadle) is tolerated in this world because he is part of his pre-9/11 world and never knew Charlie's family.

The relationship between Charlie and Alan is hardly what one might expect. On the surface, they are opposites in terms; one has lost everything, the other has everything that the American Dream prescribes: a successful career as a dentist, an apartment in New York, a family (wife, children). And yet, the two are put on a par. The film's director Mike Binder describes the relationship as follows:

> At the soul of the movie is the story of two men who don't have anyone to talk to, and as the movie progresses they have each other to talk to [. . .] I think they both become a lifeline for each other, you know, a chance for both of them to just kind of go on with their lives and make their lives work.[32]

Here, a highly successful professional in an intact marriage beset by average problems and a traumatized, dysfunctional, and at times completely inarticulate loser are compared as if they were experiencing the same degree of disaster. But the film itself does not bear this out. Although not all is well in Alan's paradise—at work, he is threatened by a sexual harassment suit and upset about the spinelessness of his colleagues; at home, he is slightly annoyed by his somewhat overbearing wife—his problems are negligible and dissipate with minimal effort on his part. Alan escapes from these rather pedestrian crises by entering Charlie's juvenile world, going to late-night movies, and becoming addicted to Charlie's video games. Indirectly, the film admits that it is not just global disasters that are difficult to deal with but also normal life. Sex relations are complicated once they transcend a sixteen-year-old's fantasies of titties and blowjobs. Family relations (which Charlie avoids and Alan negotiates with varying degrees of success throughout the film) are challenging, not only if you lose your family but also if you don't. Both men take a break from the real world, Alan with the understanding that he will eventually return to it, Charlie fully intending to be on permanent leave.

What validates this friendship is not only, as Binder put it, that the two "have a good time with each other," but also that they help each other. That Alan is, contrary to Charlie, in a fairly stable situation does not mean that he does not need help. Reminded by Charlie of his much more assertive college persona, he confronts his backbiting colleagues at work, triumphantly relating the encounter to Charlie afterwards: "See, that's old college Johnson, that's taking-no-shit Johnson." Ironically, Charlie then tells him that the assertive guy in college was actually someone

else: "Andrew Handleman. He didn't take shit from nobody. You used to take shit from everybody, though. Remember that?" Thus, the scene cleverly deflates our expectations and reveals that the relationship between Alan and Charlie is not about resurrecting the past, but about mutual support in the present. And the support is mutual; the safe and mentally sound Alan receives as much from the deeply wounded and disturbed Charlie as he offers him in return. In one of the most affecting scenes of the film, after Charlie—with much prodding from his friend and his therapist—has finally succeeded in voicing some of his grief, Charlie answers Alan's concerned question "Are you gonna be all right, Charlie? You're gonna make it, right?" with a simple "I'm more worried about you, Johnson. I'm more worried about you."

Through Charlie's friendship with Alan, we begin to understand why he chooses to stay away from the rest of the world. The attempts by everyone else—his family, his doctors, the courts—to force Charlie to face up to his loss and reenter the world are coercive rather than helpful or healthy. At Charlie's mental competency hearing, his father-in-law defines the "correct" way of mourning in highly judgmental terms. "I think about them all day. Every day of my life." Looking at Charlie, who has shut out the entire proceedings by rocking in his chair, listening to Pearl Jam's "Reign Over Me" on his headphones, his father-in-law continues in a tone of severe disapproval: "I don't understand how anyone could not." In the same scene, the DA puts pictures of Charlie's family directly under Charlie's nose. Forced to look at what he lost, Charlie goes into hysterics, screaming "Reign Over Me" at the top of his lungs until the bailiff removes him. The attempt to force Charlie to conform to the conventional way of mourning—thinking about the people you lost every day, expressing your grief in acceptable venues, such as therapy, and otherwise leading a normal life—is condemned as a social and familial form of bullying. Ultimately, it does not help Charlie but serves largely selfish purposes; as Charlie's father-in-law confesses to Alan: "We just wanna be part of his life." At the end, Charlie is set up in his own apartment, safely ensconced in his juvenile world to which, however, he is now admitting a slightly enlarged circle of friends: Alan, his therapist Angela (Liv Tyler), and the beautiful Donna (Saffron Burrows), whose romantic interest in Charlie holds out a different kind of hope for Charlie's future.

Charlie differs from the protagonists of irredeemable loser films in four distinct ways. First, he is independently wealthy, which relieves him of the endless financial struggles of the traditional loser. Charlie's problem derives not from the everyday but the apocalyptic, not from the social world but from an act of God. Secondly, he *chooses* to live outside of the world, whereas the irredeemable loser tries desperately and vainly to gain admittance to it. Thirdly, there is an explicit statement that any attempt to "fix" him—as he himself puts it contemptuously—would do more harm than good. He is, as the film's conclusion shows, best left alone to renegotiate his relationship with the world from the safe vantage point of his apartment and with the help of his friends (now in the plural). And finally and most importantly, viewers can identify with Charlie. This is possible simply because we know something about Charlie that we rarely know about losers: how he came to be what he is. On another level, Alan mediates our sense of identification. Alan's success at work and happy family life make him the guy every man wants to be, and if Alan can identify with Charlie, so can we.

One reason Charlie is so eloquent on the subject of irredeemable losers is simply that he is not one of them. He is a tragic character, conforming to Aristotle's original definition of the term in almost every way. He is a "middling" hero, an essentially good man who is beset by what Aristotle called *hamartia* (lapse of judgment) and whose life is irrevocably changed by *peripeteia* (a sudden reversal of fortune). Whereas identification with irredeemable losers is difficult or impossible, the tragic character lays claim, in Aristotelian terms, to our fear and pity: pity for the hero's tragic fate coupled with the fear that the same could happen to us. Both rely centrally on identification. The loser, in contrast, wreaks havoc on the audience's need to identify with the protagonist, and this irrecoverable distance constitutes his most interesting feature.

THE PROBLEM OF IDENTIFICATION

Since the mid-1970s, Laura Mulvey's highly influential and much-reprinted essay "Visual Pleasure and Narrative Cinema" (1975) has inspired a tradition in film theory that equates "the masculinity of the male subject with activity, voyeurism, sadism, fetishism, and story, and the femininity of the female subject with passivity, exhibitionism, masochism, narcissism, and spectacle" (see Cohan and Clark, "Introduction" 2). From this point of reference, it is difficult to assess masculinities that do not conform to this norm as well as more complicated forms of identification than the one Mulvey originally proposed. In Neale's paraphrase of John Ellis's *Visible Fictions*, "identification is never simply a matter of men identifying with male figures on the screen and women identifying with female figures" ("Prologue" 10). The polar opposite of Mulvey's ideal screen ego is not only, as has often been proposed, women but also diminished men. Screen narratives rely centrally on male fetishism but also on male masochism, expressed for example in the mutilation of male bodies in Michael Mann's films (Neale, "Prologue" 14), the monstrous males of horror films (Creed 5), or other "threats to male narcissism posed by women, society, the law" (Neale, "Prologue" 15). What Anna Clark has established for concepts of male citizenship also applies to masculinity itself: all men have male bodies, but the possession of a male body alone is not enough for citizenship, which is seen as a privilege rather than a birthright. "Men needed to perform and prove their citizenship." Definitions of masculinity serve to exclude women and "whole categories of men."[33]

The admission that "visual pleasure" can be gained from male narcissism and, perhaps even more so, from male masochism brings up the question of identification once more. Viewers of loser films are essentially forced into a problematic identification not only through characterization and cinematographic distancing techniques but also through the films' unanimous condemnation or ridiculing of "winners." Movies of the Clinton and Bush era may not know what to do with the world's losers, but they have distanced themselves considerably from the uncomplicated Reagan-era conviction that the winner deserves his good fortune. This alone puts profound pressure on the meritocratic idea that it is possible to work one's way out of poverty, sorrow, subjugation, or whatever else ails the loser. What happens in loser films when the loser tries to "perform and prove" his masculinity—the fantastically absurd good luck of the Cooler; the ending of *He Was a Quiet Man*, when the successful alternative

life turns out to be an elaborate daydream preceding suicide; the pathetic failure and misguided goal of Nixon's would-be assassin—not only shows the sheer impossibility of turning the loser into a real man, but questions the validity of the attempt. The films translate the insurmountable distance between losers and winners, or losers and real men, into that between losers and what society accepts as humans. From the loser's perspective, the exceptional is the norm to be aspired to. To be seen to exist, you have to—at the very least—win a million dollars, run your own business, have a big house, get lots of pussy, kill your friends and coworkers, or assassinate the president. The only other way to become visible is to have the extraordinary happen to you: it takes an act of God or terrorism to make us acknowledge the failed human being as a human being.

Losers in Hollywood movies launch an assault on traditional ideas of narcissistic masculinity and on our most cherished ideals of human(e) interaction. So far, not many viewers have chosen to withstand that assault. Box-office figures for all of the films under discussion, with the sole exception of *The 40-Year-Old Virgin*, range from modest to disastrous. Unless a loser achieves cult status like the Dude, audiences appear unwilling to expose themselves to the problems of identification that the loser poses. Given this unenthusiastic reception, we may wonder why the loser has become a staple character in Clinton- and Bush-era films. Perhaps the answer lies in Jeffords's suspicion that like the sensitive man of the nineties, losers—"in a remarkable inversion"—manage not only to expose us to a new (abject) masculinity "but to excuse the 'old' one as well" (*Hard Bodies* 173). Loser films provide passing glimpses at another group for whom abjection and subordination are a day-to-day reality. In some films, the loser is mercilessly heckled by other men as soon as he shows anything other than utter contempt for women (*Anchorman; The 40-Year-Old Virgin*). In the world of the films, however, endemic subjection is a serious problem only when inflicted on men. This parallels Jeffords's conclusion that the future of humanity lies not with the "hardened, muscle-bound, domineering man of the eighties," but with "the considerate, loving, and self-sacrificing man of the nineties": Robocop is more than a machine; the Terminator functions as a surrogate father; the cop turns into a kindergarten cop. And yet the grand narrative of masculinity undergoes no more than an incremental shift: "True to these earlier narratives of masculinity, the quality and continuity of *everyone's* life finally depends on these white men" (*Hard Bodies* 153 and 154).

Perhaps Jeffords's insight does not have a direct analogy to loser films. Perhaps their recurring suggestion that it is problematic to treat men as if they were invisible does not imply that it is perfectly normal to treat women that way. The fact remains, though, that loser films have failed to pick up on an obvious analogy. Identification with a loser, they seem to imply, is complex enough; identification with a woman is wholly impossible. Masculinity, no matter how abject, is still the norm and the ideal. In an exact reversal of Marx and Engels's dictum that women's condition in society is the best measure of the degree of that society's humanization, loser films proclaim that if there is a measure for humanity, it lies in the treatment accorded to hapless men.

CONCLUSION

> In the modern techno-industrial culture, it is possible to proceed from infancy to senility without ever knowing manhood.
>
> Edward Abbey

MASCULINITIES: WE'RE LOOKING FOR A FEW GOOD MEN

Imagine, if you will, the many different types of men who have populated this study lined up in a military roll-call. Walking past the rank and file, we first notice those in nonattendance. Few and far between, for example, are the "good" men that the Marine Corps is apparently also looking for—truly and unswervingly decent, principled, moral men. Cops have moved into the ethical neighborhood of criminals. Fathers need a global crisis to take care of—or even notice—their offspring. Cowboys no longer live in a mythical past in which violence served the pursuit of truth, justice, and Manifest Destiny. The masculinity of superheroes, spies, and rogues is not unequivocal but multifaceted. They confront us with a confusing array of split personalities (Neo and Mr. Anderson, Spider-Man and Peter Parker, orcs and elves), doubles (Boromir and Aragorn, Gollum and Frodo), masks (worn by superheroes, spies, and rogues), and performances (enacted by rogues and lovers). The reassuring simplicity of male perfection, if indeed it still exists, has moved from spirit to body; it is now quite normal to see ethically stunted men perform physically dazzling feats. Even as viewers struggle to make sense of these characters' inner workings, they are entertained by watching them jump from cranes (Bond in *Casino Royale*), emerge from the belly of an alien with three hand grenade pins but no grenades (Ray in *War of the Worlds*), or dispatch orcs, gladiators, gangsters, Mobsters, enemy soldiers, suit-and-tie-clad computer programs, and countless other bad guys.

In most cinematic genres, the morally "good man" is not a given but rather emerges from a series of tests that challenge his manhood and his humanity. He is a reformed rake, like the soldiers in *Three Kings*, who progress from mercenary treasure hunters to humanitarian heroes, or the lovers who begin the film as sexist philanderers but develop the ability to empathize with women. Often, though, such happy results are presented as simultaneously highly desirable, highly improbable, and highly problematic. If fathers who ignore their children learn to love and protect

them only when a global crisis erupts, why should we believe that they will treat their children with the same care once the crisis is over? If cops can catch criminals only by becoming like them, and if moreover the institutions designed to protect civilians are spurned in favor of efficient renegade cops, who will safeguard civilians from cops?

Viewers are free to interpret these nearly ubiquitous dilemmas in one of two ways: either as a narrative problem—since these films are, in many cases, asking us to settle for an unsatisfactory solution—or as a sign of sophistication, since they offer wish fulfillment while sowing the seeds of doubt about both wish and fulfillment. Many Hollywood films of the past two decades enact our fantasy that one man (rarely an institution or government) can fend off crime, evil, terrorism, or corruption; use technology for good rather than evil; renounce violence; become a good father, a great lover, a legend; save the world (over and over again); or, if all is irrevocably lost, survive Armageddon and build a new world. Yet in granting our fondest desires, these films also point out that they are illusions. Films can present authentic problems, but it is beyond their power to offer authentic remedies. Illusions are all they have got.

The irresolvability of the dilemma may well explain why there are only a few good men. It helps to look at the only two genres in which ethically sound protagonists still appear regularly. One of them is the war movie, in which, interestingly enough, the moral man is not equipped with an all-powerful and invincible body. In war films, ethical qualities like loyalty, steadfastness, and courage trump stunning physical feats. The viewer's emotional investment in a war film depends centrally on this combination of moral righteousness and physical vulnerability. But of course, the test tube in which these righteous heroes are grown is partly an extra-diegetic one. War films are subject to direct government and military influence and censorship. These censors have, and exercise, the power to compel the creation of undiminished moral characters who have vanished from virtually every other cinematic genre. To achieve such purity, war films, in spite of their claim to authenticity, occasionally edit the historical record. Thus John Stebbins, convicted of the rape of a twelve-year-old boy, metamorphoses into a morally squeaky-clean Danny Grimes in *Black Hawk Down*.

The only other genre in which we can still find a few good men, and the only one in which their appearance is not mandated by extra-diegetic circumstances, is the loser film. The term "goodness" needs some qualification in this case, for losers do not usually possess the moral probity that often characterizes warriors, but merely represent the "better" option compared with the film's "real" men. Loser films attack the world or society in which the loser lives with far more gusto than the loser himself. As many other films do, they offer viewers a solution that does not solve anything: they "fix" the loser even though they have just established that he is manifestly not the main problem. Or, in a highly unusual move in Hollywood movies, they withhold a solution entirely: the loser's battle against the world ends in defeat and destruction, leaving the film's actual problem—a thoroughly despicable society—untouched. Worse, boldly going where no other genre has gone before, loser films on occasion even withhold the possibility of identification. In financial terms, this experiment has failed, as the dismal box-office numbers for most loser films attest.

ECONOMICS

Failure is delay, not defeat. It is a temporary detour, not a dead end.

Denis Waitley

Every Hollywood film has a story line and a bottom line, and the second will always trump the first. The nonnegotiability of the bottom line expresses itself most clearly in the necessity to appeal to as broad an audience as possible. This has resulted in a proliferation of films that mix genres or embrace ideological promiscuity. Just as the loser character tells us something about Hollywood's conception of actual manhood, the losers at the box office tell us something about what makes a film financially viable. Since this book is for the most part about blockbusters, it contains few analyses of box-office failures. If we draw the line between economic success or failure at or near $100 million, we arrive at the following list of economic losers: George Armitage's *Grosse Pointe Blank* (1997, $28 million worldwide), Gregory Hoblit's *Fallen* (1998, $25 million), Andrew Dominik's *The Assassination of Jesse James by the Coward Robert Ford* (2007, $15 million), Tommy Lee Jones's *The Three Burials of Melquiades Estrada* (2005, $9 million), Paul Schrader's *Affliction* (1997, $6 million), Kathryn Bigelow's *The Hurt Locker* (2008, $49 million), and every single loser film with the exception of *The 40-Year-Old Virgin* (average gross: $21 million). Arguably the most unforgiving of all loser films, Frank Cappello's *He Was a Quiet Man* (2007), netted a mere $2,431 domestically and an abysmal $83,440 worldwide.[1]

While it is difficult to say with any certainty why these films tanked at the box office, it is nevertheless a suggestive lineup. In one way or another, these films fell foul of the recipe for success that propelled all the other films discussed in this book above the $100 million line, sometimes even, as in the case of *The Lord of the Rings* trilogy, into the stratosphere of nearly (in one case over) $1 billion. Simply put, most economic loser films engage in acts of demythologization: of killing justified by idealistic reasons (*Grosse Pointe Blank*), of the caring or at least redeemable father (*Affliction*), of the military hero (*The Hurt Locker*), of foundational myths (*The Assassination of Jesse James; The Three Burials*), or of masculinity itself (loser films). In their uncompromising look at spousal and child abuse, at the dubious rhetoric of "good guys" versus "bad guys" in the justification of violence, at the experience of death in war, at the dishonesty of foundational myths and the dreariness of modern ones, or at the untenability of traditional masculinity, these films deal in disillusionment rather than a "something for everyone" ideological promiscuity. Unlike successful Hollywood films, they do not offer the alternate "visual pleasures" of male narcissism or masochism. Instead, they launch a direct assault on viewers' senses and sensibilities.

In contrast, lucrative Hollywood films happily hedge their bets. To their credit, the problems they portray hint at other, larger problems, and the solutions they present are often marked as illusions. But they leave viewers a choice between the path of least resistance that consists in accepting the film's happy, if hardly believable, ending, and the unmarked path to as-yet-unknown solutions—a challenge to viewers to come up with plausible alternatives. Many commercial loser films, however, take a different approach. They offer take-it-or-leave-it experiences. They expose us to a cinematic world of evils, not so we can overcome them but merely to state that they are terminal.

Their final scenes leave us not at a crossroads but at a dead end. Such a dead end, however, is the polar opposite of the most persistent American dream: that no matter what horrors confront us, we can always turn back, keep going, or start over.

POLITICS

History teaches us that men and nations behave wisely once they have exhausted all other alternatives.

Abba Eban

Throughout this study, we have maintained that films function as carriers of political meanings that are often oblique, implications rather than direct messages. The masculine types described above are clearly legible signs of America's political present and past. Surely, singlehandedly wiping out evil and corruption, or saving or remaking the world, is a lot to ask of these unwilling heroes, incompetent dads, corrupt cops, sexist dinosaurs, feminized males, or downright losers. It is perhaps not too far a stretch to read the sharp discrepancy between the task at hand and the diminished stature of the American hero to whom it now falls as an expression of doubt about America's role in the world. Through the lenses of Hollywood's cameras, we witness an increasing awareness of political and social problems coupled with a decreasing faith in the omnipotence fantasy that casts America as the cure for all ills.

Certainly, the Clinton and Bush eras have dealt a few blows to the faith in America's power and glory, but none of this is, strictly speaking, new. The September 11 attacks ended our faith in the inviolability of U.S. borders and the safety of its civilian population, even as it reminds us of Cold War fears of Russian missiles wiping out entire cities, which resulted in the building of atomic bomb shelters and huge investment in the Star Wars program under Reagan. The Second Iraq War took a chink out of our conviction that America always wins, a painful reminder of Vietnam. The inception of the Iraq War, Bush 43's lies about "weapons of mass destruction," inspired a loss of faith in political leadership similar to that occasioned by Watergate. And the consequences of the Iraq War, the shameless profiteering and exploitation of resources by Halliburton and other American firms, throws considerable doubt on America's supposedly noble purpose, a question raised previously by the bombs over Hiroshima and Nagasaki. The devastation of the American welfare system and the recent financial crisis have resulted in the inability of the poor and lower-middle-class families to survive solely on the man's income,[2] a quandary that lower- and middle-class men alive during the Great Depression would undoubtedly have recognized. Whatever the political traumas of the Clinton and Bush years, we have seen it all before, and this may, disturbingly, indicate that these are not merely occasional bumps on the otherwise smooth surface of the American road to success, but endemic and therefore recurring problems.

Films tend to handle these realizations not head-on but obliquely, in inconsistent, contradictory, and ambiguous ways. They reference social and political life indirectly, but link both directly and insistently with concepts of masculinity. Characters, particularly male characters, often assume symbolic dimensions. Cowboys no longer stand for freedom, but for the bleakness of modern middle-class myths, including

family values and the American Dream; they are no longer prototypes of independent individuality, but victims of a constraining society. The American worker bee incongruously surfaces in the guise of the serial killer. Lethal conflicts of highly skilled professional killers convey the urgency of marital problems. The freedom fighter as monk (in *The Matrix,* for example) suggests that freedom, albeit ideologically desirable, is existentially empty. In a genre that addresses itself mainly to the viewers' senses, sensory deprivation becomes a major theme. Eternal life is on offer (*Lord of the Rings; The Matrix*), but it is not a life worth living. Fathers save the world by saving the child. If they do not save the world, they get a chance to start all over. We need not see this amazing array of story lines and symbolic meanings as an obfuscation of political and social issues. However, the sheer multiplicity and contradictoriness of these symbolic meanings documents an awareness of social and political problems, as well as an ongoing struggle to arrive at the preferred solution: masculinity saves the day. Thus, each film faces two problems: to find the correct formula of masculinity and to make such an ending believable. To their credit, such an ending has so far eluded most films.

Amid the mass of conflicting stories and symbols, trends emerge. One recurring feature concerns distrust of government or institutions of any kind, which, in turn, implies that the lone individual is saddled with all the world's problems. A second, related trend redefines the political as the personal and converts ideology into psychology (thus, a critique of capitalism is transformed into a straightforward denunciation of greed). Like the first, this second trend privileges the individual over society, government, or institutions. Consequently, systemic reform and structural change are presented as unnecessary. Unlike the first, however, the second offers a quick fix, since individuals reform more easily than institutions, or so these films suggest. A third remarkable trend concerns the consistent effort to cast the audience in contradictory roles: as admiring viewers of an aesthetic spectacle, as "buddies" who are made uncomfortable when they can no longer identify with their on-screen friends (and, at times, even more uncomfortable if they can), as moral-immoral judges who both enjoy and censure the film's violence, as suckers who swallow the film's inadequate solution, and as critics who reject it because they refuse to be its dupes. Viewers are, of course, entirely free to accept some of these roles and reject others. But their sheer variety and sometimes contradictoriness indicate that the masculinities performed in Hollywood films of the Clinton and Bush years address themselves to their audiences, male or female, in complicated ways that call for something beyond simple identification, emulation, or rejection.

BACK TO THE FUTURE, OR FORWARD TO THE PAST: WE'RE LOOKING FOR A FEW REAL MEN

Manhood coerced into sensitivity is no manhood at all.

Camille Paglia

Throughout this book, we have viewed the truism that masculinity is "in crisis" as the engine that drove the Hollywood machinery of the Clinton and Bush years. The advent of the sensitive man and the cult status of some decidedly unmanly characters,

such as *The Big Lebowski*'s Dude, indicate a widespread discomfort with old-style masculinity among American moviegoers. Hollywood films, we have argued, show us the trauma of destabilized masculinity and the triumph of remasculinization and replay both crisis and triumph in sequel after sequel. We have diagnosed the compulsive combination of action hero and sensitive new man as the era's most defining Hollywood movie type. But there are now increasing calls for the "real" man, the undiminished, muscular, take-no-prisoners and eat-no-quiche macho man of the 1980s, to return to the screen, and these calls seem to have begun in the very year that marks the end point of our study.

Mere months after the end of the Bush regime, Anne Thompson, in an article titled "U.S. Short on Tough Guy Actors," began the search for the manly man. "Where have the manly movie stars gone?" she asked plaintively, comparing "boyish" stars like Johnny Depp, Keanu Reeves, Brendan Fraser, and Tom Cruise unfavorably with the "men's men" of the cinematic past (John Wayne, Robert Mitchum, Humphrey Bogart, and Steve McQueen). The director Frank Miller, then engaged in a search for a tough guy actor for his adaptation of *The Spirit,* agreed: "Hollywood is great at producing male actors, but sucks at producing men. I found them all too much like boys" (cited by Anne Thompson). Apparently, no amount of fighting bravado or box-office success suffices to turn boys into men. Even after the spectacular success of the *Matrix* trilogy, Keanu Reeves is still defined by his schoolboy role in *Bill and Ted's Excellent Adventure* (1989), just like "goofy Fraser," despite his role as a "boyish mummy-fighting father" in the second *Mummy,* has never lived down his role in *George of the Jungle* (1997). Men's men, Thompson goes on to claim, have now become Hollywood's biggest foreign import since American men obviously don't measure up anymore. Hollywood's real male superstars are Aussies (Mel Gibson, Russell Crowe, Hugh Jackman, Sam Worthington), Brits (Christian Bale, Ian McKellen, Patrick Stewart, Jason Statham, Gerard Butler), and the occasional Spaniard (Javier Bardem).

Thompson is hardly alone in her quest for the American "real man." The year 2008 saw a slew of similar articles bemoaning "The Sorry State of Masculinity in American Movies" (Goodwin). Two years later, there still appears to be widespread consensus that "[w]hile America lays claim to the boy-men niche with the likes of Johnny Depp, Leonardo DiCaprio, Matt Damon, Brad Pitt, Keanu Reeves, Jake Gyllenhaal and any male in a Judd Apatow film, Hollywood's most masculine male leads are more often than not played by foreigners" ("Manly Movie Stars"; see also "Hollywood stars are a bunch of boring wimps").

Like this study, some of these writers link the present state of Hollywood masculinities directly with changes in American politics. Thompson, for instance, suggests the following explanation for the disturbing absence of American he-men: "Ours is no longer the era of straight-ahead nationalism. Americans question everything, including authority." Jean-Louis Rodrigue, acting coach and teacher at UCLA's School of Theater, Film and Television, offers a similar thought. To him, "nothing is more attractive than clarity" ("Manly Movie Stars"), which is understandably difficult to obtain in an era in which Americans question everything: "It's particularly tough for a man to have clarity (in himself, what he wants, and where he is going) in this

tenuous cultural, social, economic and political climate (which has been called 'the end of men')."[3]

Clarity, of course, can only be obtained by eliminating complexity, through the simplification of story lines, characters, the questions a film asks and the problems it tackles. We have already seen this process at work in war movies, in which writers and producers, under the censor's watchful eye, occasionally construct a one-dimensional hero who advances a straightforward agenda. While complexity certainly makes for more interesting viewing, there is good reason to believe that the next era of Hollywood films may opt for more clarity. The reason is, as ever, the bottom line.

Video games, often more lucrative than films,[4] substantially change both the role of the masculine hero and that of the viewer. They re-create the experience of combat, but from a vantage point of safety: if you're shot, you simply re-set and start over. In this way, video games recreate a pre-9/11 worldview, the idea of an unassailable, omnipotent and indubitably righteous America. In essence, they reinvent Manifest Destiny and embody the old dream of starting over in its most literal form. Because the roles of viewer and hero are now conflated, their identification is as axiomatic and immutable as the hero's contradistinction from the antagonist; it is a *passive* identification that is automatically assumed rather than chosen by the viewer. It is not up to the viewer to determine whether or not it is a good idea to kill all these aliens; it is a simple test of skill with the aim to eliminate as many as possible. Most games bypass ethical and intellectual faculties. There is no forethought or doubt, only stimulus and response.

Ex-president George W. Bush showcased precisely this elimination of thought and ethics in his recent straightforward admission that he personally authorized waterboarding as an interrogation technique. The complexities behind this admission—waterboarding is considered an act of torture and a crime both in the United States and under international law, and Bush's legal advisers were later found to have acted in "reckless disregard" of their professional obligations—were swept aside by Bush's simple claim that it "saved lives" (Sands). There is no evidence to support this. In fact, U.S. Centcom commander General Joseph Hoar confirms that the practice endangers lives by "damaging counterinsurgency efforts, and increasing threats to our soldiers" (Sands). Bush's rationale, while spurious, does have the advantage of clarity. Like a video game, tactical advantage is the only kind of thought it permits. It asks only how to shoot down as many enemies as possible, not whether one should. As in a video game, there are no consequences to the gamer, such as the possibility that if waterboarding can be used by U.S. soldiers, it can also be used *against* them. Like a video game, Bush's thinking is guided by reflex, not reflection.

If calls for Rambo's return and the past and present treatment of international politics as a video game[5] point toward a trend, films that delight in complexity will face an uphill battle in the near future. Addressing the bottom line now means targeting an ever-younger audience raised on video games. Already, a movie's financial success is tied less to box-office performance than to its afterlife in secondary markets (DVDs and merchandizing). In this scenario, old-style masculinity, which transfers more easily to video games and action figures, is making a comeback. Recent box office hits and flops confirm this assumption. Witness, for example, *The Expendables*

and *Scott Pilgrim vs. the World*: both were released in August 2010, are shaped by similar cinematic influences, and address the same audience. In many ways, the two are similar enough to inspire constant comparisons (see, for example, Ditzian and Quigley). And yet, *The Expendables*' worldwide gross of $274,470,394 beat *Scott's* miserable $47,664,559 by over $225 million. Most critics explain this with differences in the portrayal of each film's male heroes. *Scott's* scrawny geek, who confirms the post-Bush era view that "men of today are gay" (Quigley), stood no chance against the testosterone-laden *Expendables*, which starred Sylvester Stallone, Jason Statham, Dolph Lundgren, Randy Couture, Steve Austin, Eric Roberts, Bruce Willis, Arnold Schwarzenegger, and Jet Li.[6] Faced with a choice between post-Internet age smarts cum kung fu and a movie bursting its seams with 1980s brawn, audiences opted for yesterday's male image. "And with that, America has spoken: Trashy '80s action like *The Expendables?* Yay. [...] Smart, original and visually arresting genre-benders like *Scott Pilgrim vs. the World?* Fuck-off, hipster" (Quigley).

In the foreseeable future, then, a larger share of the movie market will likely fall to the creators of "clarity." We can expect to see more cause-and-effect story lines, one-dimensional characters, uncomplicated motivations, and straightforward agendas that lend themselves to syndication.[7] And if Hollywood masculinities are indeed linked with American politics, this trend will likely continue until new clarities emerge on the political horizon or until viewers get bored, threatening the all-important bottom line. When calls for Hollywood portrayals of freshly divorced wimps, traumatized and timid soldiers, youth-obsessed middle-aged teachers, impotent potbellied men, fey elflike girlie guys, or nerdy impoverished metrosexuals are on the rise, we'll know that Rambo Redux, who may well dominate the movie scene of the 20-teens and 2020s, will have to share the jungle once again.

NOTES

1. See Robinson, who points out that many Hollywood films "frame the male body in a narrative that moves from objectification/eroticization, through a temporary destruction that 'masochizes' the male body, and ends in a regeneration of that body and a reemergence of the phallic masculinity" (141). See also Fradley, who sees "masochistic spectacles of heroically suffering white men" as "the key trope in recent Hollywood action cinema" (239).
2. According to Jeffords, "sequentiality itself was one of the mechanisms for Hollywood responses to crises in the representation and marketing of U.S. masculinities in this period" ("Masculinity" 247).
3. Another important trend consists in the practice of "front-leading the picture [...] diminishing the potential damage done to weak pictures by negative reviews and poor word of mouth" (Schatz 19).
4. See Greven's discussion of the "rise of the double-protagonist film" (9). Greven claims that this doubling shows that "manhood's center cannot hold [...] that the burden of male representation must be carried by two stars rather than one" (125).
5. See Greven's claim that "a struggle between narcissistic and masochistic modes of manhood defines Hollywood masculinity in the Bush-to-Bush period" (4).
6. Schatz's claim that there are only two genres left, comedy and action-adventure (33), can be read as an acknowledgment of this trend.
7. Bordwell also notes the increasing importance of irony and "playful knowingness" (7).
8. While we appreciate the historical impact and innovative insights in Laura Mulvey's theories on spectatorship, we follow newer studies that assume that the male body is a spectacle in its own right (Powrie/Davies/Babington 3).
9. See Robin Wood, who claims that "the hysteria died out but the overemphasis on ultra-macho masculinity did not: the 90s has [sic] merely substituted a kinder, less blatant, less parodic, and less downright silly form of it" (xxxvi).
10. On the central role of blockbuster films for the financial viability of Hollywood, see Maltby 36–40.
11. See Lewis, who claims that "nineties American film went soft politically" (5). Lewis too interprets the absence of overt political messages as an economic strategy.
12. See Michael Wood, who remarks that "problem movies, over the years, have helped us to understand the 'problems' they themselves created" (128).
13. See also King, who claims that films "offer fantasies of recuperation in which real social issues are raised and resolved at an imaginary level" (*New Hollywood* 109).
14. See Braudy, who points out that in movies "psychology is not a deviation from politics; it is politics" (135). See also Dyer, who explains that the star system reinforces this trend: "stars with obvious political associations act unavoidably to obscure the political issues

they embody simply by demonstrating the life-style of their politics and displaying those political beliefs as an aspect of their personality" (*Stars* 31).

15. King makes a similar claim: "The desire to appeal to a mass market is likely to produce a degree of built-in incoherence and conflicting demands" (*Narratives* 4).

CHAPTER 2

1. On fighting and killing women in film, see the essays in Andris and Frederick; Powers, Rothman and Rothman 167.

2. On corrupt cops as a movie theme, see Powers, Rothman and Rothman, particularly 101–19.

3. See, for example, the description of FBI agent Krendler and Lecter's victim Mason Verger as more odious monsters than Lecter himself in Picart and Greek, "The Compulsions" 246.

4. Period pieces set in the more recent past, such as *L.A. Confidential*, show us screen detectives whose ethical stance is much more embattled than that of *Sleepy Hollow*'s straightforward Constable Crane.

5. In the 1990s and early 2000s, the ethical brain or brawn detective has moved to television, where he most often works for an equally incorruptible justice system. The longest-running and most successful series of this kind are NBC's *Law and Order* (1990, currently in its twenty-first season) and the *CSI* franchise originally aired on CBS (*CSI: Crime Scene Investigation*, 10 seasons since 2000; *CSI: Miami*, 8 seasons since 2002; *CSI: NY*, 6 seasons since 2004; as of this writing [2010]). On television, this idealistic view of law enforcement is rarely modified. One notable counterexample is *The Wire* (2002-08), which takes a huge bite out of the extreme contrast between cops and criminals as portrayed in standard cop shows. Criminals in *The Wire* are not always motivated by greed or bloodlust, just as the show's cops are not always motivated by a wish to protect and serve, but often by the conceit that they are smarter than the criminals they chase. Whereas *CSI* revels in the glories of forensic technology and revives the standard brain and brawn detectives, *The Wire* has been praised for its "realistic" portrayal of police work as severely undermined by bureaucracy and ethical issues. Despite its critical acclaim, *The Wire* has not been commercially successful. On *The Wire*, see "The Wire: arguably the greatest television progamme ever made"; "The Wire is unmissable television"; and Kevin Carey.

6. Greek 181; on police brutality in America, see also Champion; Holmes and Smith; McArdle and Erzen.

7. See, among others, the findings reported in Ogletree, Prosser, Smith and Talley; Waegel; Terrill.

8. On the Rodney King case, see above all Gibbs; Gooding-Williams for a relation of the entire case; Patricia J. Williams on the change of venue for the case to the nearly all-white Simi Valley, whose population had a high proportion of active or retired policemen; Crenshaw and Peller on narrative representations of the beating at the trial; Jacobs on news coverage of the case, and the essays assembled by Khalifah (black writers responding to the case). A defense of the police officers guilty of the beating is offered in Deitz's *Willful Injustice*. Deitz also coauthored a book titled *Presumed Guilty* with Stacey Koon, the senior "arresting" officer at the incident.

9. On *Dirty Harry*, see Houck; Lott 120–21, and the essays assembled by Arnold and Esser.

10. On Eastwood's cowboy roles, see the chapter on cowboys in this volume.

11. In problematizing the town's artificial racial homogeneity and in portraying the framing of two blacks, the film takes a stand against discourse that scapegoats racial minorities and against fearmongering. The simplistic perception of Armenians and Iranians as a threat

("The problem in this town ain't the people that live here. It's the element that visits") is portrayed rather critically. And yet, the blacks racing Superboy on the bridge are shown as extremely aggressive, and his error seems understandable since viewers, too, are led to believe that they are armed.

12. Freddy as a fat slacker is so effective partly because he provides an unmissable reference and the greatest imaginable contrast to Stallone's most defining roles, Rambo and Rocky.

13. See Greek for an analysis of the film in the context of the Rodney King beating.

14. The film's narrow focus on Alonzo and his men is striking. It is expressed by bird's-eye shots of Alonzo and his car that refuse to show the world around them. The only authority to which Alonzo and his crew answer are the corrupt police chief and judge; beyond Alonzo's team, no other cops—corrupt or otherwise—are shown.

15. On the symbiosis between detective and killer in films based on Harris's novels, see Philip Simpson, "Gothic Romance."

16. From a 1994 National Examiner headline, "Serial Killers Are as American as Apple Pie," cited by Schmid 25.

17. Cf., for example, Picart and Greek: "the terrorist has currently replaced the serial killer as the most monstrous of all criminals" ("Profiling the Terrorist as a Mass Murderer," 256).

18. On this trend, see McKinney; Schmid (245–57). Serial killers have, however, always been a popular topic in cinema, where they account for a far higher percentage of homicides than they do in real life. While only about 1–3 percent of homicides in the U.S. are attributed to serial murders, the ubiquity of serial killers in movies has "caused serial murder to be constructed and accepted as the dominant homicide problem in the United States" (Surette 207 and Dyer, *Seven* 37 on statistics; the quotation Surette 219). The FBI has used the spectre of serial killers repeatedly to increase and maintain its funding levels (Schmid 26, 66–101).

19. For the purposes of this discussion, it makes little sense to distinguish, as cinematic portrayals sometimes do, between paid and unpaid "workers" in the genre, for example, between paid assassins and serial killers who murder for personal satisfaction. In the cinematic tradition, the difference between the two is linked to the presence or absence of violent fantasies, a distinction originally advanced by the FBI. Robert Ressler, the FBI profiler who coined the term, defines as a serial killer anyone who, compelled by a violent fantasy, has planned and executed the murder of at least three people. In subsequent discussions among forensic psychologists, the number of victims required for the status varies (some definitions require as many as ten), but all definitions insist on premeditation and the compulsive force of violent fantasies. On the FBI's definition, see Picart and Greek, "Compulsions" 249–53.

20. The implication here is less the alignment between cop and killer implied in cop movies but between killers and the general working population. In this, serial killer films are very different from gangster films, whose "grifters" often deride the "grafters" (those stupid enough to work for a living) (*Goodfellas,* 1990; see also *A History of Violence,* 2005).

21. For this tradition, see the work of Philip Simpson, particularly *Psycho Paths*; Surette 208 and 221.

22. On *Seven,* see especially Dyer, *Seven;* Lacey; Gormley; Schmid; and Philip Simpson, *Psycho Paths* 194–202.

23. *Seven*'s producers were initially hesitant to cast Freeman as Somerset because they worried about being accused of imitating the *Lethal Weapon* series. On the character constellation Somerset-Mills, see Dyer, *Seven* 24–25.

24. Numerous critics, including Lacey 26–28 and Gormley 174, commented on Somerset and Mills as opposites.

25. On the significance of culture and learning in the film, see Dyer, *Seven* 71–73.

26. See Philip Simpson's citation of Joel Black in *Psycho Paths* 85–86.

27. Noted by many, for example Dyer, *Seven* 67; Philip Simpson, *Psycho Paths* 200; Gormley 174; Lacey 71.

28. Somerset's superior officer refers to him as a "great brain."

29. In Arabian legend, they cool the sun with ice and snow to prevent the Earth from burning up.

30. Mills's stable home, which makes him the object of Doe's envy, is a small oasis in this dystopian landscape: at least he loves and is loved in return. But even this idyll is compromised by Tracy's deep unhappiness—she is, in fact, sorely tempted to leave the city and by implication also Mills—and her inability to communicate to him either her unhappiness or her pregnancy.

31. Lacey quoting John Wrathall, 6; see also his analysis of the city on 37–38 and Fincher's comment on the city, Dyer, *Seven* 63–65.

32. Dante Alighieri, *Divine Comedy*, canto 3, lines 1, 2 and 9; citation and discussion in Lacey 50.

33. Dyer, *Seven* 77; on the added final line, see also Philip Simpson, *Psycho Paths* 201.

34. Mike Leaveck, communications director for Vietnam Veterans of America, in a 1986 article in the *San Francisco Chronicle* claiming that violence in Hollywood films has a reassuring effect on the viewer. The article is cited in Kendrick 21.

CHAPTER 3

1. The literature on the subject is too extensive to be reviewed here (see Harwood 43). Seminal sources include works by Faludi (*Stiffed*), Bly, Corneau, and Modleski (*Feminism Without Women*).

2. There are, of course, many challenges to masculinity in addition to "the crisis of fatherhood," among them the outsourcing of jobs to other countries, a restructuring of the workplace that favors "service jobs," that is, traditionally female jobs, and the dominance of an image culture where men can no longer be "doers" but are reduced to the status of onlookers. On men's changed working conditions, see Warren; Luce.

3. "[T]he concept of one male breadwinner per family has been one of the most powerful family discourses of the modern era, and one that has had dramatic effects on constructions of fatherhood, masculinity, motherhood, femininity and family life" (Harwood 44).

4. Cited and discussed in Lupton and Barclay 2. This discourse is race and class-inflected. The absence of fathers is often framed as a problem of black, poor neighborhoods, while the discourse of the "new father" usually pertains to the white, upper-middle class. On absent fathers as a social issue, cf. Blankenhorn.

5. For divorce rates in the United States between 1992 and 2002, see the Divorce Statistics Collection of the organization "Americans for Divorce Reform" at http://www. divorcereform.org/rates.html (last accessed August 10, 2009); see also Feasey 43.

6. On Clinton's mobilization of his paternal image, see Tincknell, *Mediating the Family* 62–63, Lupton and Barclay 2, and Malin, *American Masculinity* 7, 61, 64.

7. On the effects of America's "display culture" on both genders, see Faludi, *Stiffed,* and Krimmer's relation of this phenomenon to recent Hollywood films.

8. Particularly in the 1980s, when traditional men's jobs in industries were replaced by newer service-related jobs, often done by women (Harwood 43); see also Trice and Holland, "*Gump* and Gumper" 196; Reiter 15.

9. See particularly John Bly's influential book *Iron John* and related movements, such as the Rev. Wildmon's militant American Family Association, and 1990s organizations such

as The Promisekeepers and Families Need Fathers. On these movements, see Harwood 43 and 178; Tincknell, *Mediating the Family* 59–60 and 73; Lupton and Barclay 2; MacKinnon 20–21. Other writers complained bitterly about the obstacles besetting working fathers—long hours at work, the double workload at work and at home, the lack of adequate childcare, paternity leave, and so forth—that have beset working mothers for decades but gain in urgency if experienced by male parents (cf. Rotundo's long list of social hindrances to "participant fatherhood," particularly 71–77, and Trice and Holland, "*Gump* and Gumper" 196).

10. Krimmer 29; the term was coined by Solomon-Godeau.

11. Davies and Smith quoting Donna Haraway, 21. See also Krimmer; Harwood 73; Tincknell, *Mediating the Family* 56–57; MacKinnon 10–15; Silverman 3; Tasker, "The Family in Action" 253 and *Spectacular Bodies* 2–3. Philip Green states the problem succinctly: "'having it both ways' most prominently means [...] that we can 'have' our feminism or our women's liberation as entertainment without having it as a persistent politics" (86).

12. Even when mothers play a significant part (*Mrs. Doubtfire; Junior*), the films are plainly obsessed with the extraordinary feat of a male birthing or caring for children, not with the rather ordinary one of a female accomplishing the same tasks. The tendency in movies to award fathers pride of place is expressed precisely in Joyce Ostin's celebration of fatherhood in the introduction to her book on real-life *Hollywood Dads:* "Being a father is not an easy job. In fact, my husband, Michael, says it is much easier to go to work than it is to stay at home. Staying home, however, is not an option for him or for any of the hardworking men in this book. Fathers have many roles to fulfill. I could probably think of thousands, too many to list. A father has to be the friend, the disciplinarian, the advisor, the fashion consultant, the driving-school teacher, the schlepper, the tour guide, the bartender, the banker, the listener, the calmer-downer, the chauffeur, the 'bad guy,' the guest-list advisor, the rental-ski carrier, the fire minder, the spider scooper, the tick remover, the burglar watcher, and the clicker controller. After attending to all of these duties, a father can relax... until the next emergency arises. His job is relentless." And where, we might ask, are the mothers in this description of family life? Obviously, their nonparticipation in raising their children leaves them shouldering a rather hefty burden of gratitude to these untiring dads: "Wives [...]—women are forever indebted to the fathers of the world" (7).

13. Notable exceptions are Sally Field, Julia Roberts, Jodie Foster, and Nicole Kidman, all of whom have played single mothers.

14. Analyses of the film have been offered by Krimmer 32–35, Bruzzi, *Bringing up Daddy* 177–80, Philip Green 146–51, Lupton and Barclay 70, and Nicole Matthews 120–28, among others.

15. Cf. Philip Green 151: "At the moment in *Mrs. Doubtfire* when we see Robin Williams's hairy legs peeping out from under his dress, we know that everything is still for the best in this best of all possible worlds: the world in which men, now happily humanized, can safely be allowed to go on ruling." Green here reiterates the feminist criticism of the appropriation of "feminine" qualities by men, a criticism that does not, in our view, transfer cleanly to *Mrs. Doubtfire:* it is difficult to imagine Daniel as "ruling" anything at the end of the film.

16. Lupton and Barclay 70: "simultaneously the ideal mother figure and the ideal father figure"; Nicole Matthews 90: a "combination of a female appearance and a male temperament."

17. Williams has made a career of playing childlike fathers, for example in *Hook* (1991) and *Jumanji* (1994).

18. Cf. Tasker, *Spectacular Bodies* 2–3, on late 1980s father-only films such as *Three Men and a Baby* (1987) and *Parenthood* (1989).

19. Cf. Tincknell, *Mediating the Family*, particularly 142, on absent or evil mothers as figures of anxiety in 1990s Hollywood films such as *Home Alone*, 1990; *Don't Tell Mom the Babysitter's Dead*, 1991; *The Hand That Rocks the Cradle*, 1992, and others.

20. Cf. Freud's and Lacan's seminal texts on the subject and the application of these ideas to Hollywood films by Danae Clark, Bruzzi (*Bringing up Daddy*), and Reiter.

21. The director Sam Mendes on "The Making of *Road to Perdition*," supplementary DVD-material, *Road to Perdition*.

22. The film offers a paternal role model to the black community, where fatherlessness is a major issue; other race-related issues—black anger, the cluelessness of whites (Chris's bosses keep borrowing money from him)—are also allotted some screen time.

23. The film is based on the real-life story of Chris Gardner, who wrote the book on which the screenplay is based and was consulted on the making of the film; see "The Man behind the Movie: Meet the Real Chris Gardner," supplementary DVD-material, *The Pursuit of Happyness*.

24. In 2010, four years after the film aired, economists estimated that the chances to swap a lower-income bracket for a higher one are smaller in America than in any other developed economy (see Luce).

25. For Freud's theory of the Oedipus complex and father-son relationships, see particularly his "The Dissolution of the Oedipus complex."

26. These final lines essentially state that fatherhood trumps moral considerations, for they define as comparatively negligible or even unanswerable one of the most profound para- doxes of the film: that Mike, a contract killer, is cast as a profoundly decent guy. "Decent" in this context means that he kills because he owes Rooney a debt of gratitude, rather than for enjoyment like Rooney's other son Connor. He also does not kill purely for money like the contract killer Maguire (Jude Law), although Mike's job too is presented as one that puts food on the table. "Decent" also means that Mike is troubled by his job; his success as a father is mainly encapsulated in steering his son away from his own profession.

27. Rooney insists time and again that Michael is not to be harmed, but it is obvious that neither Nitty (Stanley Tucci) nor the assassin Maguire will heed these instructions.

28. Andrew Spicer offers an excellent analysis of the film in "The Reluctance to Commit."

29. See, for example, statistics and discussion in Blankenhorn, Corneau, and Dennis and Erdos.

30. See, for example, Dennis and Erdos; Emery; Bob Simpson, McCarthy, and Walker; and Clulow and Vincent.

31. A similar distinction exists in Freud's writing on fatherhood; cf. Bruzzi, *Bringing Up Daddy* xiv.

32. For the purpose of this discussion, we define the "world" as the film's diegetic world (Los Angeles in *Volcano*; Rome in *Gladiator*; the emerging United States in *The Patriot*). Often, of course, the film's world is cast as the entire world (for example, in *Signs; The Day after Tomorrow; War of the Worlds; 2012*).

33. *War of the Worlds* is an intriguingly incongruous film: on the one hand, Ray Ferrier (Tom Cruise) constantly performs superhuman feats; on the other hand, the world eventually rids itself of the alien threat, like Rachel's (Dakota Fanning) hand rids itself of the splinter: "when it's ready, my body will just push it out." However, Ray's heroics are instrumental in ensuring Rachel's survival until the world is ready to heal itself, for example, when he rescues his daughter from absorption into the alien pod by exploding it with a grenade.

34. Natural catastrophes in disaster movies appear universal and indiscriminate, but as King has shown in his analysis of *Volcano*, this is by no means the case (King, *Spectacular*

Narratives, 150). *Volcano*'s Los Angeles is a modern-day Sodom that deserves to be destroyed; the lava flood targets particularly those parts of the city most afflicted by poverty or corruption.

35. See many comments, by Steven Spielberg and others, on *War of the Worlds*; supplementary DVD-material, *War of the Worlds*.

36. On *Gladiator*, see Fradley; Cyrino; Rose; Radner; Geoff King, *New Hollywood Cinema* 178–201 and 255 and Jeffords, "Breakdown," 221; on *The Patriot*, see McCrisken and Pepper 24–35.

37. In *Gladiator*, Maximus's life as a farmer is established rather cursorily in his fleeting descriptions of his home life to the emperor and other soldiers; he is never shown as a farmer. The extreme unlikelihood of this alternate existence for Maximus is established early in the film, through Quintus's ironic comment "Maximus the farmer. I still have difficulty imagining that." Similar troubles might well afflict the audience, who are spared visions of Maximus plowing a field or milking a cow by Maximus's death, which recasts him firmly in the two roles he actually plays: a gladiator who dies in the arena and a soldier who dies in combat.

38. Both Maximus and Benjamin are reborn as saviors of the nation after their son's deaths. While Benjamin refuses military involvement before this, Maximus has served as a soldier in wars of conquest whose moral righteousness is doubted even by Emperor Marcus Aurelius; he does not take on the more idealistic duty of restoring the Republic to Rome until after the murder of his family.

39. On the historical congruence between U.S. history and the history portrayed in *Gladiator*, cf. Cyrino and Rose.

40. Although *Gladiator* equates Imperial Rome with decadence and decline, it serves up a potential Republican Rome as an easily recognizable stand-in for America, the world's oldest democracy. The equations between Rome and America, America and freedom, are drawn by many commentators in the supplementary material of the DVD version.

41. We would disagree here that the film eliminates patriarchy through the failure of the transition from father to son, and with Radner's statement that in *Gladiator*, "masculinity, nation, and history are mourned rather than celebrated" (73).

42. Gabriel is killed when he pursues Tavington to avenge his young wife; fighting heedlessly rather than strategically, for personal rather than political motives, and with no Father to hold him back, he gallops straight into destruction.

43. Many participants in both films, including directors, screenwriters, actors, producers, and costume designers claim careful attention to historical accuracy. Cf. the supplementary DVD material for both *Gladiator* and *The Patriot*.

44. Historical inconsistencies in both films are too numerous to mention. For example, Marcus Aurelius had no intention to return power to the Senate, nor did he disinherit Commodus. The film's conceit that a deviation from the patrilineal line was unusual is also ahistorical; most Roman emperors were, in fact, adopted, and Commodus was one of the very few emperors "born to the purple." For this reason, we would resist mapping Roman history onto the film's ending. We cannot conclude from the historical fact that Rome did not become a republic following Commodus's rule that the film indicates the failure of the republican project at the end. The film ends with Maximus fulfilling his promise to Marcus Aurelius and leaves open whether Gracchus actually succeeds in reinstating the republic.

45. Producer Mark Gordon, supplementary DVD material, *The Patriot*.

46. In *Road to Perdition*, the killing is justified as defense of the son, but paradoxically also through the understanding that becoming a killer is the worst of all fates: Mike kills to save his son from becoming a killer.

CHAPTER 4

1. Cf. Allmendinger, *Imagining the African American West;* Philip Durham and Jones; Taylor; Michael K. Johnson.

2. Buscombe has pointed out that women played a far greater role in frontier life than they do in the Western tradition: "the Western had too much invested in masculinity and its discontents to spend much time on what women want [. . .]. In such an extreme world women, though often the ostensible reason why the man struggles to impose the law, are regarded as little more than a distraction" (21–22). One notable exception in recent and not-so-recent Westerns is Mattie Ross in Charles Portis's *True Grit* (1968) and four cinematic or television adaptations (*True Grit,* dir. Henry Hathaway, 1969; *Rooster Cogburn,* dir. Stuart Millar, 1975; *True Grit: A Further Adventure,* TV film dir. Richard T. Heffron, 1978; *True Grit,* dir. Ethan Coen and Joel Coen, 2010).

3. Marcus on John Wayne: "professional American, he wears the mantle of Manifest Destiny easily, happy to represent America to the world, to itself, to himself" (209).

4. Baur and Bitterli 10; cf. also Koch 58 and Michael Kimmel's important essay on the link between the cowboy as a template for the "American Social Character" and U.S. foreign policy from the Civil War to the 1980s.

5. "Bush says bin Laden cannot hide," *St Petersburg Times,* September 15, 2001, http://www.sptimes.com/News/091501/Worldandnation/Bush_says_bin_Laden_c.shtml (last accessed March 20, 2011).

6. Buscombe has linked the Western's marginality since the 1970s to the Vietnam War and resulting doubts about the concept of "heroism" (8–11); see also Lenthan 116–17.

7. On Academy Awards for Westerns, cf. Kitses 2, Buscombe 84–85, and Lenthan 116–17. The only three Academy Award winners so far in the genre (in the Best Film category) are *Cimarron* (1931), *Dances with Wolves* (1990), and *Unforgiven* (1992), the latter two made when the talk about the demise of the genre was already in full swing.

8. Although prominent in Westerns, this conflation is hardly exclusive to the genre (for example Arnold Schwarzenegger as the Terminator/Governator or Cary Grant as the Ladies' Man).

9. Dir. Franklin B. Coates; cast: Jesse James Jr. and Diana Reed.

10. Bingham 234. This is one of the standard interpretations of the film; cf. also, for example, Knapp 19–20 and 162–63.

11. Cf. Buscombe 85–87 on the scholarly debate on the film as "revisionist."

12. The film's cast and crew advanced the idea of *Unforgiven* as an antiviolent film. Morgan Freeman stated in an interview, "Nothing good comes of it [violence] ultimately. It does damage the soul." Gene Hackman said of Eastwood: "I like to believe that he set out to make an anti-violence pro-woman picture." Eastwood himself: "I'm not doing penance for all the characters in action films I've portrayed up till now. But I've reached a stage of my life, and we've reached a stage of our history where I said to myself that violence shouldn't be a source of humor or attraction . . . We had a chance here to deal with the moral implications of violence" (all citations in Buscombe 72–73). Hackman supposedly refused the role as Little Bill until Eastwood convinced him that "if we do it right, it's not exploiting it [violence], in fact, it's kind of stating that it doesn't solve anything" (Breskin 382).

13. The link is made in the most traditional way: the symbolic identification of guns and penises. For example, Little Bill, after defeating and humiliating English Bob, sends him on his way with a bent gun. Corky "Two Gun" Corcoran is so called not because "he was sportin' two pistols. It was because he had a dick that was so big it was longer than the barrel on that Walker Colt that he carried." And in a dialogue snippet between the

Kid and Ned, in which the Kid criticizes Munny for not defending himself against Little Bill's beating (after he and Ned jumped out of the whores' windows to escape Little Bill): *The Kid.* "Yeah well, at least I woulda pulled my pistol, Ned." *Ned.* "Well, you did! Right outta the lady an' out the goddam window."

14. Little Bill Daggett is a composite figure made up of various intertextual allusions. For one thing, Bill functions as an alter ego for Will (Munny), a link made obvious by both characters' use of similar-sounding or identical turns of the phrase at central junctures in the film. Little Bill is also a historical allusion to Wild Bill (Hickok), who, like Little Bill, was a town marshall in Abilene, KS (Hickok lost his job there for committing two murders; cf. Rosa, *They Called Him Wild Bill*). Like Little Bill's Big Whiskey, Wild Bill's Abilene had a town ordinance requiring all visitors to surrender their firearms to the authorities.

15. In their relation to violence, women play contradictory roles in *Unforgiven;* they are cast as the instigators of violence (the prostitutes' offer of a bounty), as its victims (Delilah), and—hypothetically and *in absentia*—as capable of ending it (Munny's dead wife, Claudia).

16. Kitses 312; see also, on the same page: "Ambitious, compelling, but finally flawed, Eastwood's critique of the Western as a genre sustained by masculine codes of violence is itself all too satisfyingly sustained by that same violence."

17. "The lines 'You just shot an unarmed man,' 'Well, he shoulda armed himself' drew laughter in the theater each time I saw the film" (Bingham 242).

18. Italics indicate quotations from the film's narrative voice; dialogue quotations are rendered in regular type.

19. Andrew Dominik, who wrote the screenplay, followed the original novel closely and often quoted from it verbatim (Hansen, *The Assassination of Jesse James by the Coward Robert Ford,* 1983); Dominik's screenplay was one of the film's two contenders for the 2007 Academy Awards.

20. Bob's pursuit of Jesse clearly defines the film as a stalker movie, with a rather self-referential subtext about movie stars, their fans, their lack of privacy, and so forth. Bizarrely, Brad Pitt was the victim of an incident very similar to that described in this scene in January 1999, when Athena Rolando broke into his house, put on his clothes, and slept in his bed. On the case against her, see Martinez.

21. For example, Patterson 79–85; Alley. The two most extensive and most theoretical investigations of homosexuality in cinema to date are Chris Straayer's *Deviant Eyes, Deviant Bodies* and David Greven's *Manhood in Hollywood* (see his chapter on *Brokeback Mountain,* 218–40).

22. "Traditional views of masculinity and manhood placed value on whiteness, independence, power, control, reason, able-bodied strength, hard work, self-reliance, stoicism, heterosexual prowess, and endurance of a hardscrabble life. Historically, women, children, and people of color held a place beneath white men on the social hierarchy. The characteristics prescribed to women and children such as communicative expression (verbal, artistic, interpersonal, etc.), domesticity, gentleness, kindness, tenderness, affection, emotion, and playfulness were devalued.

Thus, Ennis and Jack find themselves in a situation where they are compelled to express their manliness through stoic silence and disinterested posturing. To appear friendly or engage in verbal repartee would compromise their subject positions as 'real' rural Western men" (Garza 201).

23. Stacy, "Love and Silence" argues the opposite, see especially 211–12.

24. Patterson castigates this interpretation as "plain stupid or [...] the result of willful distortion," without, however, offering an alternative (114).

25. In an article in the *New York Times* ("Cowboys Are My Weakness," January 1, 2006), the comedian Larry David offered the following (tongue-in-cheek?) explanation for his refusal to see the film: "I don't want to watch two straight men, alone on the prairie, fall in love and kiss and hug and hold hands and whatnot. [...] If two cowboys, male icons who are 100 percent all-man, can succumb, what chance do I have ...?" (quoted in Mehler 136).

26. The quotation is taken from W. C. Harris 118. On the reception of the film, see also Stacy, "Love and Silence" 205–06; Jessica L. W. Carey on the actors' public "negotiation" of their roles (both Ledger and Gyllenhaal have publicly advocated the "universal love story" theory while making it very clear that they are both heterosexual); Mehler, who argues that the film did not win in the Best Film category because of the homophobia of the judges; and Boyle on the controversy whether *Brokeback Mountain* is a "gay film" or a "universal love story" (88–90). Perez and Arellano have argued most strongly against a reading of *Brokeback Mountain* as a "gay" or "pro-gay" film.

27. W. C. Harris 121; see also Arellano, who has read the film as heteronormative ("The 'Gay Film' That Wasn't").

28. Stacy in his preface to *Reading Brokeback Mountain* 1–2.

CHAPTER 5

1. We will not discuss Mel Gibson's *The Passion of the Christ,* because the religious dimension of the film differs from the secular frame of conventional superhero films. Similarly, Harry Potter (Daniel Radcliffe) is set apart from the superheroes discussed in this chapter because of his age.

2. Even though savior films are drawn to the notion of fate and predetermination and ponder the possibility of human freedom, humans are inevitably granted agency.

3. Even in films that focus on a city, such as *Spider-Man,* the threat is defined as global.

4. For a detailed account of the film's Christian symbolism see Fontana; for its Buddhist references see Ford; for references to Vedanta see Lännström. One may, of course, also agree with Žižek, who claims that "there is something inherently stupid and naïve in taking the philosophical underpinning of the *Matrix* trilogy seriously and discussing its underpinnings" (198).

5. See Lichtenfeld, who calls *The Matrix* a "cyber-age Christological allegory" (233). On Neo as a Christ figure see also Witherington III.

6. See Clover; Lawrence; Yeffeth; Diocaretz and Herbrechter; Haber; Irwin.

7. See Clover, who points out that the "fact that these few, the rebels, are preponderantly women and/or people of color is one of the political charms of the movie" (69).

8. The name is, of course, that of the biblical Babylonian king. It can be read as an allusion to humankind's hubris and its subsequent humbling at the hands of God. In the book of Daniel, Nebuchadnezzar must live in the wild as a punishment for his sinful pride.

9. King makes a similar point: "Who could blame him, given the bleak nature of the naked reality and the fantastic possibilities unleashed in the simulation" (*Narratives* 191).

10. Related to this ideology is the film's aestheticization of violence. As Danahay points out, "it becomes a matter of admiring the choreography of two bodies in motion and not of fearing damage to real, physical bodies" (42). See also Nardone and Bassham who claim that "the *Matrix* films glamorize violence in a way that very few other films have" (186).

11. On choice in the Matrix sequels see Schick.

12. On the role of love in the *Matrix* trilogy see Lawler.

13. According to the latest statistics, 43 percent of Americans have less than $10,000 saved up for retirement and 36 percent do not manage to save anything at all; 24 percent of

American workers say they have postponed their retirement age; for the first time in U.S. history, more than 40 million Americans are now on food stamps; more than 40 percent of Americans who work are employed in low-paying service jobs.

CHAPTER 6

1. Even before 9/11, Cheney had been an eager participant in survival scenarios designed to test the efficiency of government after a nuclear attack or smallpox outbreak (see Mayer 1–2).

2. Under Saddam, Abu Ghraib had housed political prisoners. During the U.S. occupation, indiscriminate arrests led to overcrowding. According to Ricks, 90 percent of this prison population had no intelligence value (238).

3. In the domestic arena, the administration introduced the domestic wireless surveillance program, which wire-tapped citizens without obtaining warrants.

4. In *Die Hard*, for example, government bureaucracies are not only unhelpful, but impede the hero's progress through incompetence and inflexibility (see Jeffords, *Hard Bodies* 60).

5. In *Days of Thunder* (1990), Cruise portrays a race-car driver who has lost "his ride" because his father embezzled his money. In *Top Gun* (1986), the Cruise character is haunted by the unexplained disappearance of his father's plane and struggles to achieve his full potential as a pilot and lover, until he learns that his father was not a traitor to his country but a war hero.

6. See Lehman, who claims that "many male action films present a hero and a villain who seem to be opposites but are, in reality, very much like each other" ("Don't Blame" 112).

7. In this, Bourne resembles the terminator, another killing machine with incipient self-awareness.

8. Fleming's first choice for the role, David Niven, was rejected because he lacked the requisite macho toughness (Spicer, *Typical Men* 75).

9. Trice and Holland claim that the Dalton films initiated a transformation of the genre that de-emphasized espionage and made Bond an action hero (*Heroes* 159).

10. As Bennett and Woollacott point out, the Bond films are famous for a "putting-back-into-place of women who carry their independence and liberation too far" ("Moments" 28).

11. Bennett and Woollacott claim that "Bond embodied the imaginary possibility that England might once again be placed at the center of world affairs during a period when its world-power status was visibly and rapidly declining" ("Moments" 19). Here, we will disregard the significance of Bond as an English icon. In recent years, Bond ceased to signify Britishness and has instead become a hero of the NATO alliance. Bennett and Woollacott predict that "Bond is likely to be increasingly Americanized" (*Bond and Beyond* 283).

12. See Bennett, who calls Bond "a highly malleable signifier, capable of being adjusted to changing cultural and ideological pressures and priorities" ("Preface" xi).

13. The producers of the Bond franchise made the preference for unknown starlets an explicit policy. According to Cubby Broccoli, "there's no lady today who contributes that much success if she's high priced or otherwise" (qtd. in Bennett/Woollacott, *Bond and Beyond* 196), although, as the casting of Honor Blackman suggests, there were exceptions to this rule.

14. Braudy draws attention to this quasi-satirical attitude: "The James Bond films are successful satires because they play Bond's flawless personal style against an editorial-cartoon version of world politics. Satires of Bond films succeed only at those points where the original slips and takes itself seriously. Otherwise they are like people who make a career of imitating impersonators" (62). One might write the history of the Bond franchise as a

decrease in satirical potential and concomitant increase in the depiction of serious political challenges.

15. A true Bond villain, Elektra is orientalized. Her mother is from Azerbaijan, and as her evil nature is revealed, the costumes increasingly reveal her heritage.

16. On women in Bond films see Packer and Sharma's comment that the "Bond Girl never achieves feminist status, but rather passes from a-feminist to postfeminist no longer in need of feminism" (91).

17. She manages to signal her location to Bond, but cannot break out of a makeshift prison that would not hold Bond for five seconds.

18. According to Lichtenfeld, "much action movie terror is conducted with no underlying political conviction" (43).

19. The Bond producers Saltzman and Broccoli did not acquire the rights to *Casino Royale*. It was first produced by Charles Feldman as a spy spoof with an all-star cast, including Peter Sellers and Woody Allen (see Hagopian 30; see also Benson 4).

20. See Flanagan, who claims that a "prime example of the cinematic hero with no discernible interior life is James Bond" (112). See also Lee Pfeiffer, who points out that the traditional Bond films provide almost no background information on the character (24).

21. On torture as spectacle in action films see Tasker, who claims that "suffering—torture, in particular—operates as both a set of narrative hurdles to be overcome . . . and as a set of aestheticized images to be lovingly dwelt on" ("Dumb Movies" 230).

CHAPTER 7

1. With the possible exception of *The Hurt Locker,* the films discussed in this chapter promote the same tenets that Cawley sees as typical of the war genre as such: "A moral impulse is behind every American war [. . .] Individuals prove themselves by personally participating in combat, which teaches truths impossible to learn elsewhere. The foreignness of the enemy is a sign of evil, although 'foreignness' needn't be evil if the foreigners have acquired the cultural traits of Americans. Americans themselves are better, friendlier than other nationalities [. . .] But if there is conflict, Americans are inherently better at violence and will win" (70).

2. There is, of course, Michael Winterbottom's *Welcome to Sarajevo* (1997).

3. Prospects for success are dim. According to a study of 648 terrorist groups in the second half of the twentieth century, conducted by the RAND Corporation, military force ended terrorist activities in only 7 percent of the cases (Korb and Conley 248).

4. John F. Harris relates a conversation between Clinton and Dick Morris, his controversial adviser, during which Morris argued that no president can achieve greatness without war (243). One should add that neither Clinton nor Bush had any military experience. To avoid military service during the Vietnam War, Bush secured a position in the Texas Air National Guard, otherwise known as the "champagne unit" (Wilentz 412).

5. The film fits the classic parameters of the combat film genre (see Basinger, *Anatomy* 67–69).

6. Hammond speaks of Spielberg's "over dependence on sentimentalism, his unerring attraction for the positive story, and his mechanical expertise as the cinematic master of summoning tears" (155).

7. Although the central character in the film is not Private Ryan, but Captain Miller, the old Ryan, who visits a World War II memorial in France, frames the action; shots of him open and close the film. In the final scene, Ryan breaks down at the cross that bears Miller's name and implores his wife to tell him that he was a good man and worthy of Miller's

sacrifice. Here, Spielberg's film shifts from a celebration of the great generation to the burden imposed upon the sons who grew up under the shadow of fathers who fought the last great war, a war that, unlike all the wars that followed, is perceived as fully justified and not tarnished by moral ambiguity.

8. There is a 1944 film, titled *The Sullivans,* which focuses on five brothers from one Iowa family who all died during an enemy attack.

9. According to Auster, there is some disagreement whether or not Lincoln actually wrote the letter (208).

10. The savagery of the film's first twenty minutes led to protests against a planned ABC screening during the Iraq occupation and ABC complied by pulling it off the schedule (Bourgoyne, *Hollywood Historical Film* 52).

11. See Clarke's description of Spielberg's techniques: he "often exploded a blood squib directly beneath the camera lens, intending for the lens to be dirtied" and he "put a Black and Decker drill, without the bit in place, fixed to the pan handle of a fluid head, and locked an oblong bowl with an eccentric washer in the chuck. The resulting vibration created a nervous energy to the footage captured" (121).

12. Spielberg's motley crew does not include Afro-Americans since in "the Jim Crow American Army of World War II, no black soldier could have been in the company of whites. The American Armed Forces were entirely segregated during the war" (Rogin 83).

13. The films contain many parallels. Eastwood also depicts a lengthy beach landing sequence and frames his action with scenes of the soldiers as old men. His concluding statement "they fought for their country, but they died for the men beside them" holds true for Spielberg's film as well.

14. Eastwood is also acutely aware of the problematic role of war photography and film itself. "The right picture can win or lose a war," viewers are told.

15. Aidid, who seized and sold foreign food shipments to buy guns for his soldiers, is directly responsible for the starvation of his people. But he also opposed and went to prison for his resistance to Somalia's previous president, Mohammed Siad Barre, whose human rights record was equally dismal. As Rutherford explains, "Aidid especially feared Boutros-Ghali's role because when he was Egypt's foreign minister, Boutros-Ghali and Somalia's then president Barre were good friends—this during a time when Aidid was serving a prison sentence imposed by Barre" (55).

16. The policy that was in place before the attempt to capture Aidid focused on speaking with all parties in the conflict to avoid the notion that the United States was taking sides. Radio programs, Somali-language newspapers, and visits to local leaders were designed to explain the humanitarian mission. According to Rutherford, this strategy had worked extremely well (100–03).

17. For a detailed account of U.S. politics before and during the operation see Rutherford.

18. See Clooney's comment: "you start out doing something for mercenary reasons and personal gain, and eventually you do what's right" (qtd. in Clarke 266).

19. The film's ironic treatment of racism continues when Saddam's Republican guards are watching a tape of the Rodney King beating when Archie and his men happen upon them.

20. Some critics believe that this character is inspired by CNN's Christiane Amanpour, who became widely known because of her reports of the Persian Gulf War (http://en.wikipedia.org/wiki/Christiane_Amanpour).

21. The same holds true for wars. Although the U.S. Army has now integrated some female soldiers, it is still a mostly male affair. Ducat points out that 45 percent of men strongly supported the war on Iraq, but only 21 percent of women (ix).

CHAPTER 8

1. According to Tasker, "adventure bears much more explicit narrative expectations" than other action films ("Introduction" 7).

2. See Neale's characterization of the genre: "while imperial, colonial and ethnocentric assumptions underlie the genre as a whole, its commitment to an ethos of altruism, liberty and justice, to 'the valiant fight for freedom and a just form of government' can generate all kinds of ideological contortions and an array of quite distinct political positions" ("Action-Adventure" 76).

3. When Don Rafael visits the prison to identify Zorro, every inmate claims "I am Zorro." This theme of Zorro as a cipher is reiterated in the final scene when Alejandro tells his baby son a story about Zorro and ends with the telling words: "What face shall I give this dashing rogue? He could be anywhere."

4. Here, the film tries to have it both ways. In Diego's relation to Alessandro, paternity is not a biological given but the result of a social construction. With respect to Elena, however, nature wins out over nurture as Elena intuits that Diego is her biological father.

5. His relation to his horse also symbolizes Zorro's relation to the people. Although he steals the horse, this theft is a rescue action of a wild and beautiful creature, mistreated by the soldiers who possess it.

6. While *The Mummy* maintains clear distinctions between the Arab and the Western worlds, *The Mummy Returns* (2001) blurs boundaries. *The Mummy* mentions Evy's Egyptian mother, but does not integrate this heritage into the narrative. In the sequel, in contrast, Evy has a past life in which she was the Pharaoh's daughter, Nofertiri, while Rick is revealed to have been a Medjai. Ardeth's role is also enhanced. The leader of the Medjai now commands an army of thousands and proves his valor and courage on many occasions. In spite of these changes, though, the Arab world is still presented as a backwater, in awe of Western technology, including the bus and the airplane, and it is again the Western heroes Evy and Rick, now enhanced by their Egyptian heritage, who protect the world from Imhotep's destructive passion.

7. This is somewhat complicated by the fact that the White House ironized its own propaganda. At a White House Correspondents Association banquet early in 2004, Bush showed a film skit in which he searches for WMDs all around the White House (Wilentz 445).

8. Tellingly, when Commodore Norrington of the British Royal Navy sets out to woo Elizabeth, he is presented with a sword instead.

9. When Elizabeth does make a choice in the third sequel, Will has shown Jack's capacity for betrayal and Jack Will's capacity for selflessness.

10. http://en.wikipedia.org/wiki/Port_Royal last accessed on December 10, 2010.

11. http://en.wikipedia.org/wiki/Port_Royal, last accessed on December 10, 2010.

12. As Lichtenfeld points out, this is typical: "the villain is the villain because he is the slave to his desires while the hero is the hero because he is the master of his own" (74).

13. See also Spicer, who makes a similar point without recourse to psychoanalysis: "Audiences clearly took great pleasure in the ways in which rogues, drawn from all strata of society, dodged responsibility" (*Typical Men* 4).

CHAPTER 9

1. According to John F. Harris, Hillary Clinton "dreamed of a virtual deputy presidency, with her reigning over domestic policy" (97).

2. Preston speaks of "the necessary shedding of the wrong person" as an established plot device in romantic comedy (235).

3. On DiCaprio's divergence from the expected body type of traditional male romantic heroes see Lehman and Hunt 89.

4. The strong emphasis on empathy that characterizes the screen lover is also evident in the public persona of both Clinton and Bush. Although Clinton was the first to introduce empathy of the "I-feel-your-pain" variety to the political vocabulary, Bush clearly recognized the benefits of this strategy and campaigned on a platform of "compassionate conservatism."

5. As Preston points out, traditionally the "insularity of the couple" is typical of the genre of romantic drama, not of the romantic comedy (238).

6. See http://www.imdb.com/boxoffice/alltimegross (last accessed September 3, 2011). The film, only recently surpassed by the latest Cameron extravaganza, *Avatar,* was the first motion picture to earn $1 billion worldwide (Sandler and Studlar, "Introduction" 1).

7. Wyatt and Vlesmas describe in detail how the excessive production budget of the film featured prominently in the advertisement strategy (29–45).

8. Cameron also called the film a "gender-bending twist on the Cinderella myth" (qtd. in Ouellette 179).

9. Lehman and Hunt point to another important contradiction: although *Titanic* critiques phallic masculinity and the concomitant obsession with size, it can itself be described as "the largest moving picture ever made by the hand of man in all of history" (105).

10. See Studlar and Sandler, who argue that the film presents class privilege as "attainable but unenviable" ("Introduction" 10).

11. Malin points out that, as an artist, Jack stands apart from the working class even though he nominally belongs to it ("Classified" 86).

12. Ouellette claims that the film "promotes the illusion that the United States is now a classless society" (170). It "invites viewers to observe overt class differences and prejudices—and then dismiss them as anomalies of a bygone era" (175).

13. King also draws attention to the parallel between "the physical consummation between the two principals and the less joyful coming together of the *Titanic* and the iceberg" (*Narratives* 59). Krämer reads the iceberg as a symbol of female rage: "Whether she admits to it or not, Rose does want this power, this society, and thus this ship to be destroyed so that she can be free" ("Women First" 119).

14. The film certainly appealed to women, in particular young women. Nash and Lahti report that 60 percent of the audience was female, and 63 percent under twenty-five years of age (64). 45 percent of women under twenty-five had seen the film twice (Nash and Lahti 64.). However, they also suggest that this popularity is due largely to romantic investment in DiCaprio rather than interest in the character of Rose. On Cameron as a director of woman-centered action films see Krämer, "Women First."

15. See Keller, who claims that "Cameron's fierce women are always pressed back into the service of patriarchy" (145). According to Negra, the film's feminist aspirations are compromised by the fact that Rose's survival is presented as the fulfillment of her contract with Jack (227).

16. Massey and Hammond make a similar point: "*Titanic* demonstrates this same faith in the cinema's ability to redeem the past, the real, and 'that which was never real.'" (255).

17. On the film's sexism see Douglas, who points out that "not one of the thoughts of the women on the street is about the substance of her work, a social or political issue . . . what women really (and only) think about is dieting, shopping, men, relationships, and babies" (116–7).

18. There is a tradition of "marriage as a condition of discord and passion" (Kae Young 165) in screwball comedy, but discord does not escalate into violence.

CHAPTER 10

1. See, for example, Christopher Jencks and the response to his article by Fred Block; Egan; "A Look Back at Welfare Reform"; and Edelman.

2. The full text of the bill is available at http://frwebgate.access.gpo.gov/cgi-bin/getdoc.cgi?dbname=104_cong_public_laws&docid=f:publ193.104 (last accessed July 16, 2009). Our thanks to the Hon. Scott Clarkson for pointing us to important sources on the welfare reform bills of 1996 and 2006.

3. Edelman, citing a study by the Kaiser Foundation.

4. Between 1997 and 2000, the total number of welfare recipients in America dropped by 53 percent (cf. Schram and Soss, "Success Stories"); some areas saw even more drastic reductions (cf. DeParle, who has documented a 66 percent drop within two years in Milwaukee).

5. On the Deficit Reduction Act of 2006, see the link provided by the U.S. Department of Health and Human Services, Administration for Children & Families, on Welfare Reform Reauthorization, http://eclkc.ohs.acf.hhs.gov/hslc/Program%20Design%20and%20Management/Fiscal/Legislation%20&%20Regulations/Legislation/fiscal_far_3010_012007.html (last accessed July 15, 2009), and the discussion in Haskins, Sawhill, and Weaver, as well as Blank and Haskins.

6. Alain de Botton's *Status Anxiety* describes the social and psychological consequences of this premise at length.

7. See Botton, particularly 85–91 and 193f., on Social Darwinism and the equation of social failure with moral degeneracy.

8. See Botton 57–60 on American self-help books from the early nineteenth century to the present; on Hunt's book 86.

9. Botton 11; cf. his introductory chapter, "Lovelessness," which he defines as one of the five prime causes of status anxiety (along with Snobbery, Expectation, Meritocracy, and Dependence).

10. "Section 101: Findings," http://frwebgate.access.gpo.gov/cgi-bin/getdoc.cgi?dbname=104_cong_public_laws&docid=f:publ193.104 (last accessed July 16, 2009). For an opposing view, see Falkof, who argues that there is no tangible evidence that marriage, beyond enriching wedding planners and divorce lawyers, benefits society in any way. See particularly chapters 2 and 3.

11. In *Virgin,* there is a clear sense that Andy's coworkers are themselves rather hapless lovers; they may be more experienced at sex but are clearly adrift when it comes to love. In other words, the distance between Andy and his male buddies is not as extreme as it initially appears. Andy's coworkers have a positive part to play in his development and remain part of his social context at the end of the film, but no longer get to dispense relationship advice.

12. True Love Waits (TLW) is a Christian organization promoting abstinence outside of marriage (home page at http://www.lifeway.com/tlw/, last accessed July 17, 2009).

13. This conservative conclusion aside, the film's gender politics are strangely progressive, and there is a good deal of gender bending going on. Andy's male buddies, for example, behave like stereotypical "girls" with their girl talk, their attempts to rid themselves of body hair in the waxing scene, and their longing for intimacy (not merely sex); whereas some girls in the film behave like stereotypical "guys" (they want sex, but not all of them are out for intimacy).

14. The film's "emancipation" of its loser through violence raises misgivings, all the more so since this violence transfers seamlessly into the love dialogue when Barry tells Lena: "I want to smash your face with a sledge hammer." These words do not

reassure viewers that Barry's extreme anger issues have been resolved at the end of the film.

15. On the history of love as a socially accepted reason for marriage, see Stone; Falkof 1–42.

16. Under George W. Bush, federal funding for abstinence-only education as a method of birth control rose by 74 percent (a total of $176 million annually). Federal funding for abstinence-only-until-marriage programs began in the Reagan administration. The Obama administration eliminated two of the program's three funding streams; the third, allowed to expire in 2009, was resurrected as part of the health care reform package in March 2010. Cf. "A Brief History: Abstinence-Only-Until-Marriage Funding" (http://www.nomoremoney.org/index.cfm?fuseaction=page.viewPage&pageID=947& nodeID=5, last accessed July 16, 2009).

17. As the film later explains, Bernie is partly responsible for his own situation because of his earlier gambling addiction and his neglect of his son. Yet neither theme is developed beyond the briefest mention. Rather, Bernie's steadfast refusal to give in to Shelly's most tempting offers rather elides his gambling addiction, and his son's abuse of Bernie is both more visible and memorable than Bernie's earlier abandonment of his son. Crucially, we only find out about this because Bernie blames himself for it, which may throw some doubt on the story: as many conversations with Natalie reveal, Bernie willingly takes the blame for everything, whether or not he is, in fact, responsible.

18. On the film's commercial and critical failure, see Green et al. 127 (the citation on that page); Tyree and Walters 7–9 and 87.

19. A complete list of paper titles is in Green et al. 164–66. Some gems included "Dudespeak," "Figurin' the Fuckin' Carpet," "I Hate the Eagles: *The Big Lebowski* Meditates on Musical Genre," and "Size Matters."

20. See Robertson 40. For a description of the protest and following indictment by a member of the group, see Roger Lippman.

21. On links between *The Big Lebowski* and *The Big Sleep,* including direct quotations of scenes, setups, lines, and characters, see Tyree and Walters 14, 17, 20, 29, 41–50 and Robertson 43.

22. Coen and Coen 4–5. The screenplay is available online at http://www.imsdb.com/scripts/Big-Lebowski,-The.html (last accessed July 17, 2009). Future quotations from the film will refer to the cinema version, which differs slightly from the published screenplay by Ethan and Joel Coen. Citation and discussion of both passages in Tyree and Walters 49–50.

23. Historically, the term "dude" had associations with unmanliness; see Tyree and Walters 82–85 for a brief history of the term.

24. Like several other lines, Bush's "This aggression will not stand . . . This will not stand!" is recycled throughout the film, moving from one character to the next. Several critics have remarked on this; Tyree and Walters provide a list of crossover expressions and phrases on p. 34. "The overall effect is to suggest a kind of endemic recycling, as if the state's water or power shortages might also apply to thoughts and words" (Tyree and Walters 35).

25. Walter is based on John Milius, who wrote *Apocalypse Now* and wrote and directed *Conan the Barbarian.* Milius is "known throughout Hollywood as a maverick, a militarist, and a political conservative in a town famous for its left-leaning politics" (Green et al. 119; see also Tyree and Walters 28).

26. In a conversation with Susanne Kord, who thanks her here for the idea, Amber Hsu immediately and clearsightedly linked the Dude's behavior with Buddhism, although at that time she had yet to see the film.

27. The psychological explanation for Sy's behavior emerges relatively late in the film. Thus, Sy, who begins the film as an irredeemable loser, moves closer to the lovable loser at the

end, which may partly explain why *One Hour Photo* was financially more successful than other irredeemable loser films discussed here.

28. This includes the parts of the world that are themselves striving for change. Sam is snubbed by his "superiors" and by the repressed; his attempt to seek alliances with oppressed minorities (his suggestion to the Black Panthers to re-form as The Zebras, a joint force of black and white oppressed against the white oppressor) is rejected as ludicrous. Opposing the oppressors directly is never presented as a viable option: in *Quiet Man*, for example, both Bob and the other shooter aim for their coworkers, not the firm's CEOs or executives, who are safely out of reach on the top floor.

29. In this fascist credo, Bob only seems to lash out against his world; in reality he exemplifies it (see the big poster reading "Fascism" outside of his boss's office). That this is the state of the diegetic world (rather than merely Bob's own troubled psyche) is also indicated by the fact that he is not the only person in the film who submits to homicidal impulses.

30. The film is set in 1949 Los Angeles and should, according to lead actor Thornton, be watched "like you're watching *The Big Sleep*." But Roger Deakins, cinematographer for *The Man Who Wasn't There* and winner of the 2001 Academy Award for best cinematography, has identified the second purpose of the film's black-and-white aesthetics as creating an alienating effect. For both interviews, see the supplementary DVD-material for *The Man Who Wasn't There*.

31. The idea is the Hon. Scott Clarkson's (personal communication with Susanne Kord).

32. Interview with Mike Binder, supplementary DVD-material (*Reign Over Me*).

33. Anna Clark 5. For a social analysis of how this process of exclusion works on a grand scale, see Faludi's *Stiffed*.

CHAPTER 11

1. *He Was a Quiet Man* was not produced for release in theaters, but even for a straight-to-DVD film, these numbers are dismal.

2. Single-salary families with more than one adult are now a rarity in the United States; see statistics at the American Census website, http://www.census.gov/population/socdemo/hh-fam/cps2004/tabFG1-all.csv (last accessed November 15, 2010).

3. Quotation in "Manly Movie Stars." The article referred to is Hanna Rosin's "The End of Men."

4. This seems to be a trend in many action movie genres; see, for example, Quillen.

5. The assassination of Osama bin Laden was another major hit in the video game that is American politics. Both Bush and Obama responded to it as a gamer would to the killing of an enemy alien—gloating over the kill, untroubled by ethical considerations, and confusing a momentary adrenaline rush with omnipotence (Obama: "Today we are reminded that as a nation there is nothing we can't do"; qtd. in Tapper, Khan, Raddatz, and Effron, http://abcnews.go.com/Politics/osama-bin-laden-hid-wives-firefight-counter-terrorism/story?id=13507836, last accessed May 3, 2011).

6. Even Jet Li's martial art feats, impressive in every other movie, paled beside all this muscle: his character's running joke in *The Expendables* consists of good-humored complaints about being ignored because "I'm smaller."

7. That gender stereotypes work best in syndication is generally assumed; see, for example, "The Economics of Gender Stereotyping."

BIBLIOGRAPHY

The 9/11 Commission Report: Final Report of the National Commission on Terrorist Attacks upon the United States. New York: Norton, 2004.

"A Brief History: Abstinence-Only-Until-Marriage Funding," http://www.nomoremoney. org/index.cfm?fuseaction=page.viewPage&pageID=947&nodeID=5 [last accessed July 7, 2011].

"A Look Back at Welfare Reform." *Institute for Policy Research News* 30/1 (Winter 2008), http://www.northwestern.edu/ipr/publications/newsletter/iprn0801/ dppl.html [last accessed July 7, 2011].

Acker, Kathy. *Hannibal Lecter, My Father.* New York: Semiotext(e), 1991.

Alighieri, Dante. *The Divine Comedy.* Vol. 1: *Inferno.* Translation and commentary by John D. Sinclair. London: Oxford University Press, 1971.

All Men Are Created Equal . . . Equally Useless. Partridge Green: Ravette, 2006.

Alley, Henry. "Arcadia and the Passionate Shepherds of *Brokeback Mountain.*" *Reading Brokeback Mountain: Essays on the Story and the Film.* Ed. Jim Stacy. Jefferson, NC, and London: McFarland, 2007. 5–18.

Allmendinger, Blake. *Imagining the African American West.* Lincoln & London: University of Nebraska Press, 2005.

Allmendinger, Blake. *Ten Most Wanted: The New Western Literature.* New York, London: Routledge, 1998.

"Americans for Divorce Reform," http://www.divorcereform.org/rates.html [last accessed July 7, 2011].

Amis, Martin. *The Second Plane, September 11: Terror and Boredom.* New York: Vintage, 2008.

Amoateng, Acheampong Yaw and Tim B. Heaton, eds. *Families and Households in Post-apartheid South Africa: Socio-demographic Perspectives.* Cape Town: HSRC Press, 2007.

Anderson, Paul Thomas. *Punch-Drunk Love.* London: Faber, 2003.

Andrew, Geoff. *Stranger Than Paradise: Maverick Film-Makers in Recent American Cinema.* London: Prion, 1998.

Andris, Silke and Ursula Frederick, eds. *Women Willing to Fight: The Fighting Woman in Film.* Newcastle: Cambridge Scholars, 2007.

Arellano, Lisa. "The 'Gay Film' That Wasn't: The Heterosexual Supplement in *Brokeback Mountain.*" *Reading Brokeback Mountain: Essays on the Story and the Film.* Ed. Jim Stacy. Jefferson, NC, and London: McFarland, 2007. 59–70.

Aristotle. *Poetics.* Introduction, Commentary and Appendixes by D. W. Lucas. Oxford: Clarendon Press, 1968.

Arnold, Frank and Michael Esser, eds. *Dirty Harry: Don Siegel und seine Filme.* Munich: Vertigo, 2003.

Auster, Albert. "Saving Private Ryan and American Triumphalism." *The War Film*. Ed. Robert Eberwein. New Brunswick, NJ: Rutgers University Press, 2006. 205–213.

Babington, Bruce and P. W. Evans. *Affairs to Remember: The Hollywood Comedy of the Sexes*. Manchester: Manchester University Press, 1989.

Baker, Brian. "Gallivanting round the World: Bond, The Gaze and Mobility." *Revisioning 007: James Bond and Casino Royale*. Ed. Christoph Lindner. London: Wallflower Press, 2009. 144–158.

Balio, Tino. "'A major presence in all of the world's important markets': The Globalization of Hollywood in the 1990s." *Contemporary Hollywood Cinema*. Ed. Steve Neale and Murray Smith. London: Routledge, 1998. 58–73.

Bane, Mary Jo and David Ellwood. *Welfare Realities: From Rhetoric to Reform*. Boston: Harvard University Press, 1996.

Basinger, Jeanine. "The World War II Combat Film: Definition." *The War Film*. Ed. Robert Eberwein. New Brunswick, NJ: Rutgers University Press, 2006. 30–49.

Basinger, Jeanine. *The World War II Combat Film: Anatomy of a Genre*. Middletown: Wesleyan University Press, 2003.

Baudrillard, Jean. "The Gulf War Did Not Take Place." *Hollywood and War: The Film Reader*. Ed. J. David Slocum. New York: Routledge, 2006. 303–314.

Baur, Andreas and Konrad Bitterli, eds. *Brave Lonesome Cowboy: Der Mythos des Westerns in der Gegenwartskunst oder: John Wayne zum 100. Geburtstag*. Nuremberg: Verlag für Moderne Kunst, 2007.

Bell-Metereau, Rebecca. "Eating and Drinking, Men and Women." *Ladies and Gentlemen, Boys and Girls: Gender in Film at the End of the Twentieth Century*. Ed. Murray Pomerance. Albany, NY: State University of New York Press, 2001. 91–107.

Bell-Metereau, Rebecca. *Hollywood Androgyny*. New York: Columbia University Press, 1993.

Bennett, Tony. "Preface." *Secret Agents: Popular Icons beyond James Bond*. Ed. Jeremy Packer. New York: Peter Lang, 2009. xi-xiii.

Bennett, Tony and Janet Woollacott. "The Moments of James Bond." *The James Bond Phenomenon: A Critical Reader*. Ed. Christoph Lindner. Manchester: Manchester University Press, 2003. 13–33.

Bennett, Tony and Janet Woollacott. *Bond and Beyond: The Political Career of a Popular Hero*. New York: Methuen, 1987.

Benson, Raymond. "Can the Cinematic Bond Ever Be the Literary Bond." *James Bond in the 21st Century: Why We Still Need 007*. Ed. Glenn Yeffeth. Dallas: BenBella, 2006. 3–11.

Berger, Maurice, Brian Wallis and Simon Watson, eds. *Constructing Masculinity*. New York: Routledge, 1995.

Bernstein, Matthew. "Floating Triumphantly: The American Critics on *Titanic*." *Titanic: Anatomy of a Blockbuster*. Ed. Kevin S. Sandler and Gaylyn Studlar. New Brunswick, NJ: Rutgers University Press, 1999. 14–28.

Bingham, Dennis. "'Deserve's Got Nothing to Do with It,' or Men with No Names II: *Unforgiven*." *Acting Male: Masculinities in the Films of James Stewart, Jack Nicholson, and Clint Eastwood*. New Brunswick, NJ: Rutgers University Press, 1994. 231–245.

Black, Jeremy. *The Politics of James Bond: From Fleming's Novels to the Big Screen*. Lincoln: University of Nebraska Press, 2005.

Blank, Rebecca M. and Ron Haskins, eds. *The New World of Welfare*. Washington, DC: Brookings, 2001.

Blankenhorn, David. *Fatherless America: Confronting Our Most Urgent Social Problem*. New York and London: HarperCollins, 1996.

Block, Fred. "What Happened to Welfare?" *The New York Review of Books* 53/6 (April 6, 2006), http://www.nybooks.com/articles/18852 [last accessed July 7, 2011].

Bly, Robert. *Iron John: A Book about Men*. Shaftsbury: Element, 1990.

Boggs, Carl and Tom Pollard. *The Hollywood War Machine: U.S. Militarism and Popular Culture*. Boulder, CO: Paradigm Publishers, 2007.

Bordo, Susan. *The Male Body: A New Look at Men in Public and in Private*. New York: Farrar, Straus and Giroux, 1999.

Bordwell, David. *The Way Hollywood Tells It: Story and Style in Modern Movies*. Berkeley, CA: University of California Press, 2006.

Botton, Alain de. *Status Anxiety*. London: Penguin, 2004.

Boyle, Jen E. " 'When This Thing Grabs Hold of Us . . .': Spatial Myth, Rhetoric, and Conceptual Blending in *Brokeback Mountain*." *Reading Brokeback Mountain: Essays on the Story and the Film*. Ed. Jim Stacy. Jefferson, NC, and London: McFarland, 2007. 88–105.

Bratich, Jack Z. "Spies Like Us: Secret Agency and Popular Occulture." *Secret Agents: Popular Icons beyond James Bond*. Ed. Jeremy Packer. New York: Peter Lang, 2009. 133–162.

Braudy, Leo. *The World in a Frame: What We See in Films*. New York: Anchor Press, 1976.

Brehm, Margrit. "Beyond the Searchers: Looking for Traces on Foreign Ground." *Brave Lonesome Cowboy: Der Mythos des Westerns in der Gegenwartskunst oder: John Wayne zum 100. Geburtstag*. Ed. Andreas Baur and Konrad Bitterli. Nuremberg: Verlag für Moderne Kunst, 2007. 143–152.

Breskin, David. *Inner Voices: Filmmakers in Conversation*. New York: Da Capo, 1997.

Bruzzi, Stella. *Bringing Up Daddy: Fatherhood and Masculinity in Post-War Hollywood*. London: BFI Publishing, 2005.

Bruzzi, Stella. *Undressing Cinema: Clothing and Identity in the Movies*. London: Routledge, 1997.

Buckland, Warren. "A Close Encounter with *Raiders of the Lost Ark*: Notes on Narrative Aspects of the New Hollywood Blockbuster." *Contemporary Hollywood Cinema*. Ed. Steve Neale and Murray Smith. London: Routledge, 1998. 166–177.

Bui, Long T. "Whiteness of a Different Kind of Love: Letting Race and Sexuality Talk." *Reading Brokeback Mountain: Essays on the Story and the Film*. Ed. Jim Stacy. Jefferson, NC, and London: McFarland, 2007. 152–162.

Burgess, Adrienne. *Fatherhood Reclaimed: The Making of the Modern Father*. London: Vermillion, 1997.

Burgoyne, Robert. *Film Nation: Hollywood Looks at U.S. History: Revised and Expanded Edition*. Minneapolis and London: University of Minnesota Press, 2010.

Burgoyne, Robert. *The Hollywood Historical Film*. Malden: Blackwell, 2008.

Buscombe, Edward. *Unforgiven*. London: BFI Publishing, 2004.

"Bush says bin Laden cannot hide, tells troops to prepare." *St Petersburg Times* (September 15, 2001), http://www.sptimes.com/News/091501/Worldandnation/Bush_says_bin_Laden_c.shtml [last accessed July 7, 2011].

Carey, Jessica L. W. "Performing 'Lonesome Cowboy' and 'Jack Nasty': The Stars' Negotiation of Norms and Desires." *Reading Brokeback Mountain: Essays on the Story and the Film*. Ed. Jim Stacy. Jefferson, NC, and London: McFarland, 2007. 178–187.

Carey, Kevin. "A Show of Honesty." *The Guardian* (February 13, 2007), http://www.guardian.co.uk/commentisfree/2007/feb/13/thewire [last accessed July 7, 2011].

Cavell, Stanley. *Pursuits of Happiness: The Hollywood Comedy of Remarriage*. Cambridge: Harvard University Press, 1981.

Cawley, Leo. "The War about the War: Vietnam Films and American Myth." *From Hanoi to Hollywood: The Vietnam War in American Film*. Ed. Linda Dittman and Gene Michaud. New Brunswick, NJ: Rutgers University Press, 1990. 69–80.

Census, U.S. (2004), http://www.census.gov/population/socdemo/hh-fam/cps2004/tabFG1-all.csv [last accessed July 7, 2011].

Champion, Dean J. *Police Misconduct in America. A Reference Handbook*. Santa Barbara, CA: ABC-CLIO, 2001.

Chandler, Raymond. "The Simple Art of Murder." *Later Novels & Other Writings*. New York: Library of America, 1995.

Chapman, James. *War and Film*. London: Reaktion Books, 2008.

Chapman, James. *License to Thrill: A Cultural History of the James Bond Films*. New York: Columbia University Press, 2000.

Chapman, Rowena and Jonathan Rutherford, eds. *Male Order: Unwrapping Masculinity*. London: Lawrence and Wisehart, 1988.

Chomsky, Noam. *Hegemony or Survival: America's Quest for Global Dominance*. New York: Henry Holt, 2003.

Clark, Anna. "The Rhetoric of Masculine Citizenship: Concepts and Representations in Modern Western Political Culture." *Representing Masculinity: Male Citizenship in Modern Western Culture*. Ed. Stefan Dudink, Karen Hagemann and Anna Clark. New York: Palgrave Macmillan, 2007. 3–22.

Clark, Danae. "Father Figure." *Boys: Masculinities in Contemporary Culture*. Ed. Paul Smith. Boulder, CO: Westview Press, 1996. 23–37.

Clarke, James. *War Films*. London: Virgin Books, 2006.

Clinton, Hillary Rodham. *It Takes A Village and Other Lessons Children Teach Us*. New York and London: Simon & Schuster, 1996.

Clover, Joshua. *The Matrix*. London: BFI Publishing, 2004.

Clulow, Christopher F. and Christopher Vincent, in collaboration with Barbara Dearnley. *In the Child's Best Interests? Divorce-Court Welfare and the Search for a Settlement*. London: Tavistock, 1987.

Coen, Ethan and Joel Coen. *The Big Lebowski*. London: Faber & Faber, 1998.

Cohan, Steven. *Masked Men: Masculinity and the Movies in the Fifties*. Bloomington, IN: Indiana University Press, 1997.

Cohan, Steven and Ina Rae Hark. "Introduction." *Screening the Male: Exploring Masculinities in Hollywood Cinema*. Ed. Steven Cohan and Ina Rae Hark. London and New York: Routledge, 1993. 1–8.

Cohan, Steven and Ina Rae Hark, eds. *Screening the Male: Exploring Masculinities in Hollywood Cinema*. London and New York: Routledge, 1993.

Collins, Jim. "Genericity in the Nineties: Eclectic Irony and the New Sincerity." *Film Theory Goes to the Movies*. Ed. Jim Collins, Hilary Radner and Ava Preacher Collins. New York: Routledge, 1993. 242–263.

Collins, Jim, Hilary Radner and Ava Preacher Collins, eds. *Film Theory Goes to the Movies*. New York: Routledge, 1993.

Connell, R.W. *Masculinities*. Berkeley, CA: University of California Press, 1995.

Coontz, Stephanie. *The Way We Never Were: American Families and the Nostalgia Trap*. New York: Basic Books, 2000.

Corneau, Guy. *Absent Fathers, Lost Sons: The Search for Masculine Identity*. Trans. Larry Shouldice. Boston and London: Shambhala, 1991.

Creed, Barbara. "Dark Desires: Male Masochism in the Horror Film." *Screening the Male: Exploring Masculinities in Hollywood Cinema*. Ed. Steven Cohan and Ina Rae Hark. London and New York: Routledge, 1993. 118–133.

Cremean, David. "A Fistful of Anarchy: Clint Eastwood's Characters in Sergio Leone's Dollars Trilogy and in His Four 'Own' Westerns." *Clint Eastwood: Actor and Director. New Perspectives.* Ed. Leonard Engel. Salt Lake City: University of Utah Press, 2007. 49–76.

Crenshaw, Kimberlé and Gary Peller. "Reel Time/Real Justice." *Reading Rodney King: Reading Urban Uprising.* Ed. Robert Gooding-Williams. New York & London: Routledge, 1993. 56–70.

Crouch, Stanley. "What's New? The Truth, As Usual." *Police Brutality: An Anthology.* Ed. Jill Nelson. New York & London: W. W. Norton, 2000. 157–168.

Cunningham, Douglas A. and Richard Gabri. " 'Any Thug Can Kill:' Rewriting the Masculine Bond." *Revisioning 007: James Bond and Casino Royale.* Ed. Christoph Lindner. London: Wallflower Press, 2009. 81–98.

Cyrino, Monica S. "*Gladiator* and Contemporary American Society." *Gladiator: Film and History.* Ed. Martin M. Winkler. Oxford: Blackwell Publishing, 2004. 124–149.

Danahay, Martin. "The Matrix Is the Prozac of the People." *More Matrix and Philosophy: Revolutions and Reloaded Decoded.* Ed. William Irwin. Chicago: Open Court, 2005. 38–49.

Daniels, Ron. "The Crisis of Police Brutality and Misconduct in America: The Causes and the Cure." *Police Brutality: An Anthology.* Ed. Jill Nelson. New York & London: W. W. Norton, 2000. 240–260.

Davies, Jude and Carol R. Smith. *Gender, Ethnicity and Sexuality in Contemporary American Film.* Edinburgh: Keele University Press, 1997.

Deitz, Robert. *Willful Injustice: A Post-O.J. Look at Rodney King, American Justice, and Trial by Race.* Washington, DC: Regnery, 1996.

Dennis, Norman and George Erdos. *Families without Fatherhood.* London: IEA Health and Welfare Unit, 1993.

DeParle, Jason. *American Dream: Three Women, Ten Kids, and a Nation's Drive to End Welfare.* New York: Penguin, 2005.

Devasthan, Jyot, ed. *Theology of Buddhism.* New Delhi: Dominant, 2000.

Diocaretz, Myriam and Stefan Herbrechter, eds. *The Matrix in Theory.* Amsterdam: Rodopi, 2006.

Dittmar, Linda and Gene Michaud, eds. *From Hanoi to Hollywood: The Vietnam War in American Film.* New Brunswick, NJ: Rutgers University Press, 1990.

Ditzian, Eric. "Why 'Expendables Soared, 'Scott Pilgrim' Crashed at Box Office" (August 16, 2010), http://www.mtv.com/news/articles/1645818/why-expendables-soared-scott-pilgrim-crashed-at-box-office.jhtml [last accessed July 7, 2011].

Doherty, Thomas. *Projections of War: Hollywood, American Culture, and World War II.* New York: Columbia University Press, 1993.

Douglas, Susan J. *Enlightened Sexism: The Seductive Message that Feminism's Work Is Done.* New York: Henry Holt & Co., 2010.

Downing, David and Gary Herman. *Clint Eastwood: All-American Anti-Hero. A Critical Appraisal of the World's Top Box Office Star and His Films.* London, New York, Cologne, Sydney: Omnibus Press, 1977.

Doyle, Lieutenant Arthur (retired). "From the Inside Looking Out: Twenty-nine Years in the New York Police Department." *Police Brutality: An Anthology.* Ed. Jill Nelson. New York & London: W. W. Norton, 2000. 171–186.

Ducat, Stephen J. *The Wimp Factor: Gender Gaps, Holy Wars, and the Politics of Anxious Masculinity.* Boston: Beacon Press, 2004.

Dudink, Stefan, Karen Hagemann and Anna Clark, eds. *Representing Masculinity: Male Citizenship in Modern Western Culture.* New York: Palgrave Macmillan, 2007.

Durham, Christopher Louis. "Masculinity in the post-war Western: John Wayne and Clint Eastwood." Newcastle upon Tyne: University of Newcastle upon Tyne, 2004.

Durham, Philip and Everett L. Jones. *The Negro Cowboys*. New York: Dodd, Mead & Co., 1965.

Dyer, Richard. *Seven*. London: BFI Publishing, 1999.

Dyer, Richard. *Stars*. London: BFI Publishing, 1979.

Easthope, Antony. *What a Man's Gotta Do: The Masculine Myth in Popular Culture*. New York: Routledge, 1992.

Eberwein, Robert. "Introduction." *The War Film*. Ed. Robert Eberwein. New Brunswick, NJ: Rutgers University Press, 2006. 1–19.

Eberwein, Robert, ed. *The War Film*. New Brunswick, NJ: Rutgers University Press, 2006.

Eco, Umberto. "Narrative Structures in Fleming." *The James Bond Phenomenon: A Critical Reader*. Ed. Christoph Lindner. Manchester: Manchester University Press, 2003. 34–55.

"The Economics of Gender Stereotyping" (2010), http://www.media-awareness.ca/english/issues/stereotyping/women_and_girls/women_economics.cfm [last accessed July 7, 2011].

Edelman, Peter. "The Worst Thing Bill Clinton Has Done." *The Atlantic Monthly* 279/3 (March 1997): 43–58, http://www.theatlantic.com/issues/97mar/edelman/edelman.htm [last accessed July 7, 2011].

Egan, Jennifer. "False Promises." *The Nation* (December 20, 2004), http://www.jasondeparle.com/TheNation_122004.html [last accessed July 7, 2011].

Ehrenreich, Barbara. *Nickel and Dimed: On (Not) Getting By in America*. New York: Henry Holt, 2001.

Elsaesser, Thomas. "The Blockbuster: Everything Connects, but Not Everything Goes." *The End of Cinema as We Know It: American Film in the Nineties*. Ed. Jon Lewis. New York: New York University Press, 2001. 11–22.

Elsaesser, Thomas. "Specularity and Engulfment: Francis Ford Coppola and Bram Stoker's *Dracula*." *Contemporary Hollywood Cinema*. Ed. Steve Neale and Murray Smith. London: Routledge, 1998. 191–208.

Emery, Robert E. *Marriage, Divorce, and Children's Adjustment*. Thousand Oaks, CA and London: SAGE, 1999.

Engelhardt, Tom. "The Gulf War as Total Television." *Seeing Through the Media: The Persian Gulf War*. Ed. Susan Jeffords and Lauren Rabinovitz. New Brunswick, NJ: Rutgers University Press, 1994. 81–95.

Erisman, Fred. "Clint Eastwood's Western Films and the Evolving Mythic Hero." *Clint Eastwood: Actor and Director. New Perspectives*. Ed. Leonard Engel. Salt Lake City: University of Utah Press, 2007. 181–194.

Evans, Peter William and Celestino Deleyto. "Introduction: Surviving Love." *Terms of Endearment: Hollywood Romantic Comedy of the 1980s and 1990s*. Ed. Peter William Evans and Celestino Deleyto. Edinburgh: Edinburgh University Press, 1998. 1–14.

Evans, Peter William and Celestino Deleyto, eds. *Terms of Endearment: Hollywood Romantic Comedy of the 1980s and 1990s*. Edinburgh: Edinburgh University Press, 1998.

Falkof, Nicky. *Ball & Chain: The Trouble with Modern Marriage*. London: Fusion Press, 2007.

Faludi, Susan. *The Terror Dream: Fear and Fantasy in Post-9/11 America*. New York: Metropolitan Books, 2007.

Faludi, Susan. *Stiffed: The Betrayal of the American Man*. New York: William Morrow & Co., 1999.

Feasey, Rebecca. *Masculinity and Popular Television*. Edinburgh: Edinburgh University Press, 2008.

Fingeroth, Danny. *Superman on the Couch: What Superheroes Really Tell Us about Ourselves and Our Society*. New York: Continuum, 2008.

Finkel, David. *The Good Soldier*. New York: Picador, 2009.

Finlan, Alastair. *The Collapse of Yugoslavia 1991–1999*. Oxford: Osprey, 2004.

Flanagan, Martin. "Get Ready for Rush Hour: The Chronotope in Action." *Action and Adventure Cinema*. Ed. Yvonne Tasker. London: Routledge, 2004. 103–118.

Fontana, Paul. "Finding God in *The Matrix*." *Taking the Red Pill: Science, Philosophy and Religion in* The Matrix. Ed. Glenn Yeffeth. Dallas: BenBella, 2003. 159–184.

Ford, James L. "Buddhism, Mythology, and *The Matrix*." *Taking the Red Pill: Science, Philosophy and Religion in* The Matrix. Ed. Glenn Yeffeth. Dallas: BenBella, 2003. 125–144.

Fradley, Martin. "Maximus Melodramaticus: Masculinity, Masochism and White Male Paranoia in Contemporary Hollywood Cinema." *Action and Adventure Cinema*. Ed. Yvonne Tasker. New York: Routledge, 2004. 235–251.

Franklin, H. Bruce. "From Realism to Virtual Reality: Images of America's Wars." *Seeing Through the Media: The Persian Gulf War*. Ed. Susan Jeffords and Lauren Rabinovitz. New Brunswick, NJ: Rutgers University Press, 1994. 25–43.

Frantz, Joe B. and Julian Ernest Choate Jr. *The American Cowboy: The Myth and the Reality*. London: Thames and Hudson, 1956.

Frayling, Christopher. *Spaghetti Westerns: Cowboys and Europeans from Karl May to Sergio Leone*. London, New York: I. B. Tauris, 2000.

Freud, Sigmund. "The Dissolution of the Oedipus Complex." *On Sexuality: Penguin Freud Library*, vol. 7. Ed. Angela Richards. London: Penguin, 1991 [orig. 1924].

Gabbard, Krin. "Someone's Got to Pay: Resurgent White Masculinity in *Ransom*." *Masculinities: Bodies, Movies, Culture*. Ed. Peter Lehmann. New York: Routledge, 2001. 7–23.

Garza, Teresita. "Outing the Marlboro Man: Issues of Masculinity and Class Closeted in *Brokeback Mountain*." *Uncovering Hidden Rhetorics: Social Issues in Disguise*. Ed. Barry Brummett. Los Angeles, London, New Delhi, Singapore: SAGE Publications, 2008. 195–214.

Gates, Philippa. *Detecting Men: Masculinity and the Hollywood Detective Film*. Albany, NY: State University of New York Press, 2006.

Gehlawat, Monika. "Improvisation, Action and Architecture in *Casino Royale*." *Revisioning 007: James Bond and Casino Royale*. Ed. Christoph Lindner. London: Wallflower Press, 2009. 131–143.

Gibbs, Jewelle Taylor. *Race and Justice: Rodney King and O. J. Simpson in a House Divided*. San Francisco: Jossey-Bass, 1996.

Gilmore, David. *Manhood in the Making: Cultural Concepts of Masculinity*. New Haven: Yale University Press, 1990.

Goggin, Joyce and Rene Glas. "It Just Keeps Getting Bigger: James Bond and the Political Economy of Huge." *Revisioning 007: James Bond and Casino Royale*. Ed. Christoph Lindner. London: Wallflower Press, 2009. 67–78.

Goldsmith, Jack. *The Terror Presidency: Law and Judgment inside the Bush Administration*. New York: Norton, 2009.

Gooding-Williams, Robert, ed. *Reading Rodney King: Reading Urban Uprising*. New York and London: Routledge, 1993.

Goodwin, Christopher. "The Sorry State of Masculinity in American Movies: Enter the Flat Pack, the Boys Next Door Who are Hollywood's Unlikely New Leading Men." *The Sunday Times* (April 27, 2008), http://entertainment.timesonline.co.uk/tol/arts_and_entertainment/film/article3805205.ece [last accessed July 7, 2011].

Gormley, Paul. *The New-Brutality Film: Race and Affect in Contemporary Hollywood Cinema.* Bristol and Portland, OR: Intellect, 2005.

Greek, Cecil. "The Big City Rogue Cop as a Monster: Images of NYPD and LAPD." *Monsters In and Among Us: Toward a Gothic Criminology.* Ed. Caroline Joan (Kay) Picart and Cecil Greek. Madison and Teaneck: Fairleigh Dickinson University Press, 2007. 164–198.

Green, Bill, Ben Peskoe, Will Russell and Scott Shuffitt, eds. *I am a Lebowski, You are a Lebowski: Life, the Big Lebowski, and What-Have-You.* Foreword by Jeff Bridges. Edinburgh: Canongate, 2007.

Green, Philip. *Cracks in the Pedestal: Ideology and Gender in Hollywood.* Amherst: University of Massachusetts Press, 1998.

Greven, David. *Manhood in Hollywood from Bush to Bush.* Austin, TX: University of Texas Press, 2009.

Guerra, Joey. "One for the Ages: Review of *Brokeback Mountain*" (December 8, 2005), http://www.afterelton.com/archive/elton/movies/2005/12/brokeback.html [last accessed July 7, 2011].

Haber, Karen, ed. *Exploring the Matrix: Visions of the Cyber Present.* New York: St. Martin's Press, 2003.

Hagopian, Kevin J. "Flint and Satyriasis: The Bond Parodies of the 1960s." *Secret Agents: Popular Icons beyond James Bond.* Ed. Jeremy Packer. New York: Peter Lang, 2009. 21–52.

Hallin, Daniel C. "Images of the Vietnam and the Persian Gulf Wars in U.S. Television." *Seeing Through the Media: The Persian Gulf War.* Ed. Susan Jeffords and Lauren Rabinovitz. New Brunswick, NJ: Rutgers University Press, 1994. 45–57.

Hammond, Michael. "Saving Private Ryan's Special Affect." *Action and Adventure Cinema.* Ed. Yvonne Tasker. London: Routledge, 2004.

Hansen, Ron. *The Assassination of Jesse James by the Coward Robert Ford.* London: Souvenir Press, 2008.

Hare, William. *Early Film Noir: Greed, Lust, and Murder Hollywood Style.* Jefferson, NC, and London: McFarland, 2003.

Harris, John F. *The Survivor: Bill Clinton in the White House.* New York: Random House, 2005.

Harris, Thomas. *Hannibal.* New York: Random House, 1999.

Harris, W. C. "Broke(n)back Faggots: Hollywood Gives Queers a Hobson's Choice." *Reading Brokeback Mountain: Essays on the Story and the Film.* Ed. Jim Stacy. Jefferson, NC, and London: McFarland, 2007. 118–134.

Harwood, Sarah. *Family Fictions: Representations of the Family in 1980s Hollywood Cinema.* Foreword by Janet Thumim. Houndsmills and London: Macmillan, 1997.

Haskins, Ron. *Work Over Welfare: The Inside Story of the 1996 Welfare Reform Law.* Washington, DC: Brookings, 2006.

Haskins, Ron, Isabel Sawhill and Kent Weaver. "Welfare Reform Reauthorization: An Overview of Problems and Issues," (January 2001), http://www.brookings.edu/ES/wrb/publications/pb/pb02/pb02.pdf [last accessed July 7, 2011].

Hersberger, Lori. "How Can You Kill Me? I Am Already Dead, or: No People, No Landscape, No Conscience. Where Am I?" *Brave Lonesome Cowboy: Der Mythos des Westerns*

in der Gegenwartskunst oder: John Wayne zum 100. Geburtstag. Ed. Andreas Baur and Konrad Bitterli. Nuremberg: Verlag für Moderne Kunst, 2007. 153–154.

Hersh, Seymour M. *Chain of Command: The Road from 9/11 to Abu Ghraib.* New York: Harper Perennial, 2004.

"Hollywood Stars are a Bunch of Boring Wimps, Says hobbit Billy; Bland Movie Industry 'needs more macho men'." *The Mail on Sunday* (November 13, 2005), http://www.thefreelibrary.com/Hollywood+stars+are+a+bunch+of+boring+wimps,+says+hobbit+Billy%3B+Bland...-a0138779786 [last accessed July 7, 2011].

Holmes, Malcolm D. and Brad W. Smith. *Race and Police Brutality: Roots of an Urban Dilemma.* Albany, NY: State University of New York Press, 2008.

Holmlund, Chris. *American Cinema of the 1990s: Themes and Variations.* New Brunswick, NJ: Rutgers University Press, 2008.

Holmlund, Chris. "The Aging Clint." *Impossible Bodies: Femininity and Masculinity at the Movies.* London, New York: Routledge, 2002. 141–156.

Holmlund, Chris. "Nouveaux Westerns for the 1990s." *Impossible Bodies: Femininity and Masculinity at the Movies.* London, New York: Routledge, 2002. 51–67.

Hooks, Bell. "Doing It For Daddy." *Constructing Masculinity.* Ed. Maurice Berger, Brian Wallis and Simon Watson. New York and London: Routledge, 1995. 98–106.

Horrocks, Roger. *Male Myths and Icons: Masculinity in Popular Culture.* New York: St. Martin's Press, 1995.

Houck, Davis W. " 'My, That's a Big One': Masculinity and Monstrosity in Dirty Harry." *Monsters In and Among Us: Toward a Gothic Criminology.* Ed. Caroline Joan (Kay) Picart and Cecil Greek. Madison and Teaneck: Fairleigh Dickinson University Press, 2007. 65–90.

Howard, Douglas. "Do I Look Like I Give a Damn? What's Right about Getting It Wrong in *Casino Royale.*" *Revisioning 007: James Bond and Casino Royale.* Ed. Christoph Lindner. London: Wallflower Press, 2009. 33–49.

Hoy, Jim. "Clint Eastwood: A New Type of Hero." *The Hollywood West: Lives of Film Legends Who Shaped It.* Ed. Richard W. Etulain and Glenda Riley. Golden, CO: Fulcrum, 2001. 175–194.

Hunt, Thomas P. *The Book of Wealth: In Which It Is Proved from the Bible, That It Is the Duty of Every Man to Become Rich.* New York: Ezra Collier, 1836.

Ibson, John. "Lessons Learned on Brokeback Mountain: Expanding the Possibilities of American Manhood." *Reading Brokeback Mountain: Essays on the Story and the Film.* Ed. Jim Stacy. Jefferson, NC, and London: McFarland, 2007. 188–204.

Irwin, William, ed. *More Matrix and Philosophy: Revolutions and Reloaded Decoded.* Chicago: Open Court, 2005.

Irwin, William, ed. *The Matrix and Philosophy: Welcome to the Desert of the Real.* Chicago: Open Court, 2002.

Ivins, Molly and Lou Dubose. *Bushwacked: Life in George W. Bush's America.* New York: Random House, 2003.

Jacobs, Ronald N. *Race, Media, and the Crisis of Civil Society: From Watts to Rodney King.* Cambridge: Cambridge University Press, 2000.

Jeffords, Susan. "*Breakdown*: White Masculinity, Class, and US Action-Adventure Films." *Action and Adventure Cinema.* Ed. Yvonne Tasker. London and New York: Routledge, 2004. 219–234.

Jeffords, Susan. "Can Masculinity be Terminated?" *Screening the Male: Exploring Masculinities in Hollywood Cinema.* Ed. Steven Cohan and Ina Rae Hark. London and New York: Routledge, 1996. 245–262.

Jeffords, Susan. *Hard Bodies: Hollywood Masculinity in the Reagan Era*. New Brunswick, NJ: Rutgers University Press, 1994.

Jeffords, Susan. "The Big Switch: Hollywood Masculinity in the Nineties." *Film Theory Goes to the Movies*. Ed. Jim Collins, Hilary Radner and Ava Preacher Collins. New York: Routledge, 1993. 196–208.

Jeffords, Susan. *The Remasculinization of America: Gender and the Vietnam War*. Bloomington: Indiana University Press, 1989.

Jeffords, Susan and Lauren Rabinovitz, eds. *Seeing Through the Media: The Persian Gulf War*. New Brunswick, NJ: Rutgers University Press, 1994.

Jencks, Christopher. "What Happened to Welfare?" *The New York Review of Books* 52/20 (December 15, 2005), http://www.nybooks.com/articles/18565 [last accessed July 7, 2011].

Johnson, Audrey D. "Male Masochism in Casino Royale." *Revisioning 007: James Bond and Casino Royale*. Ed. Christoph Lindner. London: Wallflower Press, 2009. 114–127.

Johnson, Michael K. *Black Masculinity and the Frontier Myth in American Literature*. Norman, OK: University of Oklahoma Press, 2002.

Jones, Ginger. "Proulx's Pastoral: *Brokeback Mountain* as a Sacred Space." *Reading Brokeback Mountain: Essays on the Story and the Film*. Ed. Jim Stacy. Jefferson, NC, and London: McFarland, 2007. 19–28.

Jousse, Thierry and Camille Nevers. *Clint Eastwood: Interviews*. Ed. Robert Kapsis and Kathie Coblentz. Jackson: University of Mississippi Press, 1999.

Juarez, Juan Antonio. *Brotherhood of Corruption: A Cop Breaks the Silence on Police Abuse, Brutality, and Racial Profiling*. Chicago: Chicago Review Press, 2004.

Kamber, Michael. "How Not to Depict a War." *The New York Times* (March 1, 2010), http://lens.blogs.nytimes.com/2010/03/01/essay-15/ [last accessed July 7, 2011].

Kaufman, Michael, ed. *Beyond Patriarchy: Essays by Men on Pleasure, Power, and Change*. Toronto and New York: Oxford University Press, 1987.

Kaufman, Robert G. "Is the Bush Doctrine Dead?" *Judging Bush*. Ed. Robert Maranto, Tom Lansford and Jeremy Johnson. Stanford: Stanford University Press, 2009. 215–233.

Kaus, Mickey. *The End of Equality*. New York: Basic Books, 1992.

Keller, Alexandra. "Size Does Matter: Notes on *Titanic* and James Cameron as Blockbuster Auteur." *Titanic: Anatomy of a Blockbuster*. Ed. Kevin S. Sandler and Gaylyn Studlar. New Brunswick, NJ: Rutgers University Press, 1999. 132–154.

Kendrick, James. *Hollywood Bloodshed: Violence in 1980s American Cinema*. Carbondale, IL: Southern Illinois University Press, 2009.

Khalifah, H. Khalif. *Rodney King and the L.A. Rebellion: 13 Independent Black Writers*. Hampton, VA: U.B. & U.S. Communications Systems, 1992.

Kimmel, Michael. "The Cult of Masculinity: American Social Character and the Legacy of the Cowboy." *Beyond Patriarchy: Essays by Men on Pleasure, Power, and Change*. Ed. Michael Kaufman. Toronto and New York: Oxford University Press, 1987. 235–249.

King, Geoff. "Seriously Spectacular: 'Authenticity' and 'Art' in the War Epic." *Hollywood and War: The Film Reader*. Ed. J. David Slocum. New York: Routledge, 2006. 287–301.

King, Geoff. *Film Comedy*. London: Wallflower Press, 2002.

King, Geoff. *New Hollywood Cinema: An Introduction*. New York: Columbia University Press, 2002.

King, Geoff. *Spectacular Narratives: Hollywood in the Age of the Blockbuster*. London: I.B. Tauris, 2000.

King, Neal. *Heroes in Hard Times: Cop Action Movies in the U.S.* Philadelphia: Temple University Press, 1999.

Kirkham, Pat and Janet Thumim, eds. *You Tarzan: Masculinity, Movies and Men.* New York: St. Martin's Press, 1993.

Kitses, Jim. *Horizons West: Directing the Western from John Ford to Clint Eastwood.* 2nd ed. London: BFI Publishing, 2004.

Kitterman, John. "Love and Death in an American Story: A 'Vulgar' Reading of *Brokeback Mountain*." *Reading Brokeback Mountain: Essays on the Story and the Film.* Ed. Jim Stacy. Jefferson, NC, and London: McFarland, 2007. 45–58.

Klypchak, Brad. " 'All on Accounta Pullin' a Trigger': Violence, the Media, and the Historical Contextualization of Clint Eastwood's *Unforgiven*." *Clint Eastwood: Actor and Director. New Perspectives.* Ed. Leonard Engel. Salt Lake City: University of Utah Press, 2007. 157–170.

Knapp, Laurence F. *Directed by Clint Eastwood: Eighteen Films Analyzed.* Jefferson, NC, and London: McFarland, 1996.

Koch, Dietmar. "Elegiac Border Crossings: Short Evocation on the Western, in Honor of the Narrator John Ford." *Brave Lonesome Cowboy: Der Mythos des Westerns in der Gegenwartskunst oder: John Wayne zum 100. Geburtstag.* Ed. Andreas Baur and Konrad Bitterli. Nuremberg: Verlag für Moderne Kunst, 2007. 57–60.

Korb, Lawrence J. and Laura Conley. "Forging an American Empire." *Judging Bush.* Ed. Robert Maranto, Tom Lansford and Jeremy Johnson. Stanford: Stanford University Press, 2009. 234–251.

Krämer, Peter. "It's Aimed at Kids—the Kid in Everybody: George Lucas, Star Wars and Children's Entertainment." *Action and Adventure Cinema.* Ed. Yvonne Tasker. New York: Routledge, 2004. 358–370.

Krämer, Peter. "Women First: Titanic, Action-Adventure Films, and Hollywood's Female Audience." *Titanic: Anatomy of a Blockbuster.* Ed. Kevin S. Sandler and Gaylyn Studlar. New Brunswick, NJ: Rutgers University Press, 1999. 108–131.

Krimmer, Elisabeth. "Nobody Wants to Be a Man Anymore? Cross-Dressing in American Movies of the 90's." *Subverting Masculinity: Hegemonic and Alternative Visions of Masculinity in Contemporary Culture.* Ed. Russell West and Frank Lay. Amsterdam: Rodopi, 2000. 29–43.

Krutnik, Frank. "Love Lies: Romantic Fabrication in Contemporary Romantic Comedy." *Terms of Endearment: Hollywood Romantic Comedy of the 1980s and 1990s.* Ed. Peter William Evans and Celestino Deleyto. Edinburgh: Edinburgh University Press, 1998. 15–36.

Lacan, Jacques. "The Highway and the Signifier 'Being a Father'." *The Psychoses: The Seminar of Jacques Lacan, Book III, 1955–1956.* Ed. Jacques-Alain Miller. London and New York: Routledge, 1956.

Lacey, Nick. *Se7en.* London: York Press, 2001.

Lännström, Anna. "*The Matrix* and Vedanta: Journeying from the Unreal to the Real." *More Matrix and Philosophy: Revolutions and Reloaded Decoded.* Ed. William Irwin. Chicago: Open Court, 2005. 125–135.

Lamberti, Edward. "Brokeback Mountain" [Review] (2005), http://www.kamera.co.uk/reviews_extra/brokeback_mountain.php [last accessed July 7, 2011].

LaSalle, Mick. *Dangerous Men: Pre-Code Hollywood and the Birth of the Modern Man.* New York: St. Martin's Press, 2002.

Latta, Frank Forrest. *Dalton Gang Days*. Santa Cruz, CA: Bear State Books, 1976.

Lawler, James. "Only Love is Real: Heidegger, Plato, and *The Matrix* Trilogy." *More Matrix and Philosophy: Revolutions and Reloaded Decoded*. Ed. William Irwin. Chicago: Open Court, 2005. 26–37.

Lawrence, Matt. *Like a Splinter in Your Mind: The Philosophy behind* The Matrix *Trilogy*. Malden: Blackwell, 2004.

Lehman, Peter, ed. *Masculinity: Bodies, Movies, Culture*. New York: Routledge, 2001.

Lehman, Peter. "Don't Blame This on a Girl: Female Rape-Revenge Films." *Screening the Male: Exploring Masculinities in Hollywood Cinema*. Ed. Steven Cohan and Ina Rae Hark. London and New York: Routledge, 1993. 103–117.

Lehman, Peter. *Running Scared: Masculinity and the Representation of the Male Body*. Philadelphia: Temple University Press, 1993.

Lehman, Peter and Susan Hunt. "Something and Someone Else: The Mind, the Body, and Sexuality in *Titanic*." *Titanic: Anatomy of a Blockbuster*. Ed. Kevin S. Sandler and Gaylyn Studlar. New Brunswick, NJ: Rutgers University Press, 1999. 88–107.

Lenthan, John H. "Westbound: Feature Films and the American West." *Wanted Dead or Alive: The American West in Popular Culture*. Ed. Richard Aquila. Urbana and Chicago: University of Illinois Press, 1996. 109–134.

Lewis, Jon, ed. *The End of Cinema As We Know It: American Film in the Nineties*. New York: New York University Press, 2001.

Li, Xinghua. "From 'Nature's Love' to Natural Love: *Brokeback Mountain*, Universal Identification, and Gay Politics." *Reading Brokeback Mountain: Essays on the Story and the Film*. Ed. Jim Stacy. Jefferson, NC, and London: McFarland, 2007. 106–117.

Lichtenfeld, Eric. *Action Speaks Louder: Violence, Spectacle, and the American Action Movie*. Westport, CT: Praeger, 2004.

Lindner, Christoph, ed. *Revisioning 007: James Bond and Casino Royale*. London: Wallflower Press, 2009.

Lindner, Christoph. "Introduction." *The James Bond Phenomenon: A Critical Reader*. Ed. Christoph Lindner. Manchester: Manchester University Press, 2003. 1–9.

Lindner, Christoph, ed. *The James Bond Phenomenon: A Critical Reader*. Manchester: Manchester University Press, 2003.

Lippman, Roger. "Looking Back on the Seattle Conspiracy Trial" (December 1990), http://terrasol.home.igc.org/trial.htm [last accessed July 7, 2011].

Lott, M. Ray. *Police on Screen: Hollywood Cops, Detectives, Marshals and Rangers*. Jefferson, NC, and London: McFarland, 2006.

Loukides, Paul and Linda K. Fuller. *Beyond the Stars: Studies in American Popular Film. Vol. 1: Stock Characters in American Popular Film*. Bowling Green: Bowling Green State University Popular Press, 1990.

Luce, Edward. "The Crisis of Middle-Class America." *Financial Times* (July 30, 2010), http://www.ft.com/cms/s/2/1a8a5cb2-9ab2-11df-87e6-00144feab49a.html [last accessed July 7, 2011].

Lupton, Deborah and Lesley Barclay. *Constructing Fatherhood: Discourses and Experiences*. London: SAGE Publications, 1997.

MacKinnon, Kenneth. *Representing Men: Maleness and Masculinity in the Media*. London: Arnold, 2003.

Malin, Brenton J. *American Masculinity under Clinton: Popular Media and the Nineties "Crisis of Masculinity."* New York and Oxford: Peter Lang, 2005.

Malin, Brenton J. "Classified and Declassified: Cultural Capital and Class Anxiety in New Male Sons and Fathers." *American Masculinity under Clinton: Popular Media and the Nineties "Crisis of Masculinity."* New York and Oxford: Peter Lang, 2005. 61–96.

Maltby, Richard. "Nobody Knows Everything: Post-Classical Historiographies and Consolidated Entertainment." *Contemporary Hollywood Cinema*. Ed. Steve Neale and Murray Smith. London: Routledge, 1998. 21–44.

"Manly Movie Stars: Rodrigue Talks the Evolution of Masculinity in Film." *Indiewire Blog Network* (August 12, 2010), http://blogs.indiewire.com/thompsononhollywood/2010/08/12/manly_movie_stars_jean-louis_rodrigue_talks_the_evolution_of_masculinity/ [last accessed July 7, 2011].

Marano, Michael. "Who Is the Best James Bond: Dalton's Gang, A Fleming Fan Praises the Best James Bond." *James Bond in the 21st Century: Why We Still Need 007*. Ed. Glenn Yeffeth. Dallas: BenBella, 2006. 101–112.

Maranto, Robert and Richard Redding. "Bush's Brain (No, Not Karl Rove): How Bush's Psyche Shaped His Decision Making." *Judging Bush*. Ed. Robert Maranto, Tom Lansford and Jeremy Johnson. Stanford: Stanford University Press, 2009. 21–40.

Maranto, Robert, Tom Lansford and Jeremy Johnson, ed. *Judging Bush*. Stanford: Stanford University Press, 2009.

Marcus, Greil. "John Wayne Listening." *The Dustbin of History*. London: Picador, 1996. 209–215.

Markos, Louis. "Nobody Does It Better: Why James Bond Still Reigns Supreme." *James Bond in the 21st Century: Why We Still Need 007*. Ed. Glenn Yeffeth. Dallas: BenBella, 2006. 163–170.

Martinez, Nancy. "Arrest Warrant Issued For Brad Pitt Stalker" (1999), http://www.turnto23.com/entertainment/137797/detail.html [last accessed July 7, 2011].

Marx, Karl and Friedrich Engels. *The Communist Manifesto*. Trans. Samuel Moore. London: Penguin, 2004.

Massey, Anne and Mike Hammond. "It Was True! How Can you Laugh? History and Memory in the Reception of *Titanic* in Britain and Southampton." *Titanic: Anatomy of a Blockbuster*. Ed. Kevin S. Sandler and Gaylyn Studlar. New Brunswick, NJ: Rutgers University Press, 1999. 239–264.

Mathijs, Ernest and Murray Pomerance, eds. *From Hobbits to Hollywood: Essays on Peter Jackson's Lord of the Rings*. Amsterdam: Rodopi, 2006.

Matthews, Nicole. *Comic Politics: Gender in Hollywood Comedy after the New Right*. Manchester: Manchester University Press, 2000.

Matthews, Rupert. *The Age of the Gladiators: Savagery and Spectacle in Ancient Rome*. London: Arcturus, 2003.

Mayer, Jane. *The Dark Side: The Inside Story of How the War on Terror Turned into a War on American Ideals*. New York: Anchor, 2008.

McAlister, Melani. "A Cultural History of War without End." *Hollywood and War: The Film Reader*. Ed. J. David Slocum. New York: Routledge, 2006. 325–337.

McAllister, Patricia, ed. *Women and the American Economy: A National and Global Context. Policy Papers*. Cincinnati, OH: Center for Women's Studies, 1991.

McArdle, Andrea. "Introduction." *Zero Tolerance: Quality of Life and the New Police Brutality in New York City*. Ed. Andrea McArdle and Tanya Erzen. New York and London: New York University Press, 2001. 1–16.

McArdle, Andrea and Tanya Erzen, eds. *Zero Tolerance: Quality of Life and the New Police Brutality in New York City*. New York and London: New York University Press, 2001.

McCrisken, Trevor B. and Andrew Pepper. "Lessons from Hollywood's American Revolution: *Revolution; The Patriot*." *American History and Contemporary Hollywood Film*. Edinburgh: Edinburgh University Press, 2005. 15–38.

McKinney, Devin. "Violence: The Strong and the Weak." *Screening Violence*. Ed. Stephen Prince. New Brunswick, NJ: Rutgers University Press, 2000. 99–109.

Mehler, Charles Eliot. "*Brokeback Mountain* at the Oscars." *Reading Brokeback Mountain: Essays on the Story and the Film*. Ed. Jim Stacy. Jefferson, NC, and London: McFarland, 2007. 135–151.

Mellen, Joan. *Big Bad Wolves: Masculinity in the American Film*. London: Elm Tree Books, 1977.

Mellencamp, Pat. "The Zen of Masculinity—Rituals of Heroism in *The Matrix*." *The End of Cinema As We Know It: American Film in the Nineties*. Ed. Jon Lewis. New York: New York University Press, 2001. 83–94.

Mellors, Bob. *Clint Eastwood Loves Jeff Bridges: True! "Homosexuality," Androgyny & Evolution: A Simple Introduction*. London: Quantum Jump Publications, 1978.

Mercer Schuchardt, Read. "What Is the Matrix?" *Taking the Red Pill: Science, Philosophy and Religion in* The Matrix. Ed. Glenn Yeffeth. Dallas: BenBella, 2003. 5–21.

Metz, Walter. "The Old Man and the C: Masculinity and Age in the Films of Clint Eastwood." *Clint Eastwood: Actor and Director. New Perspectives*. Ed. Leonard Engel. Salt Lake City: University of Utah Press, 2007. 204–217.

Miller, Frank. *Censored Hollywood: Sex, Sin & Violence on Screen*. Atlanta: Turner, 1994.

Miller, Toby. "James Bond's Penis." *The James Bond Phenomenon: A Critical Reader*. Ed. Christoph Lindner. Manchester: Manchester University Press, 2003. 232–247.

Mirzoeff, Nicholas. *Watching Babylon: The War in Iraq and Global Visual Culture*. New York: Routledge, 2005.

Mitchell, Lee Clark. *Western: Making the Man in Fiction and Film*. Chicago: University of Chicago Press, 1996.

Modleski, Tania. "Do We Get to Lose This Time? Revisiting the Vietnam War Film." *The War Film*. Ed. Robert Eberwein. New Brunswick, NJ: Rutgers University Press, 2006. 155–171.

Modleski, Tania. *Feminism without Women: Culture and Criticism in a "Post-feminist" Age*. New York and London: Routledge, 1991.

Mulvey, Laura. "Visual Pleasure and Narrative Cinema." *Screen* 16/3 (Autumn 1975): 6–18.

Munn, Michael. *The Hollywood Murder Casebook*. London: Robson Books, 1987.

Nadel, Alan. *Flatlining on the Field of Dreams: Cultural Narratives in the Films of President Reagan's America*. New Brunswick, NJ: Rutgers University Press, 1997.

Nardone, Henry and Gregory Bassham. "Pissin' Metal: Columbine, Malvo, and the Matrix of Violence." *More Matrix and Philosophy: Revolutions and Reloaded Decoded*. Ed. William Irwin. Chicago: Open Court, 2005. 185–197.

Nash, Melanie and Martti Lahti. "Almost Ashamed to Say I Am One of Those Girls: Titanic, Leonardo DiCaprio, and the Paradoxes of Girls' Fandom." *Titanic: Anatomy of a Blockbuster*. Ed. Kevin S. Sandler and Gaylyn Studlar. New Brunswick, NJ: Rutgers University Press, 1999. 64–88.

Neale, Steve. "Action-Adventure as Hollywood Genre." *Action and Adventure Cinema*. Ed. Yvonne Tasker. London: Routledge, 2004. 71–83.

Neale, Steve. "Prologue: Masculinity as Spectacle. Reflections on Men and Mainstream cinema." *Screening the Male: Exploring Masculinities in Hollywood Cinema*. Ed. Steven Cohan and Ina Rae Hark. London and New York: Routledge, 1993. 9–20.

Negra, Diane. "*Titanic,* Survivalism, and the Millenial Myth." *Titanic: Anatomy of a Blockbuster*. Ed. Kevin S. Sandler and Gaylyn Studlar. New Brunswick, NJ: Rutgers University Press, 1999. 220–238.

Nelson, Jill, ed. *Police Brutality: An Anthology*. New York and London: W. W. Norton, 2000.

Newman, Kim. *Apocalypse Movies: End of the World Cinema.* New York: St. Martin Griffin, 2000.

Niven, John. *Kill Your Friends.* London: Random House, 2008.

Nochimson, Martha P. *Screen Couple Chemistry: The Power of 2.* Austin, TX: University of Texas Press, 2002.

North, Michael. *Material Delight and the Joy of Living: Cultural Consumption in the Age of Enlightenment in Germany.* Translated by Pamela Selwyn. Aldershot, Hampshire; Burlington, VT: Ashgate, 2008.

O'Brien, Daniel. *The Hannibal Files: The Unauthorized Guide to the Hannibal Lecter Trilogy.* London: Reynolds & Hearn, 2001.

Ogletree, Charles J. Jr., Mary Prosser, Abbe Smith and William Talley Jr. *Beyond the Rodney King Story: An Investigation of Police Conduct in Minority Communities.* Boston: Northeastern University Press, 1995.

Omry, Keren. "Bond, Benjamin, Balls: Technologised Masculinity in Casino Royale." *Revisioning 007: James Bond and Casino Royale.* Ed. Christoph Lindner. London: Wallflower Press, 2009. 159–172.

Ostin, Joyce. *Hollywood Dads.* Photographs by Joyce Ostin; Introduction by Paul Reiser. San Francisco, CA: Chronicle, 2007.

Ouellette, Laurie. "Ship of Dreams: Cross-Class Romance and the Cultural Fantasy of *Titanic.*" *Titanic: Anatomy of a Blockbuster.* Ed. Kevin S. Sandler and Gaylyn Studlar. New Brunswick, NJ: Rutgers University Press, 1999. 169–188.

Packard, Chris. *Queer Cowboys and Other Erotic Male Friendships in Nineteenth Century American Literature.* New York: Palgrave Macmillan, 2005.

Packer, Jeremy. "The Many Beyonds: An Introduction." *Secret Agents: Popular Icons beyond James Bond.* Ed. Jeremy Packer. New York: Peter Lang, 2009. 1–19.

Packer, Jeremy, ed. *Secret Agents: Popular Icons beyond James Bond.* New York: Peter Lang, 2009.

Packer, Jeremy and Sarah Sharma. "Postfeminism Galore: The Bond Girl as Weapon of Mass Consumption." *Secret Agents: Popular Icons beyond James Bond.* Ed. Jeremy Packer. New York: Peter Lang, 2009. 89–110.

Packer, Sharon. *Movies and the Modern Psyche.* Westport, CT & London: Praeger, 2007.

Palmiotto, Michael J., ed. *Police Misconduct: A Reader for the 21st Century.* Upper Saddle River, NJ: Prentice Hall, 2001.

Parenti, Michael. *Make-Belief Media: The Politics of Entertainment.* New York: St. Martin's Press, 1992.

Parpart, Lee. "The Nation and the Nude: Colonial Masculinity and the Spectacle of the Male Body in Recent Canadian Cinema(s)." *Masculinities: Bodies, Movies, Culture.* Ed. Peter Lehmann. New York: Routledge, 2001. 167–192.

Parry, Jonathan P. *Caste and Kinship in Kangra.* London: Routledge and Kegan Paul, 1979.

Patterson, Eric. *On Brokeback Mountain: Meditations about Masculinity, Fear, and Love in the Story and the Film.* Lanham, MD: Rowman & Littlefield, 2008.

Perez, Hiram. "Gay Cowboys Close to Home: Ennis Del Mar on the Q.T." *Reading Brokeback Mountain: Essays on the Story and the Film.* Ed. Jim Stacy. Jefferson, NC, and London: McFarland, 2007. 71–87.

"Personal Responsibility and Work Opportunity Reconciliation Act of 1996" (August 22, 1996), http://frwebgate.access.gpo.gov/cgi-bin/getdoc.cgi?dbname=104_cong_public_laws&docid=f:publ193.104 [last accessed July 7, 2011].

Pfeiffer, Lee. "Bland...James Bland." *James Bond in the 21st Century: Why We Still Need 007.* Ed. Glenn Yeffeth. Dallas: BenBella, 2006. 23–32.

Pfiffner, James P. "President Bush as Chief Executive." *Judging Bush.* Ed. Robert Maranto, Tom Lansford and Jeremy Johnson. Stanford: Stanford University Press, 2009. 58–74.

Picart, Caroline Joan (Kay) and Cecil Greek. "The Compulsions of Real/Reel Serial Killers and Vampires: Toward a Gothic Criminology." *Monsters in and among Us: Toward a Gothic Criminology.* Ed. Caroline Joan (Kay) Picart and Cecil Greek. Madison and Teaneck: Fairleigh Dickinson University Press, 2007. 227–255.

Picart, Caroline Joan (Kay) and Cecil Greek. "Profiling the Terrorist as a Mass Murderer." *Monsters in and among Us: Toward a Gothic Criminology.* Ed. Caroline Joan (Kay) Picart and Cecil Greek. Madison and Teaneck: Fairleigh Dickinson University Press, 2007. 256–288.

Picart, Caroline Joan (Kay) and Cecil Greek, eds. *Monsters in and among Us: Toward a Gothic Criminology.* Madison and Teaneck: Fairleigh Dickinson University Press, 2007.

Polan, Dana. "Auteurism and War-teurism: Terrence Malick's War Movie." *The War Film.* Ed. Robert Eberwein. New Brunswick, NJ: Rutgers University Press, 2006. 53–61.

Pomerance, Murray, ed. *Ladies and Gentlemen, Boys and Girls: Gender in Film at the End of the Twentieth Century.* Albany, NY: State University of New York Press, 2001.

Portis, Charles. *True Grit.* New York: Simon & Schuster, 1968.

Powers, Stephen, David J. Rothman and Stanley Rothman. *Hollywood's America: Social and Political Themes in Motion Pictures.* Boulder, CO: Westview Press, 1996.

Powrie, Phil, Ann Davies and Bruce Babington, eds. *The Trouble with Men: Masculinities in European and Hollywood Cinema.* London: Wallflower Press, 2004.

Preston, Catherine L. "Hanging on a Star: The Resurrection of the Romance Film in the 1990s." *Film Genre 2000: New Critical Essays.* Ed. Wheeler Winston Dixon. New York: State University of New York Press, 2000. 227–243.

Prince, Stephen. *Classical Film Violence: Designing and Regulating Brutality in Hollywood Cinema, 1930–1968.* New Brunswick, NJ: Rutgers University Press, 2003.

Putnam, David. "Films Without Frontiers." *Movies and American Society.* Ed. Steven J. Ross. Oxford: Blackwell, 2002. 362–365.

Quigley, Adam. "Box Office: Why Does The Expendables Continue to Thrive, While Scott Pilgrim Continues to Flounder?" *Film: Blogging the Real World* (August 22, 2010), http://www.slashfilm.com/box-office-the-expendables-stays-1-scott-pilgrim-drops-to-10/ [last accessed July 7, 2011].

Quillen, Dustin. "Time Warner Credits Videogames for Revenue Surge" (August 4, 2010), http://www.1up.com/news/time-warner-credits-videogames-revenue [last accessed July 7, 2011].

Raboy, Isaac. *Jewish Cowboy.* Trans. from the Yiddish by Nathaniel Shapiro. Westfield, NJ: Tradition Books, 1989.

Radcliffe-Brown, Alfred Reginald, ed. *African Systems of Kinship and Marriage.* London: KPI, 1987.

Radhakrishnan, Sarpevalli. *Eastern Religions and Western Thought.* Delhi, New York: Oxford University Press, 1989.

Radner, Hilary. "Hollywood Redux: *All about My Mother* and *Gladiator.*" *The End of Cinema As We Know It: American Film in the Nineties.* Ed. Jon Lewis. London: Pluto Press, 2002. 72–80.

Radway, Janice A. *Reading the Romance: Women, Patriarchy, and Popular Literature.* Chapel Hill: University of North Carolina Press, 1991.

Rae Hark, Ina. "Animals or Romans: Looking at Masculinity in *Spartacus.*" *Screening the Male: Exploring Masculinities in Hollywood Cinema.* Ed. Steven Cohan and Ina Rae Hark. London and New York: Routledge, 1996. 151–172.

Rasch, Philip J. *Trailing Billy the Kid.* Stillwater, OK: Western Publications, 1995.

Reedy, Neil and Jeremy Johnson. "Evaluating Presidents." *Judging Bush.* Ed. Robert Maranto, Tom Lansford and Jeremy Johnson. Stanford: Stanford University Press, 2009. 3–20.

Reiter, Gershon. *Fathers and Sons in Cinema.* Jefferson, NC, and London: McFarland, 2008.

Ricks, Thomas E. *Fiasco: The American Military Adventure in Iraq.* New York: Penguin, 2006.

Rischin, Moses and John Livingston. *Jews of the American West.* Detroit: Wayne State University Press, 1991.

Robb, David L. *Operation Hollywood: How the Pentagon Shapes and Censors the Movies.* Amherst: Prometheus Books, 2004.

Robbins, Anthony. *Awaken the Giant Within: How to Take Immediate Control of your Mental, Emotional, Physical & Financial Destiny!* London: Simon & Schuster, 1992.

Robertson, William Preston. *The Making of Joel and Ethan Coen's The Big Lebowski.* New York, London: Faber & Faber, 1998.

Robinson, Sally. "Emotional Constipation and the Power of Damned Masculinities: Deliverance and the Paradoxes of Male Liberation." *Masculinities: Bodies, Movies, Culture.* Ed. Peter Lehmann. New York: Routledge, 2001. 133–147.

Rogin, Michael. "Home of the Brave." *The War Film.* Ed. Robert Eberwein. New Brunswick, NJ: Rutgers University Press, 2006. 82–89.

Rosa, Joseph G. *They Called Him Wild Bill: The Life and Adventures of James Butler Hickok.* Norman, OK: University of Oklahoma Press, 1964.

Rose, Peter W. "The Politics of *Gladiator*." *Gladiator: Film and History.* Ed. Martin M. Winkler. Oxford: Blackwell Publishing, 2004. 150–172.

Rosenbaum, Jonathan. *Movies as Politics.* Berkeley, CA: University of California Press, 1997.

Rosin, Hanna. "The End of Men." *The Atlantic Magazine* (July/August 2010), http://www.theatlantic.com/magazine/archive/2010/07/the-end-of-men/8135/ [last accessed July 7, 2011].

Ross, Steven, ed. *Movies and American Society.* Oxford: Blackwell, 2002.

Rotundo, E. Anthony. "Patriarchs and Participants: A Historical Perspective on Fatherhood." *Beyond Patriarchy: Essays by Men on Pleasure, Power, and Change.* Ed. Michael Kaufman. Toronto and New York: Oxford University Press, 1987. 64–80.

Rowe Karlyn, Kathleen. "Allison Anders's *Gas Food Lodging*: Independent Cinema and the New Romance." *Terms of Endearment: Hollywood Romantic Comedy of the 1980s and 1990s.* Ed. Peter William Evans and Celestino Deleyto. Edinburgh: Edinburgh University Press, 1998. 168–187.

Rubinfeld, M. *Bound to Bond: Gender, Genre, and the Hollywood Romantic Comedy.* Connecticut: Praeger Press, 2001.

Rutherford, Kenneth R. *Humanitarianism under Fire: The US and UN Intervention in Somalia.* Sterling: Kumarian Press, 2008.

Sakeris, John. "Howard's First Kiss: Sissies and Gender Police in the 'New' Old Hollywood." *Ladies and Gentlemen, Boys and Girls: Gender in Film at the End of the Twentieth Century.* Ed. Murray Pomerance. Albany, NY: State University of New York Press, 2001. 217–231.

Sandler, Kevin S. and Gaylyn Studlar. "Introduction: The Seductive Waters of James Cameron's Film Phenomenon." *Titanic: Anatomy of a Blockbuster.* Ed. Kevin S. Sandler and Gaylyn Studlar. New Brunswick, NJ: Rutgers University Press, 1999. 1–13.

Sandler, Kevin S. and Gaylyn Studlar, eds. *Titanic: Anatomy of a Blockbuster*. New Brunswick, NJ: Rutgers University Press, 1999.

Sands, Philippe. "George Bush's Torture Admission is a Dismal Moment for Democracy." *The Guardian* (November 9, 2010), http://www.guardian.co.uk/world/2010/nov/09/george-bush-torture-admission-democracy [last accessed July 7, 2011].

Sanello, Frank. *Reel vs. Real: How Hollywood Turns Fact Into Fiction*. Lanham, MD: Taylor Trade, 2003.

Sanjek, David. "Same As It Ever Was: Innovation and Exhaustion in the Horror and Science Fiction Films of the 1990s." *Film Genre 2000: New Critical Essays*. Ed. Wheeler Winston Dixon. New York: State University of New York Press, 2000. 111–123.

Sartre, Jean-Paul. *Being and Nothingness: A Phenomenological Essay on Ontology*. Translated and with an introduction by Hazel E. Barnes. New York: Washington Square Press, 1992.

Savage, William W. *Cowboy Life: Reconstructing an American Myth*. Newman: University of Oklahoma Press, 1973.

Savran, David. *Taking It Like a Man: White Masculinity, Masochism, and Contemporary American Culture*. Princeton: Princeton University Press, 1998.

Scahill, Jeremy. *Blackwater: The Rise of the World's Most Powerful Mercenary Army*. New York: Nation Books, 2008.

Schatz, Thomas. "The New Hollywood." *Film Theory Goes to the Movies*. Ed. Jim Collins, Hilary Radner and Ava Preacher Collins. New York: Routledge, 1993. 8–36.

Scheibel, Will. "The History of Casino Royale on and off Screen." *Revisioning 007: James Bond and Casino Royale*. Ed. Christoph Lindner. London: Wallflower Press, 2009. 11–32.

Schick, Theodore, Jr. "Choice, Purpose, and Understanding: Neo, the Merovingian, and the Oracle." *More Matrix and Philosophy: Revolutions and Reloaded Decoded*. Ed. William Irwin. Chicago: Open Court, 2005. 69–80.

Schmid, David. *Natural Born Celebrities: Serial Killers in American Culture*. Chicago and London: University of Chicago Press, 2005.

Schneider, Stephen Jay, ed. *New Hollywood Violence*. Manchester, New York: Manchester University Press, 2004.

Schram, Sanford F. and Joe Soss. "Success Stories: Welfare Reform, Policy Discourse, and the Politics of Research." *The Annals of the American Academy of Political and Social Science* 557 (September 2001): 49–65.

Schram, Sanford F., Joe Soss and Richard C. Fording, eds. *Race and the Politics of Welfare Reform*. Ann Arbor: University of Michigan Press, 2003.

Seidler, Victor. "Fathering, Authority and Masculinity." *Male Order: Unwrapping Masculinity*. Ed. Rowena Chapman and Jonathan Rutherford. London: Lawrence & Wishart, 1988. 272–302.

Shaheen, Jack G. *Guilty: Hollywood's Verdict on Arabs after 9/11*. Northampton: Olive Branch Press, 2008.

Silverman, Kaja. *Male Subjectivity at the Margins*. New York: Routledge, 1992.

Simpson, Bob, Peter McCarthy and Janet Walker. *Being There: Fathers after Divorce. An Exploration of Post-divorce Fathering*. Newcastle upon Tyne: Relate Centre for Family Studies, 1995.

Simpson, Mark. "Iron Clint: Queer Weddings in Robert Bly's *Iron John* and Clint Eastwood's *Unforgiven*." *Male Impersonators: Men Performing Masculinity*. London: Cassell, 1994. 253–265.

Simpson, Mark. *Male Impersonators: Men Performing Masculinity*. New York: Cassell, 1994.

Simpson, Philip L. "Gothic Romance and Killer Couples in *Black Sunday* and *Hannibal.*" *Dissecting Hannibal Lecter: Essays on the Novels of Thomas Harris.* Ed. Benjamin Szumskyj. Jefferson, NC, and London: McFarland, 2008. 49–67.

Simpson, Philip L. *Psycho Paths: Tracking the Serial Killer Through Contemporary American Film and Fiction.* Carbondale, IL: Southern Illinois University Press, 2000.

Slocum, J. David, ed. *Hollywood and War: The Film Reader.* New York: Routledge, 2006.

Slotkin, Richard. *Regeneration through Violence: The Mythology of the American Frontier 1600–1860.* Middletown: Wesleyan University Press, 1973.

Smith, Murray. "Theses on the Philosophy of Hollywood History." *Contemporary Hollywood Cinema.* Ed. Steve Neale and Murray Smith. London: Routledge, 1998. 3–20.

Sperb, Jason. "Hardly the Big Picture: The Ellipsis and Narratives of Interruption in *Casino Royale.*" *Revisioning 007: James Bond and Casino Royale.* Ed. Christoph Lindner. London: Wallflower Press, 2009. 50–66.

Spicer, Andrew. "The Reluctance to Commit: Hugh Grant and the New British Romantic Comedy." *The Trouble with Men: Masculinities in European and Hollywood Cinema.* Ed. Phil Powrie, Ann Davies and Bruce Babington. London and New York: Wallflower Press, 2004. 77–87.

Spicer, Andrew. *Typical Men: The Representation of Masculinity in Popular British Cinema.* London: I.B. Tauris, 2001.

Stacy, Jim. "Buried in the Family Plot: The Cost of Pattern Maintenance to Ennis and Jack." *Reading Brokeback Mountain: Essays on the Story and the Film.* Ed. Jim Stacy. Jefferson, NC, and London: McFarland, 2007. 29–44.

Stacy, Jim. "Love and Silence, Penguins and Possibility." *Reading Brokeback Mountain: Essays on the Story and the Film.* Ed. Jim Stacy. Jefferson, NC, and London: McFarland, 2007. 205–220.

Stacy, Jim, ed. *Reading Brokeback Mountain: Essays on the Story and the Film.* Jefferson, NC, and London: McFarland, 2007.

Stock, Paul. "Dial 'M' for Metonym: Universal Exports, M's Office Space, and Empire." *The James Bond Phenomenon: A Critical Reader.* Ed. Christoph Lindner. Manchester: Manchester University Press, 2003. 215–231.

Stone, Lawrence. *The Family, Sex and Marriage in England, 1500–1800.* 2nd ed. London: Penguin, 1990.

Straayer, Chris. *Deviant Eyes, Deviant Bodies: Sexual Re-orientation in Film and Video.* New York: Columbia University Press, 1996.

Studlar, Gaylyn. "Valentino, 'Optic Intoxication,' and Dance Madness." *Screening the Male: Exploring Masculinities in Hollywood Cinema.* Ed. Steven Cohan and Ina Rae Hark. London and New York: Routledge, 1993. 23–45.

Suellentrop, Chris. "War Games: What Does It Mean That the Most Popular Cultural Depictions of American's Current Wars Happen to Be Video Games?" *New York Times,* September 12, 2010, 62–67.

Suid, Lawrence H. *Guts and Glory: The Making of the American Military Image in Film.* Lexington: University Press of Kentucky, 2002.

Surette, Raymond. "Gothic Criminology and Criminal Justice Policy." *Monsters in and among Us: Toward a Gothic Criminology.* Ed. Caroline Joan (Kay) Picart and Cecil Greek. Madison and Teaneck: Fairleigh Dickinson University Press, 2007. 199–226.

Sutton, Paul. "Can the Man Panic?: Masculinity and Fatherhood in Nanni Moretti's *Aprile* (1998)." *The Trouble with Men: Masculinities in European and Hollywood Cinema.* Ed. Phil Powrie, Ann Davies and Bruce Babington. London: Wallflower Press, 2004. 144–154.

Szumskyj, Benjamin. "Morbidity of the Soul: An Appreciation of Hannibal." *Dissecting Hannibal Lecter: Essays on the Novels of Thomas Harris*. Ed. Benjamin Szumskyj. Jefferson, NC, and London: McFarland, 2008. 200–211.

Szumskyj, Benjamin, ed. *Dissecting Hannibal Lecter: Essays on the Novels of Thomas Harris*. Jefferson, NC, and London: McFarland, 2008.

Tapper, Jake, Huma Khan, Martha Raddatz and Lauren Effron, "Osama Bin Laden Operation Ended With Coded Message 'Geronimo-E KIA'," *ABC News* (May 2, 2011), http://abcnews.go.com/Politics/osama-bin-laden-hid-wives-firefight-counter-terrorism/story?id=13507836 [last accessed July 7, 2011].

Tasker, Yvonne, ed. *Action and Adventure Cinema*. London: Routledge, 2004.

Tasker, Yvonne. "The Family in Action." *Action and Adventure Cinema*. Ed. Yvonne Tasker. London and New York: Routledge, 2004. 252–266.

Tasker, Yvonne. "Introduction: Action and Adventure Cinema." *Action and Adventure Cinema*. Ed. Yvonne Tasker. London: Routledge, 2004. 1–13.

Tasker, Yvonne. "Dumb Movies for Dumb People: Masculinity, the Body, and the Voice in Contemporary Action Cinema." *Screening the Male: Exploring Masculinities in Hollywood Cinema*. Ed. Steven Cohan and Ina Rae Hark. London and New York: Routledge, 1996. 230–244.

Tasker, Yvonne. *Spectacular Bodies: Gender, Genre and the Action Cinema*. London: Routledge, 1993.

Taves, Brian. *The Romance of Adventure: The Genre of Historical Adventure Movies*. Jackson: University of Mississippi Press, 1993.

Taylor, Quintard. *In Search of the Racial Frontier: African Americans in the American West, 1528–1990*. New York and London: W. W. Norton, 1998.

Terrill, William. *Police Coercion: Application of the Force Continuum*. New York: LFB Scholarly Publishing LLC, 2001.

Thompson, Anne. "U.S. Short on Tough Guy Actors." *Variety* (August 28, 2008), http://www.variety.com/article/VR1117991319?refCatId=2508 [last accessed July 7, 2011].

Thompson, Kristin. *The Frodo Franchise: The Lord of the Rings and Modern Hollywood*. Berkeley, CA: University of California Press, 2007.

Thorne, David. *"He's got a gun!"* London: Gefn, 1999.

Tibbetts, John C. "The Machinery of Violence: Clint Eastwood Talks about *Unforgiven*." *Clint Eastwood: Actor and Director. New Perspectives*. Ed. Leonard Engel. Salt Lake City: University of Utah Press, 2007. 171–180.

Tincknell, Estella. "Double-O Agencies: Femininity, Post-Feminism and the Female Spy." *Revisioning 007: James Bond and Casino Royale*. Ed. Christoph Lindner. London: Wallflower Press, 2009. 99–113.

Tincknell, Estella. *Mediating the Family: Gender, Culture and Representation*. London: Hodder Arnold, 2005.

Tompkins, Jane. *West of Everything: The Inner Life of Westerns*. New York: Oxford University Press, 1992.

Traube, Elizabeth G. *Dreaming Identities: Class, Gender and Generation in 1980s Film*. Boulder, CO, and Oxford: Westview Press, 1992.

Trice, Ashton D. and Samuel A. Holland. *"Gump* and Gumper: Men as Idiots." *Heroes, Antiheroes and Dolts: Portrayals of Masculinity in American Popular Films, 1921–1999*. Jefferson, NC, and London: McFarland, 2001. 192–203.

Trice, Ashton D. and Samuel A. Holland. *Heroes, Antiheroes and Dolts: Portrayals of Masculinity in American Popular Films, 1921–1999*. Jefferson, NC, and London: McFarland, 2001.

Tropiano, Stephen. *Obscene, Indecent, Immoral, and Offensive: 100+ Years of Censored, Banned, and Controversial Films.* New York: Limelight, 2009.

Tsika, Noah. "The Queerness of Country: Brokeback's Soundscape." *Reading Brokeback Mountain: Essays on the Story and the Film.* Ed. Jim Stacy. Jefferson, NC, and London: McFarland, 2007. 163–177.

Tyree, J. M. and Ben Walters. *The Big Lebowski.* London: BFI Publishing, 2007.

Underwood, Peter. *Death in Hollywood.* London: Warner, 1992.

Vera, Hernan and Andrew M. Gordon. *Screen Saviors: Hollywood Fictions of Whiteness.* Lanham: Rowman & Littlefield, 2003.

Vidal, Gore. *Dreaming War: Blood for Oil and the Cheney-Bush Junta.* New York: Thunder's Mouth Press, 2002.

Virilio, Paul. *War and Cinema: The Logistics of Perception.* Trans. Patrick Camiller. London: Verso, 2000.

Waegel, William B. "How Police Justify the Use of Deadly Force." *Police Misconduct: A Reader for the 21st Century.* Ed. Michael J. Palmiotto. Upper Saddle River, NJ: Prentice Hall, 2001. 217–231.

Waller, James. *Prejudice across America: The Experiences of a Teacher and His Students on a Nationwide Trek Toward Racial Understanding.* Jackson: University of Mississippi Press, 2000.

Wallis, Michael. *Billy the Kid: The Endless Ride.* New York: W. W. Norton, 2007.

Warren, Elizabeth. "The Vanishing Middle Class." *Ending Poverty in America: How to Restore the American Dream.* Ed. John Edwards, Marion Crain and Arne L. Kalleberg. New York, London: New Press, 2007. 38–52.

Wartenberg, Thomas. *Unlikely Couples: Movie Romance as Social Criticism.* Boulder, CO: Westview Press, 1999.

Wasser, Frederick. "Is Hollywood America? The Transnationalization of the American Film Industry." *Movies and American Society.* Ed. Steven J. Ross. Oxford: Blackwell, 2002. 345–359.

Waugh, Robert H. "The Butterfly and the Beast: The Imprisoned Soul in Thomas Harris's Lecter Trilogy." *Dissecting Hannibal Lecter: Essays on the Novels of Thomas Harris.* Ed. Benjamin Szumskyj. Jefferson, NC, and London: McFarland, 2008. 68–86.

West, Russell and Frank Lay, eds. *Subverting Masculinity: Hegemonic and Alternative Versions of Masculinity in Contemporary Culture.* Amsterdam: Rodopi, 2000.

Wexman, Virginia. *Creating the Couple: Love, Marriage, and Hollywood Performance.* Princeton: Princeton University Press, 1993.

White, Ray. "The Good Guys Wore White Hats: The B Western in American Culture." *Wanted Dead or Alive: The American West in Popular Culture.* Ed. Richard Aquila. Urbana and Chicago: University of Illinois Press, 1996. 135–159.

White, Susan. "Split Skins: Female Agency and Bodily Mutilation in *The Little Mermaid.*" *Film Theory Goes to the Movies.* Ed. Jim Collins, Hilary Radner and Ava Preacher Collins. New York: Routledge, 1993. 182–195.

Wiegman, Robyn. "Black Bodies/American Commodities: Gender, Race and the Bourgeois Ideal in Contemporary Film." *Unspeakable Images: Ethnicity and the American Cinema.* Ed. Lester D. Friedman. Urbana and Chicago: University of Illinois Press, 1991. 308–328.

Wilentz, Sean. *The Age of Reagan: A History 1974–2008.* New York: HarperCollins, 2008.

Williams, Linda. *Screening Sex.* Durham: Duke University Press, 2008.

Williams, Patricia J. "The Rules of the Game." *Reading Rodney King: Reading Urban Uprising.* Ed. Robert Gooding-Williams. New York and London: Routledge, 1993. 51–55.

Winchell, Mark Royden. *God, Man & Hollywood: Politically Incorrect Cinema from* The Birth of a Nation *to* The Passion of the Christ. Wilmington, DE: ISI Books, 2008.

Winkler, Martin M., ed. *Gladiator: Film and History.* Oxford: Blackwell Publishing, 2004.

Winston Dixon, Wheeler. "Fighting and Violence and Everything, That's Always Cool: Teen Films in the 1990s." *Film Genre 2000: New Critical Essays.* Ed. Wheeler Winston Dixon. New York: State University of New York Press, 2000. 125–141.

Winston Dixon, Wheeler, ed. *Film Genre 2000: New Critical Essays.* New York: State University of New York Press, 2000.

"The Wire: Arguably the Greatest Television Programme Ever Made." *The Telegraph* (April 2, 2009), http://www.telegraph.co.uk/news/uknews/5095500/The-Wire-arguably-the-greatest-television-programme-ever-made.html [last accessed July 7, 2011].

"The Wire Is Unmissable Television." *The Guardian TV & Radio Blog* (July 21, 2007), http://www.guardian.co.uk/culture/tvandradioblog/2007/jul/21/thewireisunmiss abletelevis [last accessed July 7, 2011].

Witherington III, Ben. "Neo-Orthodoxy: Tales of the Reluctant Messiah, Or 'Your Own Personal Jesus.'" *More Matrix and Philosophy: Revolutions and Reloaded Decoded.* Ed. William Irwin. Chicago: Open Court, 2005. 165–174.

Wlodarz, Joe. "Rape Fantasies: Hollywood and Homophobia." *Masculinities: Bodies, Movies, Culture.* Ed. Peter Lehmann. New York: Routledge, 2001. 67–80.

Wood, Michael. *America in the Movies.* New York: Columbia University Press, 1975.

Wood, Robin. *Hollywood from Vietnam to Reagan . . . and Beyond.* New York: Columbia University Press, 2003.

Woodward, Bob. *The War Within: A Secret White House History, 2006–2008.* New York: Simon & Schuster, 2008.

Wright, Tracy. "Visions of Apocalypse: Disaster, the Movies, and 9/11." M. Phil thesis. University of Birmingham, 2004.

Wyatt, Justin and Katherine Vlesmas. "The Drama of Recoupment: On the Mass Media Negotiation of Titanic." *Titanic: Anatomy of a Blockbuster.* Ed. Kevin S. Sandler and Gaylyn Studlar. New Brunswick, NJ: Rutgers University Press, 1999. 29–43.

Yeffeth, Glenn, ed. *James Bond in the 21st Century: Why We Still Need 007.* Dallas: BenBella, 2006.

Yeffeth, Glenn, ed. *Taking the Red Pill: Science, Philosophy and Religion in* The Matrix. Dallas: BenBella, 2003.

Young, Kay. *Ordinary Pleasures: Couples, Conversation and Comedy.* Columbus: Ohio State University Press, 2001.

Young, Marilyn. "In the Combat Zone." *Hollywood and War: The Film Reader.* Ed. J. David Slocum. New York: Routledge, 2006. 315–325.

Young, Michael Dunlop. *The Rise of the Meritocracy: An Essay on Education and Equality.* London: Thames and Hudson, 1958.

Žižek, Slavoj. "Reloaded Revolutions." *More Matrix and Philosophy: Revolutions and Reloaded Decoded.* Ed. William Irwin. Chicago: Open Court, 2005. 198–208.

INDEX

Note: Not listed in the index are:

film directors, cinematographers, producers etc. (see film title)

film characters (see film title or actor's last name; e.g.: Frodo: see *Lord of the Rings*; Wood, Elijah)

authors of scholarly literature (see bibliography)

CPSIA information can be obtained
at www.ICGtesting.com
Printed in the USA
LVHW080418210219
608204LV00012B/332/P